HANS NEUMANN

P9-CKS-655

Paul Jacques Grillo

FORM FUNCTION AND DESIGN

Dover Publications, Inc., New York

Copyright © 1960 by Paul Theobold and Company.
All rights reserved under Pan American and International Copyright Conventions.

Published in Canada by General Publishing Company, Ltd., 30 Lesmill Road, Don Mills, Toronto, Ontario.
Published in the United Kingdom by Constable and Company, Ltd., 10 Orange Street, London WC 2.

This Dover edition, first published in 1975, is an unabridged republication of the work originally published under the title *What Is Design?*, by Paul Theobold and Company, Publisher, Chicago, in 1960. The illustrations on pp. 206 and 207, as well as the diagrams on pp. 190-192, originally in color, are here reproduced in black and white.

International Standard Book Number: 0-486-20182-1
Library of Congress Catalog Card Number: 74-18717

Manufactured in the United States of America
Dover Publications, Inc.
180 Varick Street
New York, N.Y. 10014

The idea of this book came to me many years ago, when I created in an American University a new course on the Theory of Design, for young architectural students who totally ignored it.

This challenge fascinated me, as, to my knowledge, there was no manual in the libraries where the student could find a comprehensive guide to help him solve in a contemporary language the many problems about design.

In the old schools, students followed a training which was possible at the time when architecture —and design in general—was a matter of putting together elements copied from history books and re-copied from magazines, when the language was fake-Greek, fake-Roman, fake-Gothic, re-hashed sometimes into fake-Colonial. At this time, a completely untrained student could make his grade by carefully copying the right example from the right book. I remember the time when we, as students, were first given so-called "decorative" problems, because they were thought to be more simple, as they did not involve the structural problem of putting a roof on top, and as we were supposed to know nothing about structure in this first year. The first one was generally a *fountain,* or an *"exedra",* the latter always causing awe and respect by its title, as nobody knew exactly what it was. Such problems, however, are actually among the most treacherous of all, and can only be solved by an artist of mature taste and judgment who, in the last resort, may have to tell his client that, instead of a fountain or an exedra, he should build something else. But we did not know this in our candor, and obediently followed a method that was to put architecture in a rut where it was to stay for decades.

Since food, shelter, and clothing, are considered as the most essential needs of man, the art of making them characterizes the various civilizations on earth. This art is *design.* The greatest works are often the most humble. The efficient and simple beauty of man's working clothes and tools the world over is a constant cause of wonder. We can safely say that the windbreaker jacket and the Jeep did more for American respect abroad than the Marshall Plan. The art of native food, evolved from the direct products of climate and soil, is forever a sources of amazement and joy: a true American blueberry pie, a bowl of rice as only the Chinese know how to choose and cook it, etc. But design offers its greatest examples in the art of shelter, or *architecture,* because it creates the environment for living and thus makes possible the development of all other forms of art.

In this book, the emphasis will be placed on architecture, as it is the most universal expression of design, and as I am more familiar with the subject than with any other.

On the following page, I advise the designer to live dangerously. I think I followed this advice myself in writing a book in English, which is not my native tongue, and in asking advice from no one in regard to the subject matter of this book, its composition, and its final typographical design.

I must acknowledge, however, the precious help of my wife, who corrected the major mistakes in English, and in many instances placed right side up sentences which I liked to write upside down. The remaining weaknesses are my own, and I think I left them because I felt it sounded better that way.

This adventure in the American idiom has been for me a great enjoyment. It was a new experience in disciplining my inclination for long sentences born from my Gallic heritage, and also in having fun with the colloquial American tongue, even though I well realized that the thunderclap poetry of the front page of a tabloid in a day of international crisis, was beyond my reach.

In this dangerous enterprise, I should also—had I been more prudent—have left many avenues of thought without conclusion. A scientific mind may be irritated by my driving the reader at times to the end of a limb on a one-way trip from which he will have to jump on his own. But I believe that design is in such a mess today precisely because we fail to commit ourselves in definite conclusive statements about our thoughts. The "humble" attitude of the teacher who claims that he does not know himself the true answer to a problem— attitude which today seems to be fashionable at College level—is to me tainted with much hypocrisy. It is without any false modesty that I claim to have found some answers, and I believe it my responsibility to express them directly, even if my statements may at times sound somewhat dogmatic. In the course of this book, I venture also some excursions in areas of thought which may sound groundless today, as they are not—yet—backed with long experimental evidence. I propose them as hints to be taken by the student and the scholar. Some may prove worthless, but a few may prove valuable. If only one of those proves fertile in further development, I will feel amply rewarded by my suggesting it. To quote Descartes:

"And I hope that my nephews will be grateful not only for the things I have explained here, but also for those which I have purposely omitted, so that they find pleasure themselves in inventing them..."

P. J. G.

To a young designer

To you, anonymous hero knighted by the gods and entrusted by them to design the environment of mankind for the years to come, I dedicate this book.

In your years of school, you will desperately try to find your "way". And your search will be desperate until some day you discover that a school can only teach you how to learn and how to work by opening your mind not to one way of knowledge, but to the many ways opened by men of vision into the unknown territories of art—since it is true that there is an infinity of different ways to reach art, and that all are good, if they are authentic.

After your years of intolerance, you will find yourself some day left high and dry on a shore deserted of your dearest idols, with a bitter taste in your mouth. Because it is true that unless an artist believes in everything, he believes in nothing. Be ready to die for what you believe in today, but submit your idols to trial by fire, relentlessly, and keep only those which retain, through the ordeal, the original strength of their mettle.

You will also soon discover the vanity of saying of a work of art that it is greater than another work of art. You will realize that the humblest work may possess eternal greatness if it possesses sincerity.

When at length come your years of fullfillment you will find yourself alone, the only judge of your decisions, in the awesome position of the doctor at the deathbed of his dearest patient. No one then will tell you what can be done to bring life flowing again into what death is ready to snatch away. No one will tell you if you are right, or wrong. Even the experience and knowledge of your past years may be of no avail, as your only sure guide will always be your intuition.

Do not be afraid: either of your ideas, no matter how wild—or of the ideas of others, no matter how disturbing. Fear is the motive power of all intolerance, while no truly tolerant man can ever be afraid, and the artist must be uncompromisingly tolerant.

As a corollary to this, live dangerously. The mountain climber is only rewarded by the summit after having risked his life many times during the climb. Beware then of contracting too many insurances. Close your eyes to ads and magazines: don't ever forget that your work may make the magazines, but that the magazines will never make your work and may well destroy the faith you have in yourself.

Avoid brainwashing of any kind, commercial, social, political, religious. Don't let yourself be tagged by a leash of honour in "ism" that will make you one of the flock, but will blindfold you from seeing the beautiful lamb of the flock that happens to live on the next ranch. You, as an artist, must believe in everything, mostly in the

impossible. Don't ever forget that by your intuitive foresight you will find solutions to problems that seem impossible today, but which will become commonplace in the next generation.

Don't work for success, whether success to you means a degree, a position, money, or honours. You cannot reverse the process of nature: since no fruit in spring can produce flowers in the fall, you cannot visualize the harvest before the seed matures into a healthy, full-grown plant. A hot house may grow faster products, but none that can compete with the authentic product of the soil. This attitude will force you to give "no" for an answer more often than "yes", if you are concerned only with the integrity of your production. Then your "YES" will be uncompromisingly sincere. The worst lie is the lie you give to yourself as an excuse for success.

Burn your idols once in a while, and start all over again.

Art is not a process of feeling little wings grow in your back and grow and grow until they become angel wings and carry you smiling to a Heaven fragrant with sweet violin sounds and harps: when your wings start to lift you above ground, some good devil will know enough to clip them short, and you will fall and get hurt. Only through this succession of flights and falls will you experience art and grow in stature as an artist.

Often you will find your beliefs today in contradiction with yesterday's loves. Although your personality will never change, your vision of the world will. In your wonder trip of discovery through life, you will not rest in worship at the feet of only one idol, but will give to every new idol, as it passes by, a silent prayer of recognition as a thankful tribute to the enrichment it has brought to your mind.

Flout the rules as often as you can in a masterly way. Recipes are for poor cooks. Great chefs make them. The canvas of rules and codes that you have had to learn must be transgressed with vision for any art to be born.

Finally, during all your life as an artist, learn through painstaking experimentation, exercise, and practice, how to acquire a masterly knowledge of your craft.

As for your equipment as a designer, it is not costly: it will consist of your hands, your eyes, and your mind. These will be your most essential tools: they are all the arms you need as a young warrior in the battle of design. All shortcuts, mechanical and otherwise, are signs of defeat and inaptitude. Art is the highest form of athletics, and the greatest artists—a Beethoven, a Paganini, a Heifetz, or a Picasso— are among the most hard working "manual laborers".

Only through the constant practice of your grammar, your scales and arpeggios, vocalises and sketches, will you become articulate in your art.

All the rest is nonsense.

Paul J. Grillo

CONTENTS

PROPORTION

we all know what proportion means, but when can we tell if a certain proportion is good—or bad?

COMPOSITION

the intuitive decisions reached by the artist in his work are the expression of the cosmic laws that rule the Universe

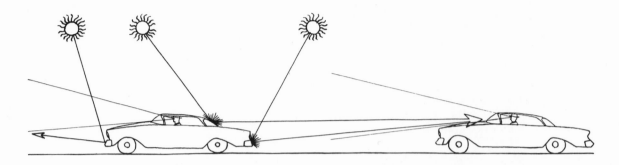

"Thinking of the eye gives me a fever"

DARWIN

When we think of the fantastic mechanism of vision—to see in full color, to focus instantly at any distance, to have split-second impressions changed in size, distance, color, and perspective—all this as a gift from nature, priceless, irreplaceable, unique. . .

And to think how we murder this magnificent instrument by poorly designed windshields, praising our own mistakes in that typical mumbo-jumbo big word high-pressure advertising copy, to persuade people that the purpose of a windshield is not so much to see through as to look "stylish".

As long as man exerts himself in designing strictly mechanical parts—motors, etc.—his design is at its best, as this kind of design cannot admit anything that is not absolutely necessary. But as soon as he designs the envelope of his machine, he seems to lose his common sense and take refuge in the language of the hat and fashion designer, talking "trend, style, line, etc."

This example shows what a serious impact design—good or bad—has on our lives. We submit ourselves everyday to murderous practices through bad design born of experimental "styling" while we would hesitate to submit our pedigreed dog to the same treatment.

Doctor Hits Wraparound Windshields

CHICAGO (CDNS)—An eye expert today called the auto wraparound windshield a "diabolical device" that ignores "all basic optical principles."

In an American Medical association symposium on auto crash injuries, Dr. D u p o n t Guerry of Richmond, Va., said it is an example of manufac-turers allowing "the so-called beauty of design to supersede the safe and functional."

The troubles with the wraparound windshield, from the eye doctor's point of view, are:

It presents a double vision to the driver from ghost images resulting from surface reflection, exaggerated by the curvature.

It causes the driver to suffer from visual distortion due to a prism effect.

It increases glare because of the focusing of light in the axis of the windshield.

Dr. Guerry, professor a n d chairman of the department of ophthalmology, Medical College of Virginia, said the "injudicious use" of chrome trim also contributes to the visual problem.

He also called for the AMA to help set up a committee of standards for driver licenses and to monitor studies to shed new information on ophthalmological causes of crash injuries.

Requirements for driver licenses in various states are a "hodgepodge," Dr. Guerry said.

introduction
to design

Design is everybody's business: we live in it, we eat in it, we pray and play in it.

And still the appreciation of design, good or bad, is considered as the privilege of the few. Our efficiency in work, our health, our nervousness or ability to relax—in a word, our happiness—for a great part, is at the mercy of whoever designed our surroundings, not only as homes, offices, and churches, but as equipment: from its lords—cars, refrigerators, stoves—to the most humble and precious of servants—the cup, the spoon, the lamp, the hammer.

This book is addressed to the public—you and me—abused day in and day out by all the bad design we have to put up with and suffer from in our lives. It is not only written in defense of the public against bad design, but also as a guide to the appreciation of good design, stripped of all hard pressure publicity or prefabricated smiles, cleaned from the dust of conventional thinking, shown in its athletic and wholesome simplicity.

It is only a question of opening our eyes to the extraordinary world around us. Nature has been lavish in good design. It is there for us to see, exposed in full view, within our reach at all times, without even moving from where we are.

Let us try to rediscover it together.

Design is not the product of an intelligentsia. It is everybody's business, and whenever design loses contact with the public, it is on the losing end. For the first time in history, there is today a total disconnection between art and the people.

When I say that design is everybody's business, I don't mean that design is a do-it-yourself job. I mean that it affects *everybody,* at *all times,* in *our lives.*

Unless we gain a better understanding of design, we shall witness our environment getting steadily

worse, in spite of the constant improvement of our machines and tools.

Take the instance of the airplane, a machine still pure, and the car, which is rapidly losing its self-respect as a machine since it has become a typical product of stylism:

In the making of an airplane, the fight is toward more simplicity. Everything not absolutely necessary, absolutely *vital* to the organism of the airplane, is shaved off, eradicated, cut out. Every rivet counts, as no one wants to add even one ounce of useless weight in the design of a machine planned for flying. Why such concern? Why has the airplane evolved so rapidly to become one of the most beautiful expressions of our time? The answer is simple: a pure necessity for survival. The airplane design is dictated by one criterium only: efficiency. Thus the airplane has become a model of elegant simplicity. No flourish of fashion has come to mar the honest purity of its design. The result is a design which achieves an organic beauty, a near-natural perfection that we can only find in living organisms. In this fantastic creation, man is slowly developing a new species of natural organism which becomes the first cousin of the other speed monsters designed by nature. The truly great designers arrived at their conclusions through the observation of nature: their masterpieces show close kinship of form and design with plants or animals which have a similar problem to overcome.

Let us see now what is wrong with car design:

Contrary to airplane design, the automobile carries in its characteristics a load of hangovers that the "stylist" cannot find the strength and honesty to strike out—or more probably is not even aware of. Why? because the car is a victim of fashion and habit.

First, the twin headlights are only a heritage from the buggy days, and obviously inspired by the

"Palomino",
the author's jeep

fact that we, human beings, have two eyes. But why do we have two eyes? Is it to see better to the left and to the right? certainly not. If this were so, our eyes, like the chameleon's, would be placed on either side of our heads—not in the front. We are thus equipped so as to have the perception of the third dimension, in *stereoscopic* vision. Does a car have stereoscopic vision? . . . With today's lighting technique, we could easily design a headlight for cars that would be a single central flat beam of light—possibly polarized against glare—where it is needed, on the road, and not as a blinding weapon. But instead, lights on our new cars have become as prolific as guinea pigs, breeding twins, triplets, and quadruplets, in front and in back, ever more powerful and blinding.

The *left driver seat* is another hangover from the time when cars were small (the superb model T) and could not seat more than *two* people in front—or in back. It is still true of most European cars. But look to what happened to the horse drawn carriage as it increased its dimensions: in a buggy, the driver sits on the side, while in the four-horse team stage coach, the driver, raised on his seat for better vision and control, is in the center of the front bench.

Then shall we talk about the *chromiumiana* and the *high gloss* enamels that transform the car ahead into a blinding hazard, and drives into your otherwise peaceful heart a racing rage to pass the blinding fellow ahead so as to enjoy your ride—until the next car moves ahead into the game. This also is a hangover: from the time when there was no possibility to make paint durable except by obtaining a high gloss. Today we can make flat finish paint, and the military use it in their equipment, for camouflage. If in the old times we had been able to have durable flat finishes, they would have

been adopted *by preference* to high gloss for reasons of good taste: is good taste a reason for car design today? no: mob preference dictates, catering to the hypnotic attraction that draws the child or the primitive man toward anything that shines.

Now I kept for the end the worse of the tortures invented by stylists to make a car ride, a nightmare: the wraparound windshield. Even with the coming of safety plate glass the deformation of vision on the side is dreadful. Here, the designer tried to copy the airplane, where the pilot is wrapped around in a plexiglass bubble that allows him to have total vision. The designer forgot, however, that the vision from a plane is completely different from a car: due to the great altitude, no matter how great the speed, the landscape is almost immobile—and also the pilot is strapped into place like an armored knight, in the very center of the bubble.

The Jeep is the only American car which has remained true to its purpose, and has not basically changed its design through stylism for the last twenty years. Like in an airplane, every piece of design in this machine is absolutely indispensable for its performance. This may explain why, alone among all other American makes of automobiles, the Jeep still imposes international respect through this total fullfilling of its purpose, without the least compromise to fashion.

Design requires a constant remodeling of our ideas as it must adapt its language to new possibilities offered by new structural materials. We used to talk architecture in terms of columns, beams, and walls. Today, we talk of surfaces, of forms like egg shells, that we can build without yesterday's crutches of columns, beams, and walls.

However, we are so saturated with columns and walls that a thing built still means columns and

Vertebra found on a beach,
Bahia de San Jorge, Mexico

walls to us. We are shocked by what the best designer puts up today. We are intrigued—yes—as we would be by some acrobatic circus act, and we keep asking ourselves: "Is this design?"

The world has not been aware of such radical possibilities in building since the invention of the brick. For the last five centuries, architecture has only been a series of variations on the Greco-Roman and Gothic themes. Our libraries, post offices and railroad stations, are enlarged carbon copies of antique temples. Churches have become photographically reduced cathedrals. We gradually have become such addicts of the habit-forming drug of monumental history that we cannot take the fresh air of the open spaces created by the athletic structures of today.

But when we analyze good contemporary design, we should acknowledge the fact that its language of form is much less foreign to us than the architectural wardrobe our ancestors used to wear. We see these "new" forms in leaves—everyday—in trees, flowers, or fruit. We treasure them on the beach as beautiful shells and stones rolled by the waves.

The designer today is offered more than ever before the opportunity of falling in step with the world around him.

Design is an end in itself. It is the achievement of man's logic in adapting his creations to his natural environment and way of life.

Machines rapidly become obsolete because they represent only a small and temporary part of the solution to a problem, and as such they are all a somewhat awkward expression of man's ignorance. The more learned and experienced man becomes, the more new machines he builds to replace the old ones, but no one can ever attain complete replacement, as the perfect machine would annihilate all other machines and render them all useless—and no machine can approximate nature's perfection, even in a small detail like the eye.

Each true work of design should be a complete achievement in itself. It should be a permanent solution that cannot be duplicated either in time or space. Each design is unique and deserves the same amount of respect regardless of size, cost, or location. Whether it is a rice bowl, a cobbler's bench, a wooden plough, the temples at Ise or Saint Sophia, it is in itself a total and admirable lesson.

Design involves all of man's creativity. He prices it according to certain values dependent upon relative standards of style, taste, and efficiency. In the great confusion that today covers the appreciation of good or bad design, a general reassessment of these values is necessary. In this highly organized society we have become the victims of two impulses which have gradually taken over one of our most precious prerogatives: Freedom of Choice. *Inertia* and *fear* control our daily lives, our thoughts, and our acts.

We have fallen into the habit of buying everything (whether material or spiritual) under false standards, and are apt to mistrust our good judgment under the psychological pressure of advertising, public opinion, and routine. We daily deny the sacred privilege of man to decide of his free will upon the things that most really matter in his life.

We no longer distinguish clearly between what is truly of importance—and what really does not matter. This disease of the personality has even reached our physical well-being, as we let ourselves be fooled daily under the false pretense of food artificially colored, gelatinized, and flavored.

The pulse of the disaster is best felt in supermarkets.

I recommend as a fascinating and most revealing

This 1888 bazooka-like typewriter may seem somewhat outmoded by the electronic typewriters of the year 1960—which in turn will look just as cutely prehistoric to the world citizens of the year 2000

You may buy this eternally contemporary piece of design in any authentic Chinese hardware shop

exercise to pay a visit to one of these institutions about once a year to witness the evolution. For instance, I have gradually witnessed the transformation of the shrimp, first guillotined for packing, then shelled for comfort, and finally deveined, I suppose because bowels are considered unsanitary. This simple example shows the three main impulses that combine into the making of what we glibly call progress: *first,* the integral beauty of the natural thing is defiled and marred. What artist has not spent delightful and inspiring hours in an honest to goodness fishmarket in places or countries where these mutilating practices are yet unknown? This "off-with-their-heads" policy is only one instance of the transformation of a product for the purpose of easier packing. *Secondly,* the product is shelled—or pitted, or pre-chewed—for comfort. The law of least effort is used as the main impulse for buying: it tends to make everything so easy that we can have no fun any more in cutting our fingers with oyster shells or develop a skilful and strictly personal way to carve a chicken. *Thirdly*—and this is part of the prudish complex—the unmentionable is eradicated, and what is left of the little corpse is embalmed, colored (artificially) and offered to the crowd as a non-shocking object exposed in its silk-lined coffin.

I was told (and Aldous Huxley wrote unforgettable pages on the subject) that some funeral homes in Hollywood have achieved fame through the practice of showing the deceased properly propped up and painted, nonchalantly "asleep" in a chair. And the good people around rejoice with just the proper amount of sadness and electric organ tremolos:—"How rested and well he looks!

He even is smiling in his sleep." What have we done to Death, the Great Unexpected, the Unknown, the Here-After—to crowd it as a paradise of painted corpses!

This is very much like the crabgrass story. Millions of dollars are spent every year to eradicate this wonderful lawn material, *the* authentic American summer grass which does not need watering through the fiercest drought. Why is it not accepted as the great gift of nature to America's torrid summers? Why don't we like and treasure it? Because it dies in the fall so as to let Winter—a mighty Great Person too, like Death—ride in, in all its awesome magnificence. The truth is that we are today overcome with fear. We cannot face any more the total poetry of reality.

I suppose it is not too clear to realize exactly what it is that our children lose by thinking that shrimps are born headless monsters, until we start tasting one of the untouched thoroughbred fruit forgotten by Mr. Burbank in some remote valley of Czechoslovakia or Normandy, like the extraordinary *mirabelle* plum that our pioneers reverently imported from Germany, and of which we still find a few trees standing and producing in lower Michigan: the pit of this one inch plum is rather large and the skin so thin that it is completely unfit for packing, but its flavor is divine and, like a true thoroughbred, does not make you think it tastes like something else. Try now one of the plums "ameliorated" and hybridized through the scientific care of Mr. Burbank's Japanese disciples: go to the supermarket again, our reference encyclopedia of food progress. Once taken out of their traveling coffin, these unpalatable, small-pitted, leather-skinned

cosmeticized fruits can keep for weeks on the shelf without rotting. They stare at you with the arrogant indifference of well-painted prostitutes and seem to say: "Who cares if you don't pick me up? Someone else will come along and pay the price, the fool!" This feeling certainly does not occur to you when walking through a good old-fashioned fruit market (we still have such old under-developed things right here in our farmer towns). The native plums sold by each farmer are all different. Some have reached the degree of true ripeness, through sun and storing care, like those French grapes that make the sauternes: what the vigneron calls the "pourriture noble" (the aristocratic rot) where the fruit is at this extraordinary stage of total fulfillment that makes it unripe one hour before—and rotten one hour later. In these small commercial ventures, we can *choose* freely and thus exercise our appreciation. In the supermarket, choice is no longer our privilege as we have abandoned it to the hands of "experts".

Then we also have the exotic mongrels: the nectarine. for instance, which tastes like an apricot—or is it like a plum?—etc. It seems that the apex of art and good taste is reached when we can say of a product that it reminds us of something else. Is not this very close to the common reflexion that this flower looks so beautiful that it is "almost" as beautiful as an artificial flower—or this landscape so beautiful that it reminds you of a beautiful kodachrome?

American taste pleasures have been modified by packing industries. Why should we be obliged to buy boned and skinned sardines? Why should we be obliged to accept only food presented as a soft pulp: bleached bread, gelatinized salads, ready-made "sponge" cakes, hamburgers, "wienees" or pitted dates have become food for people educated by industry not to need their God-given teeth. No wonder we find ourselves extolling the virtues of Chinese or French cooking, whose culinary art takes into consideration the necessity of contrast in consistency to make food more palatable.

The ironic twist is that this movement developed from an interest in man's health. Natural foods such as milk have been stepped up with vitamins. The flour, bleached for beauty and chemical purity, has been made "impure" again by adding health-giving vitamins and mineral salts.

This antiseptic philosophy starts at birth when the parents of new-born babies are forbidden to touch them except across a glass pane in the hospital nursery. It grows and controls our lives until the expert must decide for us in the most important crises of our lives. Marriage may still be our only freedom left, but for how long? Eugenics might soon change even that.

We have gradually become enveloped by a shroud of fear that does not necessarily express itself in sharp panic moves, but which has its most evident manifestation in the appalling amount of insurance people take out, to protect every move they make. The increase of new religious sects and churches—mostly in Midwestern America—is generally praised as a good sign of the time. But is it not another manifestation of the universal search for security? It is very much the same phenomenon that happened just before the year 1000 AD. Europe then covered itself with churches, as self-appointed prophets declared that the year 1000

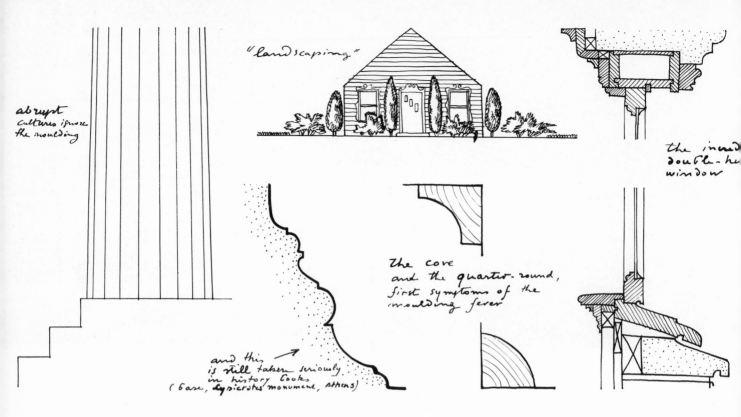

"landscaping"

abrupt
cultures ignore
the moulding

the incised
double-hung
window

The cove
and the quarter-round,
first symptoms of the
moulding fever

and this
is still taken seriously
in history books
(base, Lysicrates' monument, Athens)

would surely mark the end of the world. People felt they had to insure their souls with an after-death insurance policy. Today, we have the warning signs along the highways in the Midwest, that read, "Be prepared to meet thy God", or, "It is later than you think", or other expressions of impending doom. This fear instills belief in a threat that everything is going to end for us on earth—through the H Bomb or otherwise—and that it is more important to think of ourselves after death rather than as live beings here on earth.

This psychosis of fear, used as a means of religious proselytism, is indeed contrary to all the teaching of the great religious leaders of mankind. "Be not afraid" is a precept of the founders of all contemporary religions as a reform of the fearful rites of the Old Law. We find this over and again in Jesus' words (Matt. *15:7, 27; 17:7,* etc.) and it is the first commandment of Buddhism. Bravery —considered as the religious expression of a total lack of fear—is the most powerful and durable characteristic of the way of life of the American Indian, the *Brave.*

As a result, the false security obtained by means of insurance contracts for this life and the hereafter induces a feeling of complacency and right-eousness that is a typical trait of our American civilization today. We have a false sense of superiority in claiming the rest of the world at large "underdeveloped" because most of them ignore the washing machine and the car. We feel we must

proselytize the world to our "advanced" civilization. We still consider as "barbarian", people of such civilizations as the South Sea Islanders or the Congolese, the Turks or the Japanese, while in the secret of their hearts the designers, painters, and artists of the "Western" world envy and find their inspiration in the superb artifacts designed by those we call the "primitive" people. A visit to the Field Museum in Chicago, or to any Natural History Museum where such design treasures are displayed, is the most powerful lesson in humility that our inflated ego so badly needs.

The *fear complex,* with its complement, the *security urge,* can be considered as the pathological syndrome of our civilization. In the field of pure design, it reveals itself in many ways:

For instance, the fear of a clean meeting of the vertical and the horizontal may be traced as the essential reason for the *moulding,* which tends to *prolong* the visual time when the design, from vertical, will become horizontal. The base of all classical columns stems from this psychosis. Abrupt cultures ignore the moulding; their columns have no base, their monuments, no pedestal. The resulting effect is a Spartan directness that knows no nonsense. Such frankness may be hard to take at first, so much have our eyes been soft-cushioned with Renaissance padding, but we could soon learn to appreciate the honesty of a design which refuses to betray its message with "decorative"

Iceberg in the North Atlantic

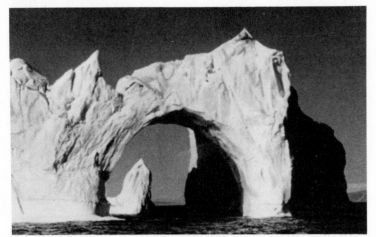

North west corner of home designed by Grillo. The pecked cypress siding boards are mitered without any moulding or "protection". Photo taken in 1959, after 5 years of exposure

compromises.

Our window sections show what fear may do to design. For fear of letting one drop of water enter from the outside to the inside, the detailing of windows has become more and more absurdly complicated—one moulding being added to another one to check the possible leaks that the first one may not have caught. This is very similar to what happens to a government struck with spying fever, or to an organization which ceases to rely upon personal verdict to evaluate an employee, judging people according to files made by others: the investigator in turn has to be investigated—and so on as a chain-reaction until nobody knows too well *what* is being investigated in the first place. It is current practice for a man who holds an executive position to receive from other organizations "confidential" inquiries on a prospective employee. This amounts to saying that an executive today no longer dares to trust his own intuition through a direct interview, but must rely on the remote control practice of a security files system compiled by others. This abdication of personal *judgment* in the hiring of personnel is a disastrous weakness which has invaded all facets of labor at all levels. Insisting on written triple-A credit (moral or otherwise) from hired personnel, in the end benefits the mediocre and rules out of the game the unusual man of character who may fail in some areas and be extremely brilliant *in what he is really needed for.*

Another common manifestation of fear in de-

sign is shown by the usual "landscaping" around the average home. The few selected shrubs (always the same kind, for fear of being different) are placed all around the house, like faithful watchdogs, hugging the walls tightly so that nobody may have a chance to see where the wall actually meets the ground. This is like trying to butter the sides of the wall with vegetation so as to soften the dreaded right angle by rolling up against the house an outdoor moulding of evergreens.

In music, we all are familiar with the endings of so many symphonic works which seem never to end: repeated chords on various rhythms that prolong the dreaded time when finally the music shall have to come to a stop. An abrupt ending may sometimes shock us, but why should a man keep talking when he has said what he had to say?

☆

This long diversion may seem out of context in an essay on the subject of Design. But we must realize that design does not stop at the form of a chair or the shape of a column. Everything man *makes* is design, whether with material as hard as granite or as elusive as thought. Design controls our whole life—our whole happiness depends on it. The human race is in danger of losing its wonderful diversity as it is put tighter everyday into the straight jacket of conformity.

We no longer can choose.

Do our gains balance our losses?

15

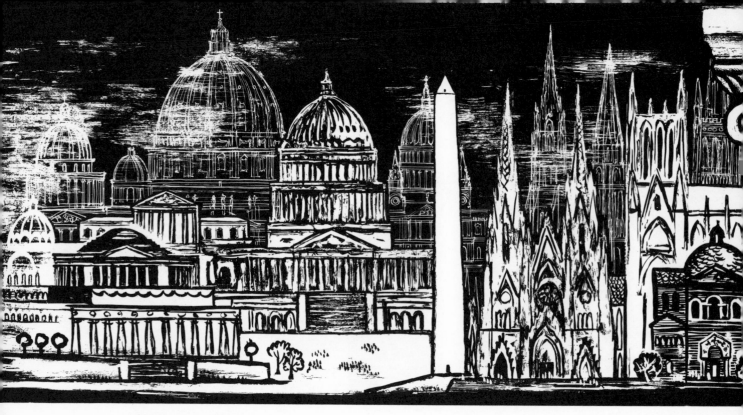

Relics or derelicts?

THE FETISH OF REPRESENTATIVE EDIFICES

Since the so-called Renaissance and mainly during the nineteenth century—the century of archeological discoveries and neo-medieval romanticism—the western world has become cluttered with carbon copies of antique and gothic buildings, blown up into gothic monsterpieces or what Guadet called "utilitarian parthenons".

A strange thing happens to public opinion when such buildings are discussed: they have gradually become so associated with what they represent that the public would not even think of discussing them without a feeling of acute guilt akin to lèse-majesté. For them, such buildings are to be left out of discussion and blindly admired because they house a sacred institution. We are still living with this taboo in mind, still building "gothic" and "colonial" churches—and columnated federal buildings with balustrades for the pigeons to enjoy.

A devout person will cease to criticize a church as a building once it becomes occupied by the Di- vine Presence. It has suddenly become the House of the Lord. By the same token, no one would any more think of criticizing the Capitol of the United States or the Lincoln Memorial than what and who they represent. But if we wake up from our routine thinking and try to find some reason for our blind admiration, we have a hard time to reconcile the rugged pioneer personality of Abraham Lincoln with the coldness of a make-believe Greek temple, or to imagine that a cross-breed between the church of St. Paul in London and the Pantheon in Paris blown up to St. Peter's size and sprinkled with detailed Roman splendor—could seriously represent the young American republic.

Our minds have become saturated with the chloroform of historical and sentimental associations, paying the same respect to the container as to the content—to the imitation-genuine-leather box as to the gem.

They say: such is the taste of the public, and we have to give them what they want. It is considered smart today, and wise, by manufacturers of new products, to accept a submitted design only after elaborate statistical tests where the reaction of the so-called public to the given product is graded. If the test shows that 60% of the people prefer red roses on their waste-paper baskets, then red roses will be painted on the whole crop of baskets. It makes one wonder what kind of a statistical approach was used in the times of horse and buggy, of the log cabin, and of the Cape Cod mariners. Where was the "stylist", then? This generalized commercial weighing of the taste of people is in reality a permanent insult to their mentality. It is taking the public for an old and disabled man who is not in his right mind and can pass away at the first shock, and therefore should be spared shocks of any kind. This fostering of man's weakness and ignorance is the most degrading attitude toward grown minds that our civilization is subjected to.

AND THE EVIDENCE OF THE FALSE WITNESSES

In the trial for design, all kinds of false witnesses come to testify. They follow in the wake of industrial progress as surely as commercials in the wake of a good TV show. They would sell anything, as long as it "moves", and to do so, they have only to draw from the gold mine of conservatism.

To conserve, in French, means to can goods. And there is much of the art of the embalmer in the mummification of the details of our ancestors' surroundings into tidbits of commercialized design, offered under stock plans for your home—number X168—in the "style" of your choice.

What in design is really only silent admission of defeat, lack of imagination, and fear of the so-called public opinion, is glamorized under high pressure advertising into *the trend*. To keep up with the trend, we want to have our little modernized colonial pocket-size mansion, with a porch crowned by a balustrade which no one will ever lean on, as there is no way to get there. Or, if the trend is "modern", we will crash open our home with picture windows even if they should look at next door's picture window 20 feet away.

But is this really what we want? Are we not the victims of the false witnesses who try to convince us that we have such idiosyncrasies, that we are weak-minded and fit for the sanitarium?

There is another kind of false witness, the counterfeiter, who sells us false goods for good money. How would our grocer react if we decided to pay our purchase with dollar bills exquisitely printed on wax-paper? We would have a hard time to convince him that wax paper is an excellent material for this purpose. And still, we cover our homes with shingles made of cardboard, stone made of concrete, and accept our fancy station-wagon with photographic decals of wood on steel that look exactly like birch—but *who* are we trying to fool?

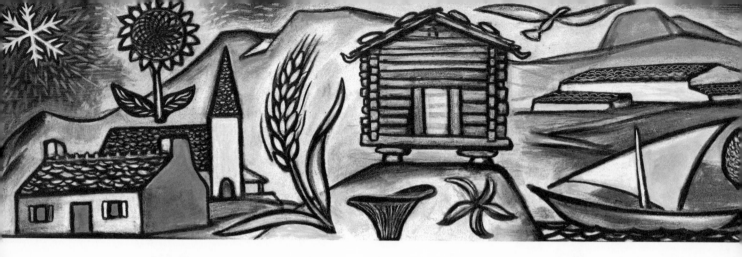

THE ARCHETYPES

This type of design is rarely recognized as such.

It consists of all the homes, farms and arti-crafts designed by peasants and villagers the world over, by the little people composed of ingenious craftsmen and shrewd practical men who have sharpened their wits and common sense in working out logical solutions to the many problems involved in living close to nature. To survive, their mode of living had to be in symbiosis with natural life. Their buildings had to be designed as natural shells to protect and help their way of living, just as forms of nature had to adjust their design to the conditions of their particular environment in order to survive.

As a result, we have an infinite variety of basic designs keyed to the natural conditions that surround a group of people living in the same region. They represent the sum of the in-

THE TWO
FACES OF
DESIGN

THE MASTER WORKS

The character of every civilization has expressed itself in master works that have become identi-fied with a particular nation and the various phases of its history:

The Pyramids mean Egypt just as the Rome of the Emperors is symbolized by the Coliseum —the Rome of the Popes by St. Peter's—France by the Cathedrals—Greece by the Parthenon or China by its pagodas.

They are what we are accustomed to call Architecture, with a capital A. We are not yet used to seeing in them an extension of the arche-types, and we are baffled by their apparent com-plexity. Their art often seems way above our comprehension. So we admire them traditional-ly with our heads more than with our hearts, taking for granted most of the time the written word of art critics and guide books, without daring to analyze by ourselves what makes them really great—or not.

These works reflect the social character of the life of a country. They can be classified into

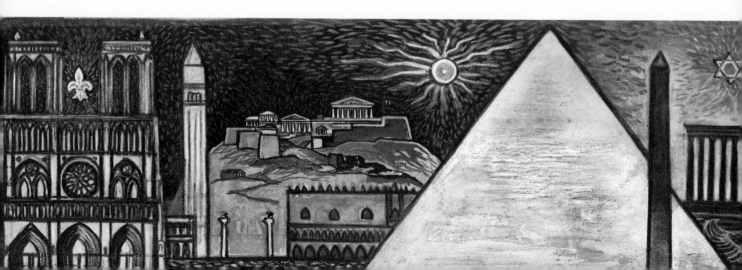

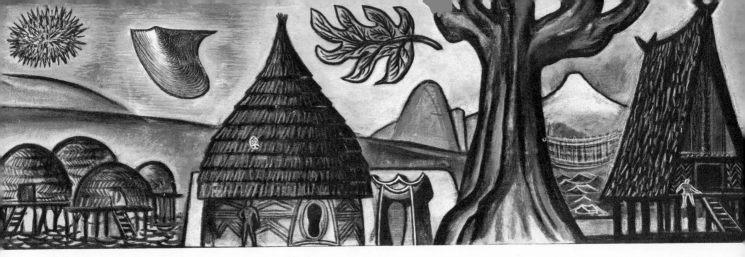

genuity and wisdom of the people. As such, they rarely show individual solutions, but group solutions that characterize a certain region of consistent climate and soil conditions. This geophysical unity precedes and commands their organization into nations.

As would be expected, this type of anonymous design shows identical solutions in countries separated from each other by half of the globe and in people separated by thousands of years. It shows that art is the common denominator among all civilizations, regardless of difference of language or degree of evolution.

We cannot expect to be a master designer before first learning all we can from these elemental conceptions, just as a navy captain must first learn the elementarty rules of sailing before commanding a destroyer.

categories of building-types, according to the different social activities they shelter; in dictatorial times they speak of dictatorship. A nation whose social foundation is the tribe, expresses itself differently from another country whose social pattern is in the form of a federative state.

Like milestones on the road of history, the Master Works recall the trek of a civilization through the ages. Appreciation of their value calls for a thorough understanding of the time when they were done and requires that our minds be projected into that time by some kind of difficult acrobatics. It explains why their true appreciation is so rare and so honestly difficult. They are to the Archetypes what classical music and Bach's cantatas are to popular ballads and songs.

The study of art, restricted to a photographic survey of the Master Works, brought about the age of eclecticism, while we will find in the study of the Archetypes a live spring of eternal youth, forever contemporary.

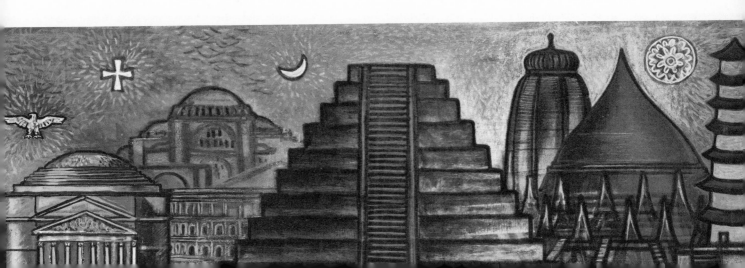

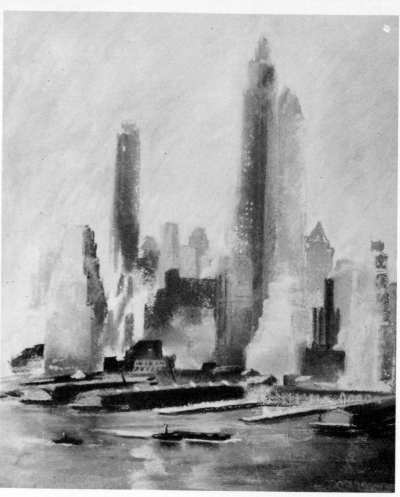

Lower Manhattan, from
Brooklyn

CHARACTER

IN DESIGN

Character in men as in buildings is a rare quality. It places them apart from the crowd of style-mongers and fashionable cliché-followers who have always made up 99% of the yearly architectural crop of mediocrity.

Throughout the centuries, if one building emerges from the sea of average architecture and asserts itself with a strong personality, we say that it has character.

This quality most difficult to define is two-fold:

1. It can be the result of an unusually perfect fulfillment of a program, and possess then what we might call the group-character of a building type: such buildings could not be tagged as anything else but a school, or a hospital, or a church. Character of this type is what is most frequently found in the best of the yearly crop;

2. But at times, a thing built asserts itself above any limitation of group building type. It has crossed some kind of design barrier where we cannot weigh it by the same values as we usually do. Not only does it fulfill its program

completely and carry throughout its design unity in form and material, but it also hugs to the site like a live animal and gives the impression that it has been there since the beginning of time. It claims program and site with such authority that it would be impossible to imagine the same site without it. Not only does it belong completely there, but it has also achieved the total anonymity of a great work of nature.

Such are a few of the great cathedrals, or the Pitti palace, Angkor-Vat, Mt. Saint Michel, or extraordinary ensembles like Bruges, Ispahan, or Lower Manhattan.

In analysing such master works of mankind, we find that detail becomes unimportant, just as we know that the trite passages in Beethoven's Symphonies do not matter.

The study of such rare gems obliges us to go beyond the detail, and to cast our judgment on the whole opus, from aloft. It is in itself a rewarding exercise in architectural appreciation, even when we have to do it by looking at reproductions of the monument—and not "in situ".

night view day view

A thing built reveals the personality of its patron. Any building or monument is the trade mark of a society and shows whether it was built under a ruthless tyrant or by the people of a peaceful country.

A World Fair always offers an excellent opportunity for judging the true personality of various governments, which reveal their character in concentrated pill form, as each one tries to express itself in the smallest possible space.

In the mystery of night rises a stone tower as cold, aloof, and inhuman as steel. The classical details of its design are intentionally so distorted that they no longer can be called pilasters, cornices, or capitals; they are more like lances that hold a dais carrying the Eagle like a trophy and symbol of imperial power. The Wagnerian Night was the stage setting for Hitler's huge crowd spectacles, and his torchlight parades that kept crowds of millions spellbound under his black magic.

But once stripped of its theatrical mystery by daylight, the tower is nothing more than elongated proportions, sterile symmetry, and a pretentious attempt at gigantism

German Pavilion, Paris
World Fair 1937

World Fair 1937
Italian Pavilion,
Paris
World Fair 1937

The Italian pavilion was built at the time when Mussolini's power had reached its maximum and was already showing signs of decline. The oversize architecture is not only pompous, but also devoid of imagination and boringly static

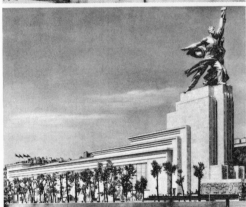

Russian Pavilion,
Paris
World Fair 1937

The Russian product, on the contrary, seems to move forward like an awesome tidal wave pregnant with all the dynamics of world revolution. The brutalism of its message is displayed more like an advertising promotion than a courteous statement of stable independence. As for the design, we find it very difficult to give it any scale: is it a building, or a souvenir paper-weight sold in a curio shop?

Netherland
Pavilion,
Paris
World Fair 1937

Holland is not trying here to impress us with a political dogma: in good business fashion, it has provided for an unpretentious shelter, by its welcoming low arcades intriguing the visitor into some kind of homecoming. On the softly curved wall, a schematic map tells us where their wealth comes from—the East Indies—and the means of going there

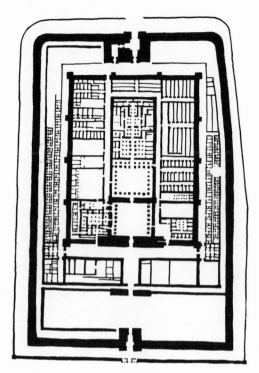

Temple at Medinet Habu

theocratic

Like a gigantic safe, the armored walls of the temple protect the awesome inner sanctum through their successive enclosures.

The entrance doors are not gates but intricate locks, easy to defend, impossible to break. Except for a few initiated, the mystery inside is total, the power of the Deity, boundless

When we walk around, we see the outside of buildings: *façades.* We appreciate architecture by judging façades: we don't see plans and fail to realize that façades only express the plan and directly result from it.

This fact is most responsible for the general lack of interest in architecture by the layman, as he feels it is chiefly made of *plans* that he does not understand and that should be left to the "expert" for discussion. It explains also why the great majority of books on art criticism that deal with architecture for the layman, show very few plans and base all their arguments and descriptions on façades and details of style.

Have you ever seen a postcard of any famous building showing a plan?

The kind of government that rules a society is revealed even more clearly in plans than in façades. The three examples shown here represent masterworks from three characteristic types of government: 1. the mysterious and absolute ruling of a deity—or theocratic government; 2. the theatrical display of power and total symmetry that is the expression of a dictatorial gov-

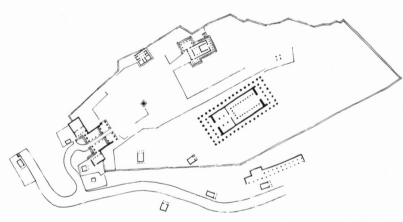

democratic

The Greek plan is organically distributed around a center of gravity, as are the vital organs of the human body within the chest cavity. Under the seemingly carefree and chaotic plan lies a thorough understanding of the flow of action and a humble and poetic obedience to the site and the contour of the land. It breathes independence and freedom, as well as respect for Nature's masterwork

The Acropolis, Athens

ernment; 3. the wandering fun and freedom of the individual that make a democratic government so dear to our hearts. Outside of this direct information about the character of a society and its patrons, these plans can also tell us a great deal about the system of construction, their roofs, and the façades they belong to, if we care to study them even superficially.

Reading a plan requires a certain kind of mental gymnastics that is great fun. After a while we may design façades as suggested by a plan, and come to realize that there are not many different solutions for a given plan.

In analyzing these typical plans, the first thing that strikes us is their different language of forms: the Greek plan, as well as the Egyptian, ignores curves. Their forms all belong to the rectangle family. This is trabeated architecture, using only lintels and columns, without vaults or arches. We can already see one very important reason why the areas in trabeated architecture were generally of rectangular forms and joined each other at right angles: If we try to cover these areas with a two sided roof, we will see that it makes the simplest intersection.

The Roman plan shows a combination of both trabeated and vaulted architecture, expressed in plan by the rounded forms and the thicker walls wherever there is vaulted masonry. We can also read in the Roman plan the spaces covered and the open spaces. For instance, (b) represents a circular court and not a half dome: we can easily deduce this from the thinness of the walls of the arcade that runs around the interior. On the contrary, (a) represents a half-dome, as shown by the thick masonry all around: these walls in turn are decorated with niches. Once we know the relation between the inter-column space and their height (we shall see later that this ratio was fairly constant and based on the module—or radius of the column) we can build sections and façades on either plan that will make sense and not be very different from what the originals were.

With the coming of reinforced concrete and the possibility of making weatherproof terraces, the plan evolved into what we will see later as the "extrovert" plan of our time.

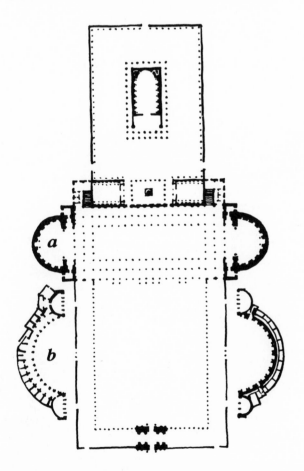

The imperial Forum of Trajan

dictatorial

The Romans, a people of engineers, soldiers, lawyers and merchants, counted few poets. Their total disregard for the beauty of natural sites and forms turned planning into bulldozing. Design became a man-made formula, no longer a poetic understanding of natural environment, no longer a search to belong—but only an arrogant claim to the right to destroy the divine order of nature. The sensitive Greek συν μετρον, meaning balance of form, was changed into the absurd Piranesian *symmetry,* meaning mere duplication of identical forms on either side of an axis. This architecture, ordered by an absolute ruler and built by slaves, rigid and devoid of artistic freedom, was the candid signature of totalitarian power. Roman design in its early republican times however, possessed a delightful freedom: the original layout of the Forum Romanum, fairly respected through the following centuries of imperial rule, shows this clearly (see page 214).

This pretentious type of planning was never more unbearable than in the verbose little-grand-plans of the nineteenth century, not even excusable as authentic products of a totalitarian government, but boasting on the contrary of expressing a democratic society

23

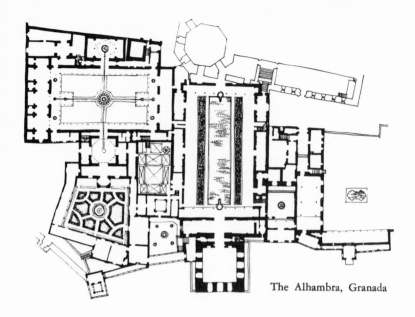

The Alhambra, Granada

In contrast with the democratic open plan of the Greek, athletic in its open spaces and welcoming to all; in contrast also with the Roman plan designed to show off power and stress military organization—both extrovert philosophies of living—we find the introvert medieval plan.

Whether Moslem or Christian, the medieval plan looks inside, for meditation and privacy, in search of isolation from the outside world.

The first reason for such introversion in plan was naturally the necessity of living within protective moats and walls as a defense against the insecurity of the times. It stemmed from fortified planning, and freed the design from the dictatorship of Roman symmetry. The plan became a natural microcosm within an irregular enclosure and by bringing direct relations between the various elements of planning, it paved the way for contemporary functional design.

The medieval plan is a complete organism self-sufficient and self contained within a protective shell of natural defenses, so formidable against the means of attack of the times, that the design inside this shell could safely assume total freedom.

the Abbey of Citeaux

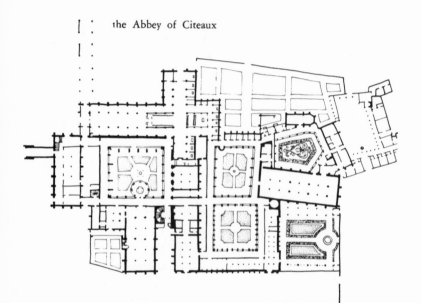

Naarden, Holland

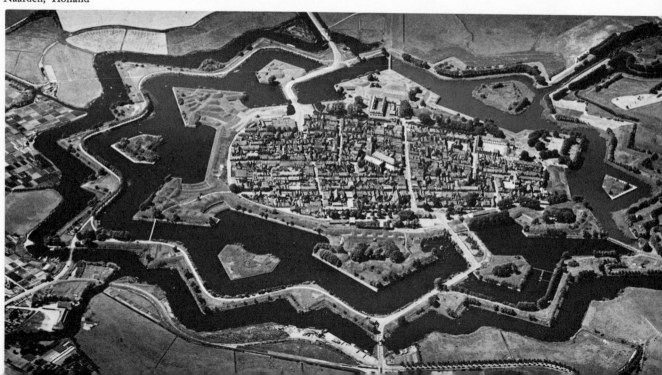

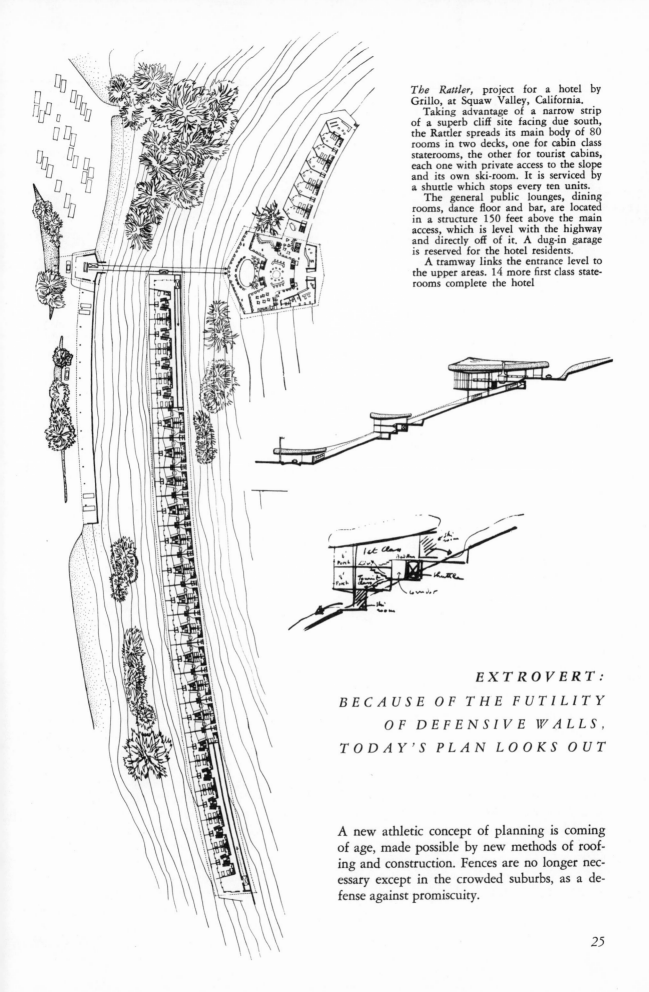

The Rattler, project for a hotel by Grillo, at Squaw Valley, California.

Taking advantage of a narrow strip of a superb cliff site facing due south, the Rattler spreads its main body of 80 rooms in two decks, one for cabin class staterooms, the other for tourist cabins, each one with private access to the slope and its own ski-room. It is serviced by a shuttle which stops every ten units.

The general public lounges, dining rooms, dance floor and bar, are located in a structure 150 feet above the main access, which is level with the highway and directly off of it. A dug-in garage is reserved for the hotel residents.

A tramway links the entrance level to the upper areas. 14 more first class staterooms complete the hotel

EXTROVERT:

BECAUSE OF THE FUTILITY

OF DEFENSIVE WALLS,

TODAY'S PLAN LOOKS OUT

A new athletic concept of planning is coming of age, made possible by new methods of roofing and construction. Fences are no longer necessary except in the crowded suburbs, as a defense against promiscuity.

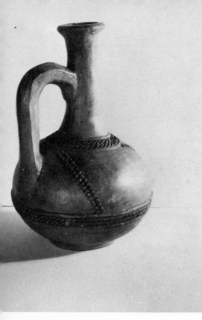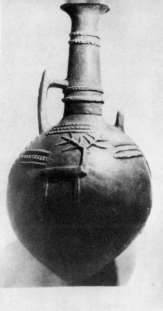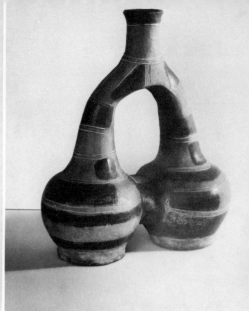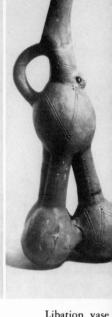

Pitcher from Libreville,
Gaboon, West Africa.
Contemporary

Pitcher from
Vunus, Cyprus.
Ancient bronze period

Ritual vase from
Libreville, Gaboon,
West Africa. Contemporary

Libation vase
from Vunus, Cyprus.
Ancient bronze period
(circa 2500 B.C.)

The recent articrafts of natives from Equatorial Africa show a remarkable similarity
with the Cypriote earthenware, made during the third millenium B.C. by the an-
cestors of Greek culture. The craftsmanship is identical. The design shows a similar
answer to a similar problem.

The three-legged pitcher from Cyprus, like the two legged design from Africa,
is designed in this shape so as to prevent the evaporation of the precious liquid
inside. We find the same kind of design in Pre-Columbian earthenware of the
Peruvian desert. The liquid was probably not water, but some kind of wine used
in religious or funeral rites.

On the contrary, the two other containers are designed *for* evaporation of water
through the unglazed pottery, to cool off the liquid. These and other similar un-
glazed pitchers are used today in desertic and hot climates all over the world

FUNCTION IN DESIGN

What we proudly call our age of technology is
in danger of being known by the historians of
the future as the age of plumbing, if we continue
to define function in design by bathtubs and
washing machines.

True functional design has very little to do
with what we call progress. In fact, it seems to
be in reverse proportion to the degree of mate-
rial progress of a civilization.

Nowhere is this more evident than in the de-
sign of the simplest and also most necessary
tools of everyday life. Handles of tools designed
by stone age people show a better understanding
of function than what we buy in stores today.
The subtle changes in the form of containers
daily used by the family of man show the direct
functional reason for what we have come to
think of as a matter of style. Every one is de-
signed to be handled in a certain way, the most

efficient for each size. The design results from
the kind of movement involved in a particular
action as necessarily as the conclusion of a theo-
rem of geometry. Every time the designer has
tried to step out of this line of human move-
ment, he has failed. We don't have to go far
down in history to find examples: we may recall
the hexagonal bathtubs and square cups of the
roaring 20's and we may be reminded of our
cocktail glasses of today, neon-colored and sten-
ciled with so-called decorative subjects that kill
all the subtle frothing beauty of a mint-julep or
take all the innocence out of ginger ale to trans-
form it into a Charles Addams witch brew.

The frame of this introductory chapter on de-
sign permits only a hint at what we will try to
study at length later on. At this time, the exam-
ples of various containers shown in the accom-
panying pictures speak for themselves.

26

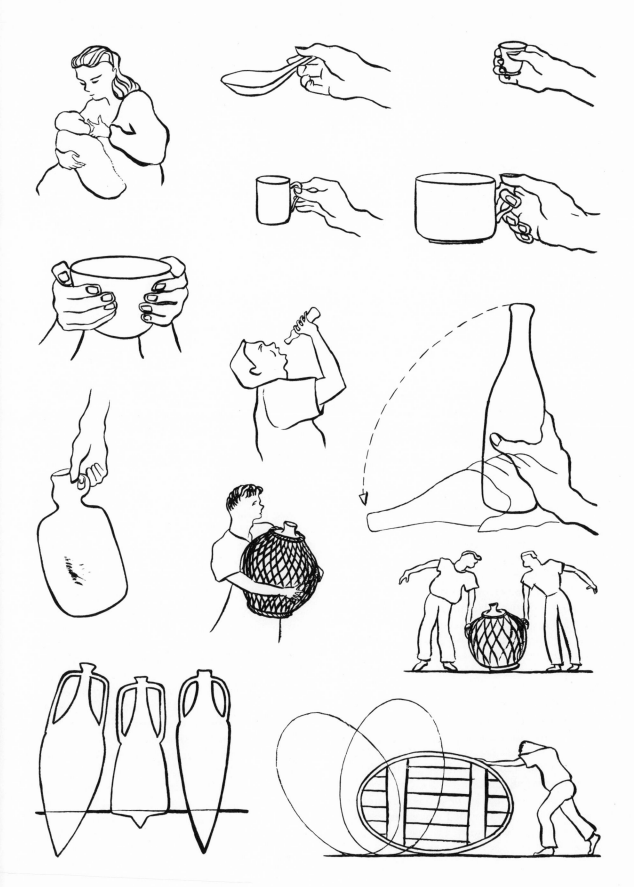

material	— the Four Elements — chemical elements — industrial materials & fabrics
unit	— electron — ratio of a progression — the number *e* — cell
scale	— progressions — series
rhythm	— space-time relation: · orbital revolutions, · pulsations (solar cycle, heart beat)
dynamism	— envelope of a curve — forms of erosion
harmony	— equation — function — group

THE BASIC LANGUAGE OF DESIGN

The fact that such diverse minds as Ruskin, Le Corbusier, Viollet-le-Duc, and Picasso agree when master buildings such as the Parthenon or Chartres are under discussion—the fact also that a Swedish farmer would be in complete agreement with the way a Japanese farmer builds his storehouse—makes us aware that there must be some kind of basic language of design, regardless of time, culture, and country.

If we care to sift out of design all that does not belong to this basic language—like a chemist extracting a few ounces of a pure element from tons of mixed ore—we are then left with a handful of laws that will give us the solid footing we need to start our study of design. We will discover that the laws that rule design of any kind are the laws of nature. They all boil down to the fundamental principle of unity that pervades all creation.

This principle has haunted the minds of philosophers since the time of Pythagoras and Aristotle. For a while, knowledge seemed to grow away from unity, into more and more different branches, each one seeming to have only a remote relation with the next. This evolution culminated in the 19th Century when specialization became a password for progress, and there was rarely a new year without a new name being added to the classified directory of sciences.

The discovery of the structure of the atom and its identity with the structure of the universe finally took the plural "s" from the big word *sciences* and brought back the principle of unity. All sciences were gradually melted into one and, as was to be expected, this science is physics, the science of nature by excellence.

The basic equation of physics, as evolved by Einstein, establishes the relation between energy, mass. and the speed of light ($E = MC^2$) as a generalization of the equation of kinetic energy.

If we transpose this into what interests us, that is, design, we find associated 1/ energy (meaning *dynamism* in design), as a result of the reaction of 2/ speed (that we translate *stress*) on 3/ mass (that we call *material*).

MUSIC	ARCHITECTURE	PAINTING	SCULPTURE	POETRY	DANCE
...umental timbre. 4 families: ...dwinds, brass, ...gs, percussion	— the four families: rock, organic, metal, synthetic	— pigments — colored lights	— wood, stone, clay, metal, glass, etc.	— language	— living subject
...half-tone, ...er-tone	— module — tatami — golden mean	— three primaries	— human canon	— syllable — verse	— step
...es: ...ajor, minor ...dian, Dorian, ...ish, Chinese, etc. ...romatic	— the orders: · Doric, Ionic, Corinthian, etc. — irrational proportions	— rainbow	— from jewelry to Mt Rushmore	— meter: · iambic, pentameter, hexameter, etc.	— pas de deux — square dance — full ballet
...signature ...ure ...nd down beat	— alternance of openings and volumes; colonades, arcades, etc.	— pattern	— recurrence of similar association of forms within a composition (frieze of the Parthenon)	— tonic accent — caesura	— beat
...ession of notes ...certain direction ...dim. sf. etc.	— direction of form — orientation — flow lines of circulation	— directional impulse of color, brush strokes, etc.	— directional axis of form — lines of force	— sequence of ideas	— sequence of steps
...ds ...ical forms	— "parti" of planning	— color scheme: · cold, warm, etc.	— bas-relief work — free-standing work	— sonnet — ballad — ode, etc.	— waltz, tango, rock & roll, etc. — parades — religious rituals

The basic concepts of material, stress, and dynamism—and their derivatives such as *unit, scale, rhythm, harmony,* etc.—can thus be translated into all branches of creativity and, by analogy, help us understand their meaning in regard to design.

If we consider the concept of *material,* for instance, we find its expression in physics as the *neutron*—in music, as the instrumental *timbre* or tonal quality of the four families of woodwinds, brass, strings, and percussion—in painting, as the two families of *pigment* and *colored lights*—in poetry as the various *languages.*

If we take another example as the concept of *unit,* we find its expression in mathematics as the *ratio* of a progression, the *key* in music, in painting the *primary colors,* in poetry, the *foot.* In architecture it becomes the *module.*

Another principle in science is known as the Hamilton Principle—or *principle of least action.* It is better known as the law of least effort. It rules form in physics as well as in architecture, as well as in human behavior. We will find it most helpful when later on we try to understand the problem of circulation in design: when we cut short the corners on alleys traced on a lawn at right angles, we follow the law of least effort. If the designer had rounded his alleys to begin with and thus followed that universal law, the design would have worked out well, instead of being disfigured into mangy grass rugs.

This brings in *dynamism* as a constant criterium of design.

It makes us aware of the life and action that will take place in buildings when people take over, and helps us foresee the dynamic problems that need to be solved on the drawing board, if the plan is to work at all.

This may sound like a rather scientific approach to the problem of design, but we shall see that by generalizing the findings of science to art, we may place art in a new light, as a necessity for living, as man's most accurate expression of intuitive creativity—a far cry from the concept of art as the luxury of an idle and wealthy aristocracy.

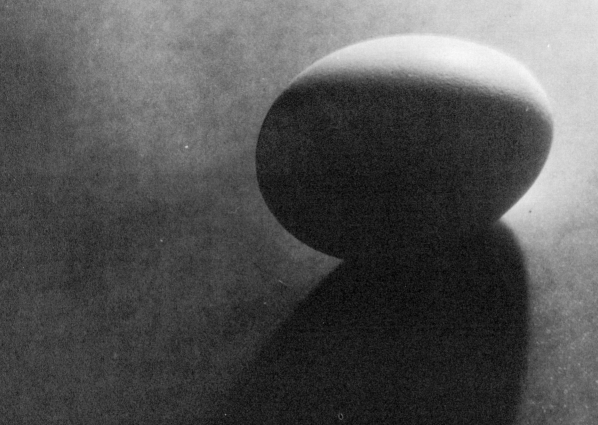

ARCHETYPES

Poetry is generally represented as a veiled lady, lazily resting on a cloud. This lady has a musical voice and tells nothing but lies.

Now—have you ever experienced the shock of suddenly finding yourself face to face with your own name as though it belonged to someone else, let's say, almost to see its form and hear the sound of its syllables without the deaf and blind routine that results of long intimacy? The feeling that a salesman, for instance, does not know a word that seems to us so well known, opens our eyes, unplugs our ears. A stroke of some magic wand brings back to life the commonplace.

The same phenomenon happens also for a thing, an animal. In the time of a lightning stroke, we <u>see</u> a dog, a cab, a house for the first time. All they have of particular, crazy, ridiculous, or beautiful, dawns upon us in awe. Immediately afterwards, routine rubs this powerful picture with its eraser. We pet the dog, we call the cab, we live in the house. We don't <u>see</u> them any more.

This is the role of poetry. It unveils, in all the strength of its meaning. It shows naked, under a light that shakes away sleepiness, the extraordinary things that surround us and that were registered as matter of fact by our senses.

No use trying to find far away strange things and sentiments so as to shock the awakened sleeper. This is the system of the poor poet and what brings exotism to us.

The point is to show him what his heart, his eyes, glide upon every day, at an angle and with such speed that he will think that he sees and feels it for the first time. This is surely the only creative power permitted to a creature.

And it is so because, if it is true that the multitude of gazes brings to statues their patine, the commonplace, eternal masterpieces, are covered with a thick patine which makes them invisible and hides their true beauty. Put a commonplace expression into its right place, clean it up, rub it hard, bring it to light in such a position that it strikes with its youth, and with the same freshness, the same upspring that it had at its birth—and you will act as a poet.

Everything else is literature.

JEAN COCTEAU
Le Rappel a l'Ordre

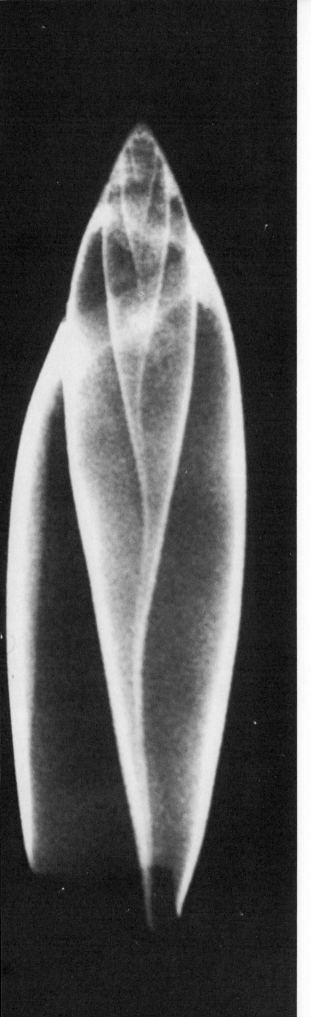

form

Design is poetry—from the Greek $\pi o\iota\epsilon\iota\nu$, to create—insofar as it associates forms into new meanings.

The work of the designer is only worth his ability to understand the laws of nature, the character of people and their needs—plus his own ideas and imagination—in short, only as much of a poet as he has in him.

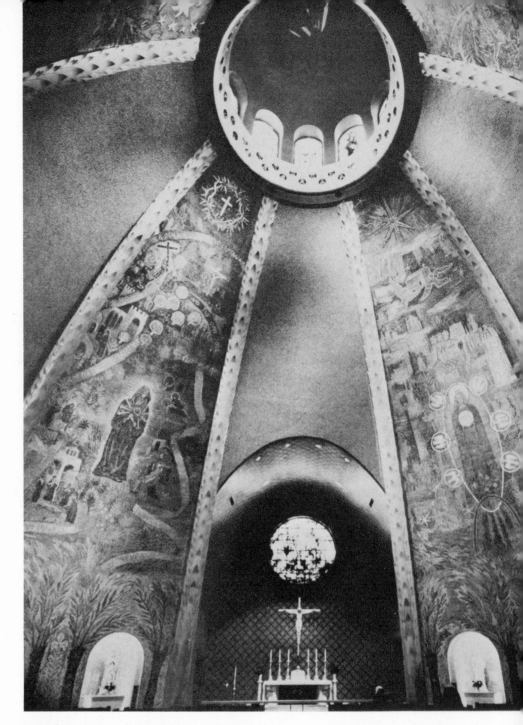

Church of Loreto in South Bend by Grillo

Architectural forms may be lines, surfaces, or volumes, but they must always possess the dimension of time, which signifies movement—and life.

The architectural equation is a function of life. And as the essence of life is movement, a drawing or photograph can never completely express the living value of a space, which is essentially fluid. It can only serve as a support for the imagination and help our mind build the full space with more drawings and photographs. Our angle of vision changes constantly with every step, ever changing the effect into a world of varied emotions. No work of architecture can be truly appreciated for its total worth until visited, walked through and through, under all lights and nights.

FORM IS THE RESULT OF STRESS AND EROSION ON MATERIAL

The forms that offer the most rigidity and resistance to the forces of stress and erosion are of most value to the designer.

Every material will react differently under forces of compression, tension, or torsion, and will assume its own forms of resistance. These particular forms are for each material an integrate part of the design language of the material. The worse mistakes in design are accomplished by using a material in forms that belong to another material.

Corn leaf study by Grillo

Pyramid of Cheops

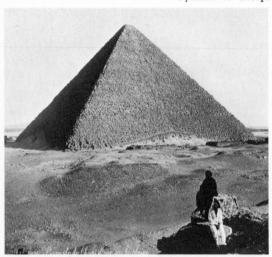

The triangle family, including all plane polygons and solids, is symbolized by the Pyramid. Its characteristic is *discontinuity*

Water tower, University of Minnesota

The curve family, including all curved surfaces and volumes, is symbolized by the Sphere. Its characteristic is *continuity*

For work or play, man needs shelters. We call them buildings, and the art that elaborates them is architecture. They vary from a tent to Frank Lloyd Wright's mile high superdream. Their first quality—regardless of what goes on inside—is to stand up: whence *structure*.

Since the cave—his first shelter—man has worked out wonders of ingenuity in developing structural forms. He found them all in observing nature and rationalizing natural forms into the ideally perfect forms of geometry.

If we analyze natural forms, we soon find out that they stem from either one of the two concepts that seem to share the world around us: *discontinuity,* and *continuity*. These two concepts always are present around us in one way or another: the beat of our heart reminds us every second of the existence of discontinuity, while the passing of time itself is a most evident example of continuity.

In geometry, discontinuity is expressed by the *angle* and all polygonal (or polyhedric) forms—while the circle and all *curved* lines and surfaces represent the continuous. Elementary algebra and arithmetics deal with the discontinuous, while integral calculus and its baby—analytic geometry—are based on the theory of continuity and has for its most widely used symbol the S curve. In nature, *crystals* represent discontinuity, while forms of *life,* plants as well as animals, seem to have the monopoly of continuity.

From these two themes that seem to rule the visible world around us, man has borrowed the forms for his structures. The realm of discontinuity has given him all the *articulate* structures made with posts, beams, trusses, or panels. They live in good company and are often associated with continuous structures in the form of vaults, shells, or other curved surfaces that we may call *integrate* structures.

36

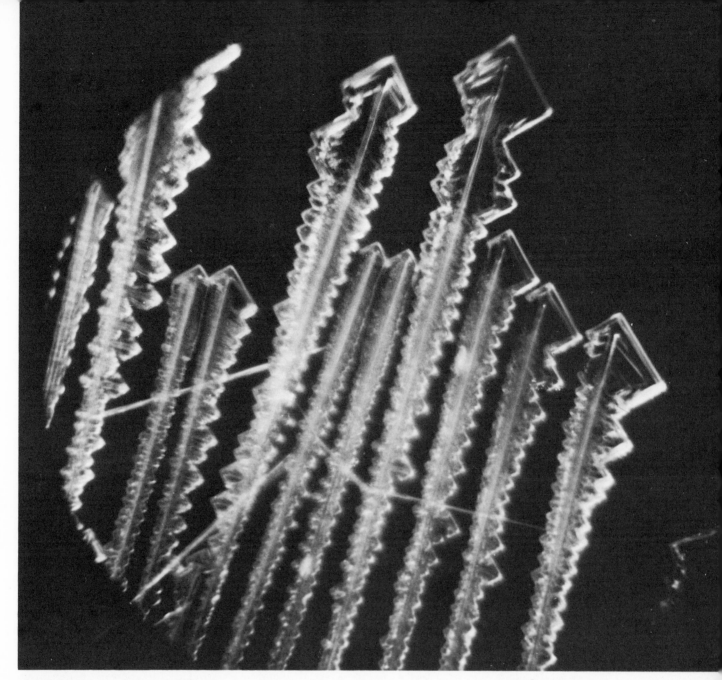

Microphotograph of lead nitrate crystals

Upper shell of a crab

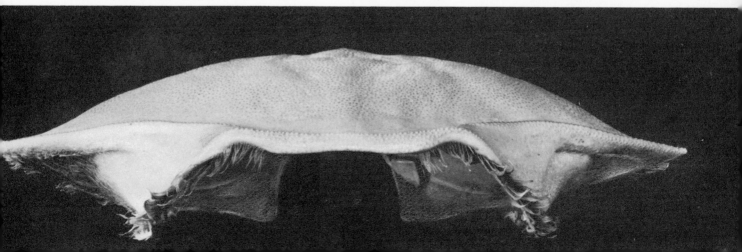

The study of the orbits of comets shows us that conic sections are somewhat organized into a sort of hierarchy according to the speed with which the celestial body moves. The fastest curve is the *hyperbola,* orbit of the comets that are too fast to be captured by the sun: they come from the infinite and return to the infinite in a completely different direction, after their close shave with our star. Next comes the *parabola,* which may be considered as a hyperbola-limit: it sends the comet back to an asymptotic direction parallel to the one it comes from, wih a speed slower than that of her hyperbolic friend. Next comes the *elliptical* orbit as the path of comets not possessing speed great enough to counteract the solar attraction. As a result, it is forever caught within the solar system and follows a closed curve, the ellipse.

The hierarchy of the dynamic curves stops at the ellipse. *It does not include the curve-limit of the ellipse, the CIR-CLE.* In the whole universe, there is not a single example of a perfectly circular orbit. It would mean immobility and total absence of stress.

Neither does it include the line limit at the top of this hierarchy: *the straight line,* considered as the limit of the hyperbola. Even at the speed limit of all speeds, light does not move in a straight line.

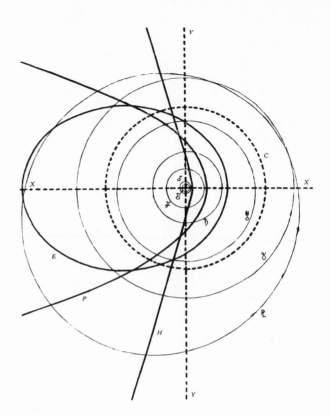

THE CURVE

Pure curves resulting from algebraic equations are never completely satisfactory in design. They all seem to lack life, while curves drawn by a human hand possess a live kind of beauty. This may be due to the fact that a mathematical curve represents only a particular function, very limited in scope, while life spells universality and constant change. When used alone in design, a pure curve has only one thing to say in the drama of design and stands out like an actor who would keep always repeating the same line. When used in connection with other curves, into a curved *line,* every link will show a sudden break in the general curvature. No matter how skillfully this junction is achieved—whether we draw an oval by the three-points method, or use a "French curve"—the break will always show as a deadly wound inflicted on the design.

Analytic curves, however—and mostly the conic sections and their derived exponentials such as catenaries, logarithmic spirals, etc., are of primary importance in the study ot design as a means of simplification. They may help us better understand the value and character of curves of similar "speed" designed by the human hand, and introduce the concept of dynamism into design.

Architectural design is the expression of the laws of stress and gravitation. The catenary curve of a suspension bridge is the exact representation of the funicular of stress: it is a graphic representation of potential energy, just as the trajectory of a falling bomb from a plane in movement is the expression of kinetic energy. The line of a fold in a drapery is an arc of a catenary. The absolute circle, as well as the absolute straight line, do not exist in nature, but only in the theoretical mind of man.

The Greek, master mathematician-artists, knew this so well that they boycotted the circle

hart of the Solar System showing only the orbits of the anets outside the Earth's and the three types of comety orbits. They all belong to the family of conics. The ld dotted lines may be considered as limit lines: XX the limit of the Ellipse when the second focus moves the infinite; the Circle C (and the whole family of rcles having the Sun for center) as the limit of the lipse when the second focus moves to the Sun's posin; the Parabola, as the infinitely enlarged section of e limit-ellipse XX in the immediate vicinity of the un; the Hyperbola, as an inverted ellipse having its foci tuated *outside* the split curve, YY being considered as e limit of the hyperbola when the two outside foci meet to the Sun.

The circle and the straight line, thus considered as linemits, are pure abstractions that represent total immobily and death on the one hand—and inconceivable speed at would mean the destruction of the universe, on the her

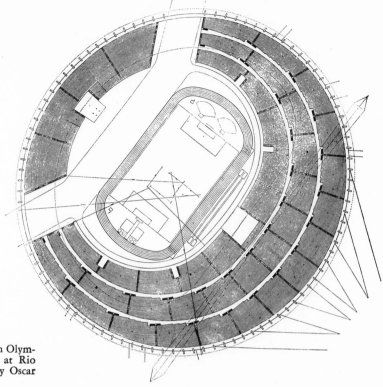

Project for an Olympic Stadium at Rio de Janeiro by Oscar Niemeyer.

and the straight line like the Bostonians did English tea. The most characteristic curves in their design were *close to* a very tense arc of a hyperbola in the heel of the Doric capital, and *close to* a logarithmic spiral in the Ionic Capital —both most dynamic and life-loaded curves of stress. We also know that *in the design of the Parthenon,* for instance, *there is not a single straight line.*

If we say "close to", it is because the Greek curves are never geometrically perfect, as they were borrowed from eroded curves of life found in nature, whether in echinoderms or shell forms. The conic or exponential equations we refer them to, should be considered as only approximations, and simplifications.

Forces of life, which create movement, design orbital curves that represent a state of equilibrium among these various forces. These curves thus create a schematic plan which is to architecture what the skeleton is to a living organism. This schematic plan only shows the main lines of stress like highways along which develop the various areas of activity. The geometrical center of the canvas formed by all the lines of stress becomes the *center of gravity* of the whole plan, the true focus of the composition—like the strategic crossing of Main Street and the main East-West thoroughfare in a town. It is referred to in a town as "the center of town". In Chicago, it is the crossing of La Salle and Monroe. In New York, 42nd Street at Fifth Avenue.

This notion of a center of gravity in design explains why and how a design is harmoniously *balanced* or, on the contrary, shocks our instinctive feeling of equilibrium. It is true of any kind of creative composition, whether in music, literature, or any of the plastic arts. This equilibrium is what makes the fulfillment of any work of art.

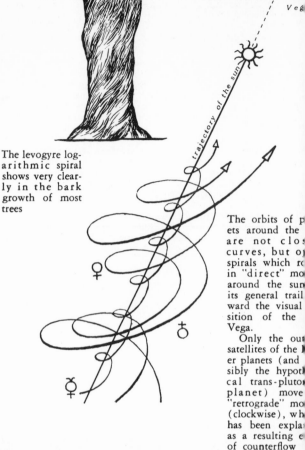

The levogyre log-arithmic spiral shows very clear-ly in the bark growth of most trees

The orbits of p[l]ets around the are not clos[e] curves, but o[f] spirals which r[otate] in "direct" mo[tion] around the sun its general trail[l] ward the visual [po]sition of the [star] Vega.

Only the out[er] satellites of the [ou]er planets (and [pos]sibly the hypot[heti]cal trans-pluto[nian] planet) move "retrograde" mo[tion] (clockwise), wh[ich] has been expla[ined] as a resulting e[ffect] of counterflow

Hat from Madagascar

The double spiral is also used in cable stranding because of its considerable strength

THE LOGARITHMIC SPIRAL

The pattern of continuous motion is organized along the path of a logarithmic spiral. At its very origin, a body submitted to a linear impact soon bends into a spiral. From spiral nebulae, first signs of order into amorphous cosmic matter, to the sunflower seed pattern or fossil cell organization, we find the spiral as the universal form of motion.

A still more extraordinary fact is that the levogyre or "left-handed" spiral is the general rule in nature. It seems to follow the Maxwell Law of electro-magnetism, the lines of force also following a left-handed or "direct" motion around the direction of the electrical impulse.

This also rules the motion of planets and celestial bodies.

Phylloceras onoense

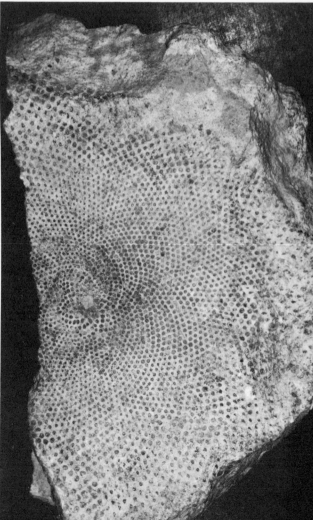

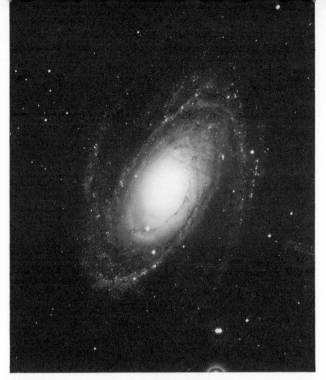

Spiral nebula in *ursa major*, Messier 81

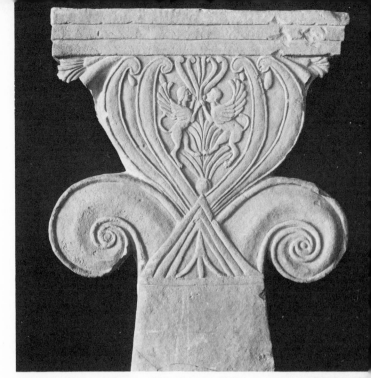

Votive Stela from Cyprus—VIth Century B.C.

Placenticeras whitfieldi

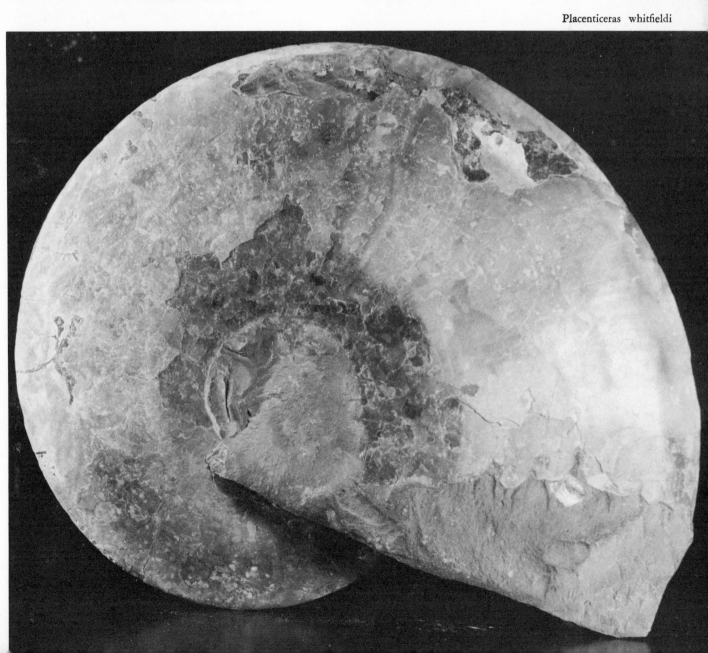

We find the theoretical study of lines of flow in the difficult branch of algebraic geometry called inversive geometry. It includes parabolic, hyperbolic, and elliptic geometries, curves of flow, and motions. Without going into this any deeper than the objective study of figures resulting from such equations, we again meet here a fascinating approximation of the forms of life. These curves are mathematically perfect, but none of them is as complex as the curve of a shell, designed by nature to offer the least resistance to the wavy motions of the pressurized fluid that hugs the shell on the ocean floor.

But while forms of life show an infinite individual diversity, mathematical forms resulting from equations or electro-physical impulses are organized in a symmetrical pattern that only allows for exact reproduction of the same forms under the same conditions. In spite of its apparent asymmetrical and disorganized pattern, the electron density projection diagrams show an identical repeat pattern exactly as in the design of a wallpaper or drapery design. We know that it is absolutely impossible to find twice the same pattern of geodetic lines on two acres of land, no matter how many acres we bring together for comparison. We may pick a million shells on the beach, and we won't find two identical specimens. We also know that no two individuals among the odd three billion people on earth have the same thumb print.

These electron density projection diagrams show lines of equal density in a pattern very similar to the contour lines due to erosion on a geographical map or the isobars on a weather map. They show "horizontals" of equal tension around the various atoms of Cl, O, N, and C in this complex organic crystals of adenine hydrochloride. But a closer study reveals the "repeat" pattern typical of crystalline organization: the fabric designer would call this type of pattern a half-drop reverse repeat

Fabric design by Grillo on the rhythmic pattern of the electron projection diagram of adenine hydrochloride

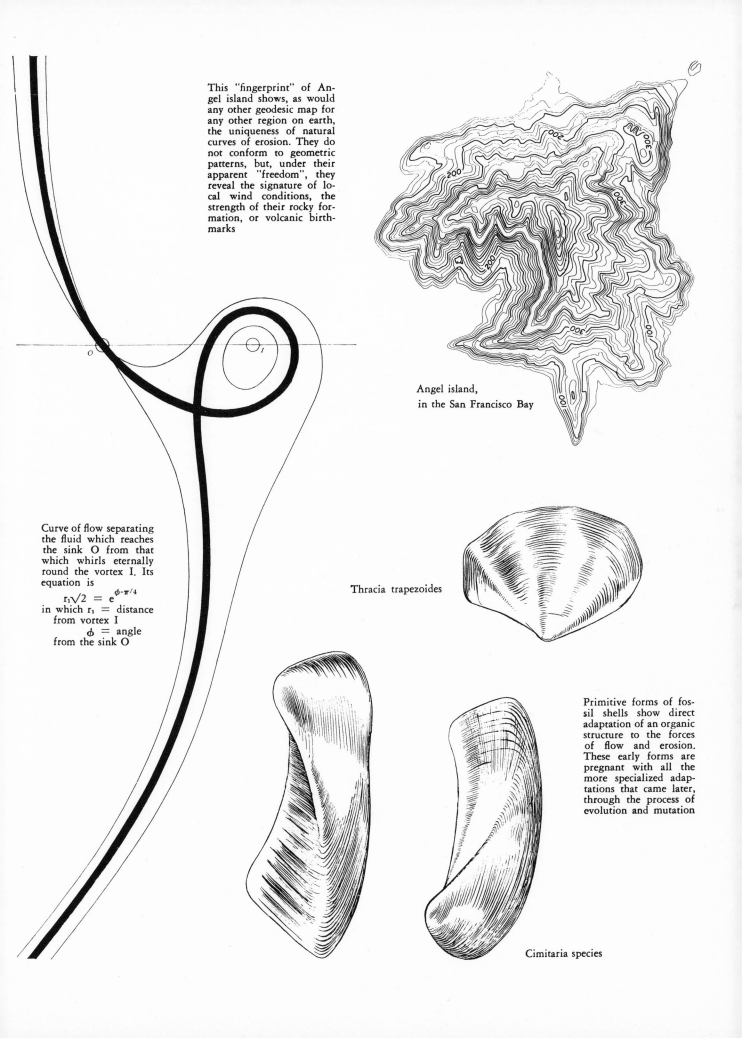

This "fingerprint" of Angel island shows, as would any other geodesic map for any other region on earth, the uniqueness of natural curves of erosion. They do not conform to geometric patterns, but, under their apparent "freedom", they reveal the signature of local wind conditions, the strength of their rocky formation, or volcanic birthmarks

Angel island,
in the San Francisco Bay

Curve of flow separating the fluid which reaches the sink O from that which whirls eternally round the vortex I. Its equation is

$$r_1 \sqrt{2} = e^{\phi - \pi/4}$$

in which r_1 = distance from vortex I
ϕ = angle from the sink O

Thracia trapezoides

Primitive forms of fossil shells show direct adaptation of an organic structure to the forces of flow and erosion. These early forms are pregnant with all the more specialized adaptations that came later, through the process of evolution and mutation

Cimitaria species

FORMS OF LIFE
INSPIRE DESIGN

Ever since Greek architecture was re-discovered during the Renaissance, architects have tried in vain to find a mathematical curve that the Greeks might have used for their Doric capitals. It was finally found out that no curve of analytic geometry could be used, for the good reason that the curve which inspired the Greek architects was not a perfect curve, but the living forms of the common sea urchins, so abundant in the Mediterranean.

In snow drifts as in crab shells, a similar curl is obtained 1/ in the snow drift, through the mechanical result of erosion by high winds on powdered snow, 2/ by the crabshell through the process of evolution to adapt the form of an animal to defend itself against its environment —in this case, to offer the least resistance to the erosive action of moving water on the sandy ocean bottom haunted by this crab.

This "pre-eroded" design in art may seem far removed from any functional purpose, as in the bamboo basket opposite. The beauty we find in it, however, is more than purely romantic. Its lines are pleasing to the eye because they also express the forms of erosion that would result from the normal handling of the basket.

Cretaceous echinoid
(Cassidulus porrectus Clark)

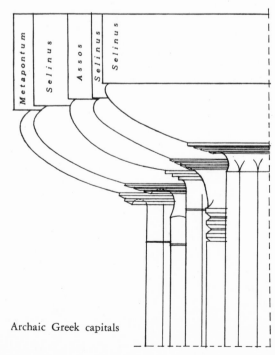

Archaic Greek capitals

Bouquet basket of bleached bamboo, inspired by the curl of a breaker, by Shounasi

The shell of a crab shows a design of combined *streamlining, pre-erosion* and reinforcing by *corrugations* of the shell, and *minimal surfaces* of torsion. A remarkable fact is the modulation of each granule according to its position on the surface, adding thus by the texture of the material itself to the strength of the strategic "mountain ridges"

Front edge of crab shell, San Francisco area

Snow drift

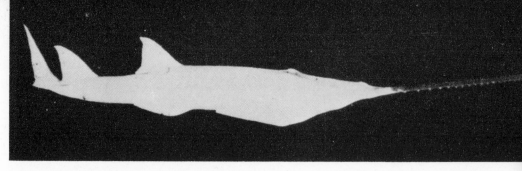

DESIGN
FOR SPEED

Sawfish (Pristis zijsron)

The design of the first airplanes was borrowed from kites, butterflies, or dragon flies, as they needed a wide sailing surface to compensate the gravity, their speed being very low. But as speed increased through the engineering of more compact and more powerful motors, planes abandoned their likeness to soaring kites or insects, because gravity became more and more negligible as compared to air resistance. The element in which flight is accomplished today is more similar to water than to air, and designers, unconsciously, have shifted their models from birds to sharks, rays, and squids.

The squid—the only truly jet-propelled animal—is the archetype of the rocket missile of our time, with its gravity-free vertical soar, totally free from the use of wind resistance in take-off.

The fish is also a gravity-less type of design, as its dead weight is compensated by inside air-pressure contained in blood cells and organs. A deep sea fish will literally explode when raised to the surface. Its instant mobility is most comparable to the jet fighter with its wide angle take-off, only possible by the compensation of gravity by speed.

Sharks, rays, and squids should be the most valuable models for the speed designer as they might be called the speed demons of the depth. Even though in mph their speed does not compare with the fastest animal on wings—believed to be the deer fly, with a record 800 mph—we may indeed call it incredible, considering the resistance of the fluid in which they move about. It is unsurpassed by man's fastest submarine.

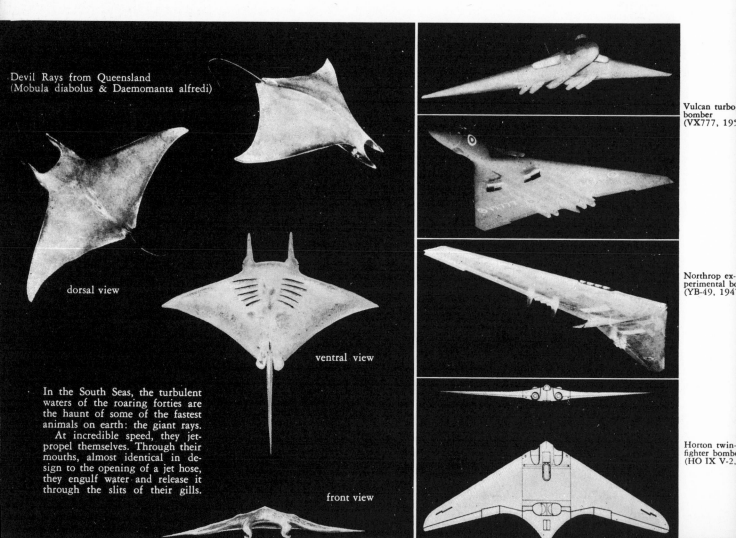

Devil Rays from Queensland
(Mobula diabolus & Daemomanta alfredi)

dorsal view

ventral view

In the South Seas, the turbulent waters of the roaring forties are the haunt of some of the fastest animals on earth: the giant rays.
At incredible speed, they jet-propel themselves. Through their mouths, almost identical in design to the opening of a jet hose, they engulf water and release it through the slits of their gills.

front view

Vulcan turbo-
bomber
(VX777, 195

Northrop ex-
perimental bo
(YB-49, 194

Horton twin-
fighter bombe
(HO IX V-2,

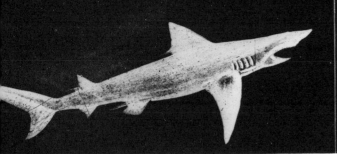

The Ganges Shark (Platypodon gangeticus)

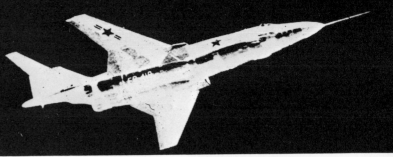

McDonnell Voodoo F-101A (1954)

V-2 rocket
WAC-Corporal
Feb. 24, 1949

Acanthoteuthis antiquus, and bones
of other prehistoric squids, from the
Oolite of England (Jurassic period)

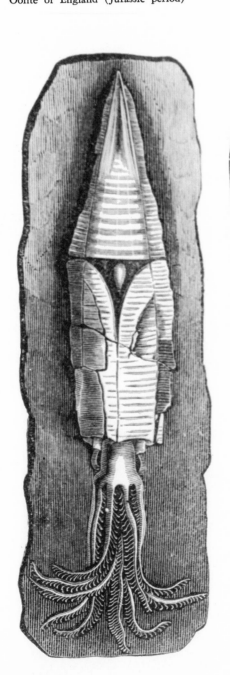

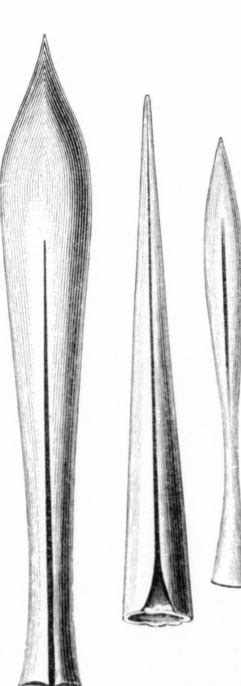

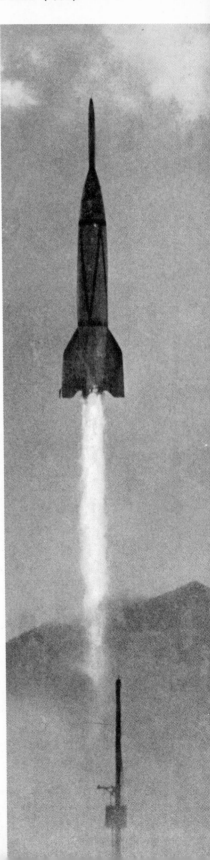

Only two years after the historic flight of Orville Wright, this extraordinary plane was on exhibition: a *turbo-propeller,* a *V shaped tail,* and hollow wings with gasoline tanks *in* the wing— such was Henry Coanda's first attempt at jet design. It took thirty-eight years to have his dream come true and his genius recognized.

Henry Coanda, a French physicist, is considered today among the great pioneers of aviation. He had learned to *see* things for the first time, with the totally new and innocent approach of the poet. While crossing the ocean to New York, he spent hours at the bow of the liner watching the play of porpoises that kept an easy pace while the ship painfully ploughed her way with the full force of her multi-thousand horse-power turbines. He found a reason for their speed and easy movements in the fact that water, going through their mouths and flowing at great speed through their gills,

created a partial vacuum effect that propelled them *forward.* He marveled at the trout, that can remain at a standstill in the midst of the fastest flowing mountain stream, hardly moving a fin—by the same jet reaction effect: thus can they also climb up thundering falls, *actually with the help of the stream of water.*

As a result of his direct observation of the movement of fish in their element, the *Coanda Effect,* well known to aero-physicists and engineers, was discovered by the great scientist.

It may be that the Coanda Effect is due to the harnessing of the chaotic Brownian movement of the molecules of a fluid into a powerful jet-stream that may boost power more than ten times. This effect has found one of its practical applications in a new type of design for the exhaust of the London buses. It produces almost total combustion of the gases and reduces the smog hazard in the City.

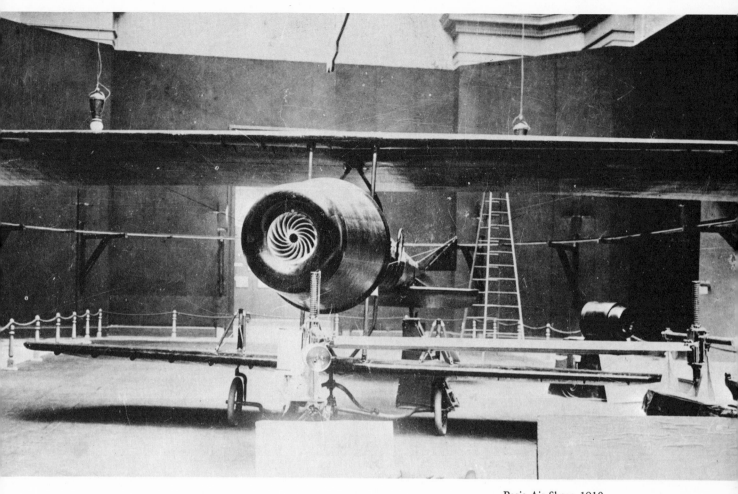

Paris Air Show, 1910.
The Coanda Biplane

In order to understand architecture, it is important that we should keep in mind the most subtle and powerful principle of all arts: the agreement between material and form, made as intimate and thorough as possible by the nature of things.

The fusion of these two elements is the absolute aim of all great art. The simplest example is offered by poetry which cannot exist without the close association or the magic symbiosis of sound and meaning.

Only through this search for a kind of union that must be imagined and take place within the living depth of the artist, and in a way throughout his whole body, can the work achieve any resemblance with the living productions of nature, in which it is impossible to dissociate force from form.

As far as architecture is concerned, we must distinguish between the kind of constructions in which form and material have remained independent of each other, from those where form and material have become inseparable—only thus will we give justice to the work and derive from it a supreme kind of enjoyment. The public too often confuses the true architectural qualities with decorative effects that are strictly external.

We are content to be moved, surprised, or amused by theatrical effects. No doubt, there exist fine buildings which attract the eye although they are made of coarse substance, or of a nucleus clothed with deceptive veneers, applied marbles, pasted ornamentation. But from the standpoint of the mind, these constructions do not live. They are masks, make-believe shells under which hides a miserable truth. But on the contrary, it is enough for the connoisseur to gaze upon a simple village church, like the thousands still standing in France, to receive the impact of total Beauty, and in some manner to be aware of the feeling of a whole creation.

PAUL VALERY
Regards sur le Monde Actuel

materials

All work of art needs a material support. But material is more in design than only a support. It is part of the work of art. It is not an added quality, but an essential part of it.

In music, for instance, the timbre or tone quality of every different instrument is the material the composer has to deal with. And we know that once a piece is composed for a certain instrument, it is always awkward and unsatisfactory to transcribe it for another instrument. Nowhere is this more evident than in the transcription of Chopin's piano pieces into an orchestral score: the material with which we reconstruct the music does not fit the design of the composer. In the field of Music, we are familiar not only with the timbre of one kind of instrument,

but with the four main families of similar timbre in which they are grouped: the strings, the woodwinds, the brass, and the percussion. We will see further on, that the same is true about the material of architectural design. The design is composed for a certain material, or a certain association of materials. If we decide to change the material, we may have to change the design also—and this is not a question of detail, but part of the design itself.

In painting, the material used is colored pigment—or colored light. The choice of color has to be completely different if we use one or the other medium of expression. In the use of pigments, we are familiar with at least three main families of material: oils, watercolor, and pastel. We know how differently a painter expresses himself when he changes his medium. The material here is such an integrated part of his art that he will rarely express himself equally well in all media: an artist will develop a preference for one of them as more fitting to his temperament, and the rest of his life will not be too long to master this medium.

In the fleeting art of the stage, the material is costume fabric, and colored lights. We know that art is achieved here by means of various fabrics from the families of silks, linens, cottons, etc., either textured or printed—even metal, furs, or feathers. When a couturier or costume designer chooses silk, the design of the costume will be radically different from what he would compose, had he chosen linen as a medium of expression. We also realize that it may be awkward to mix different families of materials in the design of a single dress, unless used as well chosen and carefully planned accent. The dissonance thus created can increase the interest, like a pinch of pepper or nutmeg in a dish—or kill it if the dish is too hot.

In his art, the architect uses all kinds of building materials. We know that as far as good cooking is concerned, the most successful dishes are not the most complicated, whether made of beef, fowl, or fish. Keeping in mind the principle of unity, we are again led to the conclusion that the less different materials we use in a building, the better the building will be, at least in regard to consistency. By consistency, we mean the close union of material and design so that one seems to be the necessary result of the other to such an extent that it becomes difficult to decide if the design was the result of the material, or if the material was chosen because of the design.

An instance of perfect consistency in design is the igloo: the whole story is told in one single material, snow. Another instance is given by the log cabin of similar design among all the people who live in the timber zone, from Norway to Japan. Wood, and nothing but wood—even down to the pegs that tie the logs together—is used throughout the whole building.

We can find similar instances of perfect consistency in the use of all building materials. In examples of total consistency in stone design, we find nothing but stone used in building floors, walls, and even roofs: whether carved out from a cliff of the Sinai peninsula in the rock city of Petra, Abu Simbel in Egypt and the Khmer temples of Cambodia, or built up of small elements in masonry, like the "trulli" of southern Italy or the celtic constructions of Scotland and Ireland.

In music, the unique quality of the string quartet comes from a perfect consistency of *timbre*. The same feeling of perfection comes from a small "a capella" choir. In painting, it is a tacit rule that materials should never be mixed: only in recent years have a few painters mixed all sorts of things on the same canvas, with rather doubtful results as far as art is concerned.

Art is not achieved by addition, but by a process of substraction that we call *selection*, or *choice*. The use of a great many materials in the same work does not show the imagination of the designer, but the contrary. The poor designer desperately clings to a rainbow of materials to hide his unimaginative design, like a dishonest cook who covers the bad taste of a piece of meat under a shower of spices.

This tendency to associate art with quantity is shown today in our over-large orchestras, and fantastic ensembles composed of dozens of cellos, hundreds of trombones, and oversize choirs: the result is on *weight,* a far cry from the athletic "sveltesse" that characterizes beauty.

The designer is rarely offered the opportunity of telling his whole story with a single material.

In residential design, for instance, the architect must use at least three different basic materials for building his roof, his walls, and his floors.

His problem is not only to choose among many different materials for every part of the design considered, but mainly to make his choice of materials that will go well together.

Here again, like the costume designer, he has to be careful not to mix silks and linens or, like the composer, to think twice before bringing into the world a concerto for harp and tuba.

Each material possesses its own particular design language, which is the expression of the three main qualities that characterize it:

Structure, which determines the particular way it reacts under stress, and will determine structural design and form directly.

Texture, which directs the choice of tools to use, that is in accord with its internal structure.

Aspect, which tags its particular color and outside skin after tooling. Although a direct result of (1) and (2), it is by this quality that the material is best known to the layman.

Every material is thus tagged by its intrinsic qualities. Understanding them is the key to consistency in design.

We will particularly insist on *structure* in our study, as it is, in the end, the most important quality in design.

The molecular organization of each material used in building is different. We might group material into five categories, according to its origin, responsible for its particular structural organization:

1. *rock material,*

that we find in its natural state in the ground, like stone and clay.

2. *organic material,*

which is, like wood, of cellular organization.

3. *metal material,*

as a refined product of the most compact molecular organization found in nature.

4. *synthetic material,*

like glass and plastics, products of man's industry.

5. *hybrid material,*

like concrete or adobe, born from the marriage of two or more of the preceding materials.

ROCK MATERIAL

There are two main groups of rock materials from the point of view of the designer: the stone family, and the clay family.

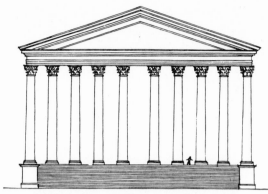

The Temple of the Sun, Baalbek

The Largest Cut Stone in the World
Baalbek, Syria

The geologist differentiates two kinds of stone: *the primary group,* where we find igneous rock, —granite, porphyr, lava, etc.—and the secondary or *sedimentary* group, from limestone to marble, characterized by its cleavability.

The rocks belonging to the primary group offer a structure similar to a fruitcake or taffy. They may be cut in any direction, as all the elementary crystals that make them are uniformly bonded together in a natural dough that gives even resistance in any direction.

Such are granite, porphyr, and generally speaking all igneous rock like lava, tuff, basalt, etc. Their taffy-like structure is the result of their being poured all at once, like peanut brittle, from openings in the earth's surface. All coral rock can also be put in this family, although of completely different origin, but because of a similar amorphous composition.

The classification we establish here reads more like a geologist's nightmare: but, as we are only interested in this study in the design value of the rock material, we find it more practical to follow a structural order of classification, rather than to classify them by their origin, period, or chemical composition.

The other group—or sedimentary group—offers a structure similar to Webster's dictionary, which is easy to open with a blunt knife along the pages, but would prove quite hard to cut with the sharpest blade in the other dimension. This kind of stone began its formation on earth during the Secondary Period, when the Great Sea covered the globe. Silt, together with shells and skeletons of dead life, kept on piling up layer upon layer in the bottom of the water, and, due to the enormous pressure above, hardened to become the soft limestone we all know well, and all other cleavable rock, like sandstone, shale and others—while the organic bodies of the dead mollusks, under the stress of pressure and time, turned into oil, asphalt, etc.

The characteristic of these rocks is their being deposited in *beds,* which gives them a direction of cleavage like the pages of a book.

Later on, some of these rocks were submitted to fantastic pressures, when havoc was created upon earth during the Tertiary period, when the Alpids—meaning the Rockies, the Andes, the Himalayas and the Alps—rose to their greatest heights. The result was to harden the soft limestone as through a sledge hammer—to *metamor-*

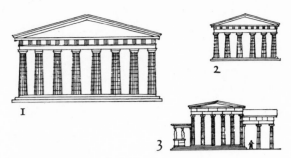

1. The Parthenon
2. The Theseion
3. The Erechtheion

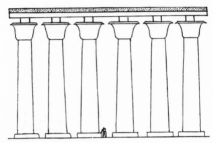

6. Temple at Karnak, Egypt

Drawn at the same scale as the Baalbek temple opposite, these three celebrated Greek temples—possibly the three most famous buildings in the world—are dwarfed by this super-colossal monument to dictatorial showmanship. But, as witnessed by the "largest cut stone in the world"—still embedded in its quarry—the Romans tried to bite off more than they could chew, and *Operation Baalbek* only rates before the judgment of time as a non-glorious defeat of the gigantic compared to the Greek sense of measure and proportion.

This also shows that design can never transgress the limits of a given material. The Egyptians transgressed it in an inhuman architecture that awes us by its scale as well as by the lack of proportion between the armies of slaves used in building tombs of cosmic grandeur—and the ruler, a single man for whom the tombs were destined. For the Japanese, the Emperor is as divine as Pharaoh for the Egyptians, but they never lost the sense of measure and their architecture, like the Greeks', is an eternal source of direct inspiration

phize it, as the geologist says—and transform it into very hard rock, but often making even more apparent its leaf-like structure. This process is very much like leaf pastry made in the bakery: Layers of soft dough are piled up on top of each other, each layer being buttered to avoid sticking, and then folded, fold upon fold, and flattened with a heavy roller. Then it is cooked and comes out as the piece of leaf pastry that we know well.

We can already see what impact both types of stone structure will have in design. Pudding-like granite will lend itself to a kind of design made of big elements that can span rectangular openings of rather large dimensions. This leads to *monolithic design,* where each element constituting the opening will be made of one single stone (monos-lithos).

We may also see in this a determining reason for such or such architecture of the past, as in olden times there was no question of transporting heavy building material beyond a few hundred miles, and builders constructed with the material at hand.

In their upper portion, the two great rivers of antiquity, the Nile and the Tigris, flow between

cliffs of excellent granite. This explains the huge monolithic architecture of Higher Egypt and Assyria, which we may call *lintel design,* because its most obvious characteristic is the complete absence of any vaulted or arched opening, every single span being covered by a single piece of stone.

Greek architecture belongs to the same family, and for the same reason. Here, the stone is not granite, but a superb hard marble that makes the backbone of this jagged country. Marble is a kind of limestone, but highly metamorphized, so that it was still possible to consider only lintel design. But marble being not so strong as granite, it could not span such wide openings as in Egypt. This is a determining reason for the scale of all Greek architecture, so much smaller than the Egyptian. It may also explain why the Romans, in turn, in their desire to show off their might with building, developed structures of enormous size everywhere they could find good stone, blowing up to gigantic size the language of Greek design—in Baalbek, for instance, where they built the largest Corinthian column of all time. One of the stones was so huge that they could not find a way to lift it. It is still lying in

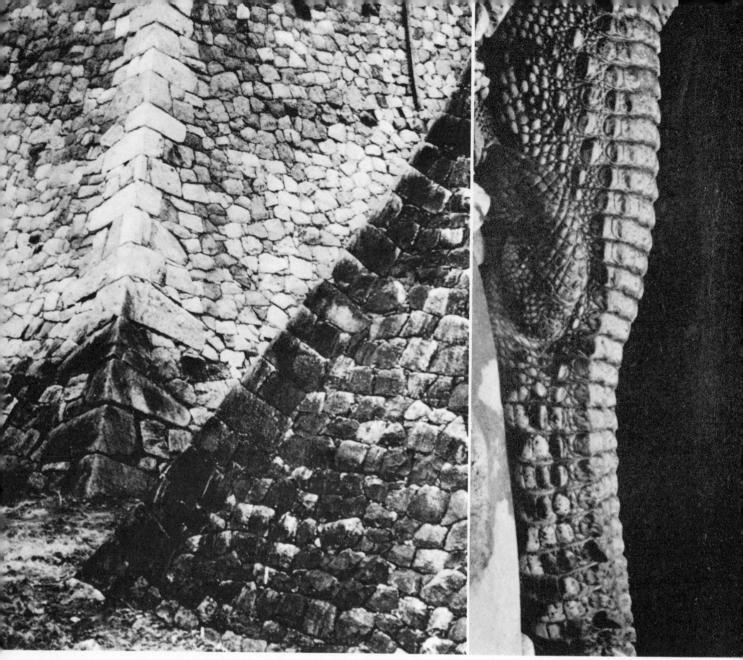

Nagoya Castle, Japan

Crocodylus Palustris

the quarry bed where they started to carve it from the rock. Another instance is the city of Apamoea, in Upper Syria, where the Romans built an immense colonnade at the same heroic scale as the Baalbek works. The largest structures of Roman design were thus not built in Italy—which lies so near the zone where the Alps broke through the earth that its rock beds are all broken up—but in the Middle East and other less geologically disturbed areas occupied by the Romans.

With material of excellent quality, no cement is necessary. This explains why most architecture of Assyria, Egypt, and Greece—only to speak of the Mediterranean basin—was built dry, exactly like the constructions made of wood blocks we all loved to build in our younger days.

They were built with such precision that even now, after millenia of weathering the erosion of wind and rain, it is hardly possible to insert a pin between two stones of such walls.

The Incas of Peru used exactly the same type of construction, and for the same reason as the Egyptians. The enormous walls of the city of Cuzco, in Peru, offer an example very similar to Egyptian wall construction. And if we go to

China or Japan, we find the same kind of material used in the Stone Hall of Siang-Fu, the Gates of the Forbidden City in Peiping, Japanese fortifications around Nijo Castle, Nagoya, and many others. But in the Andes as well as around the Yellow Sea, we find a remarkable way to place the stone work together. In these regions where earthquakes are frequent and disastrous, the stones are put together in a basket weave pattern, so that any movement of the earth would have a tendency to lock them more tightly into place and thus increase the solidity of the masonry work: it is very similar to nature's work regarding the scale pattern of saurians and reptiles, like the shell of the armadillo, the turtle, or the alligator, all animals which move around in slow and jerky movements.

A very remarkable feature in the design of Japanese walls is the insertion of much smaller stones between the larger blocks. We find a similar design in the pattern of the alligator scales in the parts of the body of the animal where the skin is quite loose—mostly the lower jowl area where scales must allow for movement in any direction. On the skull, on the back bone, and other solidly "welded" areas, the scale pattern is made only of large elements—as in the solid shell of the tortoise, and also as in the Inca walls of Peru. On the other hand, where there is no

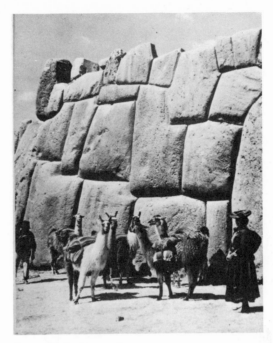

Inca wall in Cuzco, Peru

Nijo Castle. Japan

Scales around neck
of Caiman Sclerops
from Colombia

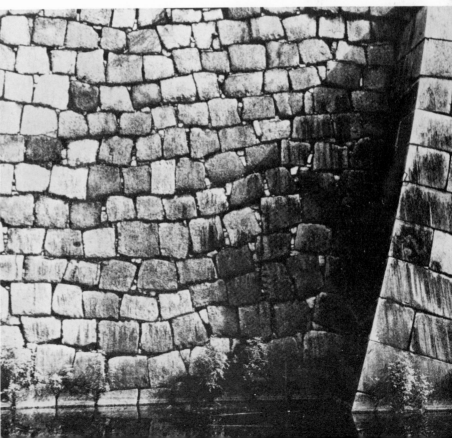

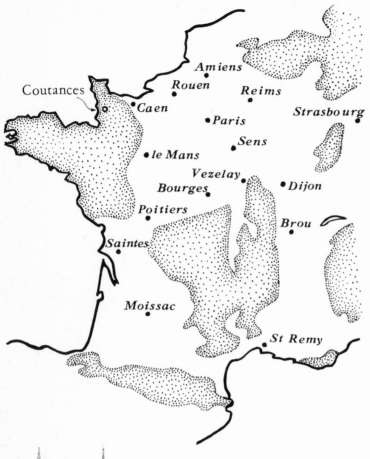

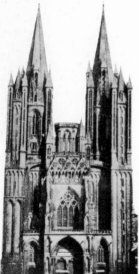

Coutances Cathedral

The dotted areas on this map of France show the granitic and hard stone regions, while the rest of its territory, formerly covered by the Secondary Sea, is made of sedimentary deposits of limestone and softer rock material.

Reims cathedral

such hard stone but only soft limestone of good quality, we find that the use of this soft stone led not only to design of smaller dimensions—or *smaller scale*—as stone slabs and lintels could only span medium size distances, but at the same time it brought about a widespread use of sculpture in design, as the material was easier to carve into ornaments and figures. This explains the lavish use of sculpture in the French cathedrals of the limestone belt that spreads like a wide ring all around the primitive volcanic core of the Massif Central. Let us insist here that it is not a question of style or period. Regardless of the historical background, we find lavish sculpture in the limestone belt, and stripped walls in the granite and volcanic regions.

This also explains the relative poverty in sculpture of all English and Norman architecture, as the material used there was either granite or metamorphized schist and gneiss as hard as flint. Sculpture and ornament remained confined, in these regions, to small compositions, generally isolated, such as the famed "calvaires" of Brittany and the celtic crosses of Ireland.

A glance at a geological map reveals where we may expect elaborate sculpture associated with architecture—or where we should find very little of it. This influence of material on design is nowhere more evident than when traveling in France through the few hundred miles between Cherbourg and Paris. Just before reaching Caen, we see the very stern architecture of Western Normandy (Coutances, etc.) suddenly change into the lavishly sculptured buildings so characteristic of Caen, where the Renaissance taste for frills and whipped cream type of ornament found an ideal medium in the soft limestone of Lower Normandy. It is like crossing a border between two radically different countries, so dif-

The great sculptured cathedrals are all in the limestone region. Note the contrast between the stern and unadorned façade of one of the greatest cathedrals of the hard stone area (*Coutances*) and the extremely sculptured façade of *Reims*

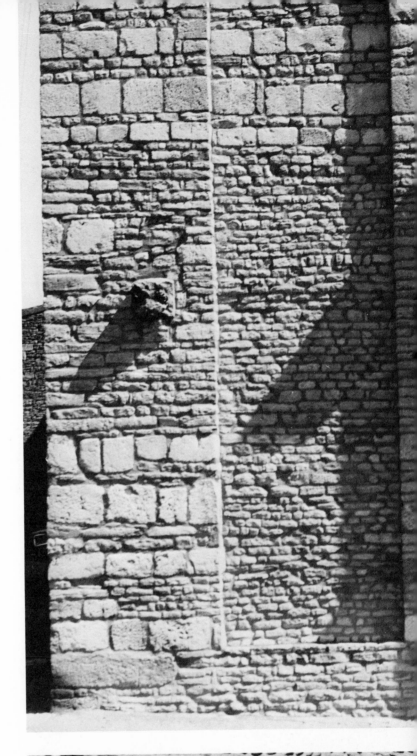

XIIth century wall in Tournus. The alternance of layers of large and small stones increases the resistance of the masonry against earth tremors, but we may notice how water found its path wherever the vertical joints were poorly staggered.

ferent is the architecture of the Cotentin peninsula (a geological island of primary gneiss and mica schist) from the plain of Caen (made of soft secondary limestone). The soil production, as well as the character of the inhabitants, is also completely different: one is pasture land and apple orchards, the other is wheat country; the first counts much illiteracy among its people, while the other is the seat of a famed university and has given birth to many a great writer. It is true that there is little sculpture in pre-Renaissance buildings in Caen, but it is also true that west of the borderline, the pastry of the Renaissance ornament could never be cooked for the lack of the necessary dough.

We come now to the other kind of stone construction called *masonry*.

When the material at hand cannot be cut into exact pieces, it is used as it comes from the quarry, at random, although within a reasonable range of size, and is put together in horizontal layers, with mortar. Contrary to the pattern used in *dry* wall earthquake construction, the stone pattern in a masonry wall must be arranged in a series of horizontal beds superposed as the wall goes up.

The strength of such a structure depends much on the new element added, the mortar, which must with time make an indestructible bond between the stones. As often is the case in the association of two materials—as it happens in metallic alloys and in reinforced concrete—the result may be stronger than either component: Roman masonry is unequaled by today's product, but it may be considered crude when compared with the fantastic mortar used by the Chinese to cement the stones of the Great Wall together—a pure white dough that dulls steel tools. In such a method of construction, there

This herringbone type of design is used near alluvial beds of great rivers like the Italian *Pô* or the French *Rhône,* where the only stone available is made of fairly large flint pebbles smoothly rounded by water erosion. Such design creates a structural skeleton which reinforces an otherwise unstable masonry.

The Chaldeans used the same design in their brick walls, and for the same reason

The whole width of Amiens cathedral
could easily be contained within the nave
of St. Sophia, and three superposed Par-
thenons. The interior of this extraordi-
nary "shell" is still unsurpassed today in
this immense articulation of space, where
the scale of man is nevertheless always
present. How far we are from the gigan-
tism of St. Peter, where the human scale
is lost.

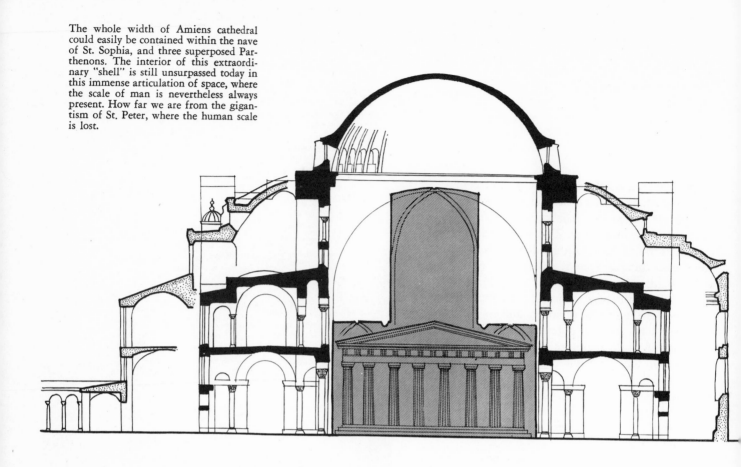

cannot be any question of spanning any sizable
opening with a single lintel: whence the *arch*
and the *vault,* as main characteristics of this
type of design. This offers a clue to why some
people on earth have developed arched design,
while others ignore it completely.

In strictly consistent masonry—stone or brick
—where straight horizontal openings are impos-
sible, the architect thus becomes more of an en-
gineer in designing the structural form that will
transfer the weight of the construction above to
each side of the opening, where the wall offers a
continuous support. As a result, we have all the
various kinds of arches.

The development of the arch marks one of
the greatest steps in design. It opened almost un-
limited possibilities for ever-widening volumes,
lightened with an ever larger and more skillful
system of structural openings. The first awkward
arched bridges of Mesopotamia and the rustic
arches built by farmers the world over to
span streams on their land, were to lead to *Hagia*

Sofia, the immense wonder of the Byzantine art,
that could comfortably shelter under its dome
the Parthenon, Notre Dame de Paris, and a
score of other "pièces de résistance". It was the
key to the design of the great cathedrals of the
Occident. But as it happens for all authentic de-
sign characteristics, the arch is not the result of
progress or historical development, but strictly
the result of a particular geophysical environ-
ment. We saw how lintel design was the normal
design to be expected in Egypt, Greece, or Peru.
Following the same reasoning, we may under-
stand why vaulted architecture has existed since
time immemorial in the valleys of Lower China,
in Mesopotamia, as well as in subtropical Sudan
or the Netherlands: in other words, in all al-
luvial basins of the world's Great Rivers, where
good stone is unavailable, but where *clay* of ex-
cellent quality is aplenty.

And this brings us to another wonderful fam-
ily the rock material has to offer to the designer,
the clay family, which speaks the *vaulted* lan-

60

guage for the same reason as stone masonry: because it is also made of small elements, but all of standard size this time.

Clay has been used at all periods and all over the world, for kings and gods alike, before it became today's poor man's masonry.

It can be *poured* between forms into a continuous structural wall (it is the European *pisé de terre*); it can also be formed into bricks that may be used after having been only *dried in the sun* (as in Chaldea, Sudan, or as the Indian *adobe)* or after having been *baked in kilns,* as our regular bricks.

Raw clay, baked in the hot sun of the subtropical desert, constitutes an excellent material, and is still much in use around the world, for the better health and happiness of countless millions of families. We tend to look down upon such primitive architecture as backward, and replace it by thin concrete or steel structures which would be unlivable without constant air-conditioning and the extra-padding of costly insulating materials. We forget that the thick, in-

expensive adobe structures possess triple-A grade quality of air-conditioning and insulation. Anyone in doubt only has to enter a native Indian pueblo home, in the scalding summer sun of Taos in New Mexico, for instance, to be at least shaken in his faith in what we like to call "progressive design". It is an amazing experience to feel for the first time the true comfort of the natural and healthy automatic air-cooling system of an earth-dwelling.

Adobe, or raw clay, presupposes a hot and dry climate, where rain is no problem. But we must remember that as soon as rain becomes part of the picture, adobe returns to mud and can hardly be considered any more as a building material. But then trees, in turn, begin to grow, as we reach the fringe of the Forest. Thus, at the same time that nature provides for ample rainfall and destroys the possibility of using raw clay, it also provides for the indispensable fuel to bake it and thus transform an impossible raw product into one of the finest construction materials ever devised by man: *brick*.

Adobe wall and oven in Taos, New Mexico

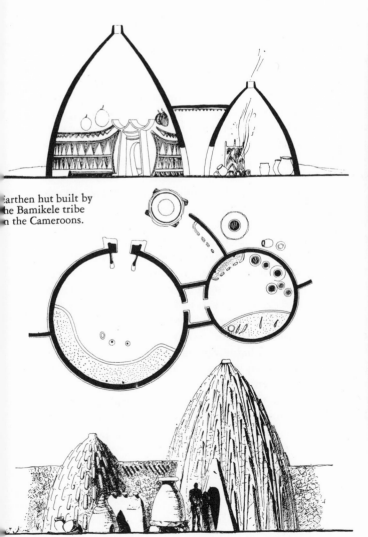

Earthen hut built by
the Bamikele tribe
in the Cameroons.

The characteristic feature of all organic material is its cellular and fibrous composition: the structural cells are organized along fibers that act like the long muscles and ligaments in our limbs. Being the most versatile and available of all building materials, organic material has become the one most commonly used the world over. *Wood* is the most important, whether used as timber assembled together into a structure, or as poles and reeds lashed together into a basket-like structural pattern. We must remember in designing with wood that it reacts as a live material long after it has been cut in the forest.

The growth of wood on earth is distributed into two areas:

(1) the northern wood belt, that extends from the northern limit of the timberline (the frozen arctic tundra) to the southern limit of the temperate zone.

Within the last few centuries, the southern limit of the forest has receded, due to the spreading of agriculture and the cutting out of large areas to open fields for cultivation. The trees in this zone are characterized by resinous species that grow close together in the dense northern forests we know well.

The wood from such trees is very straight, easy to mill and work with simple tools, light in weight and very homogenous in composition. It makes an ideal material for building.

(2) the equatorial forest, that straddles both sides of the Equator in South America, Africa, India and Indonesia. It is composed of variegated species of hard woods, some of them so hard that they blunt the best tools. Their density almost forbids their use for timber, which explains their use being restricted to veneers through the unrolling process, into plywoods. The natives use them only in their most elaborate architecture, in design dedicated to their gods and rulers. In the design of their homes, they use bamboo, reeds, and small round limbs lashed together with raphia and other rope-like material.

Between the two zones, wood is scarce and the warmer climate gives a rapid growth to the lighter woods, and makes them too soft to be fit for building: the poplar family (poplars, cotton woods, etc.) that represent the lighter woods in this area, proved to be unfit for building material. The only species left in this area for the designer are hard woods such as oak and walnut, that do not grow in dense forests, but only in small woods or as isolated specimens, making wood a more precious and rare material.

From this distribution of the most important building material on earth, two very distinct types of design were to develop:

From the northern forest stemmed the *frame construction,* characterized by an integral use of wood, without much variety in the size of section used. A consistent frame construction of practically any size could be designed strictly with 2 x 4 members. The system is very similar to a bird cage, with thin members very close together in both horizontal and vertical directions. Once the construction is completed, with walls and roof, its behavior is very much like an orange crate, the whole construction acting as a single element.

From the arid and desertic subtropical zone between the two forests, where a tree becomes a treasure of shade, stemmed a very different type of design, wood being restricted to structural members only and, as we go deeper into desertic lands, used only in the structural members to hold the roof, placed directly on bearing walls made of stone, adobe, or brick. This makes a system very similar to a skeleton where each bone acts to transmit to the next the stress of the rest of the body. This is the *post and beam* type of design that we find throughout the Mediterranean civilization, from the Middle East and the Moslem countries to all Latin countries.

With the emigration of European groups to both Americas, and the newcomers settling under a climate related as closely as possible to

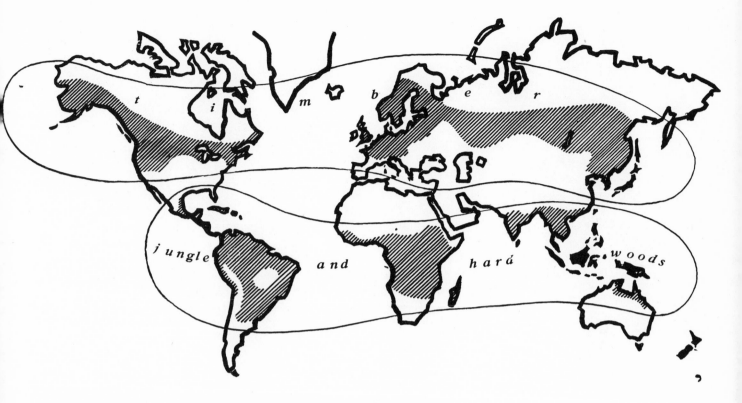

Map of the world showing the two major forest zones: the *timber belt,* a characteristic of the northern hemisphere, and the *rain forest* which straddles the Equator.

their native land, we understand that there is more than a historical fact in the similitude we find between North American homes and English cottages, between the Mexican or Argentinian haciendas and a Spanish farmhouse. In this adoption of one or the other system of construction by the settlers, we must consider it as an honest and authentic expression of the use of the material available. It is in the same spirit that we let our design today be widely inspired by the Japanese, regardless of the difference in historical background. As far as pure design is concerned, we might say that the frame construction is altogether more consistent than the post and beam construction. Progress in design has led to the use of elements gradually lighter, as progress in architectural design has constantly aimed toward spanning greater spaces with lighter structures, adding strength while decreasing weight.

This explains the strange sturdiness of flimsy looking structures like the small houses built according to the frame principle. At least once a year in the press we see photographs of such a building transported by a hurricane across a lawn, or happily floating down a flooding river with chickens perched on the roof and enjoying the journey. Moving bungalows on wheels is a current affair in this country, while it would be absolutely impossible in Italy, for instance, where frame construction is not in use. Another feature of this construction is its marvelous suppleness that comes from its multi-articulated construction. In Japan, for instance, it has helped many homes to survive the frequent earthquakes, as there also, it is the traditional mode of construction.

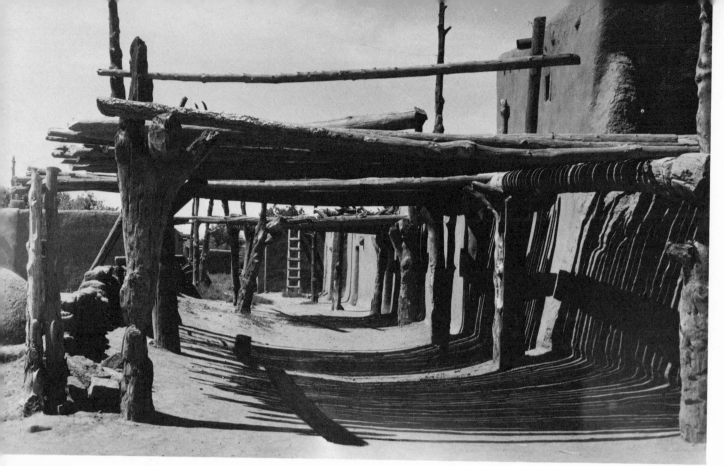

POST AND BEAM CONSTRUCTION. Covered street in Taos, New Mexico

FRAME CONSTRUCTION. Framework of a barn near Janesville, Wisconsin

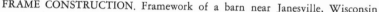

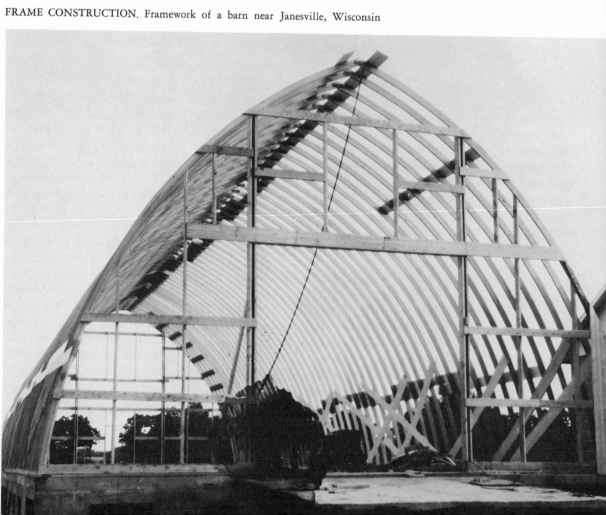

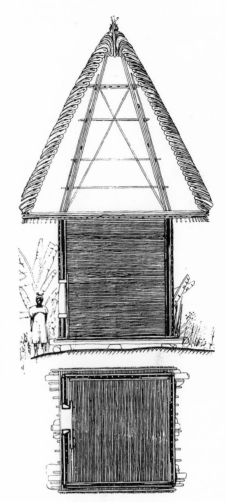

Section and plan of a Bamikele store-house (Cameroons). The roof structure is independent from the walls and fabricated on the ground. It is entirely made of lashed bamboo roofed with thatch. Note the sliding door

LASHED CONSTRUCTION

The language of materials that cannot be assembled by sawing, mortising, etc., is the oldest in the world, as it requires the help of no fabricated tools, and only manual skill, a rare quality in our time, but abundant among primitive people. It is also the most wholesome, as the material is used in its natural state, each piece being juxtaposed next to the other, without wounding its structure. The structural members may be bamboo, twigs, posts, and the ties may be made of willow shoots, rattan, rope, etc. The boy-scout type of lashed structures made of branches belong to this family. Metal can also speak this language, as in tube scaffolding and steel cable construction.

As a result, extremely light structures are created that can withstand cyclonic storms by offering the least resistance and by being able to bend easily. The whole structure is articulated on quantities of joints that never can be absolutely rigid, and insure to the whole work a great suppleness.

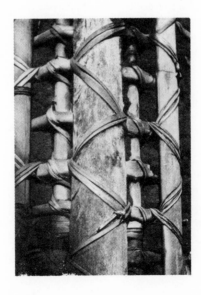

Detail of the structure above showing the lashing technique; the flat ribbon-like strands of bamboo bark used, hug the cylindrical posts with greater efficiency than would ordinary ropes

65

Metal can be considered as a higher grade of molecular organization, and as such is able to stand greater stress. It reacts under stress according to strict mathematical rules, as its qualities of structure (density, purity, elasticity) are directly controlled by man's industry. In a natural material such as stone or wood, the builder cannot know exactly the intimate structure of the piece he is using. As a margin of safety, he is forced to allow more on all dimensions of any given design. This gives all wood structures a heavier look, as the design must carry "extra fat", most of the time unnecessary, but unavoidable.

On the other hand, since metallic structures can be calculated with complete accuracy, the result is a purely athletic look, showing only the necessary sinews and muscles of the structural body, reduced to their bare minimum. This explains the main characteristic of all metal design: *lightness* through economy of material.

A simple example of this difference is offered by the problem of supporting the roof of a porch: while in wood design we may need a 6 x 10 column, a slender steel pipe 2″ in diameter will be almost too big. Steel design is thus the clean cut expression of the bare essentials in forms that constitute the language of the metal family.

Metal design depends mainly on two characteristics: (1) the molecular composition of the metal itself, responsible for its specific strength, and (2) its fabrication into forms profiled and designed so as to produce elements of maximum strength with the greatest economy of material. We can already see by this that the elements used when dealing with the hard and dense alloys of the heavy metal family will have to be designed differently from the ones that come from the family of light metals.

a. The heavy alloys

Iron is never used in its pure state, but in alloys combined to increase certain characteristics as a building material. It is offered in sections profiled at right angles, as I, T, L, and U bars that provide the standard raw material for the steel designer. The elements offered to the designer thus being bars of various rectilinear section—

or beams—the result will not be very different from wood design—but with thinner members and longer spans, as the wood elements used by the designer are also rectilinear and of rectangular sections. A steel floor is not basically different from a wood floor. A composed steel truss, whether straight or arched, is very much the same as wood structures designed for large spans: it is only a question of scale.

Only very recently has the most authentic quality of steel—elasticity—been used in a new language (what we call elastic steel design) that has not yet given its full answer to the designer.

b. The family of light metals

These metals are mostly used in their pure chemical state. Their poor tensile strength and their brittleness did not seem to fit them for their bright career as structural materials, until the stiffening effect of curvature was applied in designing their sections, multiplying the structural strength by the effect of corrugation.

They have already proven very inspiring for the designer in light structures made of tubes and profiled corrugations. We are becoming more familiar with such extremely light structures using the light metal for compression members and steel cables for tension.

The kind of design used in airplane construction could be generalized to architecture. The use of sheets, stiffened by bending or assembled in hinged polyhedric volumes of relatively small elements, may create very elegant structures that are the authentic expression of the material. By the processes of curving, bending, welding, and forming, structural surfaces of great strength and beauty may some day express a new design language striking by its poetic simplicity.

Outside of their use in the pure metallic state, light metals, in combination with other light elements, have given rise to new materials of remarkable strength, lightness, and workability. These *"metallic foams"* offer a microscopic texture very similar to pumice. They can be made into any structural form, can be sawed as easily as cardboard, maintaining, nevertheless, a strength comparable to metal. These developments are still in the experimental stage.

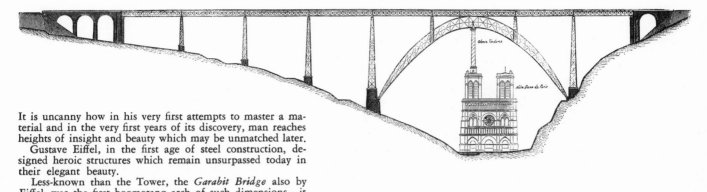

It is uncanny how in his very first attempts to master a material and in the very first years of its discovery, man reaches heights of insight and beauty which may be unmatched later.

Gustave Eiffel, in the first age of steel construction, designed heroic structures which remain unsurpassed today in their elegant beauty.

Less-known than the Tower, the *Garabit Bridge* also by Eiffel, was the first boomerang arch of such dimensions—it is 380 feet high

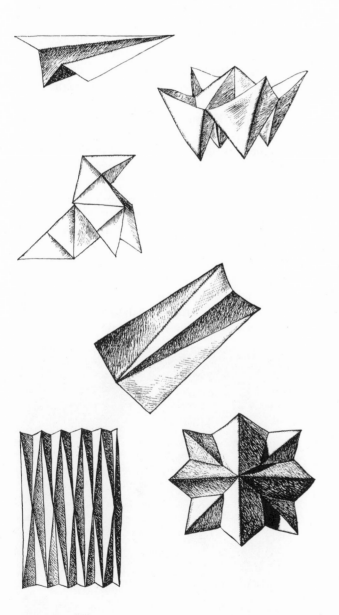

Who has not, as a child, constructed some of these fascinating paper toys. Little he knew then that his toy would be used in its structural principle in light metal construction. The Japanese have mastered this craft and design superbly clever folded paper objects

The paper arrow, placed upside down, makes a great roof, and as for strength, the typing paper sheet 8½x11, when folded as shown here, can easily stand the weight of a brick. Try it

Although they are being used to their full uniqueness by the engineer in planes, missiles, couplings, etc., these new products of man's industry open immense possibilities which have not yet found their truly authentic language in construction.

Thermoplastics seem to be the most promising of these materials. They result in permanent foams and sprays, but they still are manufactured generally in rolls and sheets, just like any other material such as paper, fabric, glass, or metal. They are mostly used as glass substitutes, and as such are poor substitutes. We see them used by architects in association with a known structural material, and used as a skin or membrane on a skeleton of metal, in flat and angular surfaces borrowed from the traditional language of wood and metal.

However, if we analyze what makes plastics unique among all other materials, we find that their chemical composition as well as their method of fabrication permit total plasticity from the time they are born in the vats until their hardening into a mature and final material after firing or cooling off. They may be molded or blown while still in the pliable stage, without the help of any foreign material.

We can thus visualize monolithic plastic foam, sprayed directly from a thermo-mixer similar to a concrete ready-mix machine, thus constructing walls and roof in one operation thereby combining strength and high-level insulation in one continuous structure.

Liquid plastics may be designed to take the shape of extremely thin surfaces of any desired curvature, and keep this shape permanently after curing. This unique property should steer the designer toward the unexplored regions of minimal surface design. Of these, very few have thus far been used. We are familiar with the helicoid, the hyperbolic paraboloid, the hyperboloid of one sheet and the catenoid, all used in shell design because they all are ruled surfaces, and as such may be economically realized on forms made of straight wood members. But others remain to be used to fit various spaces according to an infinite variety of plans and programs. New methods must be devised to realize such curvatures practically—not with the awkward system of forming them on a prepared surface —but possibly in one operation, dipping a framework in a tank of suitable size, as is experimentally done with the viscous film of a soap solution.

The result would be structures of total transparency and with complete absence of light distortion characteristic of these ultra-thin and ultra-light films under any curvature. We can let our imaginations wander in a city of tomorrow made of this unique irridescent material creating shelters of any form and any dimension, instead of the array of heterogenous materials tacked together with rivets, and other crutches.

the tetrahedron

If we break the four-dimension system of cells of the inverted tetrahedron made of soap membranes, we obtain a three-dimensional minimal surface widely used today in concrete shell design: the hyperbolic paraboloid

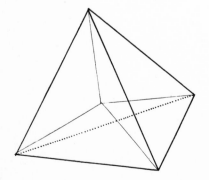

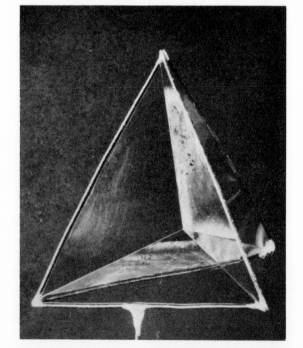

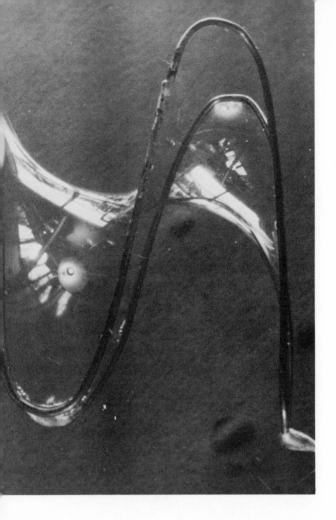

the monkey saddle

The point where the three mountains and the three valleys meet in this figure is an isolated parabolic umbilic. At this point, there is no curvature

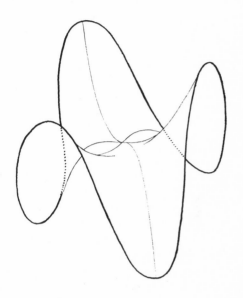

soap bubbles & minimal surfaces

Minimal surfaces may be easily constructed by dipping a wire frame into a soap solution. The frame acts as a boundary and limits intriguing combinations of beautifully curved membranes. With a mixture of soap and glycerine, and by using frames not larger than 3 inches, fairly stationary models may be made

the cube

The complete system of cells created within the cube by the soap films illustrates four-dimension space

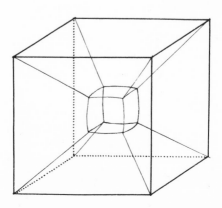

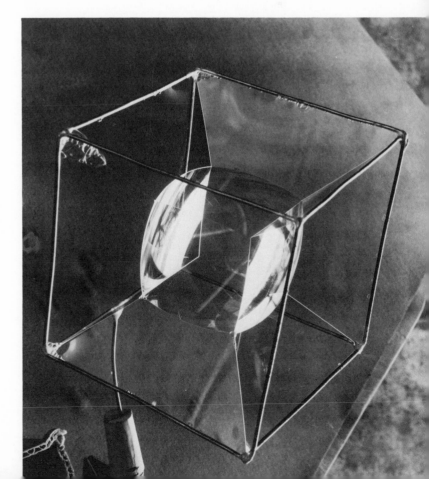

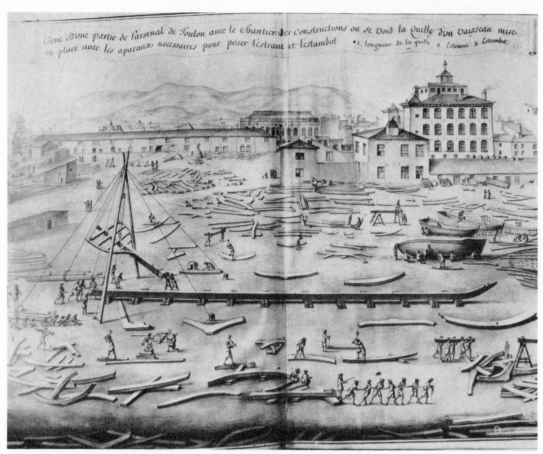

Dene Dune partie de l'arsenal de Toulon auec le chantier des Constructions ou se void la Quille d'un vaisseau mise en place auec les aparaux necessaires pour poser l'estraue et l'estambot. •1. longueur de la quille 2. Estraue 3. Estambot.

Shipyard at Toulon

NEW HYBRIDS

The use of laminated beams as curved elements of structure is really not new, as it stems from the same principle and speaks the same language as the wooden ship construction of old. Shipbuilders the world over learned to use curved wood members that would exactly fit a required design, and selected for the purpose of greater strength hard wood boughs and forks already grown into the desired curves by nature. No saw was ever used to fashion the pieces, leaving the fibers intact in their fascicled strength similar to the long muscles of an animal. (See also p. 88)

Wooden ship design thus provides a great source of inspiration for the designer of today's laminated wood structures. The twisted hull of the Venetian gondola stands out in particular as one among the most remarkable

We know how much hybridization has done to the plant world, in creating new *strains* of living organisms in which the qualities of both parents are fused into a subject that behaves with complete originality.

Man also has created new products by starting with two natural materials, and the result in many instances has proven to be an almost unbelievable success. They come generally from the association of a tensile material and a "filler" of good compressive quality.

These hybrids of the family of materials have in some instances outmoded their parents. To quote only some among the most important, we have *plywood,* born from the bonding of thin sheets of unrolled wood with synthetic adhesives. Thin plywood may be bent into very

70

strong and buoyant surfaces, a field of design which has barely been explored yet. *Laminated wood* stems from the same process as plywood, but made into beams of any curvature and thickness profiled to withstand any specified stress. The result is an athletic structure showing its muscles where they are needed, and stripped of the "extra fat" that the usual wood beam has to carry along. *Fiberglass,* made of acrylic plastic and fibers to reinforce it, is one of the most recent hybrids.

But the most important hybrid to come on stage is the glamour boy of the century: *reinforced concrete.*

The career of this amazing material started when it was discovered that by combining the tensile and elastic qualities of steel with the considerable resistance of mortar to compression, the combination of both resulted in a material that behaved differently from either of its parents. Thin profiled cantilevers became possible. Curved shells and membranes a few inches in thickness that could be designed to span wide spaces, introduced unheard of possibilities in form. Like all of man's discoveries, it also lent itself to abuse and it took a long time for the designer to find the forms that would best express the qualities of this material in all their originality and uniqueness. The first age of concrete considered this material as an economical extension of the use of steel, as it made possible spans and structures feasible only in steel construction up to then. As was to be expected, the countries of low labour and high steel costs found it the ideal material, while countries traditionally rich in steel products, but having to deal with a constantly rising cost of labour, like the United States, were not too interested in this new material. These structures of the first age of concrete show mostly lintel design, as an awkward and not too original design directly inspired from steel forms.

We are still in what we might call the second age of concrete, a rich adolescence where all promises of maturity are unfolded before us in a rainbow of possible concrete structures: thin slabs, shells and membranes, folded structures, pre-stressed, rammed, vibrated, etc., all in a richness of possibilities that unfortunately dulls the designer's sense of choice and makes it difficult for him to find the best and truest expression of this material. Like a child talented in too many directions, it is hard to find what part of his manifold talent is really the expression of his personality. When concrete finally comes of age, we shall probably discard from its design all forms that are not the absolute expression of plasticity, all forms that can be executed *in lighter weight, with less expense and more efficiency in another material,* and which are now being used in concrete construction. We will probably no longer see folded roof structures that are more expressive of sheet metal design than of concrete, and exposed ribs and arches that are still a hangover from wood, steel, and masonry construction.

What reinforced concrete can express authentically is the plasticity of two-way surfaces of all forms and descriptions. We have seen that beautiful and intriguing surfaces have not yet been investigated for their constructive possibilities, since the forming of concrete surfaces on wooden forms has restricted its use to surfaces that must be built with rectilinear elements of wood. This is perhaps the only reason for the widespread utilization of the hyperbolic paraboloid for concrete shells, since it is a ruled surface. The full extent of minimal surfaces in concrete has not yet been explored for lack of adequate and economical forming material.

This short review of the character of a material that would require volumes to do it justice can only impress upon us the main criticism of any design, with any material: *authenticity* from which stems the elegance and consistency of a solution. If we can build a structure more authentically in steel, or wood, why should we use concrete—and vice-versa?

We would avoid much misunderstanding in design and clear up much confusion, if we let ourselves be guided by the innate qualities of each material. In the case of steel and concrete, we should keep in mind that the great difference between the two systems of construction is that steel is articulated and assembled, while concrete is monolithic and rigid.

It is refreshing to see the engineer today preoccupied with investigating the total use of a material in its uniqueness. We hear today of elastic steel design, ultimate strength concrete, etc., where the language of economy and honesty brings authentic solutions unheard of before.

Detail of mosaic in S. Maria in Cosmedin, (8th century) Rome

Detail of mosaic in the church of Loreto, in South Bend, by Grillo

The art of mosaics is among the oldest. First made of marble and stone chips, as in Aquileia and in the early Roman works, it reached its maturity with the Byzantines, who used glass of many hues and metallic gold. Today, the time and workmanship involved in placing glass chips of odd sizes into a Byzantine type of mosaics makes its cost prohibitive in most cases, and reduces its use to smaller works.

In the church of Loreto, the author developed a new technique which made it possible with a normal budget to cover the walls of the entire church with mosaics of heroic size (85 feet in height) by limiting the size of the "tesserae" to a standard ¾″, and using only squares and triangles.

This work was executed with the finest glass and gold tesserae available in Italy. It covers approximately 7000 square feet of figured design

Detail of mosaic in the church of Loreto, by Grillo. Both the upper left picture and this detail are shown at approximately the same scale

MATERIAL AS A VENEER

Any material may be used in two ways: for a *structural* purpose, or as *veneer.*

While in the first case we are only interested in using its strength in the most fitting combination of forms, in the second, we are only concerned with its texture.

When used structurally, the role of a material is to hold the building together, to span openings, and make jambs, columns, struts, etc.

When used as a veneer, it is only supporting its own weight. It is applied as a *skin* over an already existing structural system.

Stone is more and more used as a veneer material, as the expense in cutting, tooling, and transportation, is now generally much too high to warrant its use as a structural material. The slabs taken from the quarry are sawed into slices following planes parallel to the quarry bed.

Therefore the expression in design is obviously different when using stone structurally or only as a veneer. When structural, the pieces are put together so as to spread stress and weight evenly throughout the part of the building involved. In a structural stone wall, the joints must be staggered so as not to offer anywhere a continuous line that may very soon develop into a crack, at a line of least resistance. Cracks are caused by vibrations, small earth movements that occur all the time, like the daily earth tides that we don't notice, but that nevertheless raise the ground a few inches twice in a day. They are also due to expansion and contraction of the material itself. The stratification of horizontal running joints strengthens the structure against such movements, allowing also for necessary suppleness by its fascicled composition.

The reaction of a veneer wall is entirely different; it constitutes a solid curtain of small elements made into a single panel, the façade. The joints may be put in any direction, as gravity does not interfere so much as other forces such as a kind of superficial tension and vacuum bonding that relieves the dead weight of the veneer elements. In the case of a very thin veneer material such as porcelain-enamel, or clay tile, it is known that as soon as the tiles are hardened into a vertical surface such as the spandrels of an office building, the great weight of this thin wall—which should add a considerable weight per square inch to the foundation directly underneath—is automatically relieved by some sort of an adhesive force exerted horizontally on the inner surface of each panel, so that in the end the vertical stress may be almost completely negligible. It seems to be transferred to the structural wall by some vacuum negative force that binds the veneer to the main structure of the building. This is very close to the force of superficial tension, if not superficial tension itself, but of another order. This effect decreases in inverse proportion with the thickness of the material in ratio to its surface.

For instance, in residential stone veneer, where the size of stones is generally small and irregular, the design must follow the structural stone design, since in this case it is not a true veneer wall, but a thin structural wall placed in front of the framework.

On the other hand in large façades, like office buildings, any pattern may be designed in assembling the veneer. The most usual is a reticulated design of rectangles or diamonds, all the slab being cut exactly the same size and form: the wall veneer is nothing but a mosaic. This explains the fantasy of veneer design, from the simplest criss-cross checkerboard pattern most in use today, to the other extreme, the mosaic, with all its pictorial possibilities.

TEXTURE AND MATERIAL ASSOCIATION

Texture can be rough or smooth, polished, glazed, or grained. It can be left natural—as in wood shingles, wood columns, and some stone work. It can be tooled by the craftsman into all sorts of patterns in which the mark of the tool is of great importance. However, whenever tool design is apparent, it is essential that it should remain the result of necessary craftsmanship, and not become an added decoration. The effect of texture is to bring out the dramatic expression of the material itself, and not to cover it with pretentious doodlings.

The final *aspect* of a material is a result of the tooling and of its natural color. This is the characteristic of our final product, that will dictate its combination with others. This brings us to the study of the laws that seem to organize the various "material schemes" which are as important to respect as the laws of color schemes in decoration.

We have seen that very rarely may the architect use only *one* material. In most cases, he must use a basic structural material, and match the others with it. His choice again will be directed by the principle of unity.

Material of similar origin generally go well together.

Natural material matches all other kinds of materials in their natural state: non-polished metal blends well with rough stone, while polished metal goes well with wood or stucco. A rough structure attracts rough friends, while a soft speaking host, smooth sanded and painted, will attract the most polished guests of design: the whole family of polished metals, lacquers, glass, and plastics. This consistency in the use of various materials will once more be our guide to good design.

The law of contrast, ever present in art, will on the other hand help us avoid our falling into excessive monotony that sometimes is the ransom of total unity. We may flout the rules in introducing to our party a clashing original which will bring, with his unusual personality, the necessary contradiction that is the life of social relations: a rough stone among superpolished friends, a gold touch amid natural woods, an accent of pure color in a generally drab color scheme will give spice to the dish. But there should always be one dominant family of materials to play as hosts to the more erratic friends.

The fact that the artists of the great periods were most aware of the principle of unity is shown by their very sober use of materials. It is true that much of this was due to the fact that transportation was difficult and the material used was what could be found on or near the spot. Transportation also meant high prices. But the essential reason was that the value of the material per ounce did not tag a work of art. True, more detail was often expected from rare materials such as gold or silver, than of less expensive ones. But in all cases, composition and art were then the only criteria of any workmanship. These periods emphasize the conquest of spiritual over material values. Material was used then as plainly as possible, and did not shout some loud story in marble, chromium, or gold, to show off how much money had been spent on the job. The work of man, composer or craftsman, was the only precious thing then. Those were periods of strong faith, and man let himself humbly be led by his ideal.

The decadent periods, on the contrary, are periods of doubt, confusion, and revolt. Like the fall of the great empires, they are notorious for their lavish use of expensive material and extensive polychromy together with poorer design. It is a sign of the bad taste and selfish vanity that is associated with all decline in culture. They generally follow in the wake of the great wars and are the curse of the winner. The reaction brings into power the "nouveaux riches" that become the new patrons of art overnight. The country that benefits from a war is rarely the victorious one: the losing party reacts more quickly, as it is a matter of death or survival, and fights back desperately and with renewed faith to grasp the elements of truth and the human values and principles on which to establish a new deal in living. By rediscovering the essential truths, it rejuvenates itself, while victory brings in its wake a decline of all authentic values in a patronizing swelling of man's ego. Man is quick to forget what he owes to nature when he is given power. We all know that the most difficult letters to write are "thank you" letters.

The comeback toward wholesome design is a slow revolution. It levels off when the new order has firmly established itself and the artist is given freedom to do his own reckoning and draw his own constructive conclusions.

Our generation seems to belong to the second part of such a period, and is in the full swing of creativeness. But the designer, in his choice of materials, is apt to be more confused than he has ever been before, and this for two main reasons:

1. Transportation is no longer a problem:

Our time is characterized by the development of almost instant transportation, putting within immediate reach of the artist any material or product on earth. The choice of his basic family of materials for design is only dictated by economy and his own fantasy.

2. The development of industry has promoted a family of new materials—which we have called the synthetic family—which are being used before their design possibilities have been fully analyzed. This "embarras du choix" calls for a cooler head and more self-restraint than ever from the designer, and creates a difficult problem of choice. This may well explain much of the poor design of today, as too many materials are being put together at random, their particular affinity for association not having yet been established.

Basic material	Character	Associations	Examples
LIMESTONE	PLAIN *Strength and wholesomeness.*	*Tapestry, wrought iron and raw metals; sculptured stone; murals in oils or casein; clay tile and stone mosaics; natural wood finish, textured material and fabrics; wool.*	*French cathedrals; Rubens in Antwerp; all peasant civilizations; China.*
MARBLE	RICH *Power and might; wealth and The Law; permanency.*	*Precious materials; silk fabrics, satin, brocade; painted woodwork, polished rare woods, glass, crystal, water; mosaics, enamels; polished metals, silver and gold.*	*Taj Mahal, Amber Palace, Pearl mosk (Delhi), Saracenic Egypt and Persia, Byzantine, Renaissance.*
WOOD	WHOLESOME AND WARM *Most versatile but smaller structures; residential, rural, not monumental.*	*Copper, brass, and bronze; cottons and linens; textured fabrics; any material with natural finish. Different woods associated in same design scheme should be true to their inherent qualities.*	*Timber zone (Hercynian Forest); any time, anywhere.*
BRICK	PRACTICAL *Opens possibility to very large structure; monumental, commercial and residential.*	*Ceramics and kiln-baked sculpture; flat enamel and bronze; decorative fabrics, brass and iron hardware.*	*Holland, Languedoc, Thermae of Caracalla, St. Sophia, great vaulted Roman and Byzantine structures.*
STUCCO	DECORATIVE *The poor man's marble; fashion, theatrical effect, charm; fits any color scheme or decor; in southern climates for exterior use, elsewhere only in interiors; non-durable.*	*Woolen fabrics; painted walls and frescoes; painted woodwork, natural wood of contrasting shade.*	*Mediterranean and all sub-tropical climates; Alhambra, Tibet, and pueblo structures.*
METAL	LIGHT *Efficiency; cold and hard; purity of line; commercial and industrial programs.*	*Alone or used with contemporary miracle synthetics (nylon, dacron and all plastics); painted and enameled surfaces, glass.*	*Contemporary; the world over in train, ship, plane design, and all public and commercial structures.*

The above chart intends to show how materials of different families can be put together so as to achieve the utmost consistency in design. Nevertheless, let us insist again that a dissonance may be welcome sometimes to bring dynamism. A perfect unity can benefit by adding to it the element of fantasy and imperfection that is the signature of man. This very personal touch in design is left to the artist's judgment, but this dissonance should never be more than an accent within a general scheme dictated by the principle of unity. It should never be the result of sheer vanity in trying to outdo the neighbour and be different from the other fellow just for the sake of showing off. It is true in all branches of art. In Music, too perfect harmony as in Mozart's symphonies may become boring by excess of immobility, while dissonance brings interest and movement—but too much dissonance brings chaos. In Painting, a dissonance within a general color scheme is welcome and sharpens the neighbouring colors. The decorator has to keep this in mind when composing a color scheme: 90% of his work will belong to the same family of hues (warm, or cold, or earth colors, etc.) but the rest will be used as accents of pure bright complementary colors—persimmon, royal blue, lemon yellow, etc. We all know how lovely any flowers—of any color—are in a garden: the reason is that they are only an accent of bright colors that brings the welcome excitement of life and dissonance in the green color scheme—like the cheerful and exciting display of flags and pennants on ships for the homecoming of the Fleet which stands out on the blue color of the Sea.

The land was the best in the world, and for this reason was able in those days to support a vast army, raised from the surrounding people. And a great proof of this fertility is that the part which still remains may compare with any of the world for the variety and excellence of its fruits and the suitableness of its pastures to every sort of animal. And besides beauty the land also has plenty.

How am I to prove this? And of what remnant of the land then in existence may this be truly said? I would have you observe the present aspect of the country, which is only a promontory extending far into the sea away from the rest of the continent and is the surrounding basin of the sea which is everywhere deep in the neighbourhood of the shore. Many great floods have taken place during the nine thousand years which have elapsed since the time I am speaking about: and in all the ages and changes of things, there has never been any settlement of the earth flowing down from the mountains as in other places worth speaking of; it has always been carried round in circles and has disappeared in the depths below.

The consequence is that in comparison with what then was, there are remaining in small islets only the bones of the wasted body, as they may be called; all the richer and softer part of the soil having fallen away, and the mere skeleton of the country being left. But in former days, and in the primitive state of the country, what are now mountains were only regarded as hills; and the plains, as they are now termed, of Phelleus, were full of rich earth, and there was abundance of wood in the mountains. Of this last the traces still remain, for there are some of the mountains which now only afford sustenance to bees, whereas not long ago there were still remaining roofs cut from the trees growing there, which were of a size sufficient to cover the largest houses; and there were many other high trees, bearing fruit and abundance of food for cattle. Moreover, the land enjoyed rain from heaven year after year, not, as now, losing the water which flows off from the earth into the sea, but having an abundance in all places, and receiving and treasuring up in the close clay soil the water which drained from the heights, and letting this off into the hollows, providing everywhere abundant streams of fountains and rivers; and there may still be observed indications of them in ancient sacred places, where there are fountains; and this proves the truth of what I am saying.

Such was the natural state of the country, which was cultivated, as we may well believe, by true husbandmen, who were lovers of honor, and of a noble nature, and did the work of husbandmen, and had a soil the best in the world, and abundance of water, and in the heavens above an excellently tempered climate.

PLATO
Critias

76

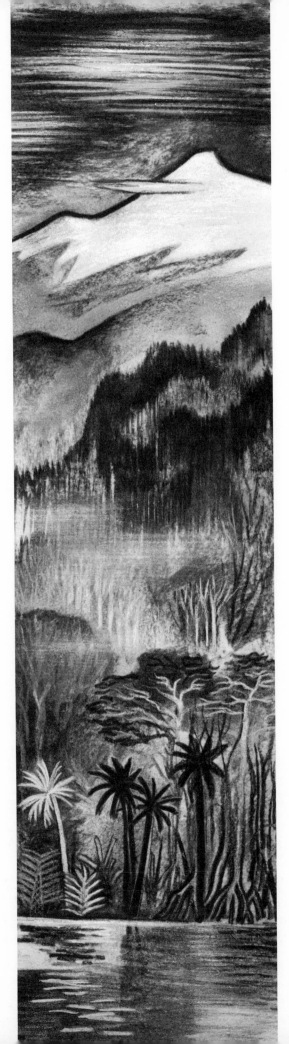

climate

The climate we live in determines our whole way of living. It creates the particular environment for every kind of civilization. From the slightest variation in climate have stemmed altogether different types and systems of society and culture.

Our blood temperature hovers within the narrow life margin between 95 and 104 degrees, and yet man is successfully living in happy communities under temperatures that range from 60 below zero to 120 above.

To survive and progress, man has learned from nature how to protect himself against the weather and has used his ingenuity to turn its liabilities into assets. From this unfolds the whole saga of the archetypes, as numerous and varied as there are different climates, offering their new solutions not only for survival, but for happy living—from one valley to another, from plain to mountain, from seashore to desert, from the equator to the land of the midnight sun.

The study of the archetypes reveals triumphant solutions of common sense and simplicity. There we find man's mind at its clearest, joining with nature in unpretentious teamwork. There we find no nonsense clothed in words like fashion, style, or sophistication. The design is that way because it could not be otherwise—and live.

In this trip to the land of the Little People, we will find ourselves refreshed as we break away from the eclectic borrowings of yesterday as well as from the neurotic doodlings of today's intellectualism.

A typical hurricane lasts about ten days, liberating heat by condensation of water in an amount equivalent to something like 10.000.000 atom bombs, enough to supply all the electrical needs of the United States for the next 600 years.

SCIENCE NEWS LETTER
August 6, 1960

According to site, climate, and latitude, nature imposes certain rules in building. If it is true that these can more or less be overruled when the program is purely commercial since its function makes it temporary, these rules become drastic when the building in question is a permanent dwelling.

Roger Bacon wrote four centuries ago:

"Nature can only be mastered by obeying its laws".

When man forgets this, the results are catastrophic. In 1950, the Saugatuck Reservoir area, near Westport, Connecticut, was hit on Thanksgiving Day by a freak hurricane. It had been beautifully landscaped before with pine trees imported from the South. After the hurricane struck, there was not a single pine tree left standing. Everything was broken, twisted, acres of forest flattened out. It had taken nature less than thirty-six hours of work to erase a million dollar project and ten years of conservation care; but if all the pine trees had been destroyed, all the other native trees that had learned to grow in that climate since the beginning of time—birch, maple, even white oak—all were still proudly standing while the newcomers littered the ground by the thousands.

Every summer, nature launches "Operation Crabgrass". The fresh green blades invade all other lawn grass, to the lawn owner's dismay. Following the advice of the expert, he has spent sizable sums in grass seeds with beautiful labels and formulas. Now he spends a fortune in crab grass killer, hours in watering a lawn which, in the Midwest area, steadily turns to the color of brown sugar as summer progresses, while the infested crab grass areas get greener and healthier under the hot dry sun. The trouble with crab grass is that no one can sell it since it grows free everywhere. The main objection is that it disappears in winter—but does it make more sense to have a green lawn in summer—or not?

What is true for trees and lawns is true for houses and everything exposed to the weather. But there, man had to learn the hard way. Through centuries of experiments, he learned what kind of roof should best fit his home.

Anything we build has to be designed to live outdoors, and to survive under all kinds of weather. It is our problem to make it as weatherproof as possible, as weather can be our worse enemy. We shall see that man has concentrated all his skill since building time began, trying to win this enemy for a friend.

In nature, we find the omnipresent necessity for every creature to protect itself against its own destruction from weather and outside elements. In the vegetal world, there are fruits and kernels, nuts and stalks, where the future generation can spend a cozy winter "like peas in a pod". The hard shell of the nut can stand severe frost if the outside envelope is not removed, as it acts as insulation against cold. In the animal world, there is the typical design of the clam, that shuts tight at the first sign of turbulence of water, warning of a storm or some kind of danger.

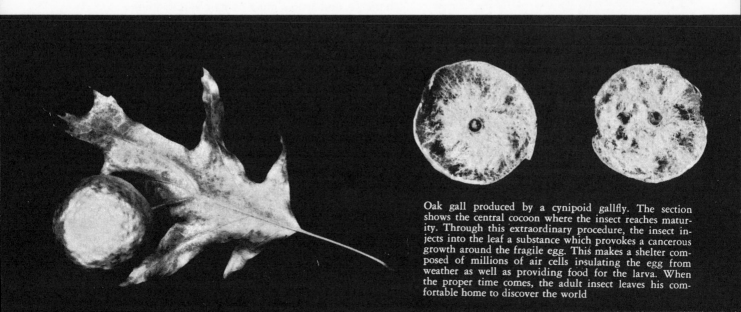

Oak gall produced by a cynipoid gallfly. The section shows the central cocoon where the insect reaches maturity. Through this extraordinary procedure, the insect injects into the leaf a substance which provokes a cancerous growth around the fragile egg. This makes a shelter composed of millions of air cells insulating the egg from weather as well as providing food for the larva. When the proper time comes, the adult insect leaves his comfortable home to discover the world

The ritual planting of a tree as a symbol of liberty was customary among many peoples. This Linden Tree was planted in the year 1438 in the village square of Samoens, in the French Alps, when the town was granted freedom by Amédée VIII, Duke of Savoie. The Chart of Freedom, locked into an iron case, was buried between the roots of the young tree, where it still lies. At the other end of the square is another beautiful linden tree, planted in 1789 to herald the birth of the French Revolution.

The plantation of trees is also a most touching way to pay tribute to the dead. The most beautiful war memorial I have seen is possibly one avenue of maples which today grace the town of Maplewood, New Jersey, each tree bearing a small plaque with the name of a son who had been killed abroad during the first World War.

Who knows what love and happiness presided over the young days of these ancestors of our town streets, today mercilessly murdered in the name of what we call "progress" and in tribute to our new god, The Car

"Where it quits Phrygia and enters Lydia the road separates; the way on the left leads into Caria, while that on the right conducts to Sardis. If you follow this route, you must cross the Maeander, and then pass by the city Callatebus, where the men live who make honey out of wheat and the fruit of the tamarisk. Xerxes, who chose this way, found here a plane-tree so beautiful, that he presented it with golden ornaments, and put it under the care of one of his Immortals"

HERODOTUS
History, Book VII

*Forests precede people,
deserts follow them*
CHATEAUBRIAND

*He who kills a tree
Kills a man*
A SERBIAN PROVERB

A ROOF IS THE MOST ESSENTIAL PART OF A BUILDING.

PEOPLE HAVE LIVED WITHOUT WALLS, BUT NEVER WITHOUT ROOFS

Man, however, who was not born weatherproof like the duck, the turtle, or the snail, must build for shelter. His first idea of a shelter was a *roof.* And the roof *is* truly the main element in any building. The Chinese, a people of wise peasants, use all kinds of characters to express in their writing the different kinds of buildings, but every one of them is crowned with a simple little sign, that means *roof,* and *shelter.* In Japanese, the roof of a house is called *yane,* meaning literally *house-root.*

There is still an important part of the world population that lives—and is among the happiest—without being sheltered by walls, but only by a roof: in the South Pacific, in Africa, and most countries of the equatorial zone.

And it is also true that when a civilized man is brought back by circumstance into primitive living, whether it be during summer hikes in the mountain or at war in foreign lands, his first thought is to protect himself against rain, tropical sun, or snow, by rigging up some sort of a roof: a tent.

When we want to find the reason for any basic design in architecture, we can usually find the answer in a universal example of shelter built throughout the world: the farmhouse built by the peasant for his family. Here, no sophistication, no prejudiced theory, no blind obedience to a certain style or period stands in the way of authenticity. The art of the peasant is eternal, as essential to him as the eggs of his chickens or the harvest of his wheat, and always up to date—as it is the result of strict logic, dictated by economy and sheer necessity. The architect often has imitated this anonymous design in his work. He has

often seen in it only an arbitrary and pretty bit of design whereas in every detail of peasant architecture there is a basic purpose. By displacing such discoveries under other skies, for other needs, he committed heresy.

There is no better training for good taste in design than to study closely every example designed by peasants, of tools, objects and buildings that we may happen to see in any country. They are the eternal archetypes.

In no part of the building has the peasant expressed his logic better than in the roof.

Roofs are designed differently according to local climate and the kind of material available. Climate is the reason for the *slope,* while the local soil conditions explain the choice of a certain *material.*

We should not be surprised then to find exactly the same kind of roof design in parts of the earth extremely far from each other, and without any possible influence on one another. This is because roof design is the result of geographical conditions that we find repeated on both sides of the equator and all around the globe. It does not depend on the particular human group of culture, history, or civilization involved—and as such, we may well say that roof design pertains more to science than art.

For instance, the peasant of the low country around Nantes, in France, builds his thatch roof exactly in the same manner as the wild tribes of central Africa and the East Indians. In another instance, the Chinese cover their temples with exactly the same tiles as the Romans did in Italy two thousand years ago and that the peasant of Spain, Mexico, or Bolivia uses today.

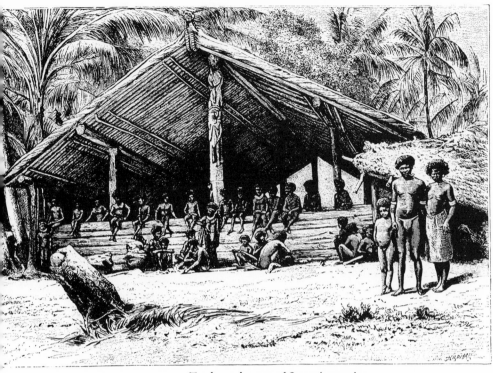

Tambu and group of Santa-Ana natives
Solomon Archipelago

This large meeting house bears a monumental roof, but ignores walls

The Chinese have assembled all characters under the same "roof" to signify some of the basic concepts of language

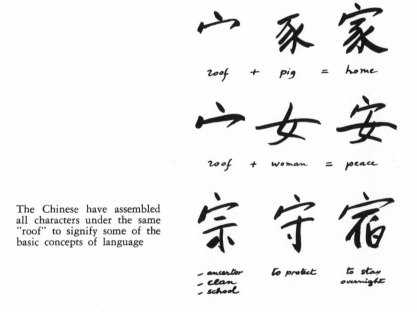

roof + pig = home

roof + woman = peace

- ancestor
- clan
- school

to protect

to stay overnight

IT IS IN THE ROOF DESIGN THAT WE FIND THE FIRST AND ALSO THE MOST VARIED EXPRESSION OF FORM AND MATERIAL

In sub-tropical Provence, high winds, flat plateaus, and lack of shade trees impose the squat horizontal architecture of the farms and other buildings. Bare walls protect against the heat, while open porches act as substitutes for shade trees

TWO CLIMATES, TWO SOLUTIONS IN DESIGN

In the cozy quietude of a deep river valley in the Jura, architecture buds up in full richness. The roofs are rounded off like the smooth backs of ducks, so as to let the rain flow gently off their skin of scale-tiles. Even the trees round up their backs like puff balls.
There is complete accord between nature and man

The massive saracenic tower
crowns the village churches in
Provence, and challenges the heavy
north wind (Mistral). Storms may
rage through the light lacework
of the belfry, but can do no more
than ring the bell. Note also the
tiles, heavy enough to resist the
winds and designed half-round to
shed the rain on the low-pitched
roof during sudden downpours

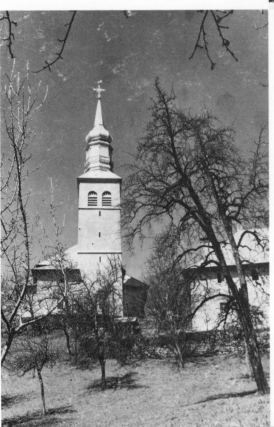

In the protected valleys of Savoie,
the church steeples rise high
and challenge the elongated pear
trees that also reach for the
precious sun

Cosy like the cabbages in the
garden, this round-backed farm of
the Jura reflects the character of
its peace-loving owners. The trees
also spread their foliage in the
same rolling forms as the good
earth they spring from

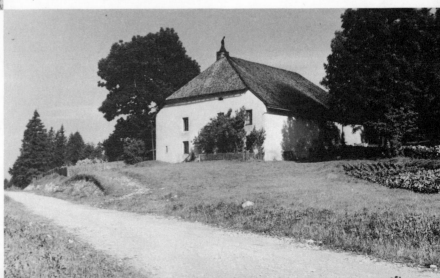

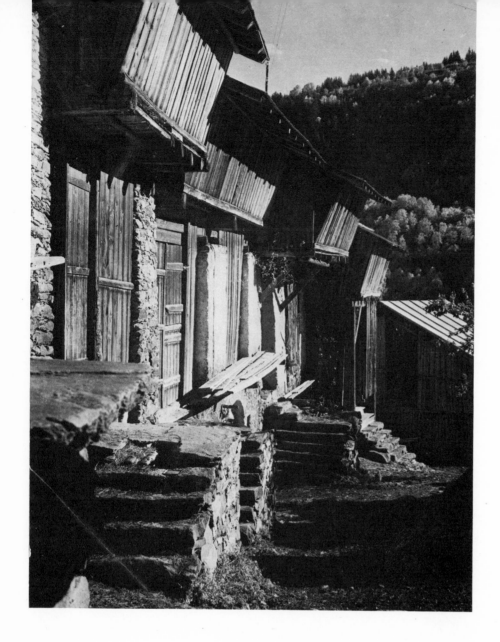

Typical overhanging haylofts structurally built like a ship's hull so as to offer more resistance to the weight of heavy snowfalls and provide for additional storage

Balconies and galleries developed strictly for utilitarian purpose.

This 12′ wide gallery in Savoy, well protected by a roof overhang, serves to dry laundry as well as onions and beans, and is a household necessity in the humid climate of the mountains.

To be useful, balconies and overhangs must be large

84

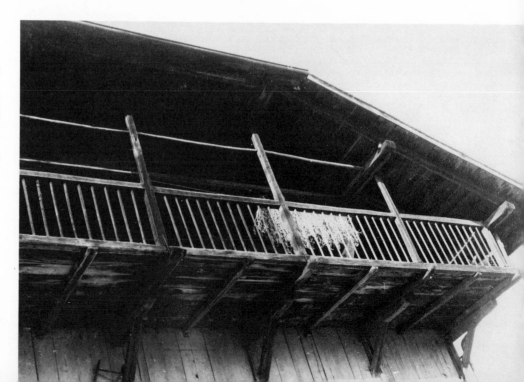

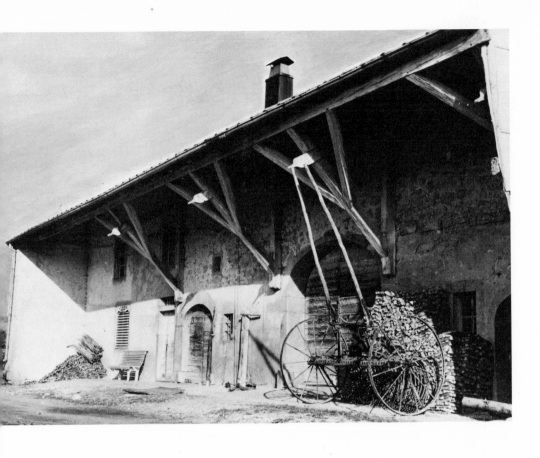

The overhang is a necessity for the peasant, who has to work outside as well as inside. For every case, every climate, and every material, he has found the most elegant solution.

This huge structure, majestic but also light and full of elegance, serves as carport as well as wood shelter and sun porch

As a contrast, this fortress-like farm house, in the burning heat of Provence, with its small windows and absence of overhang, buttresses itself against heavy winds and shuts out the sun

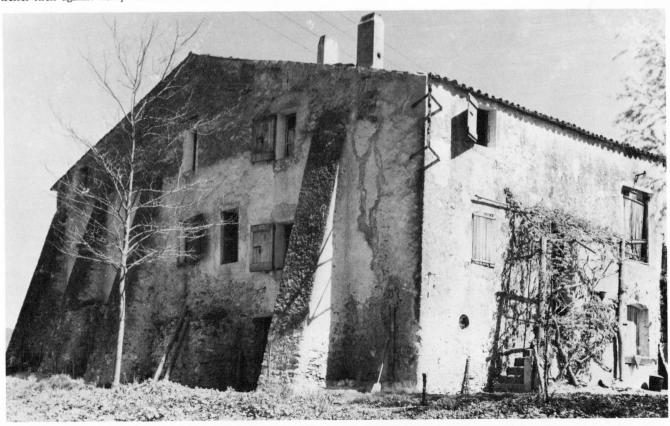

Nevertheless, we can notice one thing: while the various kinds of roof design and materials are grouped in particular areas on the globe, one of them is found in every part of the world, indiscriminately, and has been in use without interruption since the beginning of time—except in the contemporary United States. This material is thatch.

It may seem strange that we should mention the value of a material that the American architect has so completely ignored. But it is still widely used in contemporary design elsewhere. In Holland, for instance, the well-known architect Wilhelm Dudok has covered entire residential quarters, and even schools in Hilversum with thatch roofs. We can be assured that if a stern rationalist such as Dudok has used thatch so extensively, it was not for the sake of local color or a quaint effect. He had a very strong functional reason for doing so, as we shall see.

If we find thatch all over the globe, it is because it is the most versatile roof covering there is. It is *imputrescible*. It is one of the best known *insulation* materials, and as such is as welcome in hot countries as in polar regions. Another asset of thatch is its streamlining design. It offers no sharp angles, but a generally sweeping smooth surface that does not create any turbulent draft effects most destructive by their unpredictability and sudden power. Another reason for its widespread use is that thatch can be made practically everywhere on earth: rye straw, reeds, rattan, palm leaves, etc. —all make excellent thatch material. Its only drawback is that it cannot be transported. It is too bulky to be moved, and too fragile until it is set into place. This is why we find it mostly in the countries where a cereal is grown, or in low marsh lands. And it is also the main reason why it is not used in the United States, as no one would undertake a business promoting an untransportable material. The other reason is the need for specialized labor that we can still find abroad, but which does not exist on this side of the Atlantic.

Let's not forget that thatch is not a cheap material, fit for hovels and slums, but on the contrary quite expensive. If the newly built farms of the gigantic Zuiderzee project are as yet covered with tile, it is only a matter of economy. The engineers have already planted reeds alongside the canals that will make it possible to add the thatch covering within a decade, as the extra needed insulation. As I asked a farmer why he wanted to put a thatch roof over an already excellent tile roof, and thus increase his insurance premium, he curtly retorted: "My cows like the blanket I put on them in winter".

In the timber belt, wood is used as a first grade roofing material, in the form of the *shingles* and *shakes* we know well.

When wood is scarce, the peasant covers his roof with cleaved schists, that make the more or less refined *slates*.

Finally, in the subtropical zone and all quaternary alluvial regions where there is no cleavable stone but where clay is abundant and of good quality, roofs are covered with *tile*—flat or half-round—which is to roofs what brick is to walls.

Industry had promoted new materials that are extensively used, as they are easy to put on (economy of labor due to standardization) and cheaper than the natural material. But none can compete for quality with what nature has to offer. Let's see why.

If we take wood, for instance, we notice that its structure is made of millions of microscopic cells to the inch, forming a skeleton of cellulose. The rest of each cell is made of organic material bathing in a sap which, in the wood generally used in the timber belt, is mostly made of rosin. Cells in turn are grouped into fibers, each fiber acting like a shield against water infiltration. It is easy to understand that no man-made material can offer such a perfectly continuous microscopic structure. Now, when wood is exposed to weather, a complicated and slow process of distillation takes place under the influence of the sun rays, that draw the resinous fluids outside toward the heat, sublimates the most volatile ethers and alcohols, and at the same time concentrates the heavier hydrocarbides—like tar and molasses —while the unstable compounds such as starch and proteins are washed and rotted away by the alternating moisture and heat. The result, after a few years of weathering, is a darkening of the wood that becomes a golden brown, turning as dark as coal tar after a century of

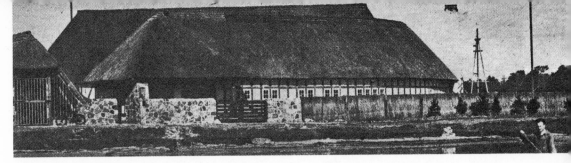

Farmhouse alongside a canal in Holland

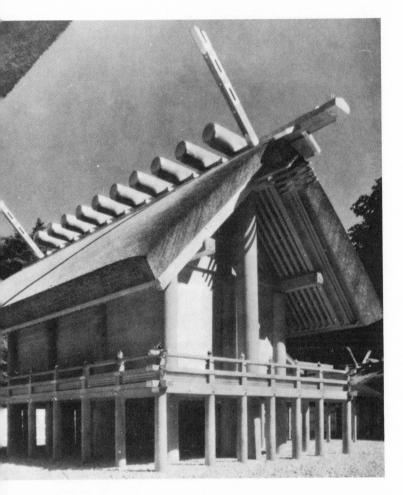

A THATCH ROOF TODAY IS A LUXURY, ONLY FIT FOR GODS, KINGS, AND CHILDREN.

The Shoden or main building of the ISE SHRINE in Japan is made of pale cypress (hinoki) and, like the other sacred buildings, is covered with thatch.

Since the reign of the Emperor Temmu (7th century A.D.) the ensemble of Ise, the most sacred shrine in all Japan, is rebuilt on an adjoining site every twenty years, exactly like the one before it, as a monument to perfection dedicated to the Shinto cult.

The last one was built in 1953 and the next will be in 1973.

This extraordinary rite is also in homage to perfect workmanship, raised to the status of a religion, and so characteristic of the Japanese

Thatch-roofed School at Hilversum, Holland, by Dudok

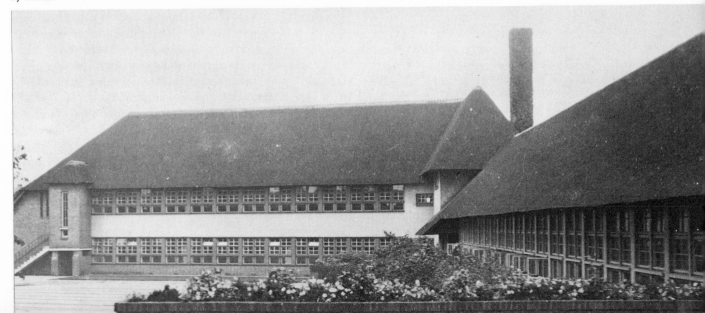

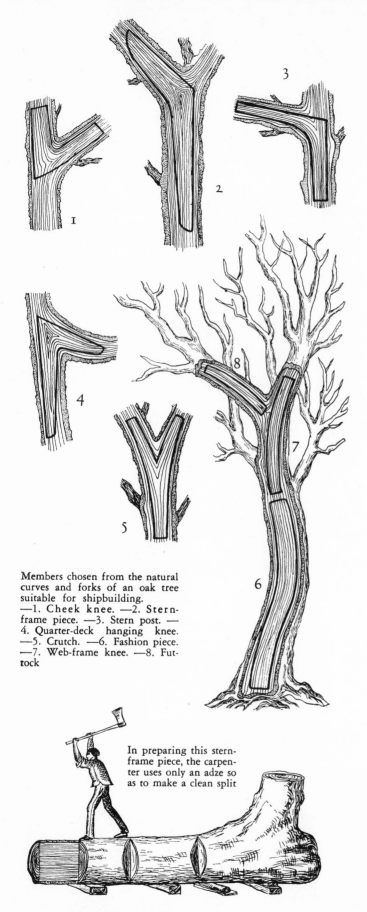

Members chosen from the natural curves and forks of an oak tree suitable for shipbuilding.
—1. Cheek knee. —2. Stern-frame piece. —3. Stern post. —4. Quarter-deck hanging knee. —5. Crutch. —6. Fashion piece. —7. Web-frame knee. —8. Futtock

In preparing this stern-frame piece, the carpenter uses only an adze so as to make a clean split

exposure to the sun. Some woods like cedar bleach into a silvery gray, but the transformation is the same. The wood becomes a sort of new material, completely rot-proof, and much harder than ever before, as its surface is transformed into a rough texture furrowed by deep fiber lines where the lighter organic material of the summer growth has been dissolved, between sharp ridges of pure cellulose impregnated with natural creosote from the inside out.

This superb and slow transfiguration that takes place during the weathering process explains why the mountaineers of the Alps—like the farmers of New England—did not care to put a coat of paint on the wood surfaces of their homes: they knew that no paint could withstand the alternating noontime heat and night frosts of midwinter. In sheltered spots in the Alps, at an altitude of 4,000 feet, readings of 95 Far. in the direct sun at noon (and zero weather the same night) are often recorded during the month of February. This explains the splendid state of conservation of chalets that may be seen throughout all Switzerland dating as far back as the 16th century. A granary thus constructed, built in 1575, was recently transported and rebuilt in the courtyard of Chillon Castle, on the Lake of Geneva: It is as good as new. We find the same type of structures and the same effects in wooden buildings throughout the West, from Colorado to California, from abandoned gold mines to ranches and sheep shelters, still in a perfect state of preservation today, and sunburned to a dark toast color.

In New England, it is interesting to notice that the older houses were not painted either, but left to the good care of weathering. New Englanders were, as a whole, sailors; they knew as only skippers do that there is nothing like sea weather to make good wood last: the white paint of the colonial homes actually comes from the South, an importation from city dwellings of England and the fashionable gentry—a direct influence of fashion upon design. The color of the wood after weathering depends on its orientation: The sides exposed to

driving rains are washed out and acquire a silver-gray hue like the deck boards of a ship. Only the parts sheltered from rain and exposed to direct sun acquire that golden brown color. The hue depends also upon the nature of the wood. Fir and spruce darken to all warm tones from honey to coal; cedar on the contrary bleaches in silvery tones under the direct sun and darkens in the shade. Red wood warms to a honey tone without ever getting dark. From dark tar to light silver, all these various hues may be found in the same building: it is called the *patine* and is the sure sign of health in the wood. It does not happen in climates where rain and warm moisture rule the weather, but only where wood cannot be attacked by warm rot and insects.

This superposition of cellular sheets that is characteristic of wood texture explains the value of wood shingles over all other material, for here we find lightness associated with a weatherproof microscopic structure. But here again we must be careful not to tamper with nature's own design. Wood shingles, to be worthwhile, should be hacked with an axe—or *adze*—, and *not* sawed. We can easily see why: when the wood is split by the axe, it is cut along the natural cleaving lines which, in wood, are represented by the alternation of the softer fast growing spring and summer wood, and the harder slow growing layer of fall and winter wood. If the surface of the shingle is split along the natural layer of fibers, it is coated with a continuous spread of cells already weathered, like as many shields completely intact. On the contrary, the saw rips the wood along a straight line, cutting open layer after layer of fibers obliquely, thus tearing the natural shields in all directions. As a result the surface offers a quantity of openings through all layers between which water, frost, and all destructive agents will find an easy way. A mountaineer would laugh at the idea of sawing off shingles for his roof. This is why the best manufacturers of wood shingles in the US—like the plants that make Oregon cedar shakes and shingles—have built special hacking machines to split the

wood along its natural layers of growth.

If we return to thatch now and try to see why it is a better insulation material than most artificial materials on the market, we find the reason in its fascicular structure. Thatch is formed by myriads of hollow stems of reeds, each stem being composed of a succession of tubes closed at each end by knots, like bamboo.

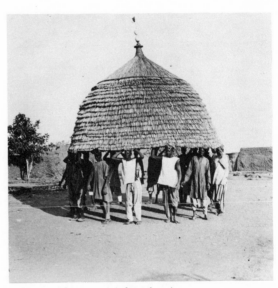

Basket-roof being carried to location
by a crew of singing natives (Lake Tchad area, Africa)

Each tube thus imprisons a column of perfectly still air, which acts as the best known insulating agent. We know that still air is the secret of good insulation. Any air current moves to compensate a difference of temperature. The enemy of the insulating engineer is the draught, or convecting air current. In the case of thatch, no air current of convection is possible, as each column of air is sealed tight inside the tubes. No man-made machine or product can compete with such perfect organization.

Western "civilization" may feel a twinge of guilt for the depleted population of the South Seas islands due to the stifling conditions of living under tin roofs that replaced their ventilated thatch dwellings and by the heavy European clothes imposed by missionaries for the sake of modesty.

THE SLOPE OF A ROOF
IS FUNCTION
OF THE CLIMATE

Steep roofs covered with shingles, slate or flat tile

Slightly sloped roofs covered with Roman tile

Flat terraced roofs (adobe)

Steep roofs covered with palmetto or other organic material

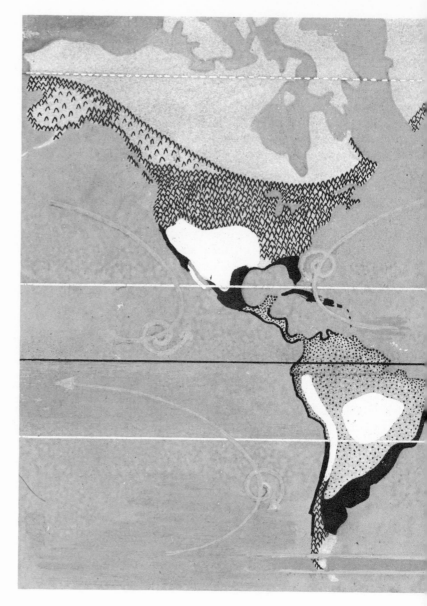

A roof is characterized not only by the material it is made of, but also by its *slope.*

Climate is the reason for every particular roof angle in the design of an archetype.

The slope of roofs offers all possible angles with the horizontal. Some vertical wall treatments may even be explained as roof design. For instance, some walls exposed to driving rains are covered with shingles, exactly like a roof. This design is found for the same reason in New England as well as in Norway.

Flat roof design is widespread nowadays, although it is not everywhere as sensible as in the architecture of Tibet, Morocco, or in the pueblo villages of the South West.

If we lay out on a climate map of the world, the regions that use the same kind of roof design, we find that within similar climatic conditions, the peasant covers his farm the same way anywhere on earth.

90

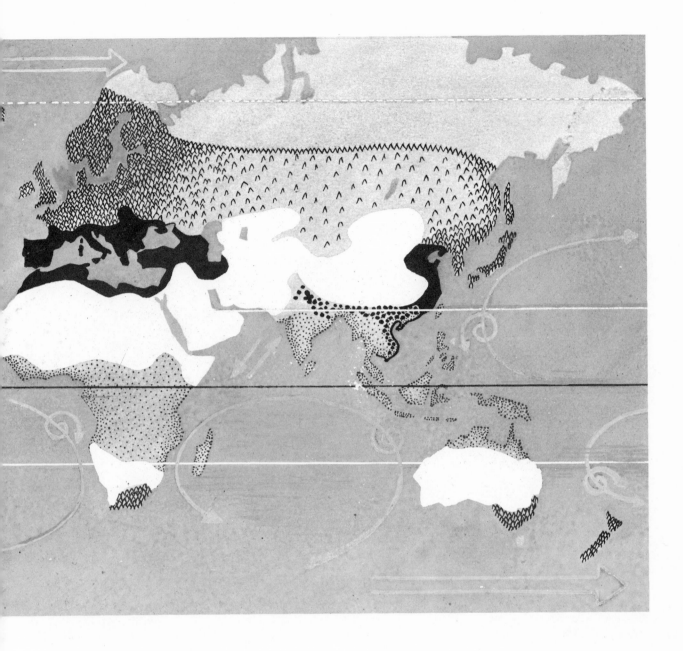

We also notice two facts:

1. Only the desertic zones use flat roofing. as in the pueblo architecture of Arizona, the Sahara border regions, Arabia, Iran, Tibet, etc. This is not done by choice, but because wood, the main material for a sloped roof, is scarce. Wood is reserved for religious and government buildings, that all have sloped roofs, which have thus become a symbol of dignity and power.

2. The slope increases gradually on either side of the tropics, in proportion to the increase of humidity. The slope is slight in the warm temperate zone, where Roman tile rules the design. It increases in the colder temperate zone, where flat tile and slate are the materials used, and it finally attains such steepness that it becomes impossible to climb atop the roof without a ladder, in the northern regions and the equatorial zones, where thatch or shingle is the material used, and rainfall is abundant.

91

LOCAL ALTITUDE AND WIND CONDITIONS

ALSO INFLUENCE ROOF DESIGN

Since climate is the reason for roof slope, we can expect to witness a difference in design according to differences in *altitude,* as climate is also affected by altitude. This proves to be true. Let's choose as an example a very small region in France where, within 100 miles, the climate changes from polar-like conditions to Mediterranean mellowness.

Map of France showing the variations of pitch
in roofs according to intensity and amount of rainfall

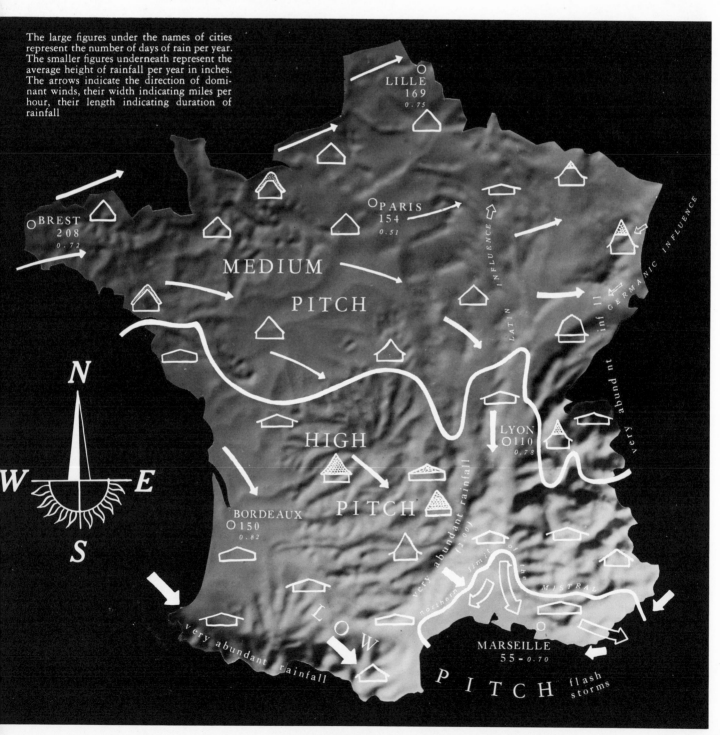

The large figures under the names of cities represent the number of days of rain per year. The smaller figures underneath represent the average height of rainfall per year in inches. The arrows indicate the direction of dominant winds, their width indicating miles per hour, their length indicating duration of rainfall

LILLE
169
0.75

O BREST
208
0.72

O PARIS
154
0.51

MEDIUM

PITCH

LATIN INFLUENCE

GERMANIC INFLUENCE

very abundant

N

W E

S

HIGH

LYON
O 110
0.78

PITCH

BORDEAUX
O 150
0.82

very abundant rainfall (100)

northern limit

MISTRAL

L O W

very abundant rainfall

MARSEILLE
55 - 0.70

PITCH flash storms

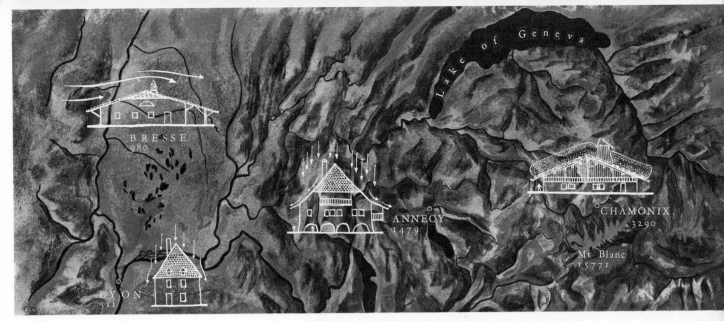

Altitude and roof conditions from Lyon to Chamonix
(the figures indicate the altitude above sea level in feet)

It is an intriguing experience for the designer to take the train from Chamonix to Lyon, and just look outside the window. Without moving from his seat, he will have witnessed a parade of every kind of slope of roof possible, and this is why:

In Chamonix, set at the foot of Mont Blanc and high in the mountains, it snows ten or more feet in a few days. Then, thirty miles down the road to Lyon, you find Annecy. There, snow is rare, but rain pours steadily, although rarely in big showers, as high winds cannot penetrate its sheltered basin. Now, you ride down 50 more miles and you will find something else. Nearing the Rhône river, you cross the Dombes plains, where the climate suddenly becomes much drier, but where storms can be terrifying. It is corn country, very similar to Indiana. Then there is Lyon, at last, on the river, deep-set and sheltered at the junction of the Saône and the Rhône, where there is a thin and dreary drizzle all winter long.

The peasant builder has provided for all these differences in climate, and has turned them into assets:

In Chamonix, where snows are heavy, the roofs are slightly sloped, with a wide overhang and covered with wood shakes. The reason: snow accumulates on the roof, clings to the wood, whereas a stronger pitch would make it slide. It soon builds up a cosy blanket offering a powerful insulation against the cold. The wide overhang also permits the farmer to reach the stable at the rear without shoveling snow.

In Annecy, where precipitation has become rain, the roofs are high-pitched and covered with small flat tiles shaped like the scales of a fish, on which the water glides as on the back of a duck. In the Dombes plains, where heavy rain storms and winds are frequent, such high hats would be carried away by the first squall. Here, roofs are low-pitched, but covered with a very heavy Roman tile, as light wood shakes like those used in Chamonix would be blown off. Each tile is designed so as to be a little gutter to evacuate the water faster, but heavy enough to withstand a high wind.

Finally, in Lyon, where there are heavy rains but little wind, the roofs are higher pitched and covered with slate, on which the rain flows harmlessly.

If you care to travel around the globe, you will find the same problem met everywhere by the native peasant with the same practical common sense. In the China plains, where winds are high and rainstorms violent but short-lived, we find the same heavy tile as under a similar climate in Italy, in France, or in California. The same low-pitched roof for snow insulation by accumulation may be found throughout the Alps, the Andes, the Himalayas and the Rockies. And the subtropical desertic climate that encircles the globe on both sides of the Equator has given birth to the same kind of architecture with earth-baked walls and flat roofs covered with a three foot thick insulation of mixed reeds and clay. We find it in Peru, as well as in Arizona, Egypt, or Tibet.

93

When a house is exposed to 60 mile-per-hour gales, it bears exactly the same impact as the body of a car driven at 60 mph. It is really strange that streamlining, which has gone to such extremes in car design, is not even considered in the average planning of a permanent home, whether on FHA lane or in the most exclusive custom made design.

And yet, in the tornado swept Midwest, Mr. Little Man is at work on his own experiment. We might call this *operation basement*. Sheltered as though in a fishing ship with only a stairway hatch and masts above deck, the crew of this "hope house" can cut its fuel bill by one third, thanks to a natural insulation which extends all the way through the earth down to China

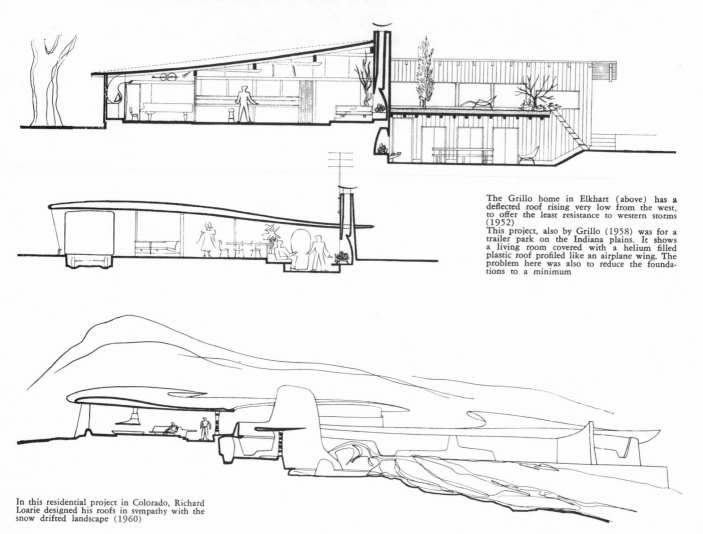

The Grillo home in Elkhart (above) has a deflected roof rising very low from the west, to offer the least resistance to western storms (1952)

This project, also by Grillo (1958) was for a trailer park on the Indiana plains. It shows a living room covered with a helium filled plastic roof profiled like an airplane wing. The problem here was also to reduce the foundations to a minimum

In this residential project in Colorado, Richard Loarie designed his roofs in sympathy with the snow drifted landscape (1960)

Winter blizzards and high winds during the tornado season sweep the Indiana plains, always coming from the same westerly direction. This community project, designed by Grillo, opens freely toward the east, where an artificial lake is made possible by excavating the sandy soil to the 12 ft. deep water table (1958)

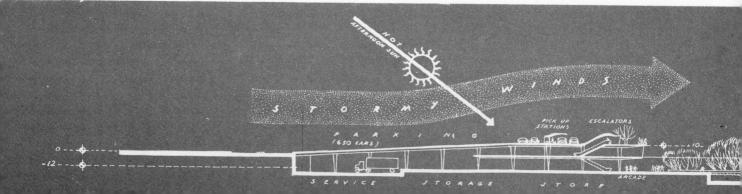

"Winds of 121 M.P.H. struck Fort Myers. Roofs
were blown from 60 homes and stores there...
Frame homes in Marathon (Fla.) were torn to bits
and lumber and furniture scattered by the wind. In
the Miami area alone, 250.000 homes were left
without electricity, cutting refrigeration and creat-
ing a critical food and health problem"

THE PRESS
report on hurricane Donna
September 11-12, 1960

NEW TECHNIQUES OPEN FRESH POSSIBILITIES IN ROOF DESIGN

Until not too long ago, it was impossible to make a roof that would not leak, unless water was shed from its slope immediately. Today, we can use our "built-up" roofs as swimming pools, as the new flexible sprayed-on plastic sheetings can cover surfaces of any curvature with a permanent waterproof skin. There is no longer any reason for the designer to follow obsolete roof patterns which have evolved from other techniques.

Roof lines may be "pre-eroded" in curved surfaces of flow, according to local wind conditions. The architect will learn this new language from the aero-engineer, who in turn learned it by marveling at the flight of the soaring albatros.

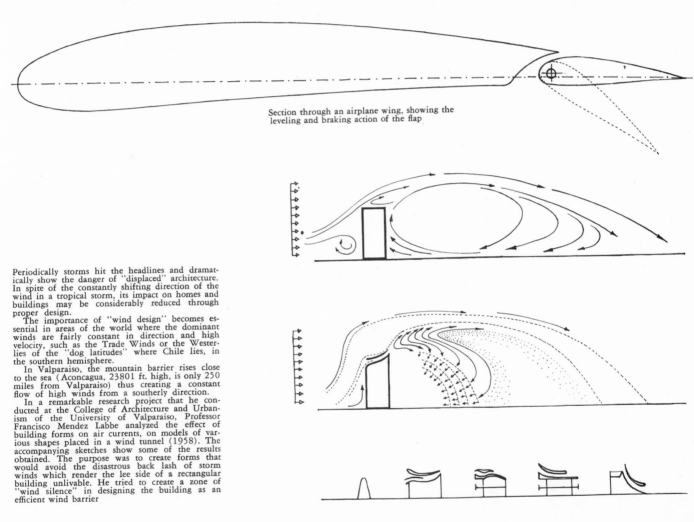

Section through an airplane wing, showing the leveling and braking action of the flap

Periodically storms hit the headlines and dramatically show the danger of "displaced" architecture. In spite of the constantly shifting direction of the wind in a tropical storm, its impact on homes and buildings may be considerably reduced through proper design.

The importance of "wind design" becomes essential in areas of the world where the dominant winds are fairly constant in direction and high velocity, such as the Trade Winds or the Westerlies of the "dog latitudes" where Chile lies, in the southern hemisphere.

In Valparaiso, the mountain barrier rises close to the sea (Aconcagua, 23801 ft. high, is only 250 miles from Valparaiso) thus creating a constant flow of high winds from a southerly direction.

In a remarkable research project that he conducted at the College of Architecture and Urbanism of the University of Valparaiso, Professor Francisco Mendez Labbe analyzed the effect of building forms on air currents, on models of various shapes placed in a wind tunnel (1958). The accompanying sketches show some of the results obtained. The purpose was to create forms that would avoid the disastrous back lash of storm winds which render the lee side of a rectangular building unlivable. He tried to create a zone of "wind silence" in designing the building as an efficient wind barrier

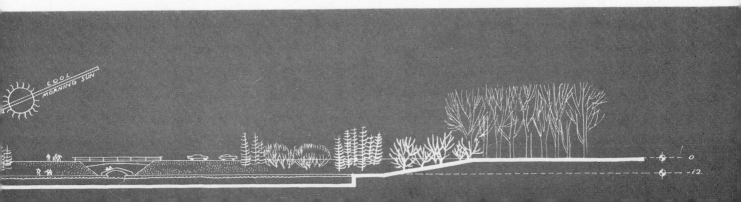

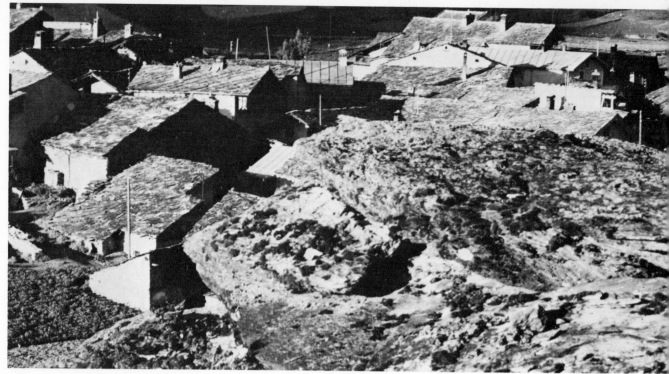

Termignon, Oisans

Flat roof, ranch slope, or attic, there is more in a roof than just a form.

This may be less striking in America than in Europe where people live in close contact with the heritage of centuries of their anonymous architecture. But there is something that breathes out of such a perfect adaptation of man's work to nature's that makes it alive and gives the impression that this farm, or that house, has always been there, and has the same absolute right to be there as this rock, or that river, or the sea, because it *belongs* there.

This intimate association of the thing built with the site where it is built is what makes a piece of architecture great, without possible discussion, regardless of size or program.

When such perfect blending happens between the site, the climate, and man's work, we can hardly tell apart master from disciple, nature from man. The resulting picture creates an effect of *mimetism* which we witness so often in the association of the animal kingdom with the inanimate world. This total symbiosis is one of the sure signs of greatness in design.

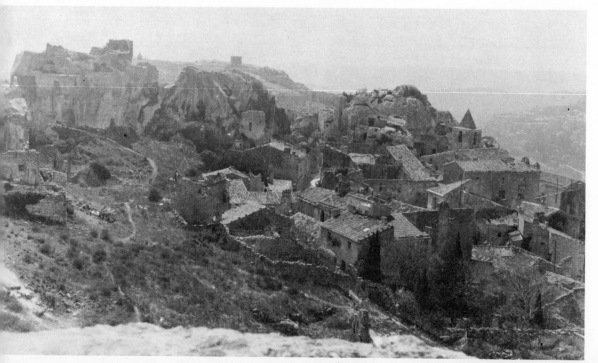

Both villages of *Les Baux* and *Termignon* continue the mountain rock side with their houses. The stone roofs are covered with the same orange red lichens and blend with the whole mountain, adding thus to the harmony of nature, instead of disturbing it. *Les Baux* seems quarried right out of the rock. Some of the homes are actually part of the hill. This was not a forsaken village, but an elegant town of the gentry of Provence during the 16th century

Les Baux en Provence

Agriopodes fallax resting
on lichens, Connecticut

The Peter Lindsay Chalet, Meribel, by Grillo

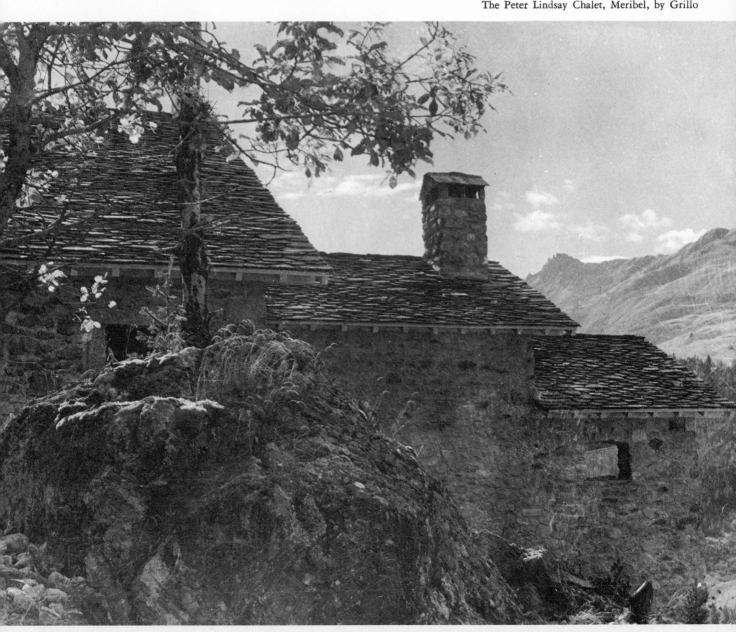

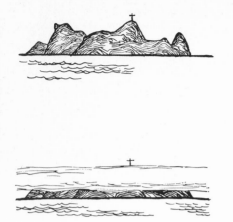

I was never impressed by the well-known landmark in Rio de Janeiro: the Christ of Corcovado, a 130 foot statue erected on top of a 3,430 foot mountain, until one day, approaching the bay from the sea, a heavy fog had settled over the land, hiding everything below Corcovado, and the statue of the Redeemer seemed to be walking on the sea of clouds. The fog, erasing the pedestal, had given true scale to the figure

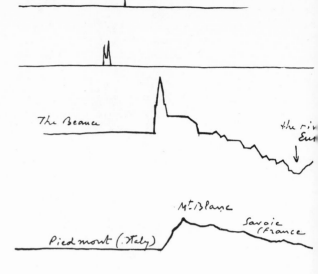

THE VALUE
OF THE SITE

Men always have been tempted by the idea of crowning hill tops and mountain peaks with monuments.

Unless the whole mountain *is* the monument, and as such is designed from base to top, such architectural feats are always disconcerting. Their success is more one of pure curiosity, hard labor, and technique, than of art. Such feats never stir the deep enthusiasm that moves the heart. The reason is that man's work, however large, will always look pathetically insignificant when it tries to compete with nature. It always looks like the mouse—in the fable of the Mountain that gave birth to a mouse.

Great works are always deeply integrated with the site. Their "aura" surrounds and her-

alds them for miles around. They make a natural site greater by their presence.

The difference is striking between Mt St. Michel and St. Michel d'Aguilhe. The Mont, like Lhassa's Potala, wraps up the whole mountain like a coat of armour. It rises from the sea directly, in a superb and complete poem of sculpture that reaches the clouds. Aguilhe is only a conversation piece, a curio set on a piece of furniture. The only sign of wonder it provokes as a comment is: —"How the d . . . did they manage to put it up there?",—as one would comment on a difficult circus act—hardly an art criticism. It becomes great only when we hide the lower part of the picture along the horizon line.

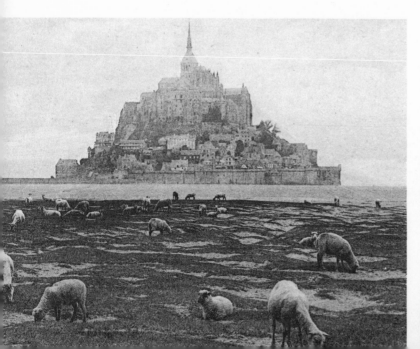

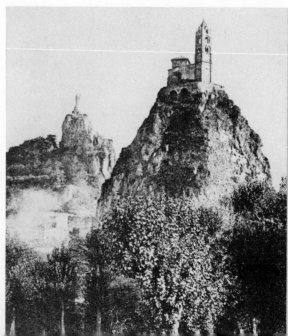

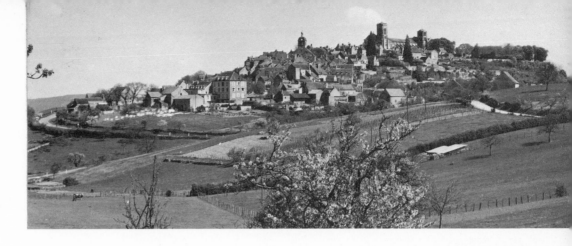

This is the *acropolis* type of a site. The "Inspired Mount" of Barrès, where the spirit breathes a greatness impossible to fathom. *Vezelay* rules over the Morvan landscape for miles around and seems to grow from the land in glorious serenity. Such is also *Toledo,* in Spain. Such is the famed *Acropolis,* in Athens

THROUGH PROFOUND AWARENESS OF SITE AND CLIMATE MAN MEETS WITH NATURE IN LIVING GRANDEUR

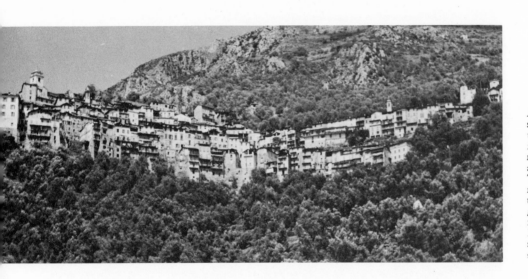

Along the southern slope of a mountain, the town clusters its dwellings in the sun, like mountain flowers, that always grow in clusters. This growth of a community is as natural as the fir groves or the gentian beds. Every flower, every tree, every home benefits from the same amount of *lebensraum* or vital space

On the desert sea, monks built their raft where they spend a life of meditation and research. No mast signals their anonymous home. No symbol of power or wordliness, either, but an intense feeling of *belonging*

99

Thou shinest beautiful on the horizon of heaven,
O living disk, who didst live from the beginning.
When thou risest in the Eastern Horizon
Thou fillest every land with thy beauty.
Thy rays embrace the lands even to the limit
of all thou hast created. Thou art Re.
Thou reachest unto every land, uniting all
for thy beloved son, Ikhnaton.

When thou descendest in the Western Land
The earth is in darkness like unto death.
With covered heads men sleep in their chambers.
The eye beholdeth not its fellow. Thieves may steal
the goods beneath their heads. They know it not.
The lion cometh from his den, the snake biteth.
Darkness is, and the earth is in silence.
He who creates them hath gone to his rest.

When thou risest at dawn, and shinest as Aton,
The darkness is routed. The Two Lands awake
and stand on their feet, for thou hast aroused them.
They wash their limbs and take up their garments,
and lift up their arms for thine adoration.
All the land does its labours, all cattle
rejoice in their pastures. Trees and herbs grow green.
Birds and all winged things rise from their nests,
their wings paying homage to thy soaring spirit.
Wild beasts and goats meet thy coming with dancing.
Freely the ships ply upstream and downstream,
And all ways are open because thou arisest.
Fish in the stream leap up towards thy face,
Thy beams plunge to the depth of the ocean.

IKHNATON'S
Hymn to the Sun

orientation

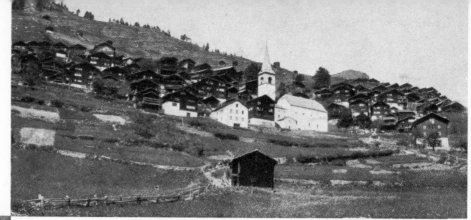

Like flowers look out to the sun, so do the chalets of this mountain village in Switzerland. It is a striking example of the group planning of a village as a colony of beings of the same species, who live with the same kind of activity. It has become a thing of beauty because it is in perfect harmony with the natural site, climate, and material, as well as with the daily work of its inhabitants

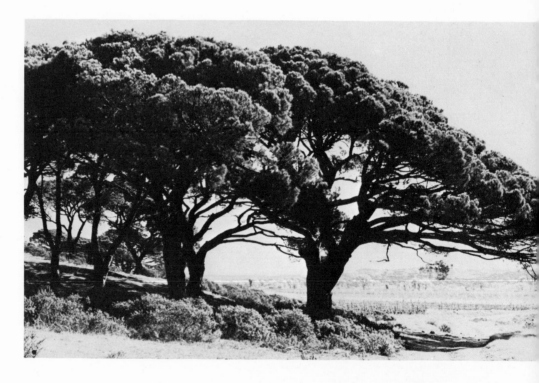

Like the rugged pine trees which crouch in a smoothly streamlined huddle against the impact of the *Mistral*—a steady icy gale from the north—so does this farmhouse lie, nesting close to the ground, offering the least possible resistance to the wind

A ship can change its course in bad weather, but a building is set in place for life. Architecture has to stand the weather from the angle at which it is set. Whence the importance of *orientation*.

Two forces of nature influence the orientation of a building: one is the prevailing *wind*, which brings destruction; the other is the *sun*, that brings life. As a general rule, a building should be *sheltered from the wind, and exposed to the sun*. In these two predicates lie the most important requirements of orientation.

The roof bears the heaviest impact of the weather. We have already seen how weather influences design under various climates, exactly as the hulls of ships are differently designed by sailors according to whether they are to navigate the long swells of the ocean or the choppy seas of the Mediterranean.

But the whole building is under stress of wind and rain and must be set so that it will offer the least resistance of exposed surfaces to storms.

To decide what should be the right orientation for a building is one of the trickiest tasks of the architect. Once it is done and the building is in place, nothing can be done to change it. Before making his decision, the designer should study all various reasons and—as the old saying goes—turn his tongue seven times round in his mouth before answering the question.

It is fascinating to watch how the peasants attack the problem and solve it. When they decide to build, they generally study the local conditions for best orientation at least for a year, under all kinds of weather. They will notice that from this little hill to the left a soft breeze rises in the morning, and that the worst storms come from behind that wooded slope over there. Only after a complete survey of all local conditions

will they start laying out the foundations, pondering the value of every tree, of every contour of the land, in their strategic approach.

Winds are of two kinds: the stormy big fellows that bring rain and snow—and the sweet little ones that cool off the stuffiness of a late summer day. Both kinds follow very definite paths that can be traced accurately within a few degrees of the compass. For instance, anyone who has lived on a shore knows that until the sun is high enough on the horizon, the breeze flows from the land, comes to a standstill in mid-morning, to blow stronger from exactly the opposite direction, from lake or sea—then abates again in mid-afternoon, to blow again from land as soon as the sun sets—and thus repeats its daily cycle all year round—except of course when the big fellows take over. By the same token, if you live on a hill side, you will feel the same alternating pulse of "sea breeze" (in this case it comes from the valley upwards) and "land breeze" (which in this case comes down from the top of the hill) that follows exactly the same cycle.

We cannot fail to realize how important it is, in residential and hotel planning, for instance, to take heed of these facts and study the particular paths of stormy winds and breezes in the exact spot where the building is to rise. It may mean all the difference between natural air-conditioning and the heat of a closed oven. It may also reduce a great deal the cost of heating or cooling. It may in short spoil the best thought in a piece of planning if the main data of the local weather are overlooked.

Our ideal building will then turn its back to the stormy winds, and allow itself to get cross-ventilation from the welcome breezes—but the most important actor has yet to come on the stage to dictate his orders to the designer: *His Majesty the Sun.*

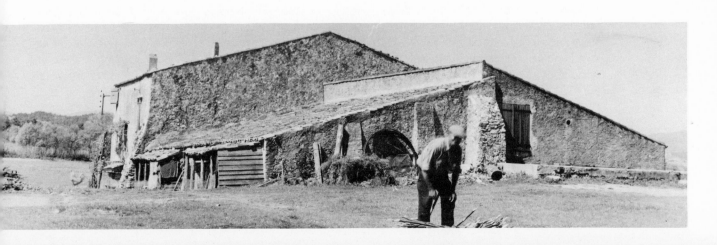

In spite of enormous progress and the inventions developed by science in the field of artificial lighting and air-conditioning, the fact still remains that the sun is the greatest and most important source of total light and power available. Any light and heat we can get from the sun by taking good care of the orientation of a building will mean savings in fuel and electricity bills, not to mention the extra help in case of emergency power failure. This is plain common-sense.

The architect, like the sailor, has to follow his compass. Each cardinal point has a very definite value and character. Let's try to analyze them.

East is the cool morning sun, after it has just risen from the horizon, when the earth has been given a good night's rest and enough time to cool off. It is also the kind of sun that melts the dark thoughts of the night, and colors the problems that seemed impossible during the darkness with the pink of optimism—the rose-colored fingers of dawn—as the Greek poet calls it. It has been associated by all civilizations with the coming of new life and spring. The word orientation itself means direction toward the orient, or east. It has always been at all times the most important point of the compass for all life on earth.

South is the fulfillment of noontide. But contrary to what is generally believed, it is not the hottest point of the compass—no more than July is the hottest month of summer. We have to consider that the value of the sun differs according to the seasons. Winter or spring sun is most welcome, at any time of day. But under the latitude of New York, summer sun is most unwelcome, at any time of the day. As it is not practical to set a building on a turntable and make it rotate with the sun—although this has been done successfully—we may wonder how the same orientation can prove to be right at all seasons. It just happens that in summer, the sun is high at noon on the horizon, while in winter, it is low, and this makes everything right, making it unnecessary to rotate our building, as an overhang of different width according to latitude will take care of the shade.

West means the hot sun of the late afternoon. When the summer sun reaches this point of the compass, it is low and supercharged with heat rays of the red and infra-red range. It is definitely the worse orientation in summer. *Occident,* (from Lat. occire) means to kill. It meant to the ancients the point where the sun god was killed by the night, but it also meant the rays that kill. It is well known to agriculturists that the west is the worse orientation (north excepted) to place fruit trees and vineyards. All French vineyards of any value are planted on the south-east or east side. The famed "Côte d'Or" (Golden Hill) where all the best Burgundies are grown is a 40 mile long ridge along the Saône river, directly facing the south-east.

North means the cold view of a sun-less sky. It means an even light, away from direct sunlight. It becomes very precious for any workroom where an even light is required, either for the preservation of precious goods, or any work where designing is involved. It is the ideal light for museums and exhibits.

Of course, all intermediary points of the compass can be considered, and among these, we will insist on the most favorable orientation for life: the south-east.

The majority of farms and any kind of dwelling are oriented to the south-east. But this is not only true for isolated dwellings. It is mostly remarkable if we study the location of the human group, from small villages to the great cities of the world.

This becomes most noticeable when traveling by air, in the early morning, when the shadows of rolling hills show best the lay of the land. In France, villages nest along the slope of the hill exposed to the south-east. On the high plateaus of the Ardèche, where northwestern winds are frequent, there is hardly a single exception to this law. The most striking case may be a small village in the low lands near Nantes called Mazin, which is built on an island of oval shape, and quite densely populated. Instead of following a radiating pattern from the center, as contemporary housing architects have designed elsewhere without regard to orientation, the sailors of Mazin have set every house facing southeast, lined up exactly like their fishing boats anchored in the snug little harbor near by.

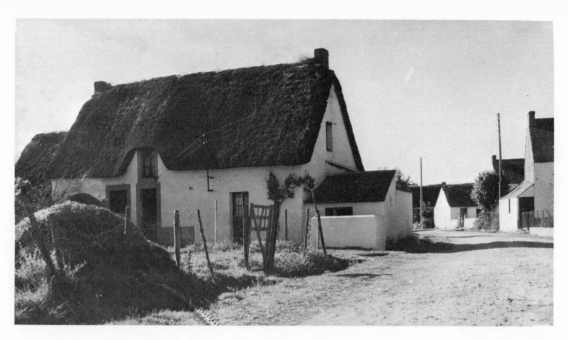

The street of Mazin village from the NE in the late morning

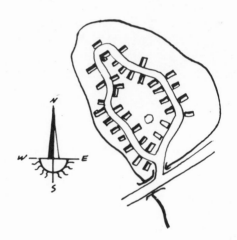

Plan of Mazin

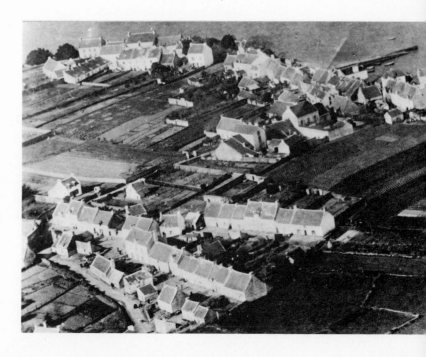

Aerial view of a coastal village in Brittany. The houses, placed in two arrow-like rows are oriented toward the wind in the same fashion as the movable arrow signaling the direction of the landing wind in an airport. Walls as well as roofs are solidly cemented

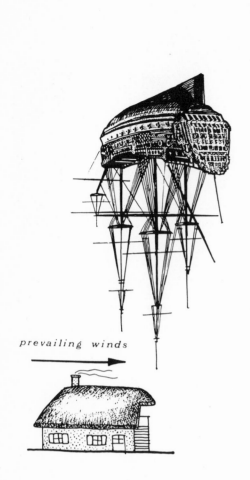

prevailing winds

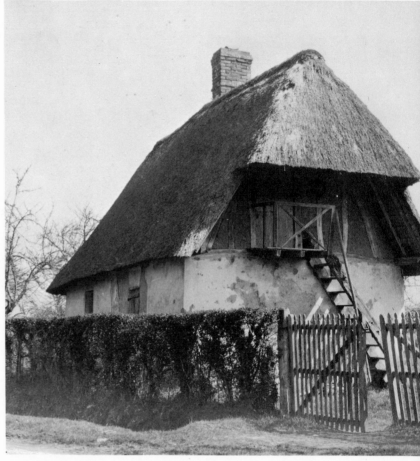

Farmhouse near Bernay

Whenever we are after good examples of sensible orientation, we only have to look for the settlements established by a population of sailors. They are always compass conscious, and borrow the forms and the orientation of their homes from their experience in seamanship.

The Normans, great seafarers before settling down to farming, have devised their farmhouses exactly like the hulls of their ships, anchored them upside down on the land, the bow to the wind and the stern sheltered toward the east. They are like ships that heave-to in a gale. The single chimney crowns the western end of the roof and draws at the least breeze, while the eastern end is wide open like the captain's quarters in the stern of a galleon.

Farmhouse near Pont l'Eveque

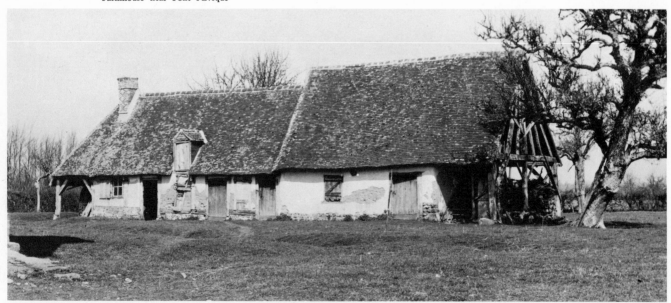

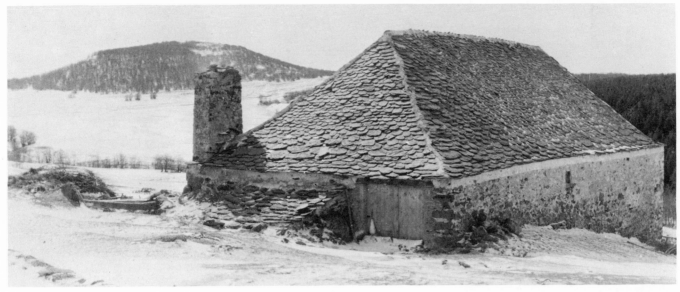

The Loire Farm. In the distance, Mt. Gerbier-de-Jonc.

Roof forms are intuitively designed by the farmers so as to offer the least resistance to the dominant winds. We might call this: *pre-eroded design.* No wonder that forms of roofs in all parts of the world offer an uncanny resemblance to the mountains which surround them. The only difference is that mountains are eroded by time, while roofs are pre-eroded by man's intuitive genius

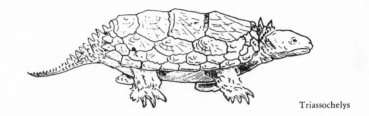

Triassochelys

A village at the foot of Mt. Fuji, Japan

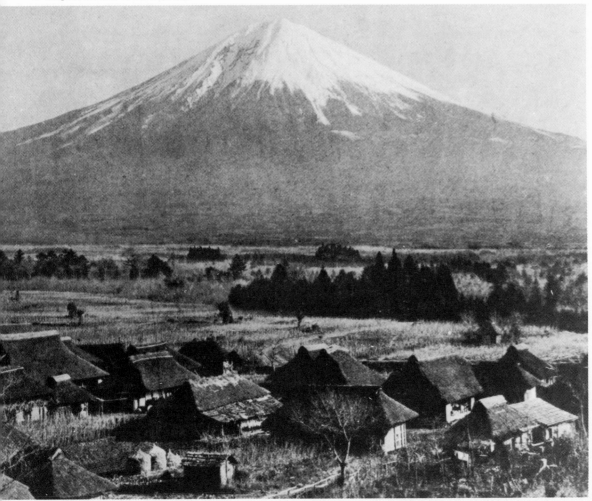

There is more than just an oriental mannerism in the curved roof lines so characteristic of far eastern architecture. The Chinese—a civilization of farmers—and the Japanese—sailors at heart—both were possibly more weather and nature conscious than any other population on earth

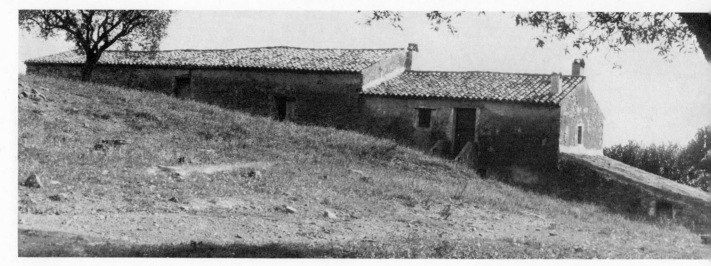

Plan Guinet farmhouse in Provence. Close view from the north

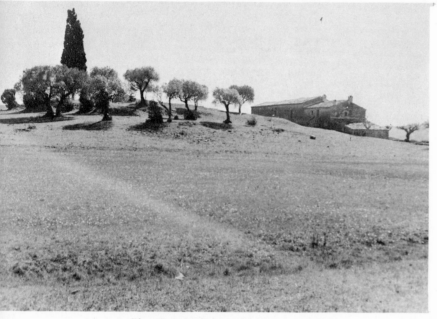

Plan Guinet, distant view from the north

Plan Guinet, south view

This masterpiece of anonymous architecture was destroyed during the war. In this farm unit where man's work is intimately associated with nature, the feeling of wind is omnipresent. Its lizard-like body hugged to the site, taking advantage of the gentle slope for shelter. Its north façade was almost completely blind. But to the welcome sun of the south, it opened many windows and doors, and two plane trees, trimmed horizontally, brought cool shade in the heat of the day. In the wake of the house stretched a grove of low olive trees, their horizontal line broken only by the lone cypress, the only tree that can stand vertically after the worst storms, as it bends and springs back as soon as the wind abates

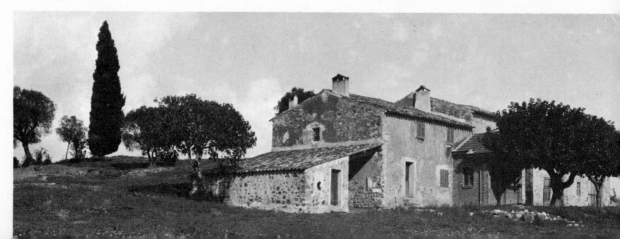

Farmhouse at the foot of
an alpine pass (Col de Vars)

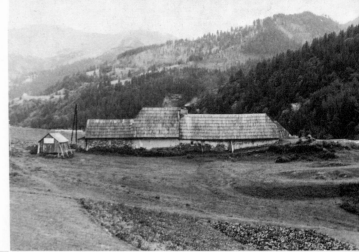

North side

This farmhouse bars the valley so as to
face due south and bends its back to
the cold northern winds that rush down
from the high pass at the top of the
valley. Notice how all other dwellings
in the background follow exactly the
same orientation

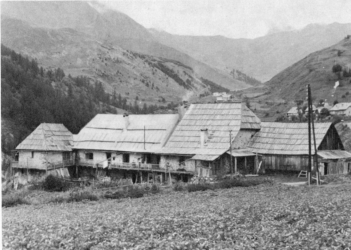

South façade

Part of the Turgot Plan of Paris—1660

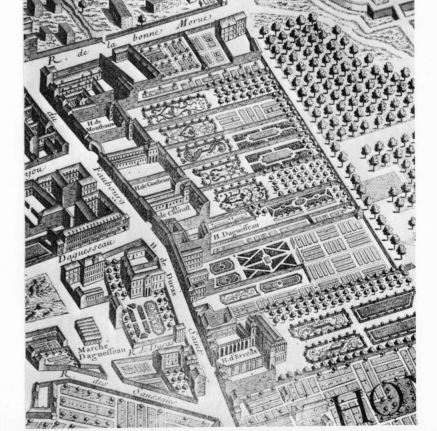

The layout of the newly designed section
of aristocratic residences along the Champs
Elysees shows a straightforward orientation
toward the sun, as in the best cooperative
housing developments of today's Holland.
The entrance court, flanked by stables and
service quarters is due north, while the
southern façade, like a wind barrier, sep-
arates the court from the sunny side, where
elaborate gardens spread out toward the
venue.

This "row-house" layout, favored then
by the most individualistic first families of
the time, actually creates more privacy for
each home than would a series of isolated
dwellings, and is the key to better group-
housing today

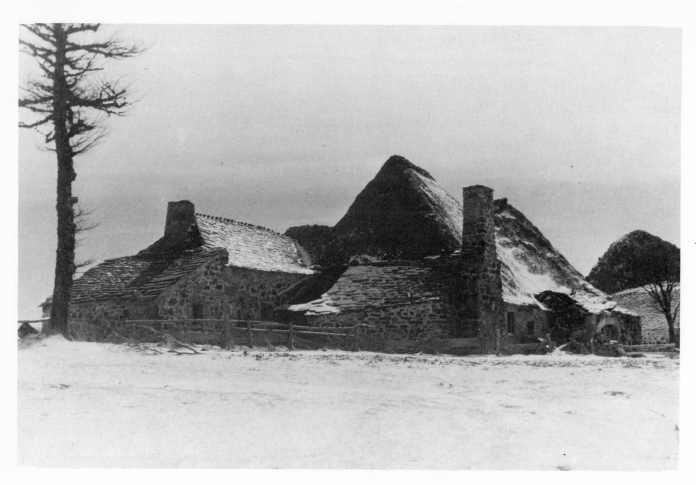

THIS 1000 YEAR OLD STREAMLINED ARCHETYPE

IS AHEAD OF THE SLEEKEST CAR DESIGN

On the high plateau of Ardèche, winds have flattened all but the strange small mounds made of harder basalt, like Mt. Mezenc (arrow) the highest peak in all the Massif Central of France. The peasants call those mounds *sucs,* or sugar loafs.

In this extraordinary farmstead, the streamlined skyline was instinctively achieved in a structure built bit after bit over a period of about 1000 years. *The slope of the thatched roof is exactly the same as that of Mt. Mezenc* in the background.

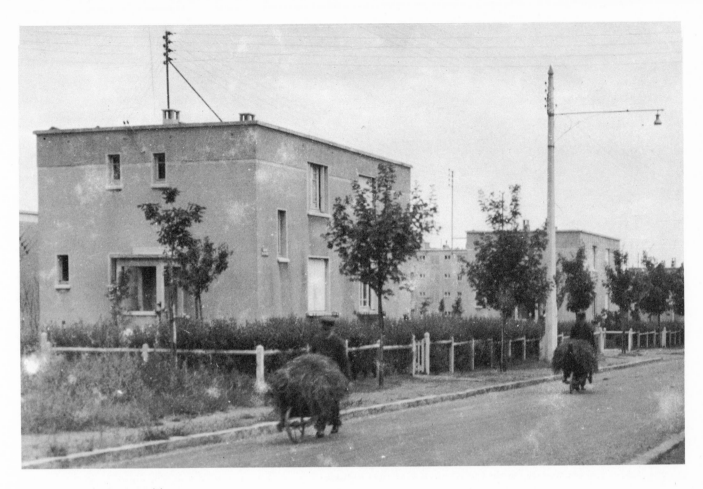

NO COMMENT

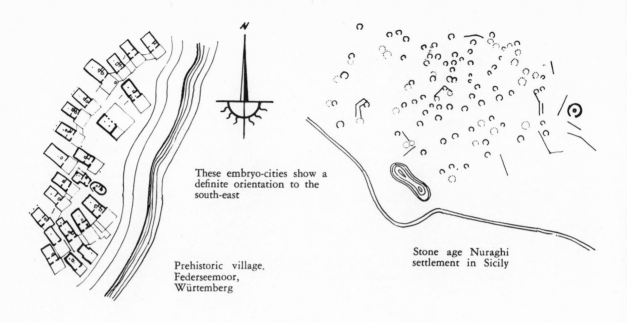

These embryo-cities show a definite orientation to the south-east

Prehistoric village. Federseemoor, Würtemberg

Stone age Nuraghi settlement in Sicily

Let us now study the location and development of the great cities of the world. We will find the same concern by the people for orienting their settlements toward the life-giving rays of the morning sun. The exceptions we find are often due to a composition *a priori* by some over-imaginative urbanist of the last century, when the idea was that cities and developments could be designed like some abstract painting, without regard to site and climate, and when the peasant's logic was not taken seriously. The world is studded with such illogical bits of planning where the people who live there pay the price of the fantasy of a short-lived fashion.

If we take Chicago, for instance, its development on the eastern shore of Lake Michigan cannot be a haphazard proposition. The curve of the southern part of the lake shore might have offered many other possibilities on the Indiana side, but none was oriented right for life—so Chicago developed higher north, where the shore straightens—and so did Milwaukee. It is not by chance either that the other shore does not offer any city of importance. Anyone who has witnessed some of the great northwestern storms on the lake will agree.

The first settlements, ancient cores of great cities, were generally on a shore—of a sea, lake, or river—as water was then, and still is today, the best and cheapest way of transportation. When a city starts on the high bank of a river, the southern exposed side mushrooms rapidly, while the other less well exposed side develops slowly, only later on, when the extension of industrial plants urges man to find undeveloped acreage close-by. In the case of Chicago, the extension toward Gary is an illustration of this fact, as well as the development of Paris to the West, and of the recent quarters of Vienna beyond the Danube. Cincinnati, for instance, on the Ohio, mushroomed into a large city while Covington, on the other side, still remains a small town. The case is the same for Philadelphia versus Camden, San Francisco versus Oakland, Minneapolis versus St Paul. It is most striking for San Francisco, that elected its site on a long peninsula, instead of the site of Oakland, so much easier to reach by mainland on the other side of the bay. We find this rule still more confirmed in the case of the capitals of the world, in the course of their very slow growth out of a primitive core of peasant dwellings.

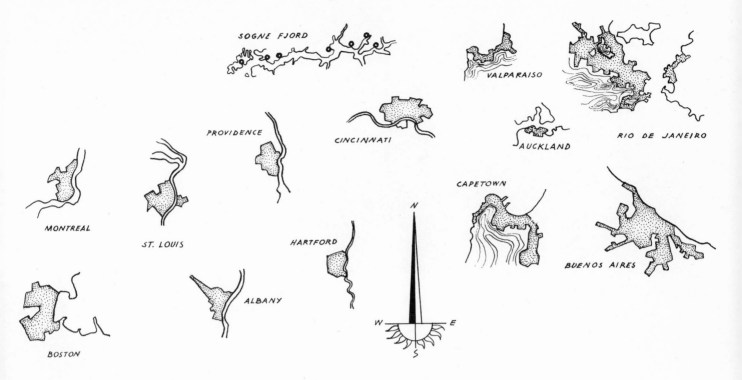

Vienna, for instance, riding lazily on the crest of the last wave of the Alps, reminds one of the proud figure head of a clipper ship sailing southeast. Oslo, London, Dublin, Madrid, Tokyo, etc., are in the same situation. We have another twin city case with Istanbul versus Uskudar, in Turkey. The entire island of Ireland shows the influence of orientation on a whole nation: the only important town on the ragged and windy west side is Galway, but look where it is settled —in a very protected bay, and on the north shore, facing due south. All three only great cities are on the sheltered east side: Dublin, Belfast, and Cork.

As we can expect it to be in all matters that regard orientation, it is the reverse in the southern hemisphere, most important cities looking north—where the sun travels in the sky. We see the same twin city proposition with Rio de Janeiro, and Nictcheroy. Buenos Aires spreads itself on the south shore of the Bay of the Plata, facing due north. Aukland, New Zealand, and Sidney, Australia, confirm the rule. There are naturally many exceptions, but the cities properly oriented outnumber by far their poorer relatives that turn their back to the sun.

New York offers a very interesting case. The original settlement was, of course, at the very southernmost tip of Manhattan Island. It developed then into the New York of today, split lengthwise by Fifth Avenue, traced along a meridian. But both sides, although almost identical in size, were to know a different fate. An artificial East Side took shape along Central Park, on its west side, but in spite of all the efforts spent to make the upper West Side fashionable for residence, it never was—as it always will seem to turn its back toward the cool eastern light, to be roasted by the killing western sun.

Orientation makes much of the difference between the Champs Elysees, Fifth Avenue, and Michigan Avenue. Any Parisian coming to New York will be surprised to find both sides of Fifth Avenue equally busy. It is because in the New York climate, the sun is extremely unwelcome for about six months, and business keeps shifting from one side to the other on the Avenue according to the time of day, which makes it even all along for the slice of the Avenue concerned. It does not have a privileged side, being oriented exactly North-South, like its sister Michigan Avenue in Chicago. The Champs Elysees, on the

113

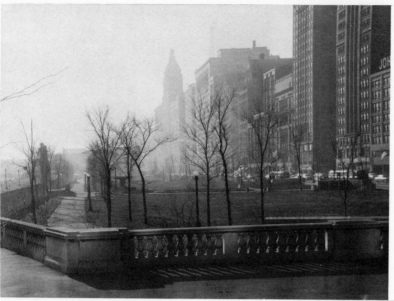

Michigan Avenue,
East side, Chicago

Farmers protect their more delicate
crops with a row of high and dense
trees against the cold wind. This pic-
ture is in Provence, but it might as
well be in Nebraska, where the far-
mer also makes use of row-tree
protection.

Chicago is dramatically planned
to be its own wind-breaker. No mat-
ter how hard the wind blows in
the "Windy City", this sunny side
of Michigan Avenue, shielded from
the Western storms by a continuous
cliff of tall buildings, offers shelter
to the pedestrian

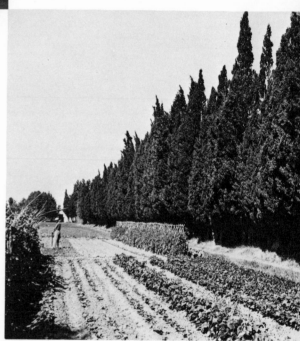

Produce farming
in Provence

contrary, runs exactly east-west. At the latitude
of Paris, with a very temperate climate, the sun
is almost always welcome. The sidewalk exposed
to the sun attracts most people, and business
naturally has grown mostly on the sunny side.
Across the street, rents are less expensive; we
find there the movie theaters, as they do most of
their business at night, and other necessary types
of business like airlines, travel bureaus, banks,
etc., that do not depend on impulse buying—
while the shops, the better known cafés and the
smaller more exclusive theaters and clubs thrive

on the other side.

Michigan Avenue in Chicago has only one
side of business, where the pedestrian hugs the
protective wall against the blasts of wind of the
"Windy City".

No artificial means developed by science can
outwit the attraction of sunlight. It is a cosmic
law beyond human reach. In sunlight lies the
greatest yet most completely reliable source of
energy at man's disposal. All other sources of
fuel look like poor relatives when compared to
solar energy.

Dilemma

Although the sun is the most important factor for the orientation of a building, there are other exigencies that must also be met, and sometimes conflict directly with the solar law. Here for the first time we meet the most confusing task for the designer: to judge what is most important for the fulfillment of the program—and overrule what is of secondary importance. This is where his art must be at its keenest, so as to decide what shall be sacrificed, as it is impossible to conciliate everything. The French say: "you cannot please everybody *and* your father". Every architectural design must accomplish this *tour de force* of bringing forth a composition where all elements seem to come in their natural order, without giving the impression that they have been forced into place, or that they result from a compromise. In short, the result must give such a total impression of necessity that it would preclude any other solution. A pure breed dog, no matter how strange it may look, will always have more authentic elegance than a mongrel. It is for the designer not to let the conflicting requirements of a program take over the pure traits of its character, if he does not want to bring a mongrel into the world.

We can see that the lighting of a home, a school, a church, a building, is far from being a simple thing. It actually adds up to a thorough *light-conditioning* design in which the basic input of natural light shall be skillfully complemented with direct and indirect sources of artificial light. This essential conditioning of light presupposes for every problem a subtle understanding of the exact quality of light required for living. This is a far cry from such extreme solutions as shown in so many contemporary schools and buildings today, where the excess of light and glare does a great deal of harm to the human eye, and tends to blunt its exquisite sensitivity. A serious increase of eye trouble has been showing recently among the children who attend our new glass-case type of schools.

How a designer can answer the necessity of giving all working rooms natural light is the best criterium of his skill and artistry. It is the first thing to look for in criticizing any plan. The main problem in planning is to reduce the dark areas and bring life-giving natural light in as much as possible., It is one of the reasons why residential planning—where, as we said before, there is no exception and where *all* rooms must have access to natural light—is such an excellent discipline for breaking in designers. It remains the most difficult of all programs, in spite of its relatively small size.

When studying in plan, the designer should watch for the black spots and reduce them one by one like so many enemy machine gun nests, if he wants to win the battle of design. Another reason for natural light in all rooms where human beings are to live some part of their day is that the designer plans for human beings and not for robots. Some kind of a view of the sky is necessary to live and work. Some kinds of work can be done without light and like mining, fuel stoking in ships, storage work, etc., where, unfortunately, it cannot be helped. But when it *can* be helped, man needs natural light to work as much as he needs food and water; it makes him happier in his work, and as a result will improve his work. During the blackout of World

War II, the glass monitors in the factories of Detroit did not let in any light during the day: once in a while, a worker would throw a monkey wrench through the skylight when he could no longer bear the feeling of being completely closed in.

There are two kinds of sunlight that interest the designer: direct light, and diffuse light. We have seen how direct sunlight commands the orientation of the different areas of a building. But diffuse sunlight must also be constantly kept in mind, as it commands the general layout of all the rooms in a building.

Unless absolutely required by their function, all rooms where man spends a considerable amount of his time during the day should have direct access to natural light. In residential programs, it is a must for all rooms, including bath

and circulations. In other programs, it may be only partially fulfilled, as the size of the program generally involves a surface of such dimensions that it becomes nearly impossible to bring direct light to every square foot of the plan— particularly in urban sites. Nevertheless, even in this category of programs, it remains essential that all working room be given natural light, unless the particular kind of activity involved, requires absolute control of light at all times, or even complete darkness like in theaters, museum and art galleries in particular instances, special areas of laboratory work, storage, etc.

Orientation depends primarily on the site and climate for which a building is designed. When the designer is given free choice of the site, there is less difficulty, but this is becoming more and more the exception. In general, the architect is

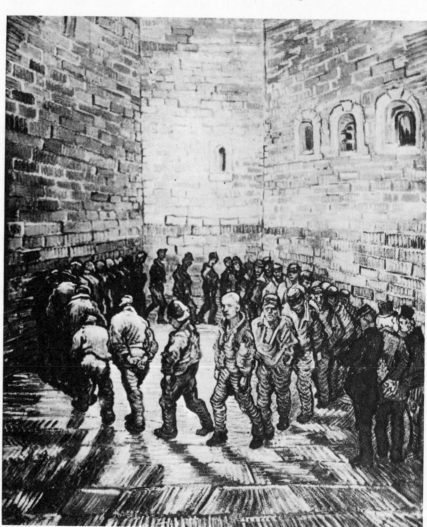

Vincent Van Gogh
Courtyard of a Prison, after a woodcut by Gustave Dore

Peter of the Sun

given a lot exactly set between the border lines of a property, and he has to make the most of it. The best interests of the promoter of any kind of program would be served if he called in the architect at the very beginning, when he has not yet made the choice of a location. This is unfortunately very rarely done.

Town planning rules and regulations have replaced the free code of urban manners that directed former societies. And as always when self-discipline is replaced by law-enforced prohibitionism, the new order gives poor results. This was unfortunately rendered necessary to avoid total chaos. It remains that the self-imposed and unspoken rules that governed the organic growth of older towns was the result of an implicit conscience in everyone to belong to an order freely established by generations of families who had done their best to take advantage of a site. New homes and buildings, although never following past mannerisms and styles, always dovetailed their layout with the existing urban landscape. Town planning, then, was a *state of mind*.

In the lack of such a state of mind we may find the main reason why town planning today lacks spirit and warmth. The "home town", dear to the heart of generations, is on the wane. New suburban communities may be more sanitary, but they have sadly failed to become true home towns. Who can feel his heart skip a beat at the thought of a "shopping center"?

Among other factors that have a bearing on the orientation of architecture, we can mention the *view,* the *feed line of access, psychological* reasons, and *scientific* requirements.

1. THE VIEW

Of great importance in residential planning, the view may prove just as essential as the sun in any kind of public planning, where people come to enjoy a diversion from their everyday life and landscape. The view becomes to them like the stage setting for a play. Its purpose is to entice people to rest, relax, and enjoy visions of nature in full beauty. It may directly conflict with the sun law, and in the case of unique and breath-taking views, it may be more important.

One of the first things to look for when we take possession of a room in a resort hotel is certainly *the view*. But we also want to be able to enjoy a leisurely sun bath on a private porch whenever we can. Sometimes, the view is toward the north, and the dilemma becomes acute for the designer. Should he disregard the value of the sun and design his bedrooms facing north, or should he disregard the view and face the south?

Very few good solutions have been proposed for this baffling problem. The most remarkable is probably the solution offered by architect G. H. Pingusson in his pace-making design of hotel *Latitude 43* in St. Tropez, built in 1931. His scheme has inspired many other architects ever since, but he was the first, to our knowledge, to have conceived a plan with an access corridor on a split-level to apartments facing two opposite directions. As a variation of this plan, he also made a true split-level scheme with one corridor servicing two floors, thus reducing by one-half the surface wasted for circulation.

Unfortunately, speculators have ruined this unique work by remodeling it into apartments and building two apartment buildings instead of the swimming pool and the cabanas.

In the orientation of the plan shown here, north is on the left, and faces a breath-taking view of the Bay

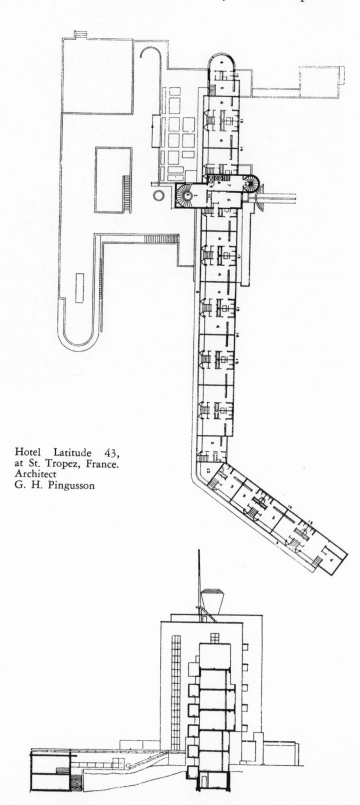

Hotel Latitude 43, at St. Tropez, France. Architect G. H. Pingusson

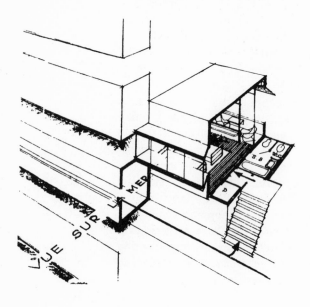

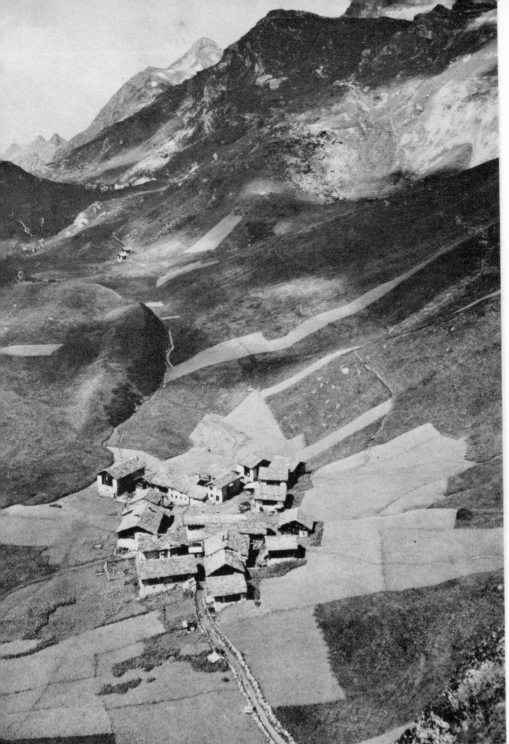

Grevasalvas, Oberengadin

HYACINTHUS AFRIC: TUBEROSUS, FLORE CÆRULEO UMBELLATO.

2. THE FEED LINE OF ACCESS

A new building will have to tap some of its life blood from already existing facilities, that cannot be moved, like a body of water, railroads, etc. The orientation of its *service line* will be determined by these pre-existing conditions. Aside from this strictly utilitarian obligation, the feed line of access may also be of monumental char-acter and determine the orientation of a building in relation to a boulevard, a mall, a harbor—as in Versailles, Washington, Venice, or a small fishing village like St. Tropez. This access line usually ends at the most strategic part of the plan, as in this mountain village, huddled at the very center of the life-giving meadows.

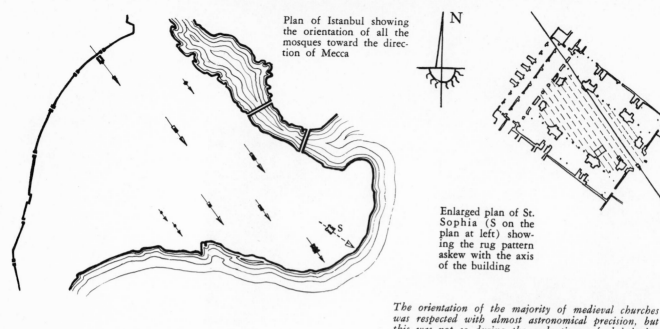

Plan of Istanbul showing the orientation of all the mosques toward the direction of Mecca

N

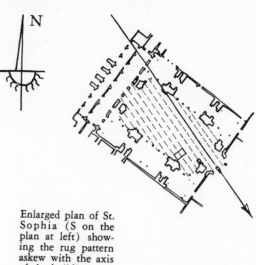

Enlarged plan of St. Sophia (S on the plan at left) showing the rug pattern askew with the axis of the building

The orientation of the majority of medieval churches was respected with almost astronomical precision, but this was not so during the early times of christianity. As a matter of fact, the basilica of St. Peter in Rome was actually "occidented". Orientation during prayer is widespread: Jews pray toward the Temple of Jerusalem, and Sabeans toward the Northern Star. The ancient Persians faced the rising sun. The Moslem pray toward Mecca, and thus are their mosques oriented. When they "occupied" St. Sofia, there was no way to move the church around, so rows of prayer rugs were set in the direction of Mecca, thus creating a very disturbing pattern

The Holy Sepulchre in Jerusalem

3. ESOTERIC AND

Christian churches, for instance, are generally *oriented* —the word being here taken in its etymological sense, meaning *looking toward the east*. The question is much discussed today, and cannot be given a simple answer: the early Fathers of the Church, Lactantius, Cyril of Jerusalem, Ambrosius, wrote as explanations that the east is the direction where the Garden of Eden was—the direction of the origin of sunlight like the light of truth—Christ on the Cross faced west and ascended into the Heaven toward the Orient —East was associated with good, and West with evil. We find the same eastern symbolism among the Chaldeans and the Egyptians. It is more than probable that the Christian church respect for the eastern orientation, only carries over the centuries the age-old sunrise celebration.

In such a case of religious symbolism, the psychological orientation becomes the foremost exigency of site: the local wind and storm conditions come next. Even if the entrance of the church is in the wind, the eastern orientation must be observed as part of the tradition—and the main entrance of the great cathedrals is generally in the wind, exposed to all the worst storms, as it has to face west.

In the case of Moslem religious buildings, the mihrab—or sanctuary—should always face the direction of Mecca, that every Moslem bows to when he prays. Mosques in Turkey face south, while in Moroc-

S. Apollinare in Classe, Ravenna

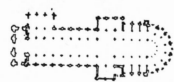

St. Etienne, Caen (Abbaye aux Hommes)

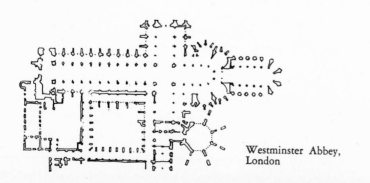

Westminster Abbey, London

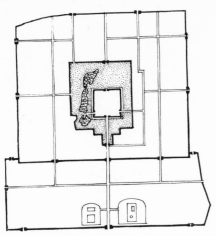

The Forbidden City, Peiping

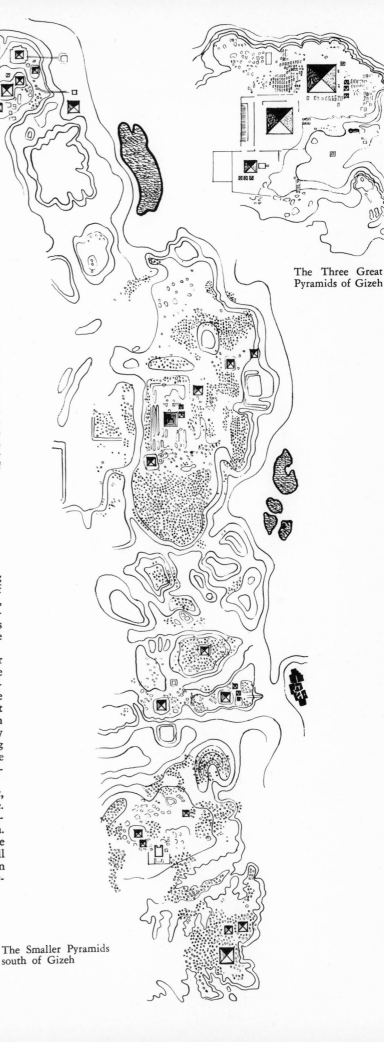

The Three Great
Pyramids of Gizeh

Orientation to the cardinal points—with emphasis on the south-north axis—stemmed originally from the scientific necessity to mark the local meridian and determine time. It is characteristic of oriental culture, first in scientific knowledge. The Chinese Altar of Heaven, heart of the Forbidden City, was actually a sacred observatory. The knowledge of the Egyptians in astronomy, such as the measuring of the earth's meridian by Eratosthene, still fills us with wonder. The fact that the Great Pyramids straddle the 30th degree of latitude can hardly be called a coincidence. All the smaller pyramids built south of Gizeh are also oriented to the cardinal points

CIENTIFIC ORIENTATION

co they face east, and in India, west.

Finally, there is a scientific reason for orienting architecture with a certain reference to the course of the sun, as in planning astronomical observatories, where the battery of meridian telescopes must be exactly set along a meridian line—or museum rooms that must have models lighted under the exact course of sunlight (relief maps, scale models, etc.)

Some monuments of antiquity find the reason for their orientation—and sometimes their very existence —based on the scientific necessity of serving as markers for pointing at a vital point of the compass: the case of the Egyptian pyramids is well known. But further back in history we find monuments for which the most important reason for being built at all may have been to determine the exact date of the coming of the equinox of spring—the most important time of the year for peasants to know when to start planting their crops.

The prehistoric alignments of menhirs in Carnac, Brittany, are lined up according to the equinoxial line. Some menhirs even have, like in Lagatjar, little markers set exactly like the marker at the end of a gun. And we find the same kind of orientation in the Maya monuments of Uaxactun, Guatemala, as well as in the whole layout of the emperor's palace in Peiping, where religious symbolism is deeply interwoven with scientific purpose.

All drawings on this double page are oriented the same way, north pointing to the top of the page

The Smaller Pyramids
south of Gizeh

The fact that there are only five regular solids was first discovered by the Pythagoreans. Kepler, whose genius left few areas of knowledge untouched, found that by successively placing each solid within the sphere inscribed within another of the five solids placed in a certain order, the diameter of the spheres would be related to one another in proportion to the distance of the five major planets, each sphere being given a thickness corresponding to the extreme distances of a given planet to the sun, at its closest position (perihelion) and its farthest (aphelion) on its orbit

KEPLERI MIRARIS OPVS, SPECTATOR, OLYMPI
 ANTEA QVAE NVNQVAM VISA FIGVRA TIBI
NAMQVE PLANETARVM DISTANTIA QVANTA SIT INTER
 ORBES, EVCLIDIS CORPORA QVINQVE DOCENT.
QVAM BENE CONVENIAT QVOD DOGMA COPERNICVS OLIM
 TRADIDIT, AVTORIS NVNC TIBI MONSTRAT OPVS.

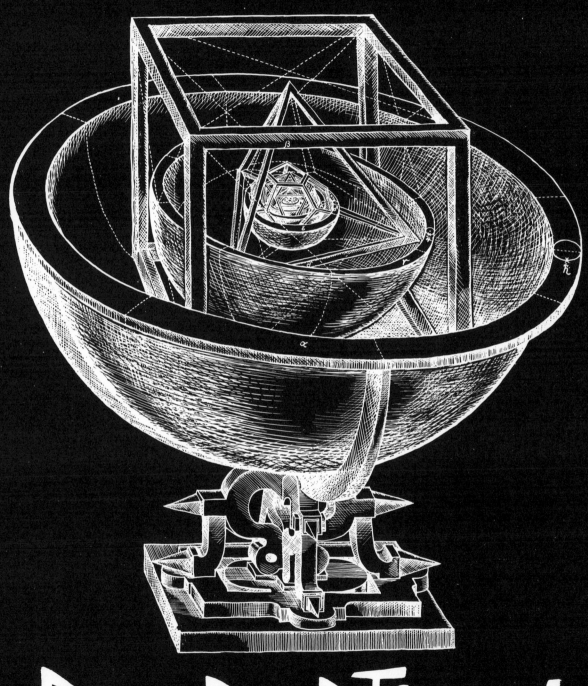

PROPORTION

Up till now, we have seen design as a result of 1) where we live, and 2) the materials we use in building. These are what we might roughly call the outside requirements. They are imposed upon us by natural laws: the weight and the nature of the material—a result of the law of gravitation and of molecular structure—orientation—dictated by the sun and its court: wind, snow, rain, and weather in general—etc.

Now, if we were to design a building with what we know, we might be able to construct a volume properly oriented and that would stand up, but which would remain impenetrable.

Our approach to design has been very similar to a survey by airplane: we have been turning around architecture, from the air, studying all the angles involved, but without ever getting very close to the building itself. We have been looking on from the outside, and at a distance. The sun, the weather, the wind, and all the materials involved in design are really something immense and, to be fully appreciated, require this kind of approach.

As a result, this survey has given us a general perspective view of the influence of natural conditions on design—what we might call the inhuman kind of perspective one gets from a few miles up in the air. Anyone who has flown over a populated area knows how, from only two miles up, all life seems to be gone from the landscape. The movement of people has slowed down almost to a standstill. Maybe it is this inhuman perspective that makes the bombing of cities possible by airmen who would not even think of deliberately killing someone they knew.

Now is the time to bring our plane down to earth, land it near a building, and see it as a pedestrian.

What looked to us like a solid crystal from the air, now appears to be surfaces studded with openings—windows, doors, hallways, etc.—we see the people coming in and out, and we wake up to the feeling of life: we feel the very breath of design. But we also find that we must add new words to the vocabulary of design, if we attempt to describe the building before us: rhythm, scale, module, that add up to *proportion,* in its most general meaning. We notice that we cannot describe anything without constantly calling to the rescue this very simple concept of proportion—the ratio $\frac{a}{b}$ between two values of the same

order. We must constantly keep in mind the ratio between two different sides of a geometrical figure that outlines a façade, a wall, a window. We now use the words length, width, depth, height, and the space it refers to becomes divided into areas endowed with very particular characteristics, that occupy around us the same privileged positions as the six faces of a cube of which we would occupy the infinitely small center: before, behind, right, left, up, and down.

These rapports between the various elements of a figure of design constitute what we call *proportion.*

This, we already know. We are already used to all these words.

But let us put the little innocent word *good* in front of the word *proportion,* and all becomes confused.

We all know what proportion is, but how do we know what good proportion is?

The expert answers with scorn, arrogance—and pity—whoever dares ask the question:—"because it is so", and we have long since abandoned the fight to ask why. The result is that anyone who poses as an expert can make us accept the worst mistakes in proportion without anyone's objecting.

We shall see in this essay that there are definite reasons that make the proportion of a design good, or bad. To make this as clear as possible, we will divide this part of our study into three chapters:

1) In the first chapter, we will study the *openings* in design, as an introduction to the theory of proportion. We shall see that most of the reasons that give an opening its proportion are easy to understand since they result directly from the scientific laws we have surveyed before.

2) In the second chapter, we will introduce the unit, which will help us realize the value of the human scale, by bringing in the notion of *relative proportion,* as all ratios considered will be expressed in relation to the human size and action.

3) In the last chapter on this subject, we will study the characteristics of what we will call *absolute proportion,* which is absolutely independent from any size or action considered. This results from the existence of dynamic rapports, among which are the golden mean, that will make us aware of the value of the world of geometry that surrounds us.

openings

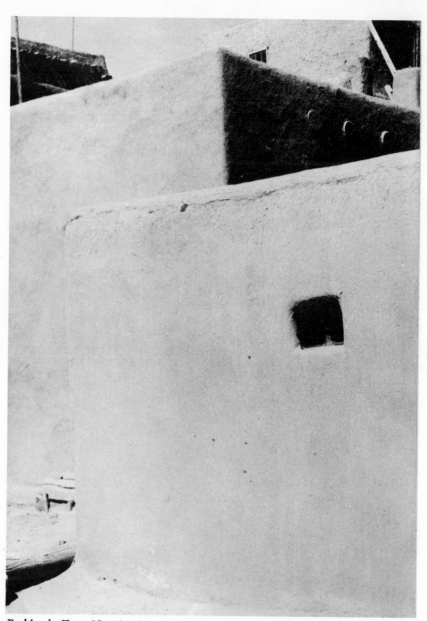

Pueblo de Taos, New Mexico

*A WINDOW IS
THE SIGN OF LIFE
TOMBS ARE SEALED*

Space takes on a new dimension when seen through a window; light acquires a magic quality that transforms everything within reach.

To us, a window has become a commonplace thing. But imagine the wonder it brought to the first man who managed to cut a hole in a wall and possess at a glance a part of the outside world, all his own.

From the time of the cave man where the only window was the opening of his cave—to the glass houses of today, the window has been a challenge to man's imagination, and the history of its evolution is a wonderful or sad record of the vicissitudes of civilization, as well as one of the most striking illustrations of man's fight to conquer light and free construction from the ties of weight and darkness.

But today, we are inclined to take for granted that the more glass there is, the better the design is. The fact that we can now make window walls as total as we want to, has blunted our sensitivity to the special value of light. The sensitive dosing of the light formula is being lost under this pointless order of maximum-light-everywhere.

The glass house as a solution for light is not a very imaginative one; surely there are times for total glass—as in an airport control tower—but there is also time for "chiaroscuro" or lighted darkness—like in Le Corbusier's Ronchamp. Light may hurt, like in some airport restaurants where the view is commanded by 90% of a glaring and merciless sky; or light may soothe and be warm to the heart like a friendly presence, dearly felt, but never imposed.

Like a fine instrument, light must be modulated for every different mood and activity of man. How is the designer to find his bearings in this delicate and difficult problem?

Ranchos de Taos, interior of Church

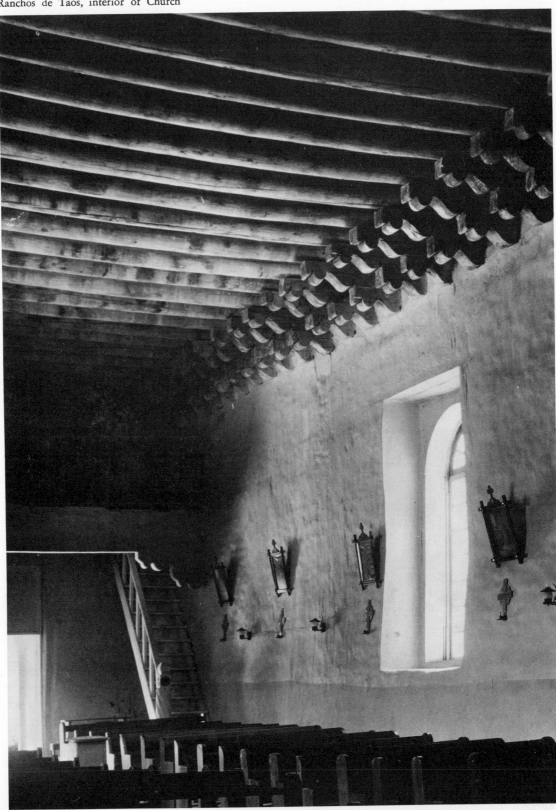

Welder

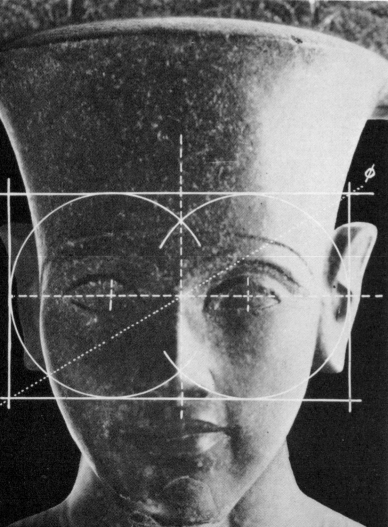

Let's start at the very beginning, and place our-
selves in the position of someone who would be
left in a completely dark room and be given
the opportunity of opening in the wall any
kind of a hole to let the light in.

If the walls were made of a substance he
could cut without too much difficulty, he would
first cut a roundish horizontal hole, so that he
could see *to the limit of his whole field of vision.*
The field of vision is a curved ellipse drawn on
the ideal sphere of vision that surrounds us, its
greater axis being in a horizontal plane when we
look standing up.

The most logical design for a window would
thus be an ellipse, on the condition that man's
eyes occupy a symmetrical position on both axes
perpendicular to the plane of the ellipse, or bet-
ter, a half-ellipsoid with the eyes of the viewer
placed at the foci—*provided the viewer does not
move his position once it is set.* Plastic transpar-
ent materials have made this possible, and there

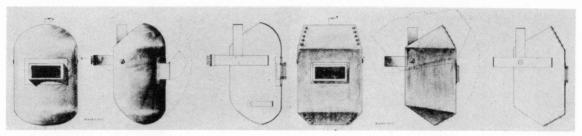

Welding helmets (1955)

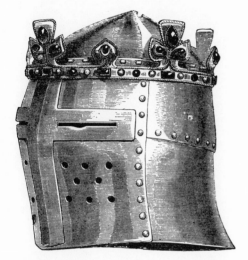

Heaume worn by St. Louis at the Battle of Mansurah
(1250 A.D.)

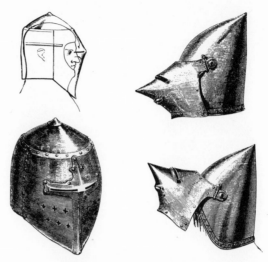

Right: French bacinet (about 1380 A.D.)
Left: Italian Heaume (XIIIth century)

are familiar examples of such "windows" in the bubble windshields of small planes, where the pilot does not move from his strapped position —and where the objects around the plane seem to move very slowly on account of the great distance and in spite of the actual speed of the vehicle. On the contrary, this is a catastrophe in car windshields of "wraparound design", where the curve has no relation with the ellipsoid of vision, thus creating distortion and effects of double refraction—and also where the vehicle, very close to the landscape, creates, by its motion, a fast changing perspective that makes focusing impossible: The worst condition of vision is found in the fringe areas to the left or the right of the driver, where it actually should be clearest, since it is on the side of the road that the warning signs are.

If this "bubble window" is possible—even excellent—in rare instances of design where man occupies a perfectly set place—like a pilot

strapped to his seat—it is not so simple in architecture, as the essence of life in a building is movement, and we have to consider all the infinite variety of fields of vision involved in the successive motions of man as he walks from one place to the other.

Until very recently, the very possibility of building spherical surfaces in a transparent material was not even considered, and window panes had to be not only flat, but rectangular, as a crude approximation of the ideal opening. The nearest approach to the ellipse of vision would be in this case *the horizontal rectangle that circumscribes this ellipse.*

It is comforting to see that here again the peasant has shown the way and, undisturbed by all fashions and styles that came his way, has kept on designing horizontal openings throughout all history. We find them in European farmhouses 1000 years old, as well as in pioneer log cabins.

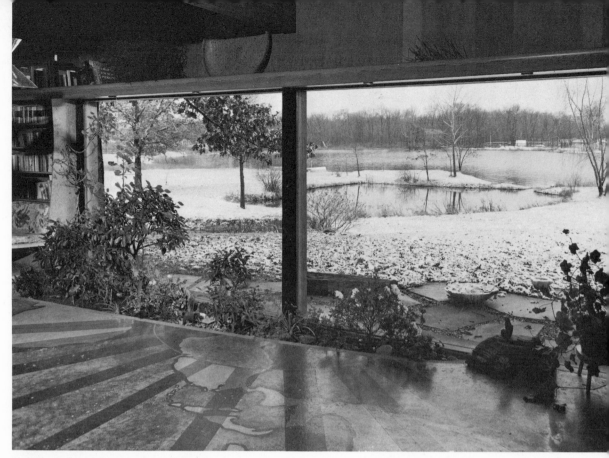

Picture window in the Grillo home

THE PICTURE WINDOW EXISTED IN JAPAN A GOOD THOUSAND YEARS
BEFORE IT WAS "INVENTED" BY CONTEMPORARY ARCHITECTS

Room in the Kobuntei, Tokiwa Koyen, Mito, Japan

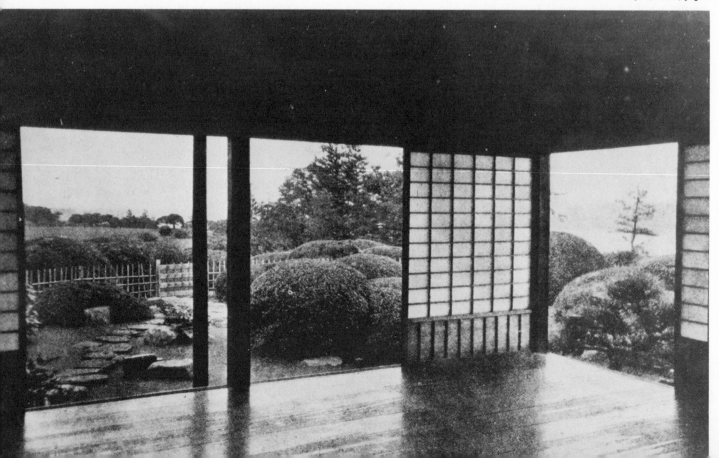

The "Chicago window" It came into being with the first steel frame buildings. This three-bay horizontal opening is characteristic of the buildings erected in Chicago after the great fire

Sliding horizontal window in a pioneer log cabin

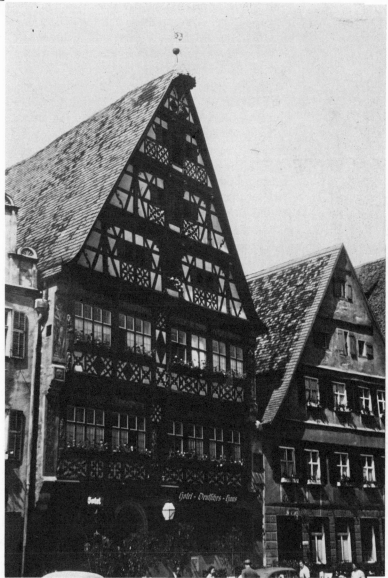

Inn at Dinkelsbuhl, Germany

Meanwhile, the vertical window came into power, and we still see 99% of all small houses being built with the dreadful vertical sash unit, although the reason for it disappeared some 500 years ago from England. It is a good example of how a particular form in design can survive long after its reason for being has vanished from earth, carried over through centuries by the peddlers of style and fashion. Why then did it ever come into being?

At the beginning, as always in design, there was a vital reason for it. In those times when Ivanhoes and Gwendolines roamed the English landscape on their steeds, not only did the sun come through the windows, but also such unwelcome guests as volleys of arrows from the next door neighbor paying his visit from the castle a few blocks down the road. Openings were then designed not only to offer some protection, but also to serve as conveniently protected shooting stations to repel the invader. The only thing horizontal in the whole system of medieval openings was the slit in the helmet of the fighting knight—a design still considered excellent for armored tanks and most of the protective helmets used today (for welding, diving, etc.) The wall openings were all designed as vertical slits, to fit the ideal movement for aiming a bow and shooting arrows, as also the most difficult target for outside attackers. All other openings were designed vertically also, to deliver in the most efficient way all other gravitational ammunition such as boulders, boiling oil, and so on: the law of gravitation that designed Yellowstone waterfall as a vertical slit in the Canyon, also ruled the vertical slits of medieval architecture.

Like all bad habits, it stuck long after the reason for its design had vanished with the progressive unification of European nations and the progressive evolution of weapons, from arrows and boiling oil to atomic missiles. I doubt that Republicans or Democrats that might occupy the rooms on the street side of the Palmer House, the St. Francis, or the Hotel Roosevelt would ever think of showering passers-by with boiling oil, though the windows are certainly beautifully designed for that purpose.

Coming back to our dark room, we realize also that if the room is small, like the cabin of a plane or an automobile, we will not need a big hole, as a small opening will enable us to see the whole landscape and be drenched with sun, while if we are in a large room, we will need large openings. For instance, it is always a surprise for whoever gets into a small European car like the German Volkswagen or the French Dauphine for the first time that he can control a wider area of visibility from the driver's seat than from the same position in one of the big American automobiles. This brings us to the notion of *scale* in design: we must assume that the dimension of an opening depends on the size of the area it must bring light into.

But if the main reason for cutting windows is to let light in, we have to take into consideration the orientation—meaning the *sun*—and the climate—meaning the *latitude* and *altitude* of the site.

In residential programs, we find most of the window area on the sunny side, while the north side has openings only for the sake of ventilation and the lighting of work areas. This is most striking in peasant dwellings where the north side is generally completely blind, except for ventilating slits in the walls.

Drawing by Chas. Addams; Copr. ©
1946 The New Yorker Magazine, Inc.

The slit opening had a strictly strategic reason for its design. It was designed to fit the kind of weapon used then, the bow and arrow, and also to offer the assailant with bow and arrow the most difficult target.

Compare these medieval vertical openings with the horizontal turret openings of today's protective enclosure of guns in tanks and battleships, motivated by the sweeping range of modern guns—instead of the vertical aim of bow and arrow

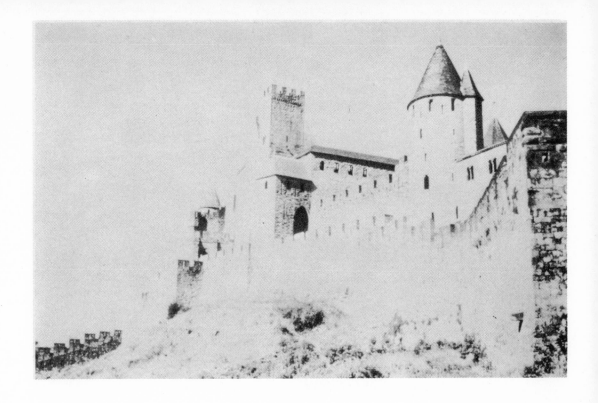

MAIN STREET, ANYWHERE

This happens to be Singapore. Boiling oil and archery are things of the past, but the slit opening is still going strong

Raffles Place, Singapore

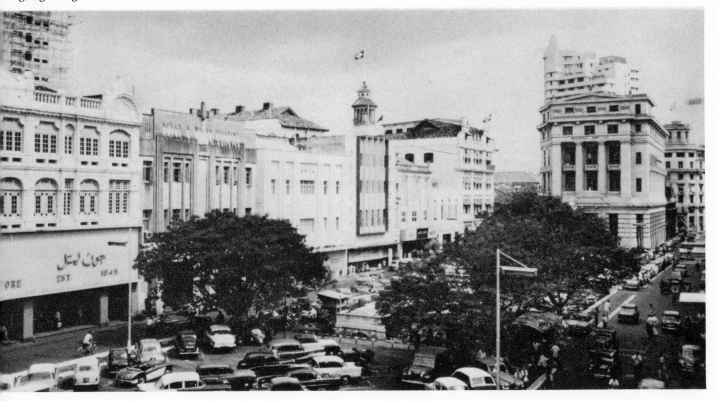

133

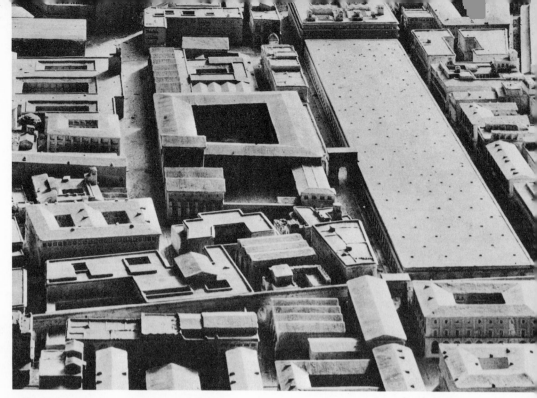

In antique Rome—as in all the Mediterranean and the Near-East—interior courts were the characteristics of all planning. They acted as small pools of shade against the merciless sun. This view of a western part of the City also shows the Septa Julia, an immense area (5 acres) covered with a seven-bay arcade, which was the largest shopping center in Rome.

The court enclosed with buildings, or patio, and the arcade, still constitute the two main features of architecture under the warmer latitudes

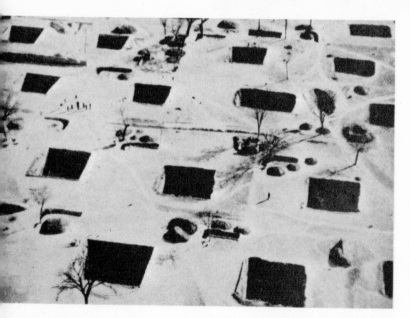

Nowhere did elegance in open portico reach such greatness as in Ispahan.

The Tschihil Sutun or Pavilion Mirrors, shown here after a drawing Coste, is unsurpassed today in its quisite lightness and artistry

If the level of the ground were raised to the top of the buildings, the picture of Rome above would look very similar to this view from the air of a settlement in China where, for an identical reason of natural air-conditioning, the farmer lives around deep well-like courts, dug in the soft lime-stone deposits.

We find also the same design in inner Tunisia where whole villages are dug underground

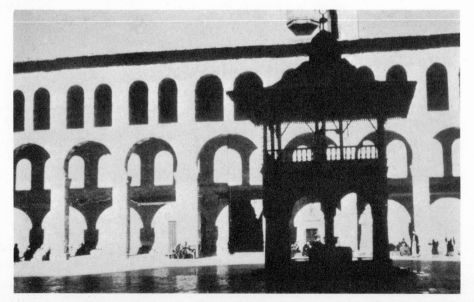

In sub-tropical countries where the desertic climate does not grow shade trees, open porticos and loggias are the designer's answer for the substitute to the tree.

The arcade achieved monumental proportions in Syrian and Persian architecture as shown here in the Court of the Great Mosk in Damas, Syria

In southern latitudes—like on the Mediterranean shores—the size of the openings is rather small, and they are scarce, even on the sunny side. The orientation, instead of being towards the outside, is reversed, and openings are towards the inside, taking light from a pool of shadow that was called *atrium* in roman architecture, and the *patio* of the Moslem which had come to us through Spain. In tropical countries, where the sun is always unwelcome, and constant ventilation a necessity, entire walls are designed to provide for ventilation in the form of screens made of reeds, wood, or louvered material. The deep Moslem screens, or "moucharrabieh", made of wood or masonry (plaster cut into a lacy design, or marble) not only let the outside air in, but actually air-condition the interior by cooling and de-humidifying the air. It is a well known fact in physics that an air flow loses temperature as it increases in velocity. This is exactly what happens to air when it forces its way through a narrow opening (like water forced through a duct of a smaller diameter), not only getting cooler in the process, but also getting dryer, as the humidity it carries will partly condense in the cooler passages of the thick screen; this very simple principle is used for drying old walls in Europe on historical monuments which often

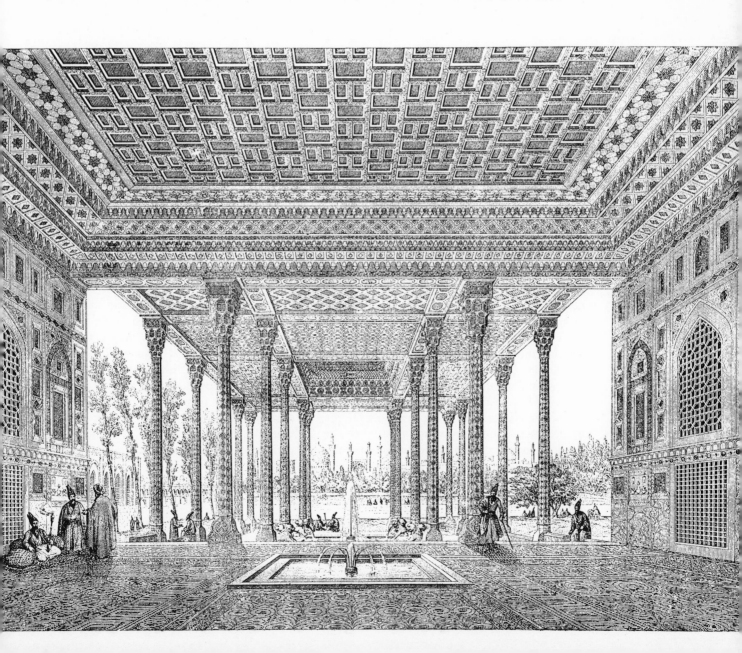

The author witnessed a natural "air-well" actually in operation, made of a hill of loose lava blocs, near the small fishing village of Puerto Penasca (Mexico). In the early morning hours, condensation water was flowing freely within the interstices of the blocs, feeding a luscious rock garden of wild flowers (Feb. 1960)

threaten to crumble under the capillary moisture absorbed from the ground. Engineer Knappen designed standard tile ducts, triangular in section and about a foot long, that are inserted into holes drilled in the masonry at a slight angle toward the outside. Each one-way duct acts as an individual dryer for the area immediately next to it, automatically siphoning the heavier humid air that flows on the bottom section of the tile while the drier air from the outside, warmer and lighter, is sucked along the top.

The "air wells" of antiquity, made of huge pyramids of loose blocks of stone, followed the same principle. They produced enough water to supply large and prosperous cities such as Theodosia for instance in Crimea, quoted by Strabo as one of the wealthiest wheat producing areas in a near desertic climate.

This illustration of changing the liability of a climate and turning it into an asset is a lesson in what may happen when, instead of considering environment and climate as an enemy, man decides to live in sympathy with it.

A simple idea like the idea of the air well, for instance, seems quite unworthy of our times of scientific conquests. Who would not laugh at the idea of piling up stones into pyramids like the Egyptians? Even though we are better equipped than they were for this kind of work, we refuse to accept the idea as "progressive".

But if we pause to think that this source of water would cost absolutely nothing, once the "machine" were built, and would continue to work as a natural "spring" for centuries to come, we should seriously endeavour to harness such an inexhaustible supply source.

In contrast with the black magic of the atom, preciously hoarded by the few, which carries in its wake the possibilities of lethal fallout and the specter of total annihilation, nature gives us the white magic of the sun free and waiting to be used.

Maybe it is because mechanical inventions bear the glory of human pride and give us the feeling of commanding the elements that we have so strangely neglected the sun, nature's greatest gift. We believe we have solved a question by fighting back with some mechanical gadget. We think we have "licked" the problem of heat with artificial air-conditioning and ice boxes, as though this solution were possible everywhere and for every budget. This sad misunderstanding between our way of living and our environment is making us live in our own world as "displaced persons", and unable to find real happiness because instead of being at peace with the world around us, our trees, our clouds, our deserts, and our seas, we have chosen to fight nature as our fiercest enemy and consider every un-natural solution, a victory.

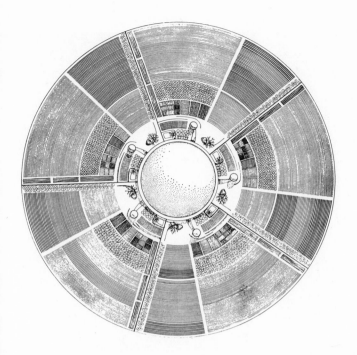

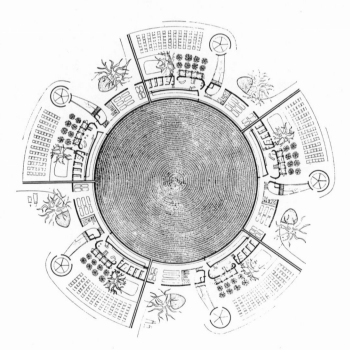

The use of solar energy to obtain fresh water is one of the most important problems in the world today. Various possibilities are being considered, among which the recovery of atmospheric moisture in arid lands offering high night and day contrasts of temperature.

In Theodosia (USSR), remains of broken limestone mounds averaging 32.000 cubic yards have been found. These "pyramids" were linked by sandstone pipes to the public fountains of the city. These "air-wells" are said to have provided the city with its water supply.

In 1929, L. Chaptal, in Montpellier, (France), built a small pyramid of 10 cubic yards and collected a daily average of 2 qts. of water during the spring and summer. From these results, Georges Lejeune and Jean Savornin at the University of Algiers (1955), concluded that the Theodosia pyramids must have produced a daily average of 160 gal. per unit—a very conservative figure as compared with the estimate of H. Hitier and H. Masson (1954), set at 14.600 gal. The actual figure would probably be higher—possibly in the vicinity of 1000 gal, as the condensation effect would increase in geometric progression with the size of the pyramid until it reached a ceiling for a certain optimum dimension.

Some areas on the globe may also be more favorable than others to make a success of this enterprise. Their climate should combine conditions of high diurnal evaporation (coastal areas of dry lands) together with high contrasts of temperature between day and night. The size and molecular texture of the stone used should also be of great importance.

These conditions existed on the Mexican shores of the Gulf of California, when the author visited the area, during the spring of 1960. Due to its high atmospheric moisture and the natural richness of its soil, the desertic coast of Western Peru also seems to be an ideal area to start such an experiment.

No definite conclusion may be obtained as to the practical value of this system until a *good size* experimental unit is built in a fitting climate with fitting materials. All experiments up to date have been conducted with units of much too small size to be conclusive.

The Grillo-Loarie project shown here consists of a pyramid of loose lava designed to provide enough water for all uses—including irrigation—needed by a basic unit of *five 6 acre farms*. The 6 acre unit of land, equivalent to the Roman *jugum*, was chosen as the area estimated sufficient to support a farm and livestock for a family. The lodging itself, for the farmer's family and the farm animals, is built directly under the edge of the pyramid, thus providing for air-conditioning. Cold storage is in back, and dry storage is provided by an outside silo, near the drying terrace. Olive, orange, and coffee trees, are associated with a grape orchard, produce fields, cereal and fodder.

The value of this method of obtaining water would be at a premium over other methods using distillation, as the water thus obtained would contain a life-giving balance of minerals dissolved from the stones, and be as healthy as pure spring water.

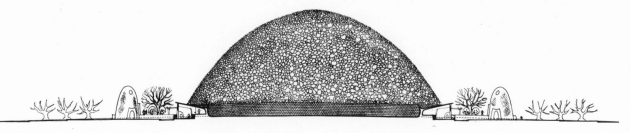

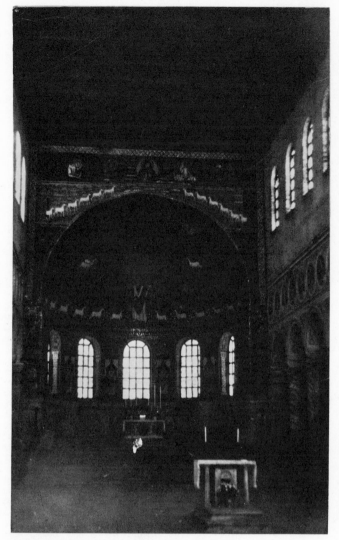

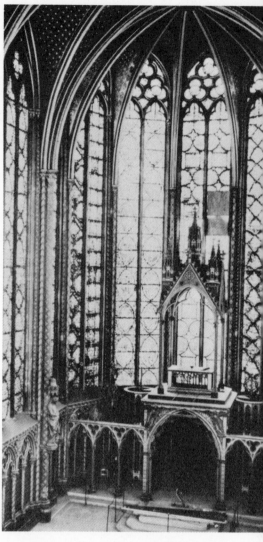

St. Apollinare Nuovo in Classe
(Latitude 44°)

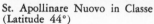

St. Chapelle, Paris
(Latitude 49°)

WALL DECORATION AND SMALL OPENINGS
CHARACTERIZE SOUTHERN CHURCHES

Church design offers an extremely consistent example of adaptation of the size of openings to every different latitude. As we follow their design from north to south, the walls become more and more important.

The result in the general design is remarkable. So much wall surface was tempting for the painter, the mosaic and the fresco artist, while scanty window space did not encourage the glass designer: whence the lavish *interior wall decoration* we find in all Mediterranean religious architecture, from Egypt to Byzantium to the Italy of the Renaissance and the golden studded interiors of Brazilian churches.

NORTHERN CHURCHES USE STAINED GLASS
IN LARGE WINDOWS

As we go northward, the building looks outside again, and the necessity for more light urged the builders of the cathedrals to lighten their structure to let the sun in.

The wall space became smaller and more chopped up, leaving practically no space for decoration. But at the same time the window space became tremendous, offering a unique opportunity for the *stained-glass* window art to develop.

We must not forget that most of the associate arts of architecture—fresco, mural painting, tapestry, mosaics, etc.—ask for wall space.

As a result of this conquest of the window over the wall, completed during the Renaissance, there remained no more wall space to develop decor. Since it coincided with the sharp decline of stained glass art, a dull drabness characterized the many religious buildings that came into being within the period that extends from the Renaissance to our days, where the uninspired design of decadent interiors exposes their lack of taste under the glare of yellow and light colored windows that hide nothing.

More light in a building does not necessarily mean progress. Only the quality of light matters. Light for work, light for play, light for pray, cannot be measured by the same gauge.

Climate, latitude, and site, are the natural determining factors. The program completes the requirements in each case.

Chartres,
North Rose
Window

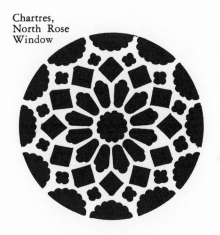

On the north side, the window, in light-diffusing blue tones, has a surface of glass almost twice as large as the west side rose, which is in dark red, light-constricting, hues.

The west wall in which the window is set, instead of being cut by large openings, like in many contemporary churches, on the contrary, offers more blind surface than any other in the cathedral. At the hour of sunset, the small window gloriously lights up like a pure ruby set on a drape of pure velvet

From the small windows of the Byzantine, the openings blossomed into the regal rose window of the Gothics, as Architecture went northward. Under the gray skies of northern Europe, interiors needed more light. This was really the reason why structure was stripped of all unnecessary padding and reduced to a skeleton of flying buttresses and wiry arches.

On the contrary, under southern skies, interiors must be padded with heavy walls for heat protection, and openings must stay small so as not to let in the heat.

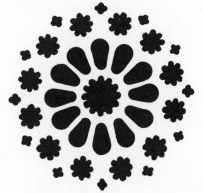

Chartres,
West Rose Window

This west façade is also the main entrance, always associated with the symbolism of the Last Judgment which precedes the access to Heaven. It reminds one of the Narrow Gate of the Scriptures, designed as a lock of darkness to prepare and enhance the mystic vision of heavenly light which follows as one enters the cathedral

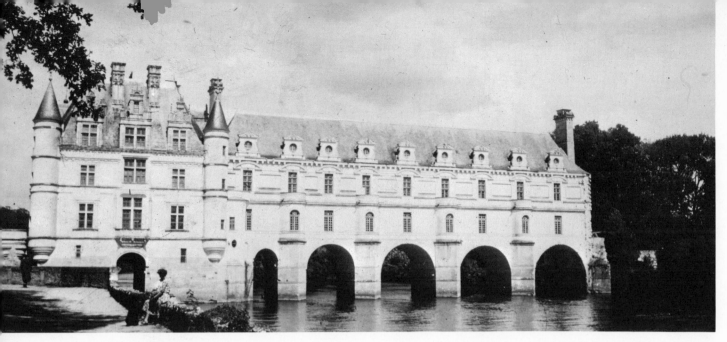

Chenonceaux

Whether in the courtly design of Chenonceaux or in anonymous abodes throughout the world, we witness the structural hierarchy of the opening, treated first as an *arcade* on the ground floor, which is the first and most obvious solution to the *bridge*. Above this *apron* constituted by a second floor, may be built any kind of elaborate construction. Notice the expression of the people's common sense in the majority of *horizontal* openings in this street house at Cluny, designed in the heyday of the vertical slit, and compare it with Chenonceaux, where we witness the survival, through a fashionable "style", of an element of design (the vertical slit window) no longer necessary. Notice also the difference between the two wings of Chenonceaux: the wedding-cake type of fashionable Renaissance court style in the square dungeon, and the better treatment of the long wing, with its differentiated openings according to the weight of the material above. The circular dormer, having nothing to support above, *can* logically be circular.

In the whole design, we feel the unconvincing "colonial" architecture, imported—together with the architect—from Italy. The small window area speaks of hot Italian sun, and certainly not of the welcome warmth and silky light of the Loire valley. This is what makes the whole of French Renaissance architecture so *unauthentically* French, though no longer Italian: a mongrel design that belongs more to a flimsy world of fashion than to the permanent character of a country

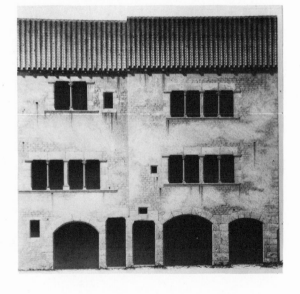

Romanesque
house at Cluny
(XIIth Century)

A new tendency is growing toward a fuller treatment of the wall in architecture. After the craze for glass and nothing but glass, the wall is coming back again, but with a new significance: no longer as a bearing member but as a divider to screen off and separate diverse areas of activity.

In the design of any building, wall spaces are like the necessary silences in music: they can often be more impressive than a lot of noise. This *law of contrast* rules all creation in art, in architecture as well as in music. A wall is like the slower movement in a symphony, wedged between faster parts, and thus making each part better appreciated by contrast. It is by the balance of action and rest that the harmony of life is created.

The pattern created on an outside wall or *façade* is a symbol of the conquest of light and lightness that has haunted man ever since he started designing architecture. But the proportion of the opening is really a balance between the necessity to *let the sun in* when it is beneficial (morning, winter, etc.) and to *keep it out* when it becomes unwelcome, as in hot countries, while letting in as much *diffuse light* and *cooler air* as possible.

Various logical rules thus dictate some sort of proportion in the design of openings. We have seen the reason for the vertical or horizontal *slit,* and for the horizontal *rectangle.* We could add the gateways, that are like locks in a river dam. They have to let people through like flowing water: their dimension in height can be just a few inches above the head of the tallest human being, but in width they must be designed so as to cope with the movement of the people involved in every case.

But we soon find out that these strictly *practical* rules, although of primary importance, are not enough. We cannot solve all problems of proportion by logic. In fact we will realize that only a few can thus be solved.

As soon as we deal with areas, volumes, and anything bigger than a little house, we encounter the value of proportion as something very new to us. To find some answers, we find that plain common sense is not enough. We must call more science and sensitivity to the rescue. Here we reach the border where art, experience, and intuition, meet a branch of science that touches physics by only one corner: metaphysics.

Modern science and research have freed the builder of many of the limitations formerly dictated by *material,* unleashing his imagination in design. We must learn to use this new freedom. Thus the value of proportion has attained a new importance in today's architecture, as the wall, considered as a bearing member, has practically ceased to exist, and the choice of its position to close or separate the various areas for living, is left almost entirely to the art of the planner.

We are left with wide open areas to distribute into spaces. The whole issue of the design battle will depend on the value of the proportion we decide to give to each of these areas.

Should we adopt the metric system?

THE PRESS

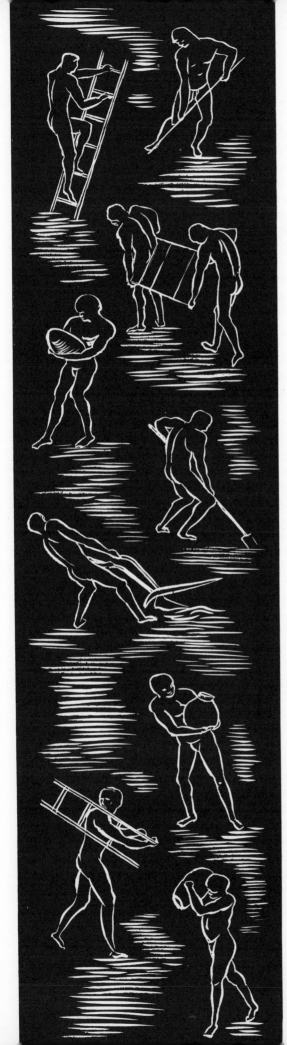

With apology to
Leonardo
Sketch by Grillo
after Leonardo da Vinci's
notebooks

PROPORTION

the world of man

UNIT
MODULE
SCALE
RHYTHM

143

An architectural program will generally give the surface of various rooms and areas, but the form of the area is left to the designer. Even if we put aside the wide choice of odd forms, curved or polygonal, and limit ourselves to the simpler rectangular forms, we know that there is an infinite number of rectangles of every imaginable proportion that may have the same area: to put it in mathematical language, all areas defined by the coordinates of any point on the hyperbola $xy = a^2$ have the identical surface. By the same reasoning, we know also that there is an infinity of different rectangular spaces having the same volume: they answer the equation with three variables $xyz = a^3$.

This means that the three dimensions that limit the volume of an office, a living room, or an auditorium, can be expressed in an infinite variety of proportions.

How are we to know which, among the infinity of numbers offered to our choice, will create harmony in their special relationship with each other? The musician is also faced with the same quandary regarding which combination of notes and intervals will *make music,* and which ones will only *make noise.*

A keen sense of proportion, of its relative value and its practical or psychological value, is one of the most precious qualities of a good designer, and also the hardest to master. We already know that in this field we are certainly greatly helped by common sense and reasoning, at least in solving simple problems. For instance, common sense tells us to avoid the *elongated rectangle* for a living room, as it makes a very unfriendly room, where entertaining is difficult: the company tends to segregate itself in isolated groups that have to be disturbed to go from one to another. Common sense tells us also to avoid the *square* for the same living quarters, as it is impossible in such an area to entertain more than one single group, without any possibility of secondary grouping. We don't have to be told either that a 20 ft. ceiling in residential quarters would be as much nonsense as a 7 ft. ceiling for an auditorium.

This is all very fine, and common sense tells us some "must nots" that can steer us clear from the most obvious mistakes in proportion. But common sense still does not tell us what then *should be* the best dimensions for a given area. This calls for a more subtle sense which is par excellence the gift of the artist—the sense of proportion that combines the appreciation of form, rhythm, and scale, which together achieve harmony. Although such a sense is a natural born gift, (some people have it, some don't) it dwells in a latent stage in everybody, as everyone is part of the general harmony of the universe and is himself a creature of harmony. It can be developed in every layman by education, like this other gift of the artist, *taste,* if not so far as to make an artist out of an untalented person, at least to make him appreciate what artists create for him to enjoy.

Until now, we have been able to use only common sense arguments to stress the basic elements of design. We have felt that we were treading on solid and safe ground. Common sense and the obedience to strict natural laws gave us our rules for designing. If the natural laws are obeyed, we know that what we build may stand for long healthy years, while if we don't follow them, it will collapse of a quick and miserable death. But we realize also that this is not enough: we know that monsters may be extremely healthy and live long years—and still be monsters, like so many perfectly constructed freaks of architecture that are, alas, indestructible. What, then, adds proportion to a building, and *what is good proportion?*

As we enter this territory, we have a sudden feeling of insecurity, as though we were opening a door into some secret kingdom where only high priests and the initiated know their way.

We shall find out, on the contrary, that this most fascinating part of our trip into designland is actually *Man's Own Land,* where he will discover the permanent quality of the bonds that tie his own world to the universal harmony of creation. We should enjoy an exhilarating feeling of health and security by realizing that our own work, when at its best, becomes integrated with Nature's masterworks as an active part of a universal order.

144

RELATIVE AND

ABSOLUTE PROPORTION

Proportion, considered as a rapport between two dimensions, can have a meaning without any sense of measure attached to it. It is the realm of pure geometry. The rapport $\frac{1}{1}$, for instance, as expressed by geometry by the pro-proportion of the sides of a square, is *abolutely* true for any square, of whatever size you choose it to be—one inch, or one mile square. This is *absolute proportion.*

But when we come to evaluate the size of a figure in relation with another, we are led to say that such a figure is *bigger,* or smaller than the other one, as we compare them together. We are then considering the *size* of the figure, and to do so we have to refer it to another well established dimension, already sizable in our minds, and that we choose consciously or not as our relative unit of measure for this particular operation. Thus when we want to evaluate a dimension, we have to refer at all times to a *unit of measure* set once for all. When we deal with figures measured as part or multiple of such a unit, we deal with *relative proportion.*

In short, let us say that relative proportion refers our design to a *scale,* while absolute proportion defines the characteristics of a *figure,* regardless of size.

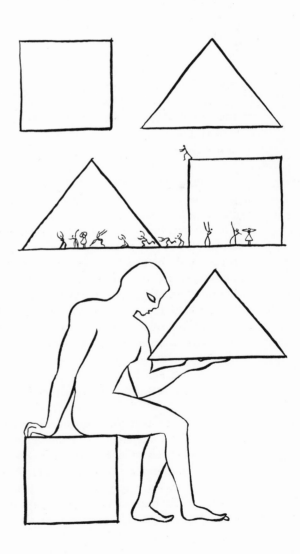

145

It may seem that we are free to choose *a priori* whatever unit of measure, whatever system of such units we please, as long as it does not lead into complicated calculations. There does not seem, for instance, *a priori,* any more reason to adopt the inch and foot system rather than the metric system, except for the sake of commodity.

We will try to show, on the contrary, that the choice of the units of measure, as defined by successive civilizations on earth, is *not in the least arbitrary.* A comparative study of the systems of units adopted by various people all over the world and throughout history shows a concordance in their choice that would be uncanny if it were not so sensible.

Man needed a unit of measure not only to allow him to size up his own creative work, but also to allow him to size up nature's creation around him *in comparison with his own size,* and *in relation with his own strength.* In other words, he needed as a common measure a unit that could be a bond between the scope of man's creative power and the world around him. But he needed a unit whose stability and invariability were already well established by his constant vision of it, whose meaning was absolutely clear in his mind and its representation immediate. It was only natural that he should find the answer in the dimensions of his own body, as this was for him *the perfect invariant,* a constant and immediate system of reference. The invariability of the relative proportions between the various elements of the body of any animal, is well known. A whole science, paleontology, applies this fact to its research. The founder of paleontology, Cuvier, could thus reconstruct the complete skeleton of one extinct animal with the help of a couple of bones.

It was only common sense for man to choose as a basic unit for measuring length that part of his body most important for him to accomplish his daily work: his fore-arm. This became the *Cubit*—the length of the fore-arm from the elbow to the tip of the middle finger, hand outstretched.

However, this single unit could not be universal. If it proved satisfactory in measuring work done with the arms and hands, it seemed illogical for measuring walking distances, or weights. Other units were thus chosen, not only according to the *length* of the limb involved in the work to measure (which *varies* according to each individual), but mostly according to the amount of *human energy* involved in the accomplishment of a given piece of work (which is *constant* regardless of the individual). Thus the *Foot* was chosen, not as representing the length of the human foot (which would only fit a race of giants) but as a *measure of the energy exerted by a man in climbing a vertical ladder.* In all countries of the world, the interval between two successive rungs on a ladder is equal to *one foot,* whether in Sweden, where men are tall, or in Japan, where men are small. It covers the vertical distance that a man, climbing up a vertical ladder, can reach in one step, *and keep going up* with the least fatigue. We can see how directly it is related with the cubit, if we notice how important the energy of our arms is, when we climb a ladder.

A Unit, in short, is a standard measure of a working man's limitation in a particular activity.

Man's strength cannot go beyond an asymptotic limit in all fields, a ceiling of achievement,

whatever his race, size and effort. In the Olympic Games, men of very different build compete in sports, always getting closer to a *limit* performance that cannot be reached under penalty of death by overstrain. Records become meaningless when they differ from one another by only a fraction of a second in a performance that lasts hundreds of times longer. The Olympic athletes are thus competing in a pre-superhuman area far removed from the average human field of action. Lower down in the scale *are* the majority of average human beings of all races and nations, workers in all fields, and very close to each other in their muscular strength: it is from this group that the value of the various units was chosen.

The choice of a unit based on some form of human energy (cubit and foot) is not only true of the *length* system of measures. It is also true of the choice of the various units adopted by people of all countries in the world to measure *surfaces* and *weights*.

In regard to the surface units, the *Acre* or its equivalent is found the world over, with only slight variations according to the different natural environment of the various races, which also explains the variations in value of the cubit and foot types of units among the people of different countries—and also in the same country according to *climate* (duration of the working day under different latitudes) and *land configuration* (plain or mountain). One acre originally meant the *surface of land that a man can harvest with his scythe in a day* (in cattle-raising countries) or the *size of the wheat field that can be plowed by a yoke of oxen in a day* (in cereal growing countries). In France, it is named *Journal* (*Jour* means day) and its value oscillates around one

acre according to the different provinces (smaller in the mountains, it is larger in the plains, which is only common sense). In Italy, it is the *Giornata* (0,94 acre). In the Spanish countries, it is the *Fanega* (1,5 acre) whose name explains itself, as *Fanum* in latin means hay. In Hungary, the *Joch* is worth 1,07 acre. The *Tagwerk* (meaning day's work) of Bavaria and Wurtember hovers also around the value of the acre.

We find the same consistency in the units for measuring liquids or dry goods. The *Quart* and its equivalent around the world (French *Litron*, smaller than the *Litre*, and still used in all fine wine bottles of Burgundy, Champagne, Bordeaux, etc.) is *the amount that can be lifted easily from a table with one hand outstretched*. It is a table unit of measure. The *Gallon is what can be easily lifted with one arm from the floor and transported at arm's length* to a certain distance. The *Bushel*, the amount of grain that can be easily *carried on the shoulders* in a sack, etc.

By the same token, we find in the *League* (French *Lieue*, Spanish *legua*, Portuguese *Legao*, etc.) the distance a man can cover in one hour in a *leisurely* walk. As we see, there is no question of using units for record performances, but for a sustained effort with the least amount of fatigue, in other words practical units for everyday use. The *Fathom* is the measure of the space encompassed by both outstretched arms, and so is the French *toise*—but it is also the distance from your eyes down to the floor (French word *toiser*, meaning to look down on somebody) and the height where an adult loses footing in water and may drown. The English

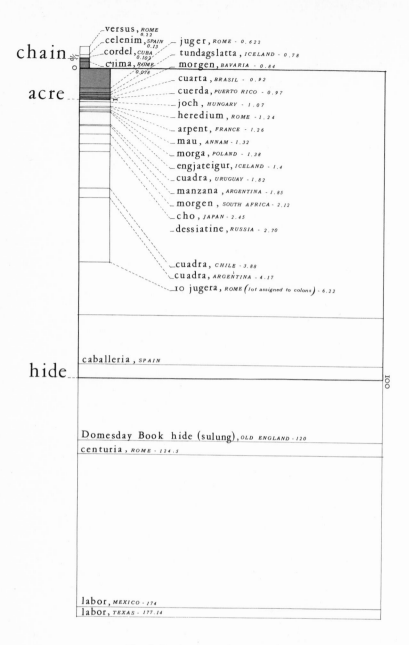

chain

acre

hide

versus, ROME 0.22
celenim, SPAIN 0.13
cordel, CUBA 0.101
clima, ROME 0.078

juger, ROME - 0.622
tundagslatta, ICELAND - 0.78
morgen, BAVARIA - 0.84
cuarta, BRASIL - 0.92
cuerda, PUERTO RICO - 0.97
joch, HUNGARY - 1.07
heredium, ROME - 1.24
arpent, FRANCE - 1.26
mau, ANNAM - 1.32
morga, POLAND - 1.38
engjateigur, ICELAND - 1.4
cuadra, URUGUAY - 1.82
manzana, ARGENTINA - 1.85
morgen, SOUTH AFRICA - 2.12
cho, JAPAN - 2.45
dessiatine, RUSSIA - 2.70

cuadra, CHILE - 3.88
cuadra, ARGENTINA - 4.17
10 jugera, ROME (lot assigned to colons) - 6.22

caballeria, SPAIN

Domesday Book hide (sulung), OLD ENGLAND - 120
centuria, ROME - 124.5

labor, MEXICO - 174
labor, TEXAS - 177.14

Drawn at the same scale here are shown some of the major land units used in various lands and by various people.

The hierarchy of units, sub-units and multiples is the true expression of how the farmer conducts his work. We may notice three distinct families of units:

1. the acre and its variations, up to the Russian *dessiatine* (2.70 acres), which represents the day's work in plowing. It also represents the morning's work in harvesting, the afternoon of the same day being used in stacking hay or cereal for drying. It explains the recurrence of the root *morg* (morgen, morga) meaning morning. The unit size of the acre varies according to site and nature of staple crop.

This is a unit of work, not a basic unit for family settlement.

2. The unit for social group comes next with the lot assigned to colons by the romans, equal to 10 jugera or 6.22 acres. This was the amount of workable land to raise a family, composed of an olive orchard for oil, plow field for cereals, and produce land plus grazing land for a goat, a few sheep and a mule.

3. With the *caballeria* or the *hide* we witness the granting of the knight's fee, the first rank in chivalry, the first grade in aristocracy. But this was really not purely a gift to the new knight: it was a grant of land to be defended against invasion and loot, and a pledge to *protect* the farmers who had settled in this area. We can see here aristocracy as a social necessity of the times, creating a class of defenders of the soil, (the military of today) whose duty was to protect the life work of the producing farmers. The insecurity of the times rendered necessary this social reform: we have a tendency today to overlook this aspect of medieval society, more impressed as we are by the few abuses than by the beneficial effects of a sound system of government. It is very similar to the household or "clientèle" of a Roman patrician family and their perfectly happy "slaves", and also identical to the old Southern Estate concept. During that period and for a time, it worked quite well

Yard is the unit by excellence for measuring fabrics, as it encompasses the normal stretch of a girl's arm when measuring a material on the edge of a table: the meter, although not much larger, causes fatigue after a while in this kind of work. The *Rod,* still widely used among the carpenters, is the practical limit for the average single beam span: beyond this dimension (16½ feet) the carpenter must shift his design to an assembled truss. It is still the implicit modular unit used in spacing the columns in the plan of a skyscraper, and still marks the limit between the two categories of timber work: simple frame triangulation—and complex truss design.

In the division of time, the day constitutes the

cosmic unit, independent of man—but the division of the day into duodecimal units (hours) and sexagesimal sub-units (minutes and seconds) directly reflects human life and energy. We may even find from this necessity for man to divide the day by 2, 3, 4, and 6, the very reason for adopting our duodecimal hour system, the number 12 being exactly divisible by these numbers. From the two-beat rhythm of the human heart—averaging one *second* of time—to the first unit of solar rhythm (the *day*), a consistent system of units developed. The *minute* may be considered as the limit for man to "visualize" time in immediate perspective. The *hour* in turn is the unit of labor: it is the minimum span of

time in which a man can accomplish a profitable work: it is the unit of salary, and also the length of a class, as it represents the limit of undivided attention, corresponding to the kind of intense mental work involved in a class. We know how difficult it is for any lecturer to keep the attention of his audience over this limit. The *two-hour* rhythm corresponds to the maximum time a man can devote to laboratory or craft work without feeling fatigue. Every *three hours,* man's stomach needs refueling: whence the mid-morning and mid-afternoon coffee-break, now an accepted custom in most administrations, and only a return to the more normal schedule of the farmer. The *four-hour* span is what the navy calls a *watch;* the normal limit of alertness for a man who can move around freely (also the limit for driving a car safely). The *six-hour* division into morning and afternoon, evening and night, corresponds to moods of human behavior related to the position of the sun on the horizon: morning hopes and ambitions, afternoon fulfillment, evening recreation and social life, and night's rest. It is also the span between the three major meals of the day. The division in the three *eight hour* periods of the day also is an important human rhythm as 8 hours of sleep are considered as the average need of man.

We thus find in all units of measure a basic link with *human energy.* It shows the importance of the *human scale,* as a source of permanent reference for measure, and makes us realize how all creative work of man is directly related to his own size and energy. A clue to understand such a remote and abstract work of architecture as the Parthenon might be in the fact that the human scale is the unit used throughout the design: we might consider it as a temple to Man. Dr. Funk Hellet, in his analysis of the Parthenon, shows that the number 1.681 meter, which corresponds to the average man's height, is the key to the proportions of the monument and calls it the "secret module of the Parthenon".

These notions have been forgotten since the end of the 18th century in Europe, and have since been discarded as obsolete, impractical, and more or less tinged with superstition. The general adoption of the metric system by all but English speaking countries has promoted a new standard of proportions and dimensions that cannot satisfy the designer. The rigidity of such a system where all secondary units are related decimally to the 1/40.000.000th part of the length of the meridian of Paris is in itself an absurdity, although in itself the *Meter* is an extremely remarkable unit, as we shall see later, and in fact already existed 5000 years ago, although not by its present name. . . .

We are beginning to judge the results of the *exclusive* use of the meter and the decimal arithmetic proportions of the metric system in the poor proportion of the majority of designs in countries that have adopted this system, since the time they put it into practice, while the uncanny persistency of good proportion in countries that still ignore the metric system may often be a source of astonishment to any visitor gifted with a sense of proportion. The reason is not that the designers of these countries have a better sense of proportion than the others: it is that, without their even knowing it, they are tuned to the scale range of human activity, exactly as a radio set can only make a certain station heard if it is tuned to this particular wave length.

When measures are no longer related to the human scale, we find the decimal metric system very valuable. Thus we find scientists who deal with minute quantities using the milligram. Stamps and camera lenses are measured in millimeters, but for telescopic mirrors, we still speak in inches—as they are within the human range and are designed in dimensions expressed in an even number of inches. When the astronomer comes to measure the immense distances of intersideral space, he feels again the need of referring to the human scale to give meaning to his figures: thus he refers to the distance traveled by light in the time of one heart-beat, the *second,* as a unit, and counts in light-*years,* comparing in this manner intersideral distances with the span of the human life.

For the same reason, we find that the physicist changes from the millimeter to the *angstrom* when he deals with wave lengths of infinitely small dimension: the system of reference with the human scale is then the range of the visible radiations (that man can visualize), that occupy the center of his system of reckoning and which, from ultra-violet to infra-red, measures from 3800 to 8000Å.

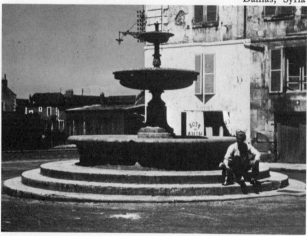

Fountain,
Damas, Syria

Fountain,
Auxerre, France

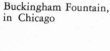

Buckingham Fountain,
in Chicago

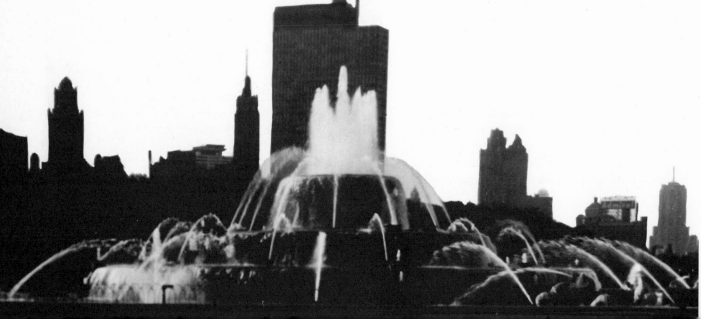

We realize now that every different kind of human activity needs a different gauge to be measured properly. Using again the comparison of the radio set, we know that each separate station will make itself heard and become alive for us only when we push the corresponding button in our car radio, or turn the TV dial to the proper channel. If we transpose this into the designer's world, we can understand that every kind of activity, characterized by a program, will need a particular unit—the wave length of this particular activity. This unit characteristic of every program is the *Module*. It sets the pace of life. It grants *Scale* to the design.

The choice of the module depends upon the *size* of the program considered, and its destination, meaning the *rhythm* of its pace. It is to the design what the dimension of a weave stitch is to a fabric, or what the dimension of a single net square is to the whole net—from the foot-size drag-net designed for catching floating mines to the quarter-inch netting used in catching sardines.

A modern incorrect interpretation of the module is that it was devised as a convenient and practical tool to simplify and standardize dimensions in design for the sake of economy and speed. This is a side reason, surely, but not the essential one. The choice of a module does not primarily depend on the most economical size of material available, but on the range of the spectrum of activity involved—what we call *Scale*. To understand better this essential con-

cept of *module* and *scale,* let us first stress that it has nothing to do with the so-called inch-scale that seems to have become the trade weapon of the designer commonly used to backfire any criticism on proportion. Often, on a plan, we will find that an area is too small, or too big, without the help of the inch-scale. Then we take the tool in our hand, check dimensions, and tell ourselves: "—Well, I was wrong: this space actually measures so many feet, then it *must* be wide enough". When tempted to yield thus to the rule of the inch-scale, just think how well at ease a battleship looks in the Hudson River, and try to picture it in Turtle Creek. Try to visualize your home fireplace transported into your church. There is in Chicago's Grant Park a fountain—with a capital F—superb in proportion if not in detail. Try to replace it by anything smaller: it would be dwarfed into ridicule, as on such an enormous area, a bigger yardstick is needed to appreciate dimensions. This feeling of a design fitting its space and surroundings is what we call *Scale.* A design may be good in all other respect, but if its scale does not fit where it belongs, it is wrong—while many a design in poor taste is admissible if it possesses the quality of scale.

Another example to make us understand better what scale means is offered by house-trailer design, as compared with normal residential design. In a house trailer, a 2 ft. door seems large, and 6 ft. 6 in. is good for a ceiling, while it is hardly acceptable in a home.

Fountains are a good subject, to study the value of scale. From the unique still pool of water of the moslem to the gigantic fountains of Chicago or Versailles, we notice that scale is not achieved by sheer *size,* but by a skillful *dosage* of design elements so as never to lose the feeling of the human scale itself.

Without the small lower elements of its design, this Liege fountain would soon lose all "scale" and only become *tall,* just like the solitary 300 ft. high plume of water which graces the harbour of Geneva, Switzerland, and which fails to be impressive as it has nothing to relate it directly to the world of motion and dimension of man

Fountain at the Water World Fair, Liege (1936)

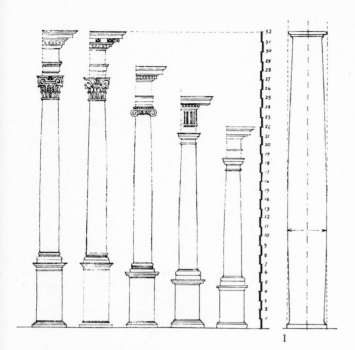

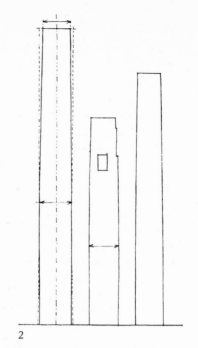

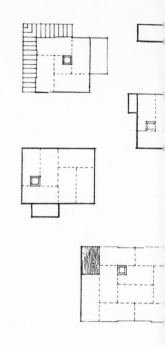

The Five Orders of classical archi-
tecture drawn at the same scale

In Western Antiquity (1) as well
as in Far Eastern medieval Japan
(2), module and entasis rhythm
design

Tea Room Plans
A tatami is shown at the upp
right corner

In Antiquity, all architecture was strictly mod-
ular, as all design was worked on a modular
weave. The best known example is the series of
the Roman Orders, according to Vitruvius: Tos-
can, Doric, Ionic, Corinthian, and Composite.
The module chosen was the radius of the only
circular element of the plan: the column. The
close relationship between the number PI and
the golden mean may give a clue to this choice.

The dimension of the module was the unique
characteristics of every monument, and varied
for every monument—no two columns in all
antique architecture being exactly alike—but
once chosen, the proportions of the various or-
ders used throughout the same monument fol-
lowed the same series.

In music also, the composer has at his disposi-
tion various "modes" as a canvas on which he
embroiders his melodic and harmonic combina-
tions. There are not only the better known
major and *minor,* but all the series of other
modes such as the Lydian, Dorian, Ionian, Irish,
Chinese, etc. But once the mode is chosen, the
whole composition is usually written in this
same mode.

In architecture, we could compare the orders

to the musical modes, fitting every "mood" in
design, the heavier orders (Toscan and Doric)
being used for the lower part of an edifice,
while the more elegant Ionic and Corinthian
were used on top.

Thus a *solid* element—the column—not an
element of *space,* was chosen as a module in an-
tique architecture: this expresses the fact that all
antique architecture is essentially *solid,* made of
heavy bearing walls with relatively small open-
ings and limited spaces. But in the evolution of
design, the bulk of solid elements kept becom-
ing smaller in comparison with the open areas,
as it was ever striving toward more lightness
of material and more openness. It was natural
then that, inasmuch as architecture became more
a question of space, an element of space be chos-
en as the modular unit, rather than an element
of structure. Whence the choice of space mod-
ules in contemporary architecture, as well as in
the very light and open wood design of Japan.

The Japanese construct all their design on a
modular unit that represents the size of man. It
is called *Tatami,* and is represented by a mat
approximately 3 x 6'. The dimension of rooms
is always an exact multiple of this unit. This is

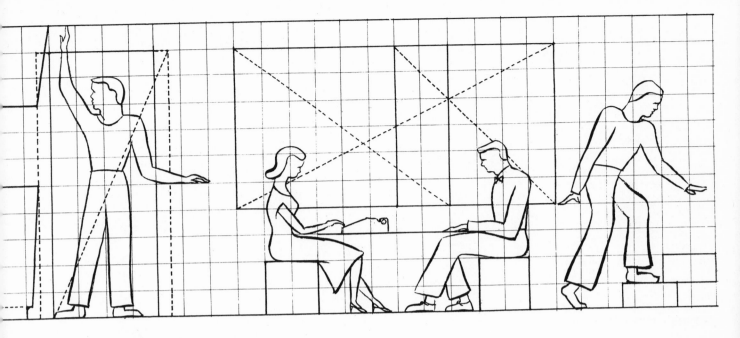

Standard 8″ concrete block modular grid pattern on which are shown various elements of residential design. The dotted lines show rectangles in harmonic proportion

true to such an extent that a room is not designated by its dimension in meters or Japanese feet (the *shaku,* equal to 0,994 foot has for its next multiple the *ken,* equal to 6 shakus) but in so many *tatami* (one ken by 3 shakus). We find in this one of the reasons why all Japanese architecture is so human in its proportions and is more and more taken as a source of inspiration and reference by contemporary home designers.

Modular design is present everywhere in our everyday life. For instance, the mile-square weave of our city streets and country roads is a pure modular pattern. So is the sky-scraper design, the module being, as we have seen, the carpenter's rod, the reason for its choice seeming to be mostly a reason of economy, as such a pattern brings a corresponding section of trusses that is most economical in steel. We must not forget however that the reason for design is not primarily economy in dollars and cents, but the most efficient fulfillment of a program of human activity. There is nothing less "economical" than poor economy. People realize when it is too late that *only a millionaire can afford to buy cheap;* by the time they come back

to sensible buying, they often are already ruined. In the case of the office building, if such a module was chosen it is mainly because the height of 12 feet is the most convenient for diversified work, and a pattern of 16′ x 16′ squares lends itself most conveniently for partitioning rooms into fitting areas for work—the result being the use of trusses one foot wide.

In residential design, the most workable module seems to be the 16″ weave, which corresponds to the *Cubit*—or its half, 8″, which is the *Hand Span.* No wonder that we should use as the unit for man's shell the dimension of his working unit: the fore-arm or cubit. It explains the fantastic success of the most popular masonry unit of today: the *cement block,* which has for dimensions 8 x 8 x 16″. 10 blocks make 6′-8″, a perfect height for a door. Four blocks reach the window sill. One block is the height of a step, two reach a seat, three make a table. We will see when we study the harmonic proportions in the next chapter that this unit lends itself easily to harmonic design. It is another remarkable example of the importance of Mr. Designer Anonymous in the history of art in general and architecture in particular.

Chaconne by J. S. Bach

East frieze of the Parthenon, fragment

Rhythm, or recurrence of a certain pattern of sounds, numbers, figures, colors, or movements, is so closely associated with life that it seems to be the very expression of life itself.

The two irregular successive beats of your heart that mean life to you, is a rhythm whose pattern changes with your emotions, your health, your age. In all creative work, be it poetry, music, architecture—*rhythm* means *life.*

In music, rhythm is created by the recurrence of a modular pattern which runs through the composition and adds a third dimension to the interweaving of the horizontal melodic line and the vertical harmonic progression. In this pattern, the rhythmic unit is the *beat,* and its module the *measure* (*modulus* in Latin means a small measure). A second form of rhythm shows a more hidden pattern from which, at first, rhythm seems absent. This is the "long measure", which, in poetry, takes the name of *free verse.* This very antique form developed in parallel with the clearly rhythmic music, both as reli-

Poncho in tapestry weave
Coast Tiahuanaco, Peru

Medieval
Plainchant

gious expressions, one to support sacred dances, the other as a higher expression of poetic speech, reserved to converse with the gods. One archetype of this "free rhythm" is the medieval plainchant, itself an offspring of the forgotten sacred music of antiquity, where tonic modulation follows the progression of poetic verse. We also find it in its popular form in the Sevillan "saeta" and the *Cante Jondo* of Spain. Claude Debussy, marveling at the "free" singing of birds, introduced this mode of expression in larger forms of contemporary music.

In architecture, we find the same two patterns represented. The first, by measured series of arcades, columns, and openings, clear in modulation and sequence—the second, in rhapsodic façades like the extraordinary Doges Palace, where the distribution of various size elements creates a single subject composed like a heroic ode. We find it also in the stunning pattern of openings in the southern wall of the church of Ronchamp, by the architect Le Corbusier.

Now since we have to review the origins of arts and in this present "period" of ours, we say that geometry is stated by most persons to have been invented by the Egyptians and to have owed its birth to the re-measurement of their patches of land. This was made necessary with them because the rise of the waters of the Nile obliterated the proper landmarks of each land holder, and it is no wonder that the invention of this and other forms of knowledge arose out of the need of them, since everything produced by birth proceeds from that which is incomplete to that which is mature: so the transition will naturally be from perception of the need, to calculation of the means to meet it, and finally to a mental recognition of the means.

PROCLOS
The Summary

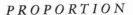

the world
around us

The world around us is a world of numbers—
numbers that spell life and harmony. They are
organized by the geometry of figures, all related
to one another according to a sublime order, into
dynamic symmetry.

Glimpses into this magnificent kingdom form
the basis of all our knowledge and it seems that
in this domain the ancient civilizations had gone
further than modern science.

The 15 first digits on the Egyp-
tian Royal Cubit (it totals 28
digits), from a rubbing full size
made by the author in the
Louvre Museum. Hieroglyphics
of gods show on one face of
the tetrahedral prism of wood
on which the lines are carved

157

In spite of its ability to express human activity readily, such a varied system of measures that uses inch, foot, cubit, rod, etc., could not satisfy the urge of man for rationalization and order, which is his way of showing his faith in the principle of unity. His belief in a unique principle of creation led him to refer all measures to a single basic unit, to which all other sub-units would be related by simple arithmetic computation. This metaphysical urge was also enforced by the practical and vital importance of having an identical reference basis for measurements of similar products and quantities among all peoples of the world. In their attempt to anchor this all important unit to an invariant quantity outside of any human inaccuracy, the scientists-legislators of the day decided that it would be the 1/40.000.000th part of a meridian of the earth. As they made their decision in Paris, they chose this particular meridian as the meridian of Paris. Although such a dimension cannot be an absolute invariant (the length of any meridian being impossible to calculate exactly due to the essentially *inexact* surface of the earth, in constant transformation through erosion, tides, atmospheric pressure, etc.) it was as near an approximation as possible. A rod-proto-type made of the most inert alloy known —platinum-iridium—was cast and has been kept ever since at constant temperature 60 feet underground after two notches were engraved on it, at the distance of this fraction of meridian from each other, *with an approximation equal to the width of the engraving tool.* It was called the *meter.*

If we consider the quantity of operations involved, and the necessity of checking an already debatable *exact* dimension with *inexact* tools, we can only realize the fallacy for man to try to create anything *of mathematical exactitude,* and the childishness of pretending to achieve mathematical accuracy (meaning a coefficient

of error equal to zero) in any of his work. To the mathematician, anything with a coefficient of error of any kind is not even to be considered —except in the calculus of probability, where errors are averaged into laws. He deals only with exact figures and numbers. Anything other than exact is non-mathematical. For the physicist, the engineer, the architect, and man in general as a builder, approximation is the daily bread: if it is true that his constant preoccupation is, of course, to reduce the error to a minimum, he has learned to live with it, and considers it as negligible when it shows up after the third decimal place.

With this in mind, we can grasp the meaning of this most extraordinary fact: the Egyptians who built the great Pyramid for the Pharaoh Cheops, 4500 years ago, used a unit *equal to the present-day meter,* this being exact to the third decimal place, which makes the coincidence of the two integers absolutely fantastic. They used it as a hidden—or esoteric—unit, integrated in their common system of measures. It was not directly expressed, but omnipresent, as the integer *one.*

We have to use the term *coincidence,* as we have no way to explain that the royal cubit of the Egyptians[1] is equal to the twelfth part of the circumference of a circle of which the radius is exactly equal to *one meter* (by *exactly,* again, we mean exact to the fourth decimal place).

We have another puzzling coincidence in the world of measures with the Japanese *shaku* already quoted before, which is equal to our *foot* with an error of 6/1000 (0,994) but still very coarse in comparison with the Egyptian coincidence, the error being only 5/100000 (0,00005). It seems that, in antiquity, higher mathematics were considered as the privilege of some few initiated men, and were

[1] The Egyptians distinguished between the *royal cubit,* used only for measuring things pertaining to pharaoh, as it seems, and the *little cubit,* common unit for everyone else. The value of the royal cubit, as we shall see further, was almost 1/5th longer than the other. Pharaoh and princes of royal blood always were pictured as larger figures than the surrounding people. This custom prevailed throughout the Orient.

not disclosed to the general public. When Euclid discovered that the diagonal of the square is incommensurable with its side, it was called "unutterable" (*alogon*) by the Pythagoreans and the members of their order were sworn not to divulge the existence of the *alogon* to outsiders. As quoted in *Proclos*—a Greek philosopher of the fifth century—

> "it is told that those who first brought out the irrationals from concealment into the open perished in shipwreck, to a man, for the unuttterable and the formless must need be concealed. And those who uncovered and touched this image of life were instantly destroyed and shall remain forever exposed to the play of the eternal waves."

The Egyptians have left us a papyrus written by a scribe named Ahmes during the 17th century B.C. It is called the Rhind Mathematical Papyrus. In it many problems of practical value for the farmer in everyday life are treated as examples. It seems more like a modern manual of elementary arithmetic "ad usum populi" than the total knowledge of Egyptian higher mathematics that many eminent scholars have seen in it. It seems quite believable that the Egyptians, following the accepted custom in dealing with science in antiquity, kept their more important findings secret, and only gave the people some practical and even crude ways of measuring and reckoning to help them solve problems they met in everyday living. The fact that Ahmes gives for the value of pi such a crude approximation as 3,1605—while it is certain that the mathematicians of his time had already found a very simple construction to figure pi *geometrically* with a value exact down to the fourth decimal place (3,1416) seems in favor of this opinion. The crude value of pi given in the Ahmes Papyrus seems rather to be a sort of decoy to lure the people away from the great secrets of science.

We thus find two systems of measure, side by side. One is based on a single esoteric unit *one,* this system opening the way to the most exact geometric construction of pi ever devised to my knowledge. The other system is directly derived from human proportion, its purpose being to give the people a body of simple units *ad hoc* for every field of their activity, each one in turn divided fractionally into smaller units for commodity.

The first system is *decimal,* while the second is generally *duodecimal.* The reason for a duodecimal system is that the integer 12 has 2, 3, 4, and 6, for divisors and gives a very convenient series of sizable sub-units as *round numbers,* while the decimal system has only 2 and 5 for divisors, which makes the division by 3 or 4 irrational or loaded with decimals. A jump from 2 to 5 for subdividing a unit is too great to be practical, while the unbroken progression of the first four integers as natural dividers of 12 gives the duodecimal system its extreme suppleness and convenience in all the simple operations of everyday living. It has been pointed out that due to this quicker way of mental computing and multiplicity of coins, the railroad ticket windows in England are never as crowded as they are in countries that plough under the decimal system of change.

It is remarkable that even the most die-hard partisans of the decimal system cannot do without the duodecimal division of their year into months and their day into hours.

The Egyptians integrated both systems of measure in the pyramid of Cheops, their most significative monument, like a geometrical figure. The heart of the monument, the *Royal Chamber,* has for length $5/3 \pi$ meters, or 10 royal cubits. On the other hand, if we consider the half-meridian section of the Pyramid, the triangle thus obtained, called *triangle of Price* (after the name of his discoverer) is the only right triangle having its sides in geometrical progression, the elements being 1 and $\sqrt{\phi}$ for the right sides, and ϕ for the hypotenuse (ϕ being symbol for the golden mean, or $\dfrac{\sqrt{5}+1}{2}$).

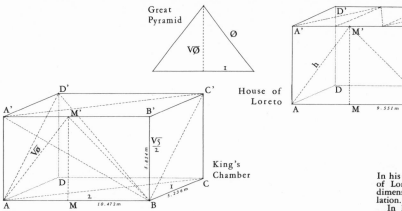

The exactitude of the orientation and proportions of the Great Pyramid of Gizeh is a source of wonder. To mention only the most important among the many branches of the system of proportion which rule its design, we show in these two drawings:
1. The section of the monument, defining the triangle of Price.
2. An isometric model of the King's Chamber, in which all ratios stem from the golden mean

In his research on the proportions of the House of Loreto, the author discovered that all the dimensions of the solid were in harmonic relation.

In his research he used the dimensions as quoted by Hutchinson in his book on the House of Loreto, after the architect Ferri, commissioned by Pope Clement VII to take exact measurements of the House. Other sources consulted are from Mgr. Bartolini, Gianizzi, Serragli, and Caillau.

The plan is made of *six triangles of Price*, the section of *one harmonic rectangle*, and the interior elevation of the long wall is made of *one square plus one harmonic rectangle*.

Even though this may be purely coincidental evidence, this seems hardly probable as *all three dimensions* are exactly harmonic and derive from the golden mean

If we build a right triangle with the *little cubit* as one side of the right angle, and the *royal cubit* as the hypotenuse, we obtain the most important triangle in design, used not only by the Egyptians, but by all antique civilization, the Greek, and the Master Builders of the cathedrals; in the following, the symbols C, c, ø, and m are thus defined:

C. *The Royal Cubit* 0,5236 m
 ratio between the volume of the cube and the inscribed sphere, its diameter being equal to the sides of the cube. It is also the ratio between the length of a 30 degree arc of the circumference of a circle having *one meter* as radius.

c. *The Little Cubit* 0,4236 m
 it is the length of the fore-arm from elbow to the tip of the middle finger. It was fixed by the Egyptians as equal to C minus 1/10th of unit *one*.

φ. *The Golden Section* 1,618. . .
 is the ratio between the diagonal and the side of the regular pentagon.

m. *The Unit One* 1
 is equal to our present day meter (with an approximation of 0,00005 or an error of 50 microns) and considered as the number *one*, or secret unit of all creation.

If we consider also that the smaller side of this right triangle is the average length of the *foot* as adopted among various people on earth, it will sum up the extraordinary importance of this figure throughout all great architecture, whether archetypes or master buildings. It is the *Harmonic Triangle*. Its hypotenuse equals C and its long side c. Its angles are respectively 36 and 54 degrees. Geometrically, it is the right triangle built with the radius and apothem of the regular pentagon. It was the drafting tool of the master builders of the Middle Ages, *their* triangle, replaced today by the less subtle figure built with 30 and 60 degree angles that came into general use with the 45 degree triangle because of the simple proportion (½) of its sides. By abandoning the use of the harmonic triangle, much of the good proportion in design was lost. We will come back to this later on when we mention the other harmonic figures in proportion. At this point, we can say that the 30 degree triangle used nowadays in all design offices the world over does not derive from the pentagon, figure of life, but from the hexagon, a crystalline and static figure that is also much in favor today in spite of its inherent sterility.

This reduction of the harmonic triangle, designed by the author, has for hypotenuse the royal cubit, and the little cubit for its larger right angle side. The smaller side, slightly larger than the English foot, is slightly smaller than the *pied de roy:* it represents an average value for the foot.

On the smaller side are designed the series of irrational rectangles, derived from the *square one,* while on the longer side are designed the series of rectangles derived from the *square one* and the *golden mean.* The diagonal of both series will allow the designer to evaluate immediately the proportion of any drawn figure by laying this triangle over it.

The smaller construction in the 36° angle shows the design of the harmonic pentagon with $\dfrac{C}{10}$ as diagonal and $\dfrac{1}{\phi}$ as its side.

A remarkable fact, discovered by the author, is that the distances of the major planets, can all be expressed in simple golden mean ratios, if we call *One* the distance of the Earth to the Sun.

This is not a geocentric statement, as it would be just as valid if we consider as unit any distance of the planets to the sun: it happens to be more convenient for this drawing evidence.

The author suggests that this amazing "coincidence" may bring a clue to the original formation of the solar system, by the "jelling" of original spiral nuclei into elliptic orbits. This would suppose the initial solar system to be originally in the form of a logarithmic spiral in golden mean ratio. Further research is being conducted by the author on this subject

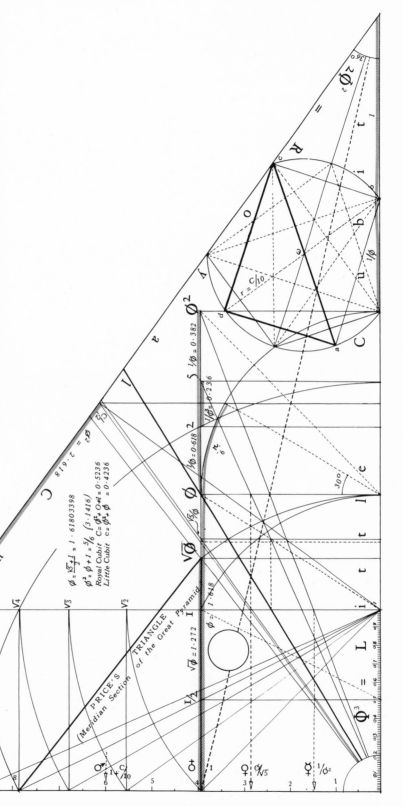

When studying the relation of the Egyptian cubit with the meter, we are struck by the fact that their common denominator is the factor π. They are related to one another as the cube is to the sphere ($\frac{\pi}{6}$ being the ratio between the cube and the inscribed sphere). The problem of squaring the circle has always intrigued the mathematician, until it was proven to be mathematically impossible, leaving it to the philosopher to dwell upon this very impossibility as a most intriguing fact. The fact that the *exact* circle does not exist in nature anywhere may also have conferred to its representation and the number π itself some kind of esoteric properties that may explain the choice of the nearest divisor of π to the length of the fore-arm or cubit. The fact that the Egyptians decided to have *two* cubits, the larger one—so much longer than the average man's fore-arm—being reserved for kings and gods, shows the unique importance of the number represented by the royal cubit.

But this still does not explain the choice of an exact replica of the meter (with an error of 50 microns) as their unit *one,* used in Egyptian architecture as well as in Greek temples. Some Egyptologists may deny that there should be anything else but a coincidence in the use of our present-day meter by a people who lived over three millenia before our time, but at the same time, they cannot help remark the uncanny fact that measures made on monuments surveyed and excavated in Egypt come repeatedly in even figures when measured with the help of a meter scale. The fact that the pyramid of Cheops is exactly situated on the 30th degree of latitude north (⅓ distance from Equator to Pole) may lead to a solution.

To understand the reason for such a choice and the splendid consistency of the Egyptian system of units, we must compare the golden mean ϕ to the number π. We will thus make evident the remarkable coincidence between ϕ —a rapport that is at the root of all creation and from which derive all living forms—and the number π, one of, if not the most important number in mathematics.

WHAT IS ϕ ?

Before analyzing the nature of ϕ, let us state the fact that the pentagon is never found in any crystalline form (from which *life* is absent), while it is found everywhere in living organisms. The hexagon is found in living and crystalline forms alike, as we find lower forms of life whose symmetry is hexagonal—as in a few species of starfish and other elementary sea creatures—but it is only associated with very elementary organisms.

ϕ is the ratio between the diagonal and the side of the regular pentagon. With this geometrical definition, we can construct ϕ very simply as shown on the figure.

We can also define it as the positive root of the equation

$$\phi^2 - \phi - 1 = 0$$

which shows a remarkable property of ϕ, as it permits us to express all powers of ϕ in a linear function of ϕ:

$$\phi^2 = \phi + 1, \quad \phi^3 = 2\phi + 1, \quad \phi^4 = 3\phi + 2, \text{ etc.,}$$

thus combining arithmetic and geometric progression in a series in which each term equals the sum of the two preceding ones.

But the main reason for its fame might very well be found in the approximation:

$$\pi \doteq \frac{6}{5} \phi^2 \quad \begin{cases} \phi^2 = 2{,}618035 \\ \dfrac{5\pi}{6} = 2{,}617993878 \end{cases}$$

which is true to the fourth decimal place, and gives for π a very simple value exact to 0.00005th, or with an error of 2″6/10th to one mile.

This fact would be sufficient to explain the importance of ϕ throughout antiquity and the middle ages, although the secret of this construction was never given openly, as far as I know, and was probably carried from generation to generation of scholars and master builders as a trade secret. This value of π is of sufficient exactitude in all problems of practical geometry met by the builder, the architect and the engineer.

ϕ is also the key to a simple construction of $\sqrt[3]{2}$ and thus brings a practical solution to the second of the famous three problems considered as impossible to solve with straight edge and compass alone by the mathematicians of antiquity, and proven since to be impossible by modern mathematics: 1/ the quadrature of the circle (or construction of π), 2/ the duplication of the cube (Fermat's Last Theorem), and 3/ the trisection of the angle.

I have figured three simple geometrical constructions that give the value of $\sqrt[3]{2}$ (duplication of the cube) with the following approximations:

1/ o, 00055
2/ o, 00049
3/ o, 00035

Let it be understood in this that what I am bringing here is only *a very close approximation* to a geometric solution which is well proven to be impossible. My point is that such an approximation is close enough to be considered sufficient in all *practical* cases, as the error is of a smaller order than the normal coefficient of error due to the inaccurracy of tools.

More details about the properties of the ϕ series and its arithmetic cousin, the Fibonacci Series

1,1,2,3,5,8,13,21,34,55,89,144, etc.

(in which each element is the sum of the two preceding ones) that tend to ϕ as a limit, will be found in the few books on the subject by Hambidge, Matila Ghyka and Funk-Hellet, that can be consulted with great profit by the student for his own research. He will realize the value of harmonic geometry in helping him out in the field of proportion.

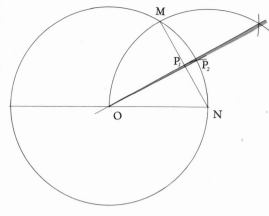

Approximate construction of a 1° angle: with ON as radius, construct an arc of circle having N for center which cuts the circle O in M. P_1 being the middle point of the cord MN, and with NP_1 for radius, intersect in P_2 the circle O. The angle formed by OP_1 with OP_2 is a fairly close approximation to one degree

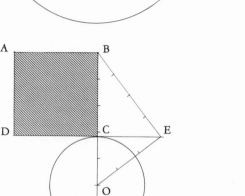

Approximate construction of a square equivalent to a given circle:

Construct first the Pythagorean triangle with the larger angle in O and the opposite side tangent to the circle in C (its sides are related as the numbers 3, 4, and 5); build a similar triangle OEB. The square built on BC is equivalent to the circle O with a fairly close approximation.

(We know that it has been proven impossible to construct a square *exactly* equivalent to a circle)

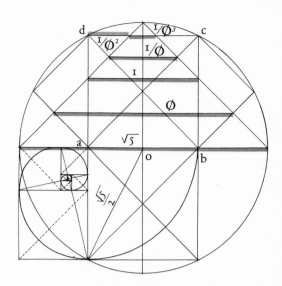

Construction within a given circle of harmonic segments of the golden mean.

Construction of the logarithmic spiral in golden mean ratio

A remarkable approximation of π can be constructed simply by using golden mean proportioning (the approximation is to the fourth decimal place: about 2,5 inches on a one mile distance). This construction is proposed by the author. Given a circle of radius OB = 1, construct the circle with DB = 3 for radius. From a point C with CB = 5 raise the perpendicular to CB which intersects this second circle in M. We know that CM = $\sqrt{5}$; MB cuts in N the perpendicular to CB in D.

We then extend CB to EB = 9 from H (such as HB = 4). Construct the circle with CH = 1 for radius which cuts in F the perpendicular HF to CB. The line EF intersects in G the perpendicular to CB from B. We have thus constructed two segments which add up to

$$\frac{3(\sqrt{5}+3)}{5} \text{ or } \frac{6}{5}\phi^2.$$

We obtain in X_1X_2 the construction of $\frac{6}{5}\phi^2$, which is equal to 3, 1416

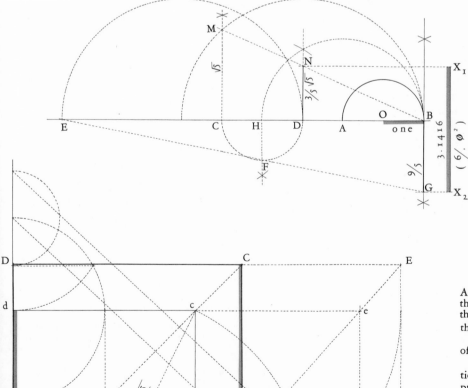

Another remarkable approximation of the second of the "unsolvable" problems, the duplication of the cube. It comes to the construction of $\sqrt[3]{2}$.

The construction shown here is one of three proposed by the author.

Here again, this simple graphic solution gives the value of $\sqrt[3]{2}$ with an approximation of the order of the 4th decimal place, therefore of sufficient precision for designers, engineers, builders, etc. Knowing that

$$\sqrt[3]{2} \doteq \left(\frac{\phi^3}{2}-1\right):\left(\frac{7\phi}{6}-1\right)$$

(with an error of 0,00049 by excess), the problem consists in constructing $\frac{\phi^3}{2}$, which is equal to $\frac{\sqrt{5}}{2}+1$. The construction is self-explanatory

This excursion into mathematics may seem far from our main concern, proportion in design. But it may help us understand better why the key figures in design are not the series of rectangles built on proportions involving straight integers (arithmetic progression of the *static* proportion) but the series of rectangles and figures built with irrational functions of straight integers (geometric progression of the *dynamic* proportion). This gives us a clue to the evident decadence in proportion that followed the adoption of the metric system or of any decimal system of proportion.

Another property relates any one of them directly to the other, as they all are derived from the square by the simplest geometrical construction. Thus they all belong to one single family and, when used in the same composition, can associate with each other harmoniously, like people of the same family who speak the same language. On the contrary, if we place next to each other two rectangles of the static series, whatever their difference in size, they won't harmonize together, as they speak a different language: a design in which such rectangles are associated will be heterogenous, and lack unity. This property of the series of irrational rectangles is extremely precious to the designer in modular composition, prefabrication, etc. We must remember that the $\sqrt{4}$ or 2 rectangle, the fourth of the series, has $\sqrt{5}$ for diagonal, and is the Japanese modular unit, or tatami, from which all proportion in Japanese architecture derives.

This series of irrational rectangles is also called the *Euclidean series*. The most important is the one built on the golden section, directly related to $\sqrt{5}$. It seems to satisfy our sense of proportion better than any other. One of the reasons may be because it is the proportion of the rectangle circumscribed to the ellipse of human vision. Once you have drawn such a rectangle and compare others to it, you will find it uncanny how any longer sided one will seem *too long,* and any shorter sided one will seem *too short.*

Another rectangle widely used, mostly for its property of having for gnomon its identical replica (its bisection being identical to its duplication) is the rectangle built on the diagonal of the square, the "alogon" $\sqrt{2}$. It has become the standard proportion of most windows of the villages and towns in Europe throughout the last centuries, as well as the window pane of standard proportion. Its property of keeping the same proportion if bisected, has been used in the design of commercial papers, library and office cards, as a means of standardization of formats (it is the so-called German format). It is used in the design of office furniture and file cabinets, as it makes it possible to divide in half any drawer without any waste of space, to file two successive dimensions of papers. In modular prefabrication its use in design may bring considerable economy, by avoiding any waste of material by cutting.

The sheet sizes for printing paper are cut into harmonic proportions: the larger sheet format, for instance, *Imperial,* is in proportion with the harmonic rectangle, and the typewriting paper (8½x11″) format—the same format as the sheet size on which this book is printed—is the rectangle of Price (ϕ, $\sqrt{\phi}$, 1).

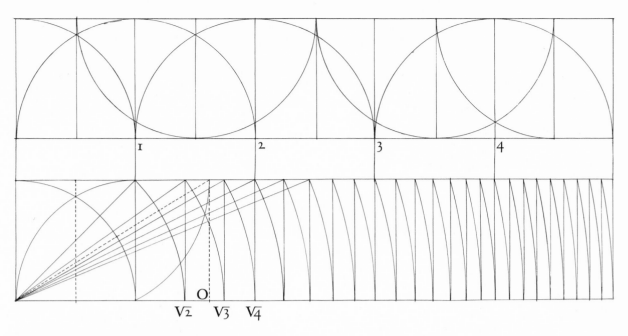

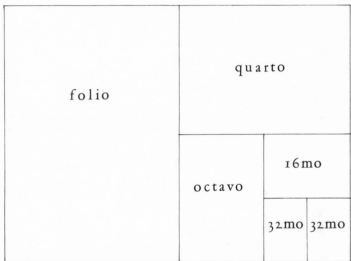

The two upper drawings show the arithmetic proportion as against the Euclidean or irrational proportion

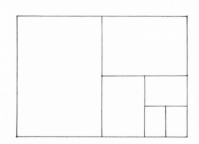

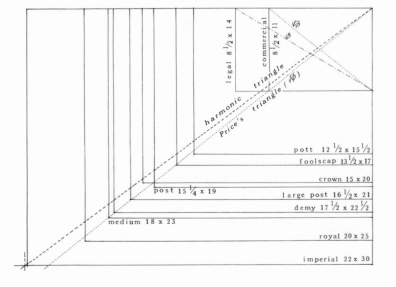

The figure above shows the bisection of the $\sqrt{2}$ rectangle into homothetically similar half-rectangles (German format)

The upper right figure shows the bisection of one of the traditional formats (imperial) into folio, octavo, quarto, etc., to fit the folding of a printed sheet.

The lower right figure shows, at the same scale, some of the most commonly used formats together with the harmonic and Price triangles. We may wonder at the close identity of these formats with golden mean proportion.

It is even more remarkable that both of the most used formats today (Commercial and Legal sizes) are very close approximations of the golden mean (legal) and the square root of the golden mean, the triangle of Price or also the half section of the Great Pyramid (Commercial)

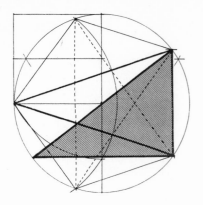

Harmonic triangle (grey area): hypotenuse and long side of right angle related like royal and little cubits. The hypotenuse is also the diameter of the circle circumscribed to a pentagon having for its side the smaller side of the right angle. Angles equal to 36 and 54 degrees

Pentalpha triangle (solid lines) a part of the magic five pointed star figure, or pentalpha. An isosceles triangle, its apex angle also measures 36 degrees

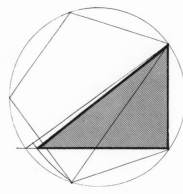

Price triangle ($\sqrt{\phi}$) The only right angle triangle of which the sides are in geometric progression (tg = cos), it is the meridian section of the Great Pyramid:

hypotenuse = ϕ
long side = $\sqrt{\phi}$
small side = 1

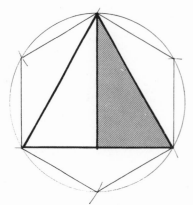

Timaeus triangle ($\sqrt{3}$) quoted in Plato as the most beautiful triangle. It is the half of the equilateral triangle. Angles: 30 and 60 degrees

hypotenuse = 2
long side = $\sqrt{3}$
small side = 1

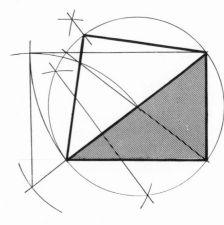

Pythagorean triangle (3-4-5) Shown in grey, it is also called the sacred triangle, and is the only right angle triangle having all its sides in even proportion. This property makes it very valuable —even today— when surveying without a transit: a simple rope where knots have been marked at distances of 3, 7, and 12 feet, serves the purpose.

The *45 degree triangle* ($\sqrt{2}$) is shown in solid lines

The canvas frame sizes used by painters also belong to the harmonic series: the "portrait" canvas is in proportion $1 \times \sqrt{\phi}$, etc. We mentioned before other figures like the *Harmonic Triangle,* of which the hypotenuse is equal to the sum of the three first terms of the ϕ progression $(1, \phi, \phi^2)$ while the longer right side is equal to the sum of the second and third term (ϕ, ϕ^2). We have seen that these two dimensions are the royal cubit and the little cubit of the Egyptians.

Another precious triangle we also mentioned is the *Triangle of Price,* the only right triangle of which the sides are in *geometric* progression $(1. \sqrt{\phi}, \phi)$. It is the half-meridian section of the Great Pyramid. It was also widely used during the gothic period. A third triangle, known as the *Sublime Triangle* or triangle of the *Pentalpha,* is the isoceles triangle obtained by joining a vertex of the regular pentagon to the opposite side. Its angles are respectively 36 and 72 degrees. Its sides are in ϕ ratio, and the angle at the base is equal to twice the smaller vertex angle.

We can also mention the only right triangle having its sides in *arithmetic* progression: the 3,4,5, triangle, or *Triangle of Pythagoras.*

We realize better the amazing consistency of the Egyptian system of associated units, all built around the value of ϕ, as the two-beat rhythm of life, followed in a continuous line by the builders of all the great works ever designed, from the remotest times in the history of mankind, to the dark ages of the 19th century, when the line was suddenly broken and the solutions gathered by centuries of science and art thrown to the dogs by the childish rationization of legislators unfamiliar with the great world around them.

Since the new approach to design started by the cubist movement, a few decades ago, we have been groping into the past to try to put together again a consistent system of proportion that will express itself in modular design. The main answers have been retrieved, but it is left to us now to use them in a complete integration of harmonic proportion and functional design. Only then will we be able to say that what we are designing is art and architecture.

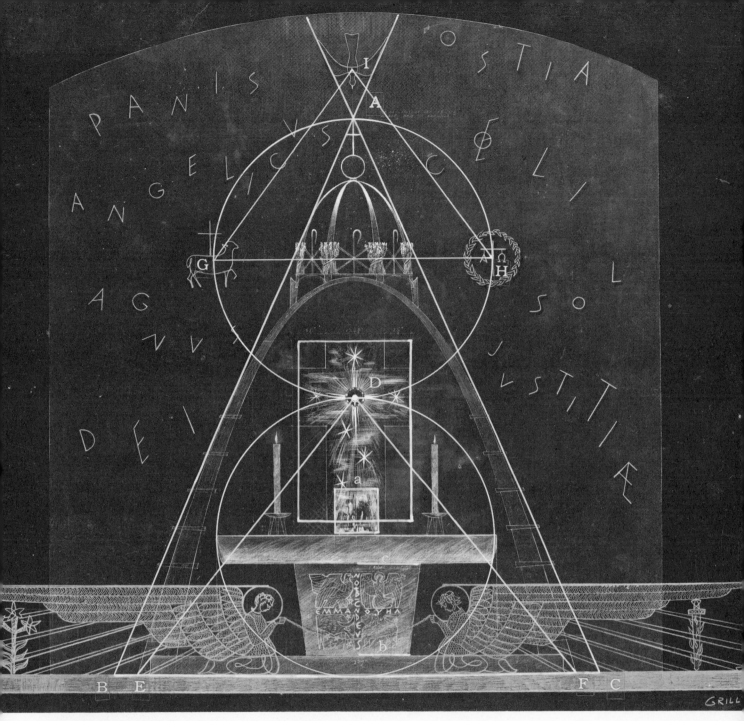

Convent of St. Mary, South Bend
Chapel of perpetual adoration.
as originally designed by Grillo

The harmonic grid aims at establishing an esoteric link
between man and God:

The tabernacle *a* measures one cubit foot, taking the
foot as man's unit. The altar base is a trapezoid, the two
bases *b* and *c* are related in the same way as the royal
cubit is related to the little cubit, or man's cubit. Its di-
mension is exactly two cubits in width.

The three persons of the trinity are placed equilateral-
ly in H (the Father) G (the Son) and I (the Holy
Ghost). GH is also the diameter of one of two superim-
posed circles, the first one being the length of the altar
table (the table is exactly in the proportion of the golden
man) the host in the ciborium is placed at the meeting
point of both circles. The throne is a lucite sheet in the
proportion of the golden mean, carved with the seven
stars of the apocalypse. The ladder of Jacob, which holds
the crown, and the crown itself, considered as a canopy
over the altar, are contained within a pentalpha triangle

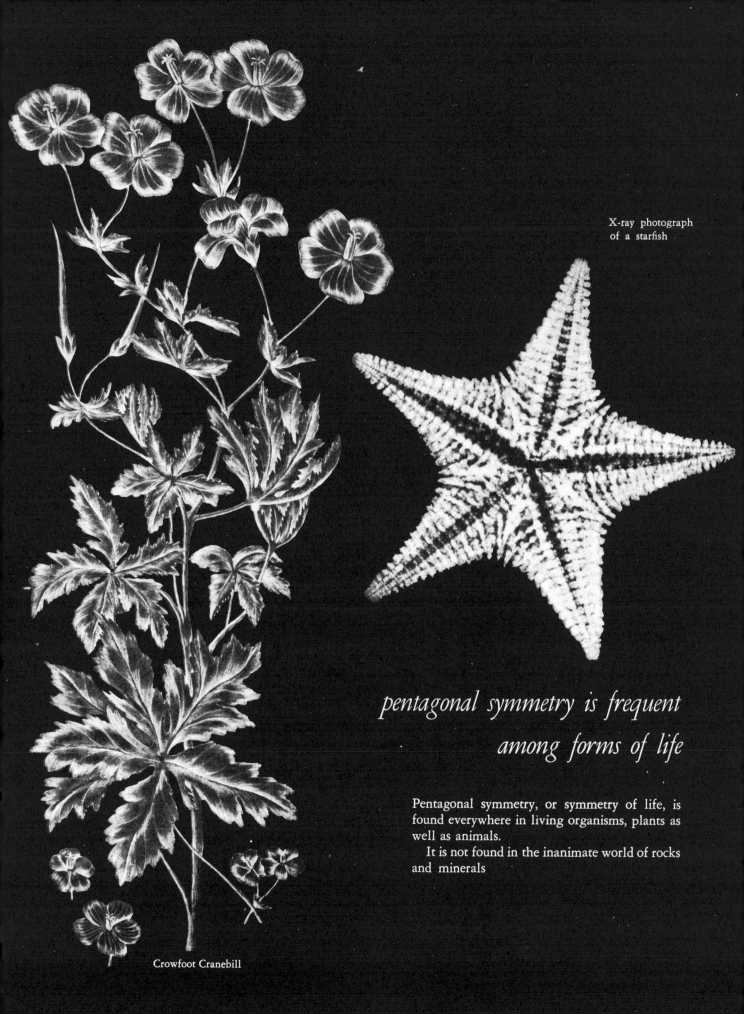

X-ray photograph
of a starfish

pentagonal symmetry is frequent

among forms of life

Pentagonal symmetry, or symmetry of life, is
found everywhere in living organisms, plants as
well as animals.

It is not found in the inanimate world of rocks
and minerals

Crowfoot Cranebill

crystal forms ignore pentagonal symmetry

crystal symmetry is classified in 32 classes, none
of which belong to the pentagonal system

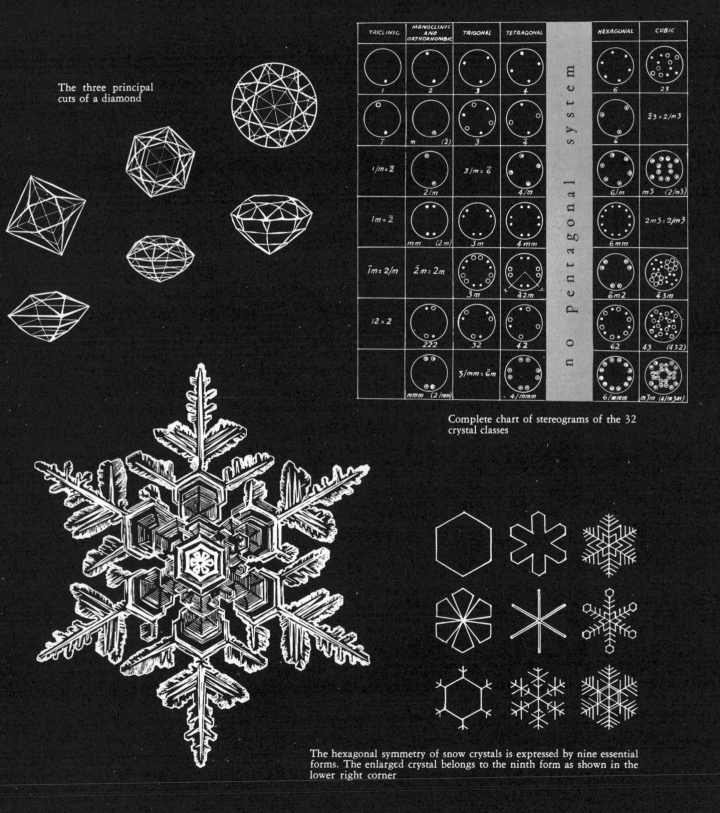

The three principal
cuts of a diamond

Complete chart of stereograms of the 32
crystal classes

The hexagonal symmetry of snow crystals is expressed by nine essential
forms. The enlarged crystal belongs to the ninth form as shown in the
lower right corner

Fragment from the manuscript of
the sonata for piano and violin in
G major, by Beethoven

With reference to the movements and inter-mingling of our family of chords, it is of prime importance to discriminate between the two opposite phases of motion, witnessed everywhere in nature: the normal movement, in obedience to the law of gravity; and the imparted, compulsive, coerced movements. To illustrate: I hold a brick in my hand; if I simply let go of it, it will drop to earth, as sure as fate; but, by applying force, I can make it fly upward or sidewise.

Were it not for the operation of these two forces, we could build no houses: the imparted force lifts the material into its required place; the natural force (gravity) holds it there, giving stability to the structure. It is precisely the same with chords: they may move along the line dictated by nature, or they may be forced (gently, let us hope) to move in any direction the composer desires.

PERCY GOETSCHIUS
The Structure of Music

energy

The equation of energy associates mass and motion. It expresses the two forms in which energy is distributed: *potential*, and *kinetic*. The world around us is made of forces *in equilibrium*—or energy in its potential form—and forces *in motion*, or kinetic energy. Equilibrium and balance of forms, as defined by the platonistic *Summetria*, are characteristics of the design of the *organs* or components of a program and their grouping into a plan, while motion is expressed along the lines of *circulation* that link the organs together.

Is there a definite and characteristic expression in geometry for either form of energy? And if so, can we apply it to design?

Wood relief from
the tomb of Hesire,
Cairo Museum

The two forms of energy are clearly represented by two great families of lines and surfaces. The armature of design is organized along lines of force that belong to both families—lines of equilibrium, and lines of motion. They constitute the skeleton of the composition. We must consider that they do not have to be straight, and in fact are rarely so

Cracking pattern of india ink on glass

THE CRACKING PATTERN IS AN EXPRESSION OF POTENTIAL ENERGY

Potential energy finds its expression in a lattice of lines and surface that meet in an equi-angular pattern. They usually are orthogonal, or meet like the bissectrices of the equilateral triangle, at a 120° angle. They are best illustrated by the net of lines that develop in a mud field as it contracts when drying. The pattern thus created is characteristic of the geometry of potential energy. We shall call this the *cracking pattern*, characteristic of the orthogonal net.

THE EROSION PATTERN OF OSCULATING CURVES OF FLOW IS THE SIGNATURE OF KINETIC ENERGY

Kinetic energy is represented by lines and surfaces of flow which meet at osculating points. The pattern of erosion lines in nature constitutes a typical flow pattern. We shall call this the *erosion pattern,* characteristic of the tangential net of osculating curves.

Drainage pattern in tidal mud flats at low tide near Yarmouth, Nova Scotia

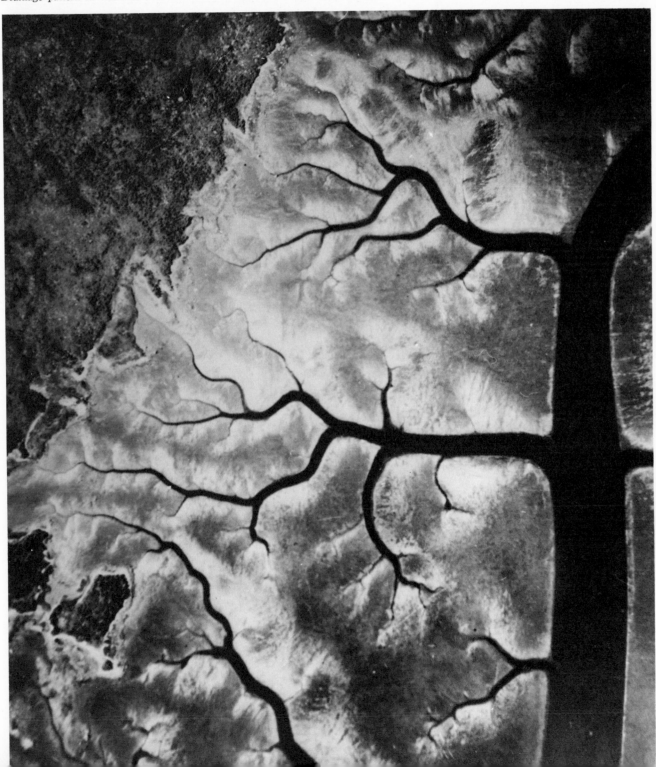

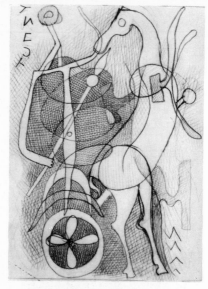

drawing from Braque's sketch book

In the representation of surfaces, the artist intuitively uses orthogonal families of curves. The result is a strongly "constructed" graphic expression, most evident in line sketches, where every line counts as *line of force* of the composition

The lines of force, or lines of maximum curvature in a surface, form an orthogonal net in which each line of one family (solid lines) intersects another from the other family (dotted lines.)

We find this orthogonal net represented in a structure submitted to any force as the two families of lines of stress and strain. Tension is represented by one family of curves, compression by the orthogonal conjugate family. This is put in evidence in the structure of the *trabeculae* of a solid bone—the femur head, for instance—disposed so as to offer the maximum resistance to both tension and compression.

In any design, the artist follows instinctively this orthogonal rule, *the lines of forces of the composition* meeting at right angles. The result is equilibrium, but loaded with high potential energy. This type of equilibrium is very different from the one achieved by the absence of energy: a hunting dog pointing at his game in a tense state of equilibrium represents an accumulation of potential energy ready to be triggered by the slightest move from his quarry. A dead cat also is in a state of total equilibrium, but its limp form on the ground is only the result of the cumulative weight of his members, and the result is as void of energy as a heap of sand.

This concept of potential energy in the state of live equilibrium explains how some forms in design are as "dead" as the cat, while others are as loaded with live energy as a bird ready to

In all the following drawings on these two pages, are shown various orthogonal nets of curves, after examples chosen from geometry or from art —orthogonal net of confocal conics (hyperbolas and ellipses)

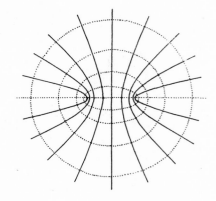

—geodesic curves of an ellipsoid. These orthogonal curves (generalized ellipses) are, in any part of the surface considered, the paths of shortest distance between any two points of the curve considered. This pattern of minimum constitutes the most forcefully expressive graphic representation of a surface: we can visualize its three dimensional form without the help of shades or shadows

Two geodesic nets are pictured in this drawing of an helicoid: one (solid and dotted lines) represents the lines of maximum and minimum slope on the surface—the other (dashed lines) is made of an orthogonal net of lines of equal slopes, or isoclines, which are characteristic of the particular pitch of the helicoid

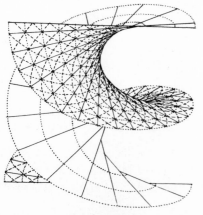

Belgian Congo
Baluba mask

take off and poised on the shore in total equilibrium. This form of potential energy is infinitely more powerful because of its high suggestibility than the already released forms of energy of what we might call the *action art* that flourished in the 1900's, whether in the "decorative" details of Sullivan's architecture or the acrobatic bronze statues of this frozen snapshot type of composition. We have an example of the effectiveness of the contrary with the St. John Preaching, by Rodin, who has both feet on the ground (an impossible attitude for any man walking) but who walks with more powerful dynamism than any of the action figures that *claim to depict action, but only are frozen expression of energy already spent.*

The Egyptians knew this, as their pictures of walking people show them with both feet on the ground.

Sullivan's decorative details show—as all "art nouveau" does—either a doodling type of repetitious elements unrelated in form, scale, and space, or a wild disorganization directly influenced by the new discovery of the frozen forms of camera art.

No photograph of a foaming breaker is ever effective, as the essence of a breaker and its great beauty lies in *movement*. We may be impressed by the technical tour de force of the photographer and marvel at high speed stroboscopic pictures, but *life* cannot be represented by an infinitesimal fraction of time: its very essence is *continuity*. The cracking pattern is the expres-

Sullivan's decorative details—as does all "Art Nouveau"—ignore the minimal pattern of orthogonal curves. It tries to achieve a composition with osculating curves alone, in forms directly influenced by the new discovery of the frozen pictures of camera art. The result is anarchy, just as when cells disorderly outgrow each other in cancerous tissue

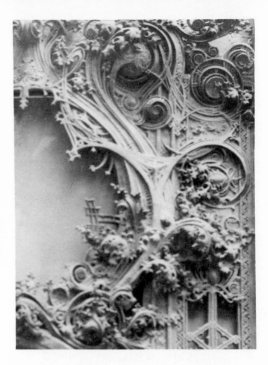

Botticelli, Spring.
15th century (detail)

American Primitive painting,
19th century

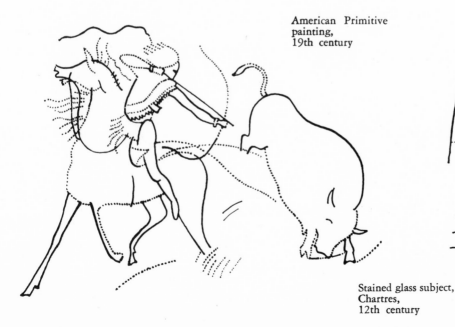

Stained glass subject,
Chartres,
12th century

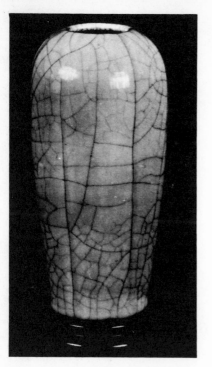

Chinese Vase

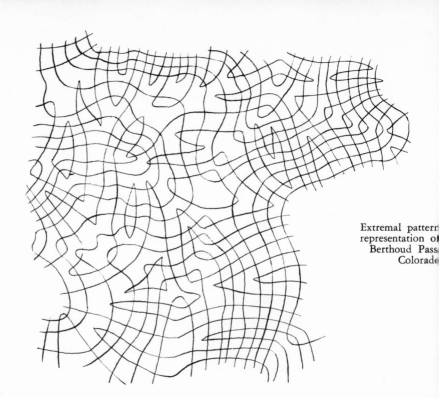

Extremal pattern representation of Berthoud Pass Colorado

The cracking pattern is the expression of total structural stability. We may wonder why a pattern associated with the idea of destruction should serve as a model for stability: but a structure is actually a pattern designed to offer the maximum strength at the weakest points, and the cracking pattern, considered as a pattern of rupture, is the pattern of the weakest points of a material, or of a surface.

Its negative duplicate becomes the pattern of the strongest lines of forces of a structure. We can imagine that if we build a wire structure made exactly as a negative of the cracking pattern on the Chinese vase, we shall have the strongest possible skeleton for its surface. For this reason, the cracking pattern has been widely used, although unconsciously, in all forms of design, from Chinese characters and Egyptian hieroglyphs—to stained glass windows and paintings. In stained glass art, it expresses the necessary design of a reticulated structure for the leads that hold the glass together; Hieroglyphs and Chinese characters, considered as the expression of an idea into the frozen structure of a *word,* also are designed in a cracking pattern. In painting, where the concept of structure is more difficult to define, we also find the attraction of the artist for the cracking pattern not only for his over all composition, but some times used alone as an abstract pattern (Klee, Braque, etc.). Perhaps it is its inherent beauty as a representation of forces in perfect equilibrium that make us admire a cracked enamel pattern and make us deliberately produce such effects on

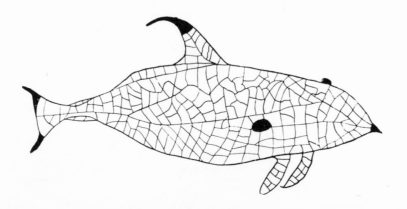

Whale. Engraving. Skogerveien, Buskerud, Norway

Representation
of a surface strictly
by a maximal
pattern

Maximal pattern. Georges Braque

chinaware and sculptural ceramics.

Any surface may be graphically represented by a pattern of equidistant geodesic lines, or by any orthogonal lattice, without the usual help of shades and shadows. Artists intuitively use this mode of expression, mostly in the art of linear drawing or etching, where half-tones are forbidden.

We may call the lattice thus formed with two families of lines of maximum curvature (or two families of isoclines) a *maximal pattern*. The lattice obtained by representing a geodesic surface with its contour lines and its lines of maximum slopes may in turn be called an *extremal pattern*. This pattern is widely used in maps as the most effective representation of relief.

A "doodle" is only
a chaotic mesh of lines
which has nothing to do
with art

Maximal pattern. Enlarged
reproduction of an engraving
from Jacques Gallot's
Misères et Malheurs
de la Guerre

Woolly-haired
rhinoceros.
Painting in red.
Font-de-Gaume,
Dordogne

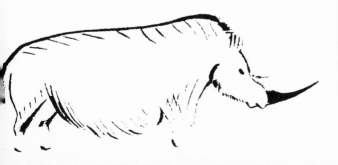

Slalom is a Norwegian word used to describe the curves traced on the snow by a skier: as these curves are typical of curves of human motion, we have used the name to apply in general to all curves of human motion

IN DESIGN, THE SHORTEST DISTANCE BETWEEN TWO POINTS IS NOT THE STRAIGHT LINE, BUT THE SLALOM

Slaloms are curves of natural acceleration and deceleration that represent trajectories *constantly controlled by man.*

A ballistic missile obeying only initial thrust and gravity will describe an orbit mathematically perfect of the conic section family. But as soon as man sits at the controls, he will make his own orbit, his *slalom.*

Curves described by a man in movement—a car, a bicycle—on a flat surface, are two dimension slaloms, or curves of the second order that may be approximately analyzed in quadratic equations.

A mountain climber, an airplane, a submarine—as well as a skier—describe third order slaloms that may be analyzed in cubic equations.

The interest of slalom curves for the designer lies in the fact that they are all *curves of least effort,* and thus represent the most *economical* pattern of flow.

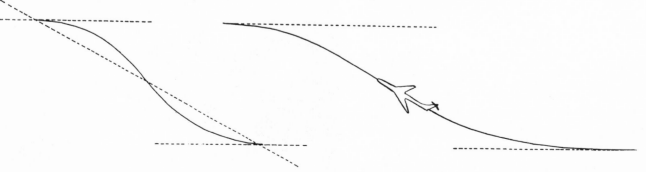

180

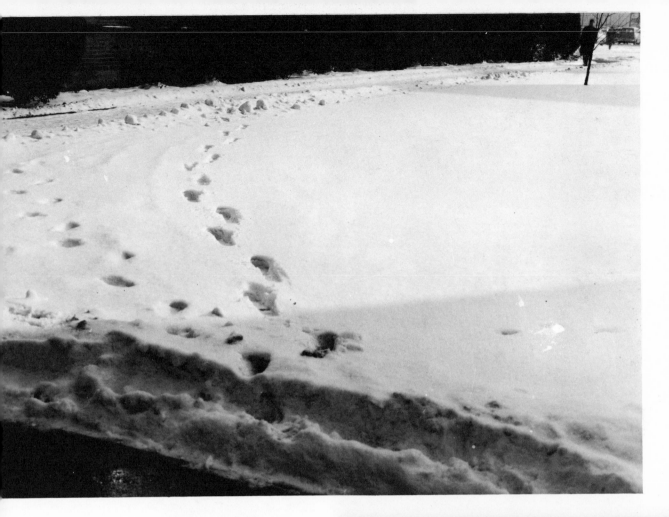

Path freely designed by foot erosion after the snow has covered the concrete walk. The ground is perfectly flat

One day, a student, late for his class, decided to cut short the two right-angle lanes. His steps trace a slalom. Another student followed, and as he was even more in a hurry, his slalom is shorter and more curved.

After the snow settled and covered the lanes everywhere, the rectilinear lanes were forgotten in favor of the elegant and soft curves that replaced them, like the natural slalom curves traced by skiers through the "gates".

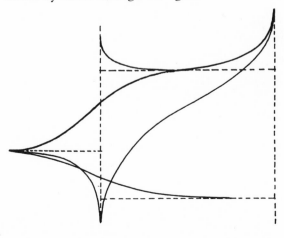

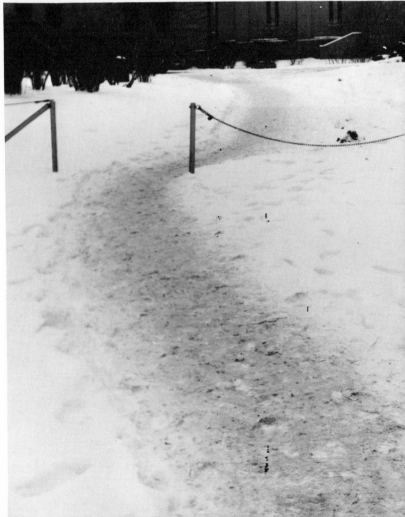

Winter

University of Notre Dame Campus

Summer

These two pictures, taken a few months apart, show a slalom traced in perfectly free way, and —after the snow had melted—the engineered path, designed with a transit, and straight. It would be good practice for designers to let the lanes be made naturally for at least a year before deciding on the final design, which should be directly inspired by the signatures of man's motions across the landscape. The result would be of simple and natural beauty: it would eliminate fences and mangy corners.

182

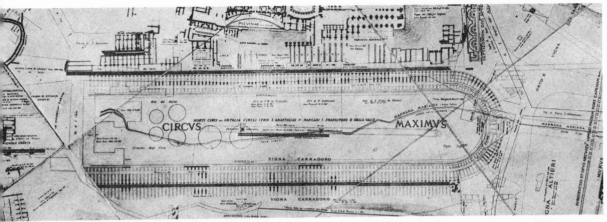

Circus Maximus in Rome, after Rodolfo Lanciani

EROSION OF MOVEMENT

Even though the Roman concept of design was clad in the armour of the axial duplication formula, it never was as bad as when seen through the inaccurate restorations by XIXth century architects, as the Circus Maximus in Rodolfo Lanciani's *Forma Urbis*—or in earlier works like Piranesi's. Until Paul Bigot made his own research, the plan of Circus Maximus, was believed—as shown in Lanciani's plan—to be in the shape of a regular hairpin. Nevertheless, some odd details, like the inclination of the spina in the arena and a strange bend in the foundations of the tribunes, seemed to defy the rigid law of roman symmetry.

Paul Bigot finally showed that these oddities were in reality the expression of carefully balanced planning. A perfect duplication of the width of the arena on either side of the spina would have necessitated a much wider plan, as it would have had to fit the maximum possible width, corresponding to the span of all the chariots placed abreast, in the starting position.

The plan was designed in the shape of a funnel (or rather of the sole of a shoe), as, obviously, less space was needed after the start, when the chariots began to outdistance one another in the seven-round race around the spina. This also explains the angle the stables (or carceres) make with the long sides of the Circus.

The Circus Maximus was all planned for movement, and pre-eroded to fit the movement involved in the circus races.

Circus Maximus in Rome, after Paul Bigot

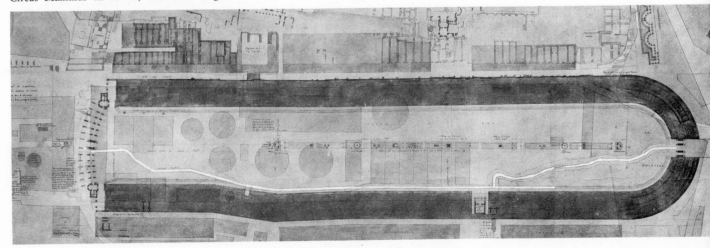

Searles spiral is considered the most useful and practical of transition curves for highway design. It is a true spiral which can be used for every possible spiral highway problem, as any spiral may be obtained by simply reducing or enlarging the master figure. The characteristics concerning the constant change of curvature remain exactly the same through this procedure. This is the most important factor to consider, as from it depend the smooth change of pace of a vehicle and a constant—as well as minimum—centrifugal effect

Clover leaf curves
realized with Searles spirals

Parabolic raccording of two lines forming a wide angle with each other. This method may be used in highway design only when the angle is more than 140 degrees and on long distance stretches

Curves may be mathematically computed as far as they are to represent the "free fall" or, more generally speaking, the free *motion* of an innert body abandoned in vacuum. But as soon as man as a pedestrian, or a driver, or a pilot, is at the controls, the trajectory responds to his intentions, and becomes the resultant of a series of decisions that follow one another like links of a chain with the whim and beauty of human motion.

That is why no mechanism, no equation may ever duplicate this chain of thoughts that write their signature in the wake of man in motion. The best instrument to reach their domain will always be the human hand, with its extraordinary fluid system of articulations that start at the finger's last knuckle and end at the shoulder. Only the human hand can duplicate other human motions, because it responds to man's will and intuition.

This fact is beginning to be applied in airplane design, where artists are being hired to design curves of smooth acceleration and erosion, to help find the most *organic* profile for a wing, or a fuselage.

The various spirals were already a great progress, in smoothness of curvature variation, on the arcs of circle used in the past. Among these, Searles spiral is accepted as the best.

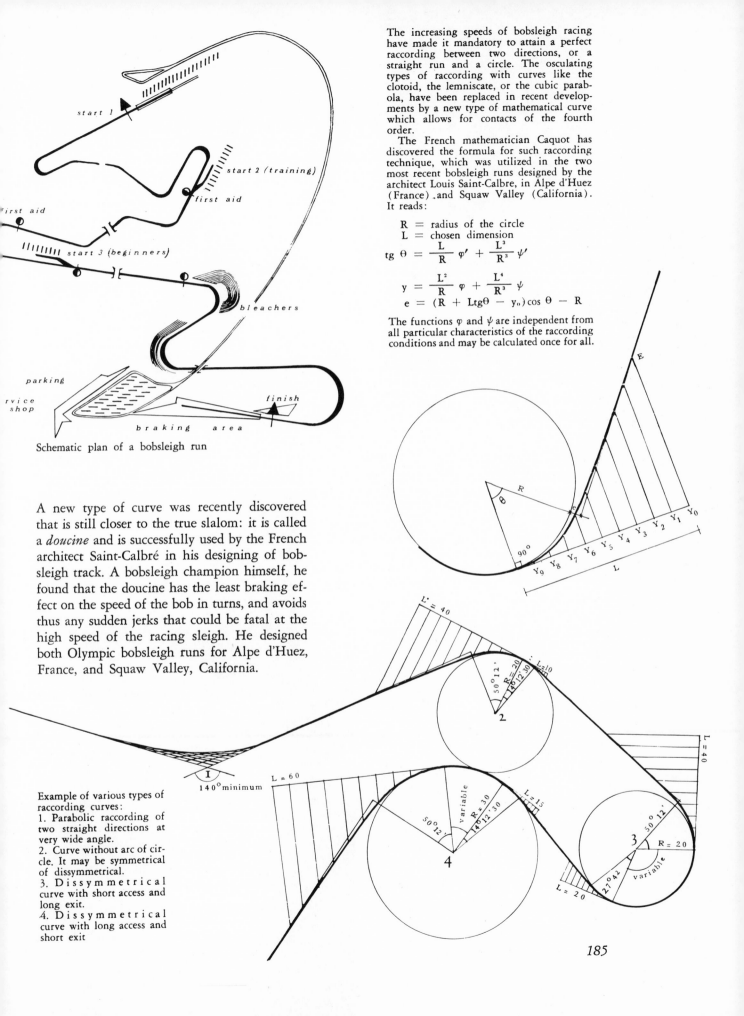

The increasing speeds of bobsleigh racing have made it mandatory to attain a perfect raccording between two directions, or a straight run and a circle. The osculating types of raccording with curves like the clotoid, the lemniscate, or the cubic parabola, have been replaced in recent developments by a new type of mathematical curve which allows for contacts of the fourth order.

The French mathematician Caquot has discovered the formula for such raccording technique, which was utilized in the two most recent bobsleigh runs designed by the architect Louis Saint-Calbre, in Alpe d'Huez (France) .and Squaw Valley (California). It reads:

R = radius of the circle
L = chosen dimension

$$\operatorname{tg} \theta = \frac{L}{R} \varphi' + \frac{L^3}{R^3} \psi'$$

$$y = \frac{L^2}{R} \varphi + \frac{L^4}{R^3} \psi$$

$$e = (R + L \operatorname{tg}\theta - y_0) \cos \theta - R$$

The functions φ and ψ are independent from all particular characteristics of the raccording conditions and may be calculated once for all.

Schematic plan of a bobsleigh run

A new type of curve was recently discovered that is still closer to the true slalom: it is called a *doucine* and is successfully used by the French architect Saint-Calbré in his designing of bobsleigh track. A bobsleigh champion himself, he found that the doucine has the least braking effect on the speed of the bob in turns, and avoids thus any sudden jerks that could be fatal at the high speed of the racing sleigh. He designed both Olympic bobsleigh runs for Alpe d'Huez, France, and Squaw Valley, California.

Example of various types of raccording curves:
1. Parabolic raccording of two straight directions at very wide angle.
2. Curve without arc of circle. It may be symmetrical of dissymmetrical.
3. Dissymmetrical curve with short access and long exit.
4. Dissymmetrical curve with long access and short exit

185

What we admire as natural beauty is created by the association of the two distinct patterns: *mountain ridges* are organized into the lines of force of a cracking pattern while the *river beds* describe the slalom pattern of least effort in valleys of erosion:

On one hand, the structural equilibrium of forces that fight for survival against the all powerful law of least effort.

On the other hand, the soft and delicate pattern of erosion, that with the help of time will level the landscape into the infinite plain.

This kinship between forms created by man and forms created by nature, both of which we may call *beauty,* may be the intuitive and unexplained reason for the authenticity of a work of art, or its failure. Wind erosion creates a pattern very similar to the mud field pattern. The design made here is also an orthogonal net of lines of forces that express equilibrium between conflicting actions. The constant movement and shifting of sand dunes is due to the necessity of reforming such patterns of equilibrium under the stress of constantly shifting wind directions. The pattern has to remain at all times a pattern of equilibrium.

Sandia Mt. area, Bernalillo quadrangle, Sandoval County, New Mexico

NATURE COMBINES BOTH CRACKING PATTERN AND SLALOM IN OUR LANDSCAPE

Great Sand Dunes National Monument, Alamosa and Saguache counties, Colorado

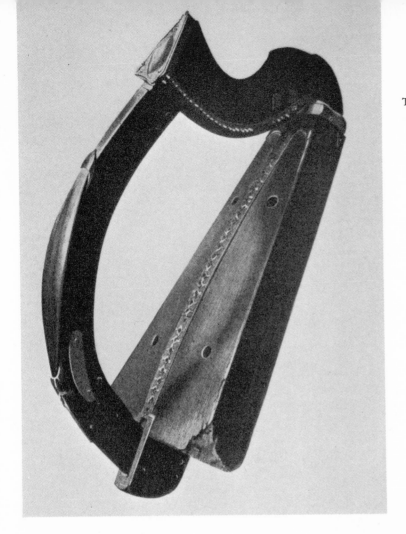

The Lamont Harp

Design is streamlined for speed not only in the case of the rocket, the airplane, or the car. Tools, musical instruments, kitchenware and all other man's artifacts are also pre-eroded design into streamlined curves that fit the particular movement involved: playing the harp, cutting hay or carving steak. The forces put into action always accomplish the same work in modeling the design as do the prevailing wind and water currents on a sandy shore. It is the intuition of the designer to foresee and pre-design the envelope of the particular motion involved in every case.

Apalachicola and Cape St. George quadrangles, Franklin County, Florida

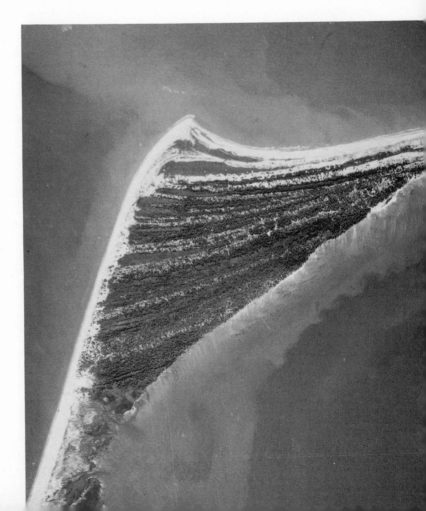

Work is the art of the lonely man.
From love were all the nations born.
But without the humble help of those who know how
To bake bread and make wine
To mend carts and milk cows,
What would become of your world, O Epistemon?

ANONYMOUS GREEK

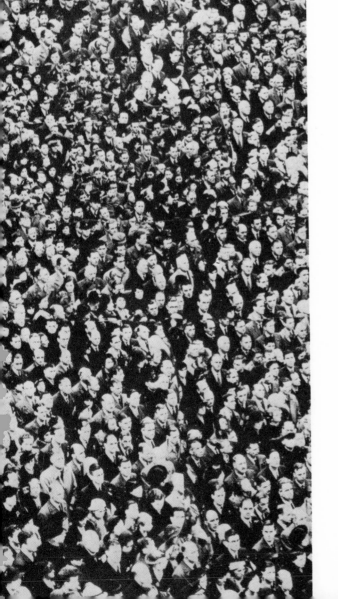

mass

A building is a man-made organism.

As in any living organism, a building is made of various organs, linked together by a circulatory system that carries the blood cells throughout the whole body. Every organ is there to fulfill a definite purpose. Each one is designed to accomplish most efficiently its particular function. We cannot imagine a human organism where the brains would be placed in the chest, or the heart in the head. There is also for every element of an architectural program a certain place that fits its function, in relation with the others. This *position* of every element within the general scheme is thus the most important in any kind of composition, as it is from this relative disposition of the various organs that depends the possibility for the organism to live—or be born dead.

We also know that if the head of a human being is too large in proportion to the rest of his body, this person will be a macrocephalic idiot. If his heart, lungs, or liver are reduced in size by some disease, he will not live long. We al-ready see by this analogy the paramount importance of the *proportion* of one organ in a composition in relation to another. This ever present sense of proportion, analyzed in its elements in the preceding chapter, must always direct the thought of the designer if he wants to launch into the world a composition that has a chance to live. We will see as we go along that it is impossible to dissociate the concept of proportion from any form of composition, and we shall often refer to it as we try to analyze the elements of composition. We don't say "artistic composition", or "creative art", as it would by saying the same thing twice—like talking about "Mount Fuji Yama", as in Japanese *Yama* already means mount. Let us state here once and for all that composition is the very essence of art and that any composition worthy of its name is a true work of art—whether a well composed dinner, or Michelangelo's Last Judgment—and also that all art is *essentially* creative.

THE THREE AREAS

In architecture, the organs are the various *areas* where a certain kind of activity takes place.

We can roughly classify them into three categories, reflecting the principal domains of man's activity in society, that we shall find in every program, small home, palace, church, theater, or city:

1. *Public* relation, where the outside world does its exchanges with art, science, and industry.
2. *Privacy,* that comprises not only the quarters granted for quiet and secluded hours of rest, but also all the quarters devoted to undisturbed activity, in particular all *working* areas.
3. *Service,* a necessary part of (1) and (2), as any activity needs servicing to be kept alive, at both ends of the life line: *receiving* and *delivering,* while *storing* must be considered at all times in all areas.

1. *The Site:* a table
The Time: breakfast
composition—or distribution of space into the three areas of *public relation, privacy,* and *service*—may very well start around the breakfast table: after a quick glance at the morning paper *(privacy)* Mr. joins Mrs. in a cup of coffee *(public relation)* prepared by Mrs. on the electric percolator that stands in the corner *(service).*

190

2. A one-room cottage is the next step from the table breakfast: As in all drawings in this set, *medium gray* is for service, *dark gray* for privacy, and *light gray* for public relations.

In planning areas on the bridge table, orientation is secondary, as we can *move* the table so as not to face the light when reading the paper, and to enjoy the morning sun and the view while sipping our coffee.

But as soon as we *build*, and however small is our enterprise, *proper orientation for each area is essential.*

3. Small house plan: note that at this stage the car has become incorporated with the house service in a garage. This is quickly abandoned as the cars of today are built to stand all kinds of weather: the more logical version of the garage is found in the two next stages as *parking*, becoming more and more important in

4. A combination motel and restaurant, and

5. A campus type of educational program combining administration, cafeteria, auditorium and classes, each area being expressed by one or more independent buildings.

1. The most common layout for a little house in a development. By thus placing the house in the middle of an already small lot, privacy is impossible and the whole garden is only a glamorized alley all around the building.

2. The usual layout for a farm. Instead of being placed in the middle of the acreage, the farm is usually placed in the north-west corner, thus allowing for the best use of land and orientation. The discipline of farming explains the adherence to a right angle composition.

3. By placing the building (house or other) askew with the *artificial* boundaries of the lot, we recover the natural site in full and benefit on all points (see further: *Planning for Free Men,* page 202, and also pp. 196-197)

Each of these areas is very comparable to the great *systems* of the human body: digestive, nervous, etc. They in turn are composed of an organized canvas of smaller organs working in gear with the general activity of the area.

The proportion given to every area varies greatly according to the program. For instance, in industrial building types, we might have

> public 1%
> privacy 90% (working)
> service 9%

while a community building might be well represented by

> public 80%
> privacy 5%
> service 15%

and a church

> public 95%
> privacy 1%
> service 4%

Every area in turn is an organization in itself and can be subdivided into smaller areas. For instance:

Public areas involve *recreation, rest, reception,* regions of *quiet* and regions that are bound to be *noisy.*

Privacy represents all areas involved in *administrative work* (offices), *education, production,* etc.

Service is distributed into *receiving, packing, delivering,* and *storing* (including parking of vehicles).

Now, within each of these subdivisions, planning is organized according to the human group that is to use them:

> *children* and *adult* quarters, within a residence
> *executive* and *employee* quarters, within a working area,
> *truck* service and *passenger car* service, within a service area.

The exact size of each area, at least in commercial building types, will generally be stated in the program. In residential types or monumental programs, the right proportion is usually left to the flair of the designer.

To the *interior areas,* fixed in the program more accurately, are to be added the *exterior areas,* that generally are only loosely defined within the size of the lot. This part is just as important as the rest and should show the same threefold discrimination (public, privacy, and service).

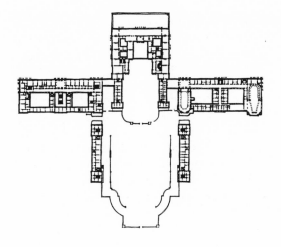

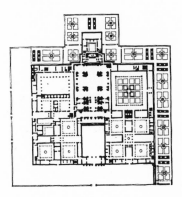

Julien Guadet, in his remarkable "Theorie de l'Architecture", comments on both plans and shows how in the Escorial God occupies the place of honor and the king a monk's cell, while in Versailles, Mansard placed God in a side chapel while the king's bed is the focal point of the whole composition

The designer weighs the importance of each area and its subdivision in his mind before he does any kind of designing. He often puts his conclusions into the form of some kind of a chart, as a diagrammatic scheme that will direct his choice to a particular plan. At this stage, he is like the druggist who weighs his various ingredients before mixing them into a formula. He is now ready to consider planning. But even before he goes into any analyzing, the artist in him should have the vision of the character of this particular program. This should come as a total revelation as he reads his program for the first time, when all his nerves are taut into seeing through, between, and beyond the written lines. We shall come back to this when we try to analyze the creative process.

The first step in any study is thus to assign to every area its approximate importance not only as to the space it should cover in the composition, but also as to its relative proportion in regard to the others.

We can easily understand how difficult and vital this first step in planning can be, as there generally is a choice between various dispositions that may seem at first glance to work equally well in the over-all scheme. Identical programs may bring about two radically different solutions. Between the Escorial and Versailles, for instance, there is a world of difference in composition, although both are the same program of a palace for an absolute monarch—but the palace for His Most Catholic Majesty Philip II of Spain ended by having the character of the Convent of Convents—while the show place of Louis XIV, the Sun King, ended by looking like an oriental initiation temple where the king's bedroom occupies the position of the Inner Sanctum.

At this stage, the highest and most subtle approach to function and efficiency—what we call *character*—is the deciding factor toward the best fitting solution, and the most efficient. This is what makes of architecture an art, as no science, however transcendental, can solve this problem in the expression of human character.

Now, if we assume that after having moved around all the areas in various positions examining each one in its proper relative proportion, we have come to what we consider—for the time being at least—the ideal disposition. What we have now is a schema, a kind of *chart*, but not yet a *plan*. To transform this chart into a working plan, we must provide for convenient and easy relation between the areas that must work together. If we leave them isolated, like so many islands on the high seas, no general activity can take place, no exchange of trade—meaning life—is possible. They must be linked together by means of communication, like cities need airlines, railroads, roads and waterways, quite similar to the circulatory system in a living organism. The designer calls this system of communications the *circulations*. Their disposition and their various sizes in the three dimensions are just as important in the general study of a program as the areas themselves.

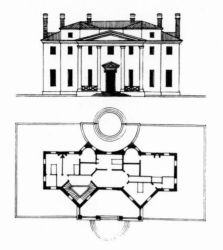

House
by Emilio Terry

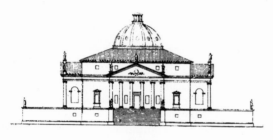

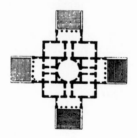

House
by Andrea Palladio

These two little symmetrical horrors designed by famous architects of the past, are well representative of the kind of nonsense which is born when architecture on the drawing board loses contact with the poetry of reality. The absurdity of a layout like the Emilio Terry house is unbelievable. Had he purposely designed everything the wrong way, it could hardly be worse. A roof bristling with chimneys, a total disregard for orientation, vertical slit windows, etc. and, of course, four neo-Roman columns and the unavoidable pediment which "graces" the entrance.

As for the Palladio monsterpiece, what is it? a mausoleum? a museum? a temple for some unknown god?

It is supposed to be a house

A *plan,* for the layman, means a technical drawing difficult to understand. In a plan, common elements such as windows, doors, columns, are represented as we never *see* them, and it requires a mind well acquainted with the gymnastics of conventional indication to understand them as windows, doors and columns, instead of a jungle of abstract lines. People are used to pictures, as pictures are understood immediately. Even though a picture—no matter how perfect a photograph it may be—shows only a small part of a building under a very particular angle and tells very little of the story, the plan, that on the contrary tells us so much about the whole story, is discarded by the layman in favor of the picture. How many books of architecture for the general public dare print plans together with the wealth of photographs they generally display? We know that there are very, very few small numbers. Very rarely do we see plans actually discussed in this kind of literature, while volumes are written on the comparative value and meaning of façade details, decorative elements, very thin in meaning, as compared with the architectural value of the whole plan.

In the domain of general education, history courses key their thin review of architecture on outside details of decorative "styles"—never on the true character of planning, which is the essence of architecture.

A plan is much more than the picture in two dimensions that meets the eye. Even though it *is* a picture and should be considered as such, it should never be considered first of all as a picture. This mistake has often been repeated in history. From the hyper-symmetrical little villas of Palladio and the English "circles" and "crescents" of the Regency—to the Church-In-The-Form-Of-A-Fish and Frank Lloyd Wright's triangular or diamond-shaped modulation, some of the greatest architects have yielded to the temptation of this game of alliteration and geometric abstraction.

A plan is the most important among all conventional *drawings* needed to give a fairly expressive representation of a three dimensional building: section, elevations, etc. A plan is in reality a horizontal *section.* Drawings showing

194

vertical sections of the building may be just as important in the general presentation, as the plan drawings. One of the reasons why the floor-plan drawing *is* more important and shows more information than any other in the majority of projects, is that it shows a section at the level of people's activity throughout the building. The fact that people walk on horizontal planes makes any more explanation unnecessary. If we were designing for flies or bats, walls, ceilings, and façades would then be the most important drawings.

We may point out at this time the misleading appeal of the scale model to the layman as a three dimensional representation of a building or group of buildings. A model actually represents architecture as seen from many hundred feet in the air, and architecture is not designed for airplanes, but for pedestrians. The excessive realism of a reduced scale model is only a fallacy, as we cannot walk *into* a model and visualize the various perspectives that would unfold before us in the actual building.

A model may at times be valuable in showing a whole city, as the design of a whole city, like a map, is best grasped from the air. But scale models of buildings are only toys that may appeal to the child in every one of us, but mislead us into thinking of them as a total representation while they only show a very partial and unusual angle of the composition. The time and money spent in making models would be better spent and repaid a hundredfold in return, if spent in sharpening our wits about conventional

drawing. To rely upon a scale model for explaining every different project is somewhat similar to the idea of counting on our fingers as a better substitute for mental reckoning, or, in music, to write in full every note in a score with a typewriter instead of using staves and the usual symbols. The analogy with musical notation is very close, as a musician by looking at a score can actually hear it sing in his mind with the particular timbre and dynamics of every different instrument. Beethoven was deaf when he wrote his most immortal pages. In the same way the designer must project himself into the building he represents with the various conventional drawings and actually *is* at all times in the composition he draws on his board. The completed building is only the *confirmation* of his work, like the execution of a symphony in the concert hall. What musician would accept a mutilated short score for the electronic organ as a substitute and model representation of his composition for a full orchestra?

Models can only be useful in cases when the forms visualized by the designer escape two-dimensional representation. This happens also in some areas of music where new marriages of sounds never heard before have to be checked by orchestral experimentation and scores rewritten afterwards. Shell forms and gauche surfaces belong to the kind of design that need model analysis.

After this parenthesis on the fallacy of most scale-model analysis, let's go back to our study of the plan.

THE PLAN CONSIDERED AS A STRUCTURE

Another reason why plans show more information than any other drawings is the fact that from a plan drawing we can easily imagine the kind of structure and space intended for it. This gymnastic was easier in the times and places where a sloped roof was the necessary cover for any building. When looking at a me-

dieval plan, for instance, or any plan before the steel and concrete revolution, we need little practice to visualize at a glance the general volume *and silhouette* of the building or group of buildings. If, for instance, the architects of two centuries ago had to roof an open area like any big supermarket, they would design a roof like a

cathedral for it. And they did. A glance at the old covered markets in Europe, or such buildings with large halls designed to shelter crowds, makes this clear. Cathedrals and public markets designed by medieval architects are still the most conspicuous landmarks in most European cities. The two great families of buildings —the *one story open space,* and the *multistory building*—are clearly expressed by the plan. Whether antique, medieval, or contemporary, whether stone, brick, steel or concrete, the plan shows the same characteristics of (1) widely spaced foundation points—for the open hall type of one storey structure—and (2) a net of columnar modulation—for the multistorey building.

Since the coming of flat roofing, volume cannot be easily deduced from the plan, as was possible in the case of the sloped roof. This feeling for the third dimension has become less of an automatic deduction and is now left to a more subtle sense of space. This makes it more difficult for the contemporary architect, but also opens unique possibilities. The medieval architect, like a feudal knight hindered in his movements by his armor, was limited in his choice of forms by the strict armor of geometrical roofs, while he is now as free in his moves as a swimmer in open water. The *slave plan* is more and more becoming a thing of the past. We shall see when studying the problem of circulation what a revolution the open plan has created, a much more radical and expressive *Renaissance* than the so-called Renaissance of Bramante, Palladio, and its decadent sequels.

This extreme freedom in design has brought in its wake the danger of *laxity, confusion,* and *disorder.*

All arts have followed the same evolution. At the same time that the musicians and painters found total freedom of expression, the development of reinforced concrete brought freedom to the architect.

The evident drawback was to make art look easy, at the precise moment that it really was becoming more difficult. While artists' work often looked like childish doodlings, this by no means meant that children could do as well as mature artists. This misunderstanding opened the gates of Art—this most excruciating discipline of the human mind—to the amateur, and

at the same time blindfolded the public to the true sense of *values.* We are only too familiar with the Childrens' Art Exhibits—which have very little to do with art.

We don't sufficiently realize that the seemingly most unleashed "doodlers" of contemporary painting—as for instance people of superficial judgment might call a Picasso or a Braque—are in fact extremely well trained in the discipline of academic drawing, and can only achieve their complete freedom of expression in art because of their thorough academic training and masterly technique in their craft. For this very reason, it is of great importance that the contemporary designer should find his most valuable experience in the study of medieval and antique solutions in the composition of architectural space.

When we analyze forms of erosion, we shall see that the so-called free-form is in reality anything but free. It is the result of a strict obedience to the power of forces that rule all motions. It is the direct expression of the lines of force that command all composition.

These lines of force operate in all directions, but the most important to consider are of two kinds: 1/ the resultant from the weight of the structure that holds up the roof—or the floors above—, a *vertical* force. 2/ the various attractions or impulses which govern the life within the building, namely orientation in all its forms (sun, winds, view, etc.), traffic patterns leading to areas of work rest, play etc. Such lines of force are rarely straight and often conflict with one another. These are generally *horizontal.*

We can already see how a plan made of rectangles can be most unfit to serve as the envelope of all these intricately conflicting curved lines—lines of traffic of all kinds, sweeping lines of vision, solar orientation, etc.—

We may recall at this point the fact that the true reason for planning rectangular rooms and buildings was, as mentioned above, the unavoidable prismatic roofing and its aftermath, the *joint,* with its companion, the *flashing.* The greatest revolution in construction may well be the jointless roofing, which permits a seamless construction by "welding" roof and wall into one, thus allowing the builder to use any form at will, in all three dimensions.

Odes have been written in praise of the right angle. I maintain that the future of design lies,

Problem: place six desk spaces in a room having only one window wall and two accesses on the diagonal of a rectangle

1. Conventional layout

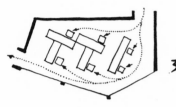

2. By using an angular layout, we gain more elbow room per man, and also a more normal path of easy slaloms for traffic movements (see p. 180)

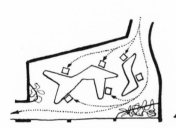

3. Breaking wall lines into wide angles, we gain more freedom and create a pleasanter room

4. Finally, if we go all the way and "pre-erode" wall lines and furniture to fit human motions, everywhere using angles wider than 90 degrees, we can use the living space to its maximum, at the same time permitting the introduction of plants in the idle corners

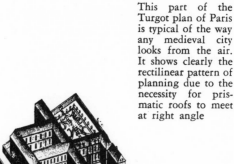

This part of the Turgot plan of Paris is typical of the way any medieval city looks from the air. It shows clearly the rectilinear pattern of planning due to the necessity for prismatic roofs to meet at right angle

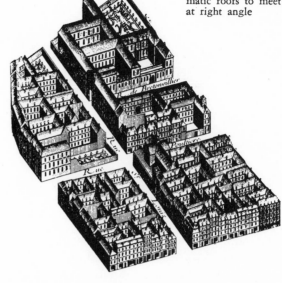

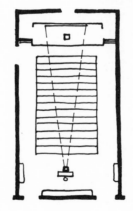

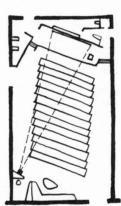

In these two layout solutions for furniture and partitioning of a rectangular conference room for 100 seats, we can readily appreciate the advantages of angular planning on a conventional layout. Both speakers (lecturer and projector) are located within the angle of two walls, exactly as we place the speakers in a hi-fi layout. The speaker may also face the audience without being blinded by the projector. Other gains are obvious: 1/ oblique spacing in back permits easy handling of back stage service, 2/ saw-tooth arrangement of aisle seats permits easier exit and access to row seating, etc.

on the contrary, in escaping from its servitude, and learning the difficult art of mastering the use of *wider angles and curves*. This affirmation may become clearer after the reader follows our reasoning in the next chapters of this book.

We can now understand that when we refer to a plan as a structure, it means not only its expression of purely physical construction, but mostly the equilibrium of the areas it defines, submitted to the many forces which control human living. We can, in the same manner, speak of the structure of a painting, or of a piece of music. We can speak of a *strong* plan, or of a *weak* plan. We can also understand better why a composition may be weak in plan, even if it may defy centuries with the pure physical strength of its construction.

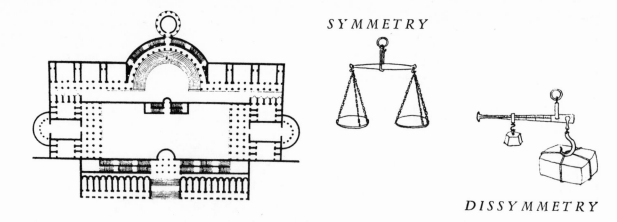

THE PLAN CONSIDERED AS A PARTI

We now see that we should not primarily consider a plan as a drawing, but as the expression of the whole architectural solution of a particular program. Thus considered, we call it a *parti,* from a French word that means *decision* (as in the expression "prendre un parti", meaning to take a decision). This becomes in English the word *party* to designate a political group of definite social characteristics.

If we consider the general plan as a *geometrical* space, regardless of the relation of the various areas in their functional and organic values, we may consider two great families of plan that are very expressive of the general character and social characteristics of a people and a time: the *symmetrical* parti and the *dissymmetrical* parti, to use our common language of today.

"Symmetry" as we use the word today, no longer has its original meaning of harmony and balance of forms. It has come to mean geometrical symmetry, or mirrorlike reflexion, a strict *duplication* of forms on either side of an axis. This definition applies to most Roman plans, and to Greek and Roman revival architecture of the Renaissance upward to the XXth century. Since it denotes a preconceived idea of form, it shows the prevalence of engineer*ism* and mathema*tism* on art. It represents the dictatorial rule of a somewhat elementary reasoning over sensitivity and intuition.

By *dissymmetry,* we actually mean the *summetria* of Plato. An example would be a mobile perfectly balanced in mid air that does not show any axial composition, designed so that the weight of one side exactly balances the other side, around the point where it is suspended. This point, that we will call the *centroid* of the composition, coincides with the center of gravity or mathematical centroid of the composition considered as a geometrical space.

This type of planning shows a discreet understanding of the charm or the respect of the grandeur toward the natural site. It is by excellence the expression of free thought and free people. It expresses individualism, as opposed to dictatorship and slavery: it is the plan of most archetypes. The Greeks found in it the expression of their poetic and individual thought. It is also the Cistercian plan of the Middle Ages, used as an expression of monastic humility. It is the plan that expresses most simply the casualness of today's living, as compared with the formal ways of yester-years.

Although the dissymmetrical parti will generally fit the majority of today's programs, the symmetrical plan remains of great value when the program requires grandeur and authority— whether as an expression of religion, government, or death—as befitting a superior power that is beyond us and that we may not discuss.

198

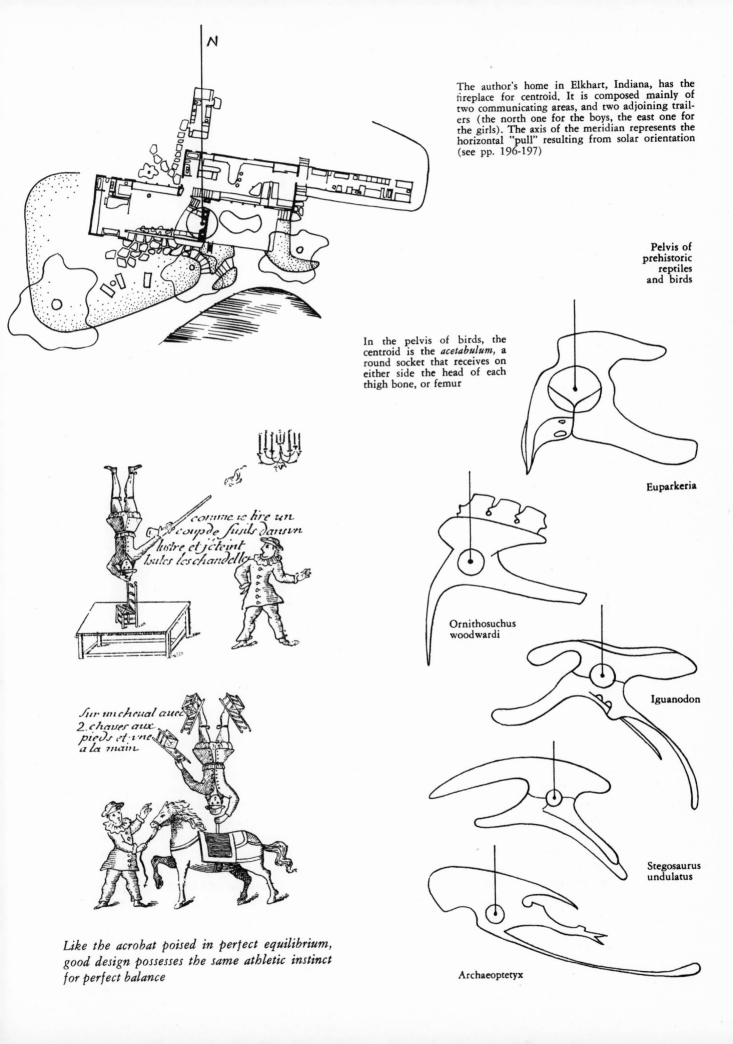

The author's home in Elkhart, Indiana, has the fireplace for centroid. It is composed mainly of two communicating areas, and two adjoining trailers (the north one for the boys, the east one for the girls). The axis of the meridian represents the horizontal "pull" resulting from solar orientation (see pp. 196-197)

Pelvis of
prehistoric
reptiles
and birds

In the pelvis of birds, the centroid is the *acetabulum,* a round socket that receives on either side the head of each thigh bone, or femur

Euparkeria

Ornithosuchus
woodwardi

Iguanodon

Stegosaurus
undulatus

Archaeoptetyx

Like the acrobat poised in perfect equilibrium, good design possesses the same athletic instinct for perfect balance

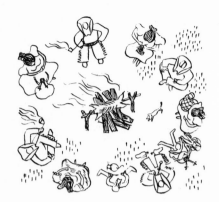

the arena

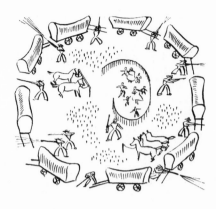

the look-out

the amphitheater

The arena is an introverted layout for extrovert people who like company. This is the parti for "togetherness". We find its most total expression in the native compound villages of primitive people. It is the friendly parti by excellence, *the public relation parti*

The look-out, in turn, is an extroverted layout for introvert people who insist on privacy. It is a defensive type of parti. We find its most authentic expression in the medieval castle. But it also may become an ideal solution for privacy in hotel and residential planning

The amphitheater—a variation on the arena theme, although more common— also speaks of public relations, of friendly gatherings, where a certain kind of activity is to be enjoyed by many. We find it in public halls, schools, markets, etc. It is by excellence the concave shore of a beach

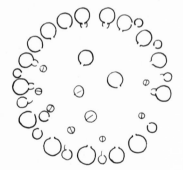

Village compound, North Cameroun

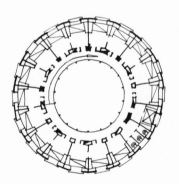

Sestrieres, Italy, tower hotel,
V. Bonadé Bottino, architect

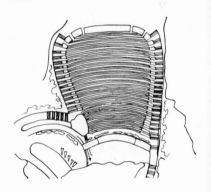

Red Rocks amphitheater, Denver,
Burnham Hoyt, architect

Someone has said that there are only ten dramatic situations, as all possible plots may be placed into the framework of one of these ten basic themes.

In the art of planning, we might well limit these basic themes to six: the *arena,* the *look-out,* the *look-in* (or amphitheater), the *fan,* the *random pattern,* and the *military.* We could even actually reduce them to four, as the amphitheater may be considered as an extension of the arena, and the fan as an extension of the lookout.

These can be called archetypes in the fullest sense of the word. They are the creative expression of four driving urges or ideas of man in society: extroversion, introversion, conservatism, or liberalism. The defensive spirit shows as well in the design of a home as in the design of a fortified town, if the owner of the home is an introvert, or just someone who prizes very high his right to privacy.

This may make clearer the reasons why some partis cannot "work" for certain programs, why

the fan

the random pattern

the military

The fan, again, is a variation on the look-out. It stresses privacy, but without going so far as to shut the door completely on the neighbour. It is the ideal plan for residential programs, where a certain amount of friendliness is as important as the necessity for privacy

Drop a handful of rice on a plate and you will obtain the random pattern. It disregards orientation. Rabbits, chickens, sheep, etc., in restricted area, offer the same pattern. Crowded without any breathing space, this has also become the typical plan of suburbia

Order, discipline, anonymity, and also lack of freedom, is reflected by the military parti. In its purest state, it is the roman camp. But today we find it everywhere. The dictatorial grid pattern of the roman camp has become also the pattern of our "democratic" towns

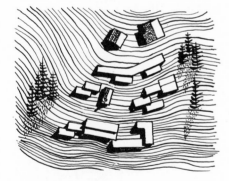

Meribel, France, village
Paul Jacques Grillo, architect

Company Town, anywhere

Roman camp, after Polybius

the use of the look-in type, for instance, cannot be used for the bedroom wing of a hotel, and on the contrary, why the look-out plan can never be successful where public relations are important, whether they are of commercial, educational, or religious nature.

Sometimes, the use of one type instead of another may give a clue to a plan of the past which, in our day and time would not *work,* but which was very successful where and when it was done: the residential features of the Georgian town of Bath, in England, for instance (the Royal Crescent and the King's Circus) were based on both the look-in and arena types, because they were aimed at a society which enjoyed "looking-in" on the aristocracy elegantly riding down the square in their open carriages, or on horseback, showing themselves off and greeting one another.

Such a plan today would be nonsense, as horse, buggy, and pedestrian, have been replaced by a fast moving car.

PLANNING FOR SLAVES

Whether in the hull of a slave trader ship or in an Egyptian village compound, slaves are packed in a military *right-angle* discipline. The *gridiron* plan here, typical of the military camp, is made of a rectangular lattice of dead-end lanes, symbolic of the dead-end life of the slave. How can we call ourselves free when the very pattern of our streets today is such a sad manifestation of our slavery to routine and reflects such a desperate lack of freedom?

Floor plan of a slave ship showing the packing of negroes

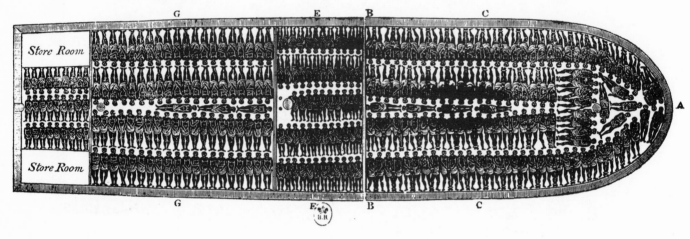

Slave workers quarters in the enclosure of the temple of Horus, Luxor, Egypt

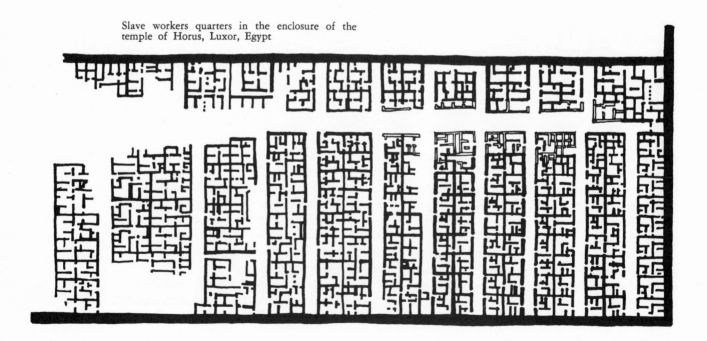

Plan of a church
in Lombardy

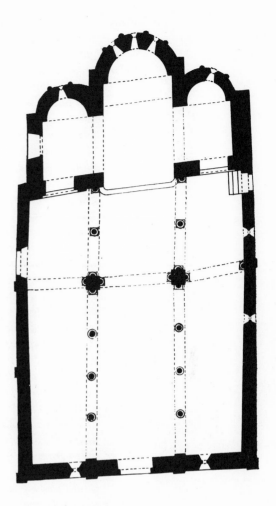

Part of the town of Palaecastro
(early Aegean culture)

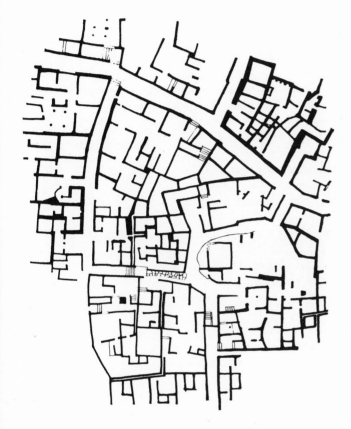

If we judge by their church plans, the Lombards must have been among the freest of men. We could not find in all Lombardy a single church with a true right angle, or a plumb wall. There is a saying in Lombardy that masons use potatoes instead of lead for their plumb lines, and, as mules are fond of potatoes, the "lead" never stays long enough at the end of the line for the mason to raise his wall straight . . .

PLANNING FOR FREE MEN

While disciplined right angle rules out fantasy for the inmate of a gridiron plan, a spirit of adventure finds its expression in delightful patterns of carefully *organized disorder,* which characterize the layout of all free settlements, from the primitive village compounds of African tribes and town of Mycenian culture, to the most elaborate cities of Medieval Europe—Toledo, Amsterdam, Venice, etc.

We could call this the "medieval plan", because it reached its peak during this millenium, when architecture was the work of anonymous builders, rather than the fashion show of the particular ruler of the times. This type of layout lingers in a sequence of ever changing spaces and perspectives, through streets that curve into one another and never end against a dead wall.

This joyful indifference to any rectilinear discipline shows even in the layout of buildings, as in this Lombard church above.

When the year had accomplished its return, thus spoke
 Mahecwara, the god whom all the gods adore and who
 gives food to all the animals:
—I am proud of you, O B'agirata, most virtuous of all men.
 I shall accomplish your great desire. I will hold
 as it falls from the Heavens, the River of the Three Ways.
Upon these words, he climbed to the highest of the Himalayas,
 and ordered the River which unfurls in the sky, crying:
 "Ganga, come!"
*Then, falling from the Heavens, **Ganga**, the divine, unbridled*
 the immense power of its waves upon the head of Civa,
 god of infinite splendor.
There cloudy, immense, roaring, Ganga wandered upon the head
 of the great god during the time for a year to
 accomplish its course.
Then, Civa gave freedom to the waters of Ganga. Letting down
 a single lock of his hair, he thus opened a way through which
 was let loose the River of the Three Beds, this proud river
 blessed by the gods, this purifier of the world, Ganga.
The river progressed, here faster, there slower and in curves.
 At times it spread in a wide berth and at other times, its
 deep waters moved sluggishly, and again, at times, its waves
 fought one another, while dolphins played among the most
 varied species of reptiles and fishes.
From everywhere the Heavens were wrapped in lightning. The air,
 filled with myriads of white crests, sparkled as a lake
 filled with a multitude of silvery swans glitters in the fall.
Water, fallen from the head of the great god, rushed upon the
 earth, where it ran up and down, swirling many times before
 it followed a peaceful course.
This coming of Ganga upon the earth at last filled with
 pleasure all the three worlds. The saint, clad in royal
 and dazzling splendor, B'agirata, drove a divine chariot,
 in front of all.
Then, followed by its great court of waves, came Ganga,
 in the wake, as if dancing.
Spreading its waters here and there in light spirit, adorned
 with a feathery garland of foam, twirling in the swirl
 of its wide swell, always delicate with airy lightness,
Ganga trailed the road traced by B'agirata, as though in
 pursuit of the enjoyment of carefree fun.
All the gods and all the creatures and all the animals
 that live in the waves, followed in great joy the
 course of the famous river, adored in all the worlds.
Everywhere B'agirata went, there Ganga also followed.
 The king thus came to the edge of the Sea, and thus
 Ganga followed him.
He entered the Sea and took the river with him to the
 entrails of the earth, and when he reached the Tartare,
 he blessed the ashes of his ancestors with the sacred water.
Then, transfigured into godly figures, they all went to Heaven,
 in joyful bliss.

RAMAYANA,
The Descent of the Ganges

motion

From a mural
by Grillo

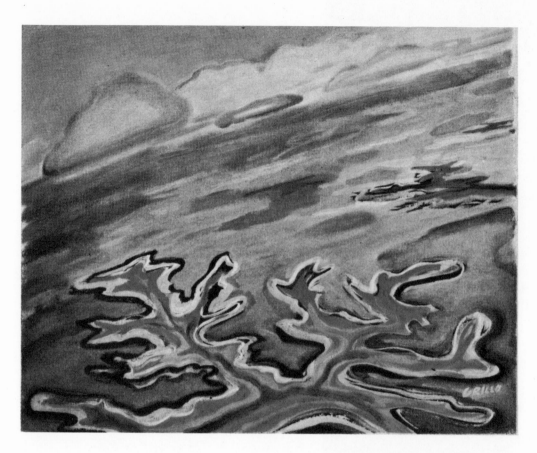

The birth of the forest, a pastel done by Grillo, while flying above central Brazil, near Carolinas

No country can be known and developed without roads.

This is the first step toward civilization. First, there were the rivers, that opened inland ways into a new continent toward new frontiers: they were the highways to start the exploitation of riches and bring new life into heretofore unknown territories. If a country is completely isolated, it might as well be forgotten, as if it were on another planet. In architecture, even the most secretive bank vault has to possess at least one door. Dead-end walls and one-way trips are only the fate of prisoners and slaves. Life in a free world is a two-way proposition: it means exchange, and it develops along roads of access, roads of work, roads of leisure, and roads of exit.

A building—or a group of buildings—is, in a way, like a continent, full of potential riches of many kinds. We have compared these riches to the various organs in the body of an animal, organs which differ from each other in size, function, and in their very position within the body itself. To link these areas together organically, we need to establish a complex and thoroughly studied web of connections, very much like the circulatory and nervous system in a living organism. *These connections should never short-circuit* one another any more than the wiring system of an electronic machine.

206

In every system, we will have to differentiate between the main arteries that connect the three main areas together—and the smaller system of blood vessels, nerves, and capillaries that link the major organs together.

This part of planning requires the most delicate judgment. We may go so far as to say that the way it is handled will show if the designer is a real artist or a poor amateur. A program will always specify the areas; it will *never* specify the circulations; the choice of their size and relation to each other is left entirely up to the designer. The complete success of the plan, meaning the final health of the organism as a whole, is entirely in his hands. A poor system of circulations may well ruin the best proportioned system of areas, and make life miserable for the people who will use them.

A program, like a tract of rich and fertile good earth, holds untold amounts of potential energy stored in various areas of planning, and ready to be liberated as soon as roads are skillfully sketched to link them properly together. Life then begins to flow, and a new organism is launched into life by the magic wand of the charcoal stick.

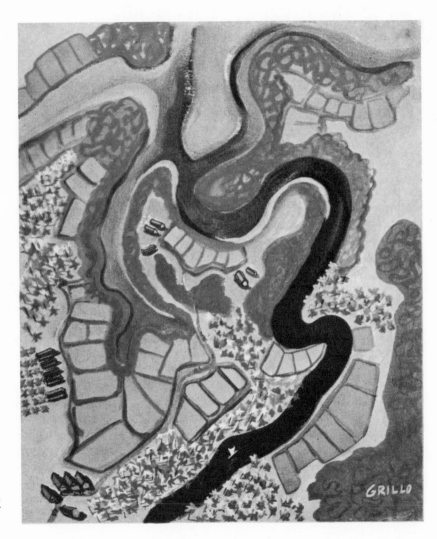

Native village in coastal swamps, eastern Brazil, near Aracaju. Pastel by Grillo

THE PRINCIPLE OF
LEAST ACTION ORDERS
HORIZONTAL MOTION

The horizontal plane of circulation is the most normal, as it is easier to move around horizontally than to develop enough horse power to climb many flights of stairs

Sixth floor plan,
Kaufmann Department Store,
Pittsburgh, Pa.

From the 3rd century A.D. when Hero of Alexandria found that the path of light reflected on mirrors between an object and the eye, is a *minimum* distance—to the latest developments of Einstein's theory of relativity, mathematicians have studied the principle of least action. Descartes, Maupertuis, Lagrange, Hamilton, etc., have contributed their share in establishing this most important principle, better known to us as the very human *law of least effort.* It rules the whole theory of circulations in design.

For instance, when we climb stairs at the young pace of a meter per second, we require from our muscular system an energy equal to about one horsepower (one horsepower being by definition the amount of energy necessary to lift 75 kgs one meter during one second). If we do it twice a day, it is nothing. If we do it 10 times an hour, it will soon begin to tell on our behavior, as our muscular engine will ask for more fuel. If we cannot provide this fuel in the form of a snack meal of some kind, our work will slow down. This is so well known that the habit has developed nowadays of the "coffee break" in mid-morning or mid-afternoon, in factories and offices, that definitely increases the working power of the employees and greatly compensates for the time devoted to this refueling.

The Chinese, that we like to quote as being first in wisdom, built nearly all their cities no more than one story high. In Peiping, for instance, quoting the architect Mirams in his book on Chinese architecture, "The effect is delightful: when standing in a courtyard of a town house, it gives the effect of a house apparently set in the country, although in the middle of town, with only trees and distant mountains showing above the enclosure walls of equal height."

208

The fact that in Peiping there was an imperial rule that all buildings be lower than any within the Imperial City, may have been decisive in this layout, but it remains as the most normal and common layout in social clusters where the family is the unit. We find this same type of layout in all villages and cities that could grow freely without the iron belt of defensive fortifications: in cities built in peace or in a new world away from the threat of wars. In insular England and the neutral countries of northern Europe (Denmark to Sweden) as well as in Brazil (Recife, Bahia, etc.) or in the Moslem world Cordoba, Ispahan) the cities are made of low houses like Peiping.

One storey building conveys a restful feeling of peace and easy-going living. Multistorey architecture developed from the need for protection and for building within the very small enclosures of the medieval castle—as also in today's New York—because space was scarce and could not be extended. As the plan could not spread out, it had to shoot upwards. This tendency survived throughout the Middle Ages, when it had its reason for being. Then later on, when Europe became better organized and safer as a whole, architects still kept the habit of building multistory structures that were no longer necessary, as the fortified enclosure had lost its value as a means of protection. We have seen that they also kept designing, in Victorian main streets, windows more fit for shooting arrows and dumping boiling oil than to look out at peaceful passers-by.

The last remnant of this type is the 19th century American farmhouse raising its three storeys in the middle of the vast expanse of inoffensive plain, without any reason for its height but to offer a good target for lightning and tornadoes. These farmhouses could not even have the excuse of being efficient stockades against Indian warfare, as they were built after this part of the country was pacified.

It took the radical thinking that all wars bring in their wake to bring residence planning back to one storey structures (witness the growing popularity of the so-called ranch house). We are again coming back to Chinese wisdom and obedience to the powerful law of least effort. The shorter the distance between two areas to be linked, the better the result will be. The law of least effort has taught us this much. But if we want to understand completely the real problem of circulation, we must bring in the idea of *movement*.

In design, we are not dealing with geometrical solids as pure abstractions, but as forms to be linked together and penetrated by human movement. *Our conception of the shortest distance between two points, as a designer, may differ considerably from the purely mathematical concept.* Our definition of the shortest distance between two points in design will be *the distance that may be covered with the least effort,* in other words, the line with the least breaks or jerks in the natural flow of the human movement considered. In short, it is the most *economical* distance, requiring the least amount of energy and fuel, and as a consequence, *the most efficient.*

For instance, *service circulations* mean fast traffic, as any wasted time is a dead loss for the organism. They should be as short and straight as possible. If they reach a certain length, they should be mechanized by conveyors of some kind, so as to save precious time. *Public circulations,* on the contrary, must be organized in certain instances so that the public will actually cover as much ground as possible (the "possibility" being limited only by the capacity of public interest; it should never reach the limit of boredom and fatigue). In a department store, the actual *loitering* of the public is carefully organized in plan, in order to increase temptation for a prospective buyer. What is called *impulse buying* is the result of this pleasant promenade in aisles designed for slow motion, like the lanes of an English garden. In a museum or an exhibition, low partitions are set so as to canalize the public in slow motion through the whole show, as the farmer does in dry country to irrigate his fields. The circulation often even ends in a standstill area of rest and meditation, where the public is purposely led—as in lobbies, lounges, terraces, etc.

In a *single room*, the arrangement of furniture sets the circulations. In a *single building*, partitions control them, and in the *grand plan*, circulations are organized between masses and volumes of buildings.

The furniture arrangement should be understood as an integrate part of the task of the architect, especially in regard to residential programs. Corridors and closed circulations tend to become obsolete (the "box-type" of plan) but the so-called open plan must not fool us by its seeming lack of organization. It must be even more organized in detail than the closed plan, with built-in furniture, low-walled spaces, etc., creating as many sluices and locks as a well controlled and *easy flow* of traffic requires.

People moving around behave much like a fluid, as long as they can be far enough apart not to get into each other's way. As soon as they "pack" into some inextensible space (like the subway at rush hour) the traffic slows down to a critical standstill. If we let a hundred people walk in a corridor 50 feet wide, we know they will keep their normal pace and will not get in each other's way—since no two individuals walk at the same speed, they will gradually outdistance each other. But if we gradually reduce the 50 ft. space into as little as 4 ft., we know that the pace of the crowd will gradually slow down until they are packed almost to a standstill in the well known "waiting line". We also know that if, instead of people, we have to deal with a fluid, the speed of the fluid will, on the contrary, *accelerate* as we reduce the opening of the duct. When we reduce the opening of a garden hose by twisting its nozzle valve around until it is reduced to a pin point the water speed is increased a hundredfold. This is because a fluid is composed of microscopic molecules infinitely small in comparison with the size of the duct, while people, like sand or lead shot, pack up and refuse to move as soon as the ratio between the size of the opening and their own size becomes too small.

With this remark in mind, we can use the analogy of water with the exception of the rush hour type of circulation in analyzing circulations in design.

In fast flowing sections, a river bed is almost straight, and if it bends at all, it erodes the sides into a very slight curve.

In slow moving stretches, the slope being almost horizontal, the river eases its course into well-rounded curves, or expands into wide pools and, when the current comes to a standstill, the curve may become an *almost perfect* circle.

However, it is never a *perfect* circle, as when the current stops, another kind of erosion takes over: the wind and wave action. We have then those magnificent lazy curves that are found on ocean shores, like the extraordinary arcs that make the shores around the city of Rio de Janeiro. We have there a unique example, rarely found on earth, of combined horizontal erosion (the beaches) and erosion in space (the mountains around the bay) all of which are related to the family of second order curves and quadrics, and all entrancingly beautiful.

We like to say that Nature hates the straight line. By this we mean that nowhere in nature can we find a single straight line. Why? Because everything in nature is submitted not to one single force, but to many conflicting forces coming from every direction, with every kind of energy, that keep bending the initial impulse into a complicated curve or a series of tangential curves. Einstein showed that even light does not travel in a straight line, but is *bent* by gravitational forces when in the vicinity of a celestial body.[*]

As soon as we have movement of any kind, the same thing happens. Thus we will notice that man does not move in a straight line. If he has to turn, he will not follow a right angle. Only soldiers at exercise are taught to make square moves, and we all know how stilted and difficult it is for any soldier to master the half-turn. If we painted the soles of our shoes and walked across a building while the paint were still wet, we would notice that our trajectory is not a succession of straight lines, but a continuously curved line as we try to keep clear of all obstacles that lie around us: walls, furniture, columns, etc.

If we design circulations within rectangular spaces, we will find dead spots around the straight corners. By designing a curve instead, we substitute the natural paths of human motion for these artificial right angles. The design then becomes the envelop of the orbital curves along which people move normally. The necessity for rounding off corners and designing slalom curves instead of sharp corners is evident in the design of paths and lanes. For instance, a lawn soon becomes mangy and bald inside the right angles and, as a next step, some kind of unfriendly fence is placed that spoils all the natural beauty of a green.

*This fact was first proven during the total eclipse of the sun in 1919 during observations made on the Island of Sao Tome. By superposing photographs taken six months before, of the same area of the sky where the sun was eclipsed, the light coming from the stars in the vicinity of the disc of the sun, showed a deviation inversely proportional to their angular distance to the edge.

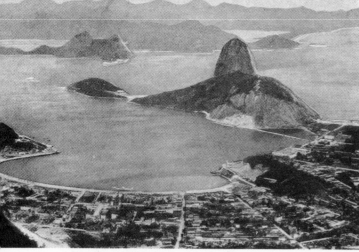

Rio de Janeiro
1900

Man has not yet learned to respect the natural beauty of the greatest landscapes on earth. In creating the Bay of Rio and its surrounding mountains, nature had been lavish in grandeur and beauty, but this unique landscape is being gradually spoiled by ruthless engineering. New land is being "conquered" from the bay all the time, changing the aquiline profile of the shores into rectilinear platforms. These two pictures, taken at a 50 year interval, show the gradual disfiguration of Botafogo Bay, at the foot of the Sugar Loaf

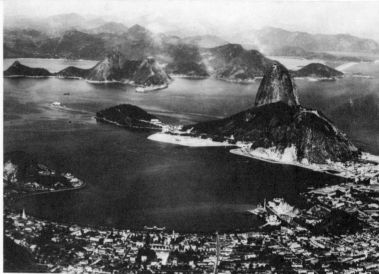

Rio de Janeiro
1950

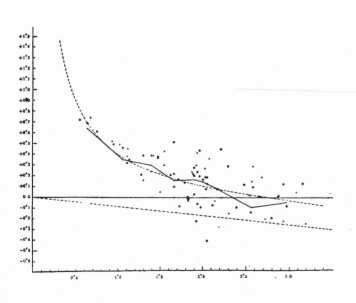

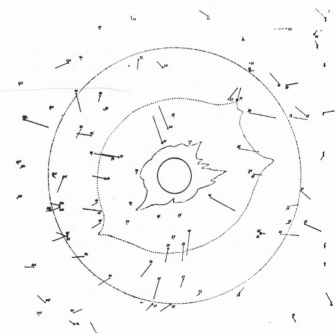

Results obtained by the Campbell mission at Walla (Australia) during the solar eclipse of 1922, proving with remarkable accuracy the Einstein effect. The radial displacement of each star is shown on the map at right by arrows of various length. The chart at left shows horizontally the distances to the center of the sun, and vertically the value of the displacement, for the 92 stars measured.

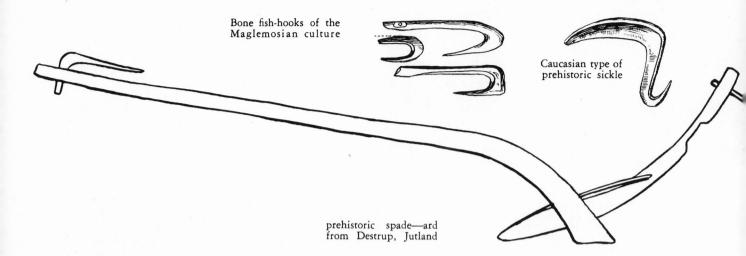

Bone fish-hooks of the
Maglemosian culture

Caucasian type of
prehistoric sickle

prehistoric spade—ard
from Destrup, Jutland

The reason that coins are round in all world currency can be understood when we think of the damage pockets and purses would suffer from the friction and tearing from any polygonal coin.

The effect of the erosion by human movement is most striking in furniture design. Formerly, when all furniture pieces were rectangular, the test for perfection was in the achievement of very sharp lines. With time, erosion took the upper hand and the sharp piece of furniture, after a few years of bumps and knocks, became gently rounded off for the benefit of the next generations who treasured its smoothness as another rare virtue of the "antique". Much of the charm of good antique furniture comes from its *friendly* and smooth corners, smoothed and streamlined not by time, but by its infinitesimal sanding off by the daily friction of human movement. In contemporary good furniture design, the lines are deliberately smoothed off, the edges rounded *like the handles of old tools*. This gives a clue to the fact that good design in contemporary furniture can fit any surrounding, without regard to style. Design is then at its best. Its *pre-eroded* lines meet the eroded design of antique furniture on the same level of friendliness and livability.

These few examples show the necessity in all design for man to consider *movement* as an essential part of it. *No design is done strictly to be looked at. It has to be lived with, and there is no life without motion.* We live in a universe where energy—of any kind—is the product of material and motion. Streamlined curves of least effort, whether in man-made design or in nature, are the normal expression of the equation of energy.

We might very well state as a definition that good design is *the expression of forms of least effort.*

Streamlining is today associated with the idea of speed, but speed is really only a minor need for its use. We laugh at a streamlined baby-carriage—but we forget that rounded off flow lines are perfectly logical *if* they express the envelop of movements of the baby inside, *who is only immobile when he is asleep.* We wonder why a chair should be streamlined when it is stationary. We forget that no one could sit absolutely still in a chair for more than a minute without developing cramps, a backache, and great general discomfort. The envelop of our constantly shifting movements is a streamlined surface extremely difficult to define except by experiment, as not only our skeleton moves around the articulations, but the joints themselves are also in motion. The surface edges—

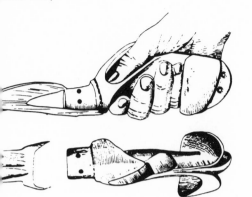

Bronze Age sickle from ~~ingen, Switzerland (cir-~~4000 B.C.)

Stockholm, Slussen: clover leaf surgery through the "heart" of an old city. Separate channeling is provided for all kinds of surface traffic

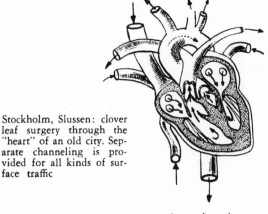

section of a human heart showing the crossing of the main blood highways

what the mathematicians call *boundaries*—must at any rate be well smoothed out and rounded off, to fit the quick curved moves and soft texture of the human body.

Coming back to the problem of horizontal circulations, we see that they can be traced logically only by being designed according to speed and volume of traffic. The areas of almost complete immobility must be designed like the deep bends on a slow river where corks and other flotsam accumulate in happy promiscuity.

This type of purely *physical erosion* is only one side of the story. We are not dealing with physical motion alone, since we are involved with people. We are also dealing with psychological motion—meaning *emotion*. There is such a thing as psychological erosion. For instance, we feel the psychological need for space around certain objects. The kind of erosion that radiates from a light, for instance, can still be considered physical, but the space needed in the nave of a cathedral above the heads of the people is definitely psychic. No physical reason may explain it. So is the space around the Washington Monument. By the same token, the *closeness* of space around the cathedral of Strasbourg (and we could say, around *all* the cathedrals in Europe as they were originally designed, before the small buildings in their vicinity were bulldozed out to create large and dead open "squares" under the fallacy of surgical town planning) resulting from the friendly closeness of the dwellings around it, is the result of the psychological need for close protection, like chickens huddle close to each other under the wings of the mother hen. This is all part of the human expression of character in a group of buildings, or of the life of people within a single building.

We see that the *reading* of a plan does not require a vast experience in abstract symbols and that an inch scale and calculations don't help us much in sizing up *the real value* of a plan. The main criterium is to understand how people move around through the circulatory system, and mostly *how smoothly and easily* they do move from one area of activity to another. We can all "read" a plan just by following the moves of people in it, from the time they land at the port of entry (*entrance*) until the time they come out of the building—as a worker, a visitor, a patron, or a boss—and by projecting ourselves into the mind of the different kinds of people and different kinds of activity they get into while in the building. After this test, we can state if—or not—the plan *works*. And this should, in the end, be the major criterium to any architectural composition.

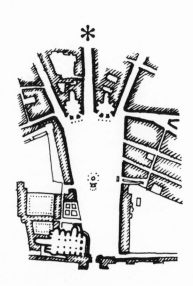

Forum Romanum. The focus of the Roman Forum was the tribune (Rostra) where the orator addressed the people

St. Peter, Rome. The focus is the loggia from which the Pope addresses the people

1. invitation

extension of access by invitation so that the greatest number of people may come close to the focus of exchange between interior and exterior spaces

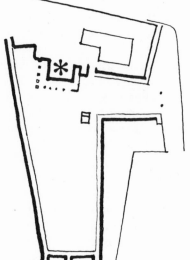

This type of layout is characteristic of the occidental civilization. It was the form preferred in medieval free towns for the numerous squares, large and small, which dotted the city like living rooms for the community.

In the medieval society, the town square was a stage permanently set for open air markets, pageants, plays, and meetings of large crowds

The Piazza del Popolo, in its original design shown here, is the north gate to Rome (Porta Flaminia). It focuses toward the central avenue (Corso) leading to the heart of the City

In San Marco (Venice) the focus for both piazza (larger square) and piazzetta (smaller square) is the main entrance to the Basilica

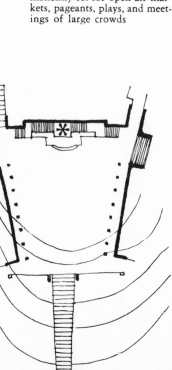
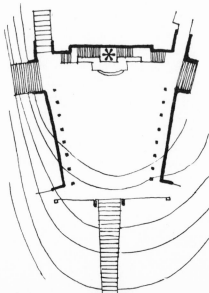

Piazza del Campidoglio, Rome. Its focus is the top of the stairs leading to the Palazzo del Senatore

2. initiation

restriction of access by initiation to an inner sanctum where only a few are admitted, the greater number of people being kept at a safe distance from the sacred focus

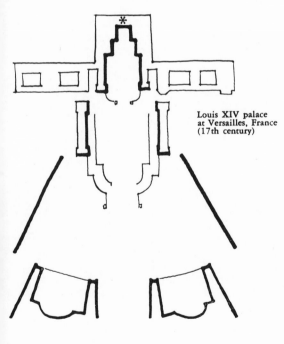

Louis XIV palace
at Versailles, France
(17th century)

Great temple
at Bhubaneswar,
Orissa, India
(circa 1000 A.D.)

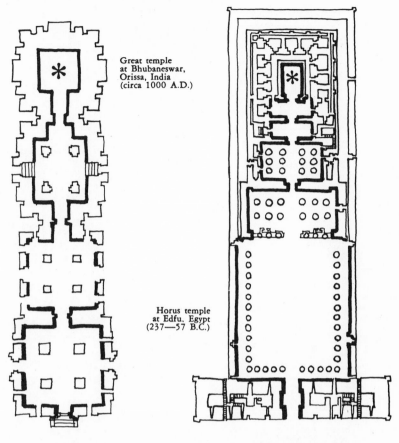

Horus temple
at Edfu, Egypt
(237—57 B.C.)

the oriental version

The initiation temple of northern India is like a tropical flower, hiding in the depth of its calix the precious shrine to the god. It is preceded by a series of halls for various ritual gatherings and dances, the crowd staying at all times outside on the plazas and terraces which are the domain of the non-initiated.

The Egyptian temple, although strictly of initiative character, is already a transition toward the western solution. Its clean-cut lines forecast the Greek temple. But here, the initiation is even more remote and hidden than in the indo-aryan temple. In the tomb-like inner sanctum, the novice will spend three days in suspended animation, a death-like trance from which he will awaken as a member of the initiated few

the occidental version

The western interpretation of the theocratic plan is more open. Although the feeling of initiation is evident, it is no longer a secret, but serves to exhibit the Divine King.

The only passport necessary to enter the palace was to wear a sword. The ceremonial of the "lever du roy", where Louis XIV admitted a selected group of courtiers to his bedroom to witness his getting up every morning, was a kind of solar rite celebrating the resurrection of the sun-king after a night of apparent death.

Versailles possesses a grandeur that comes from the remarkable balance of its proportions and the breath-taking contrast between the very small "Marble Court" and the immensity of the western terraces. The decadent plans that stemmed from this heroic archetype lack scale. They possess only grandiloquence, pomposity and ridicule—whether in La Granja, Sans-Souci, or Karlsruhe

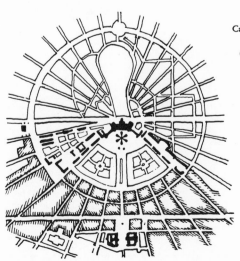

Castle and town
of Karlsruhe,
Germany
(18th century)

Immediate approach to Notre Dame as shown in the Turgot plan (1650). Surgery was already at work, the "rue neuve"—or *new street*—having been recently opened

Another example of historical surgery. In Antique Rome, this time. Nero, after the Fire, cut open this wide and unexciting boulevard, the *via nova*, as a new approach to the *Circus Maximus*

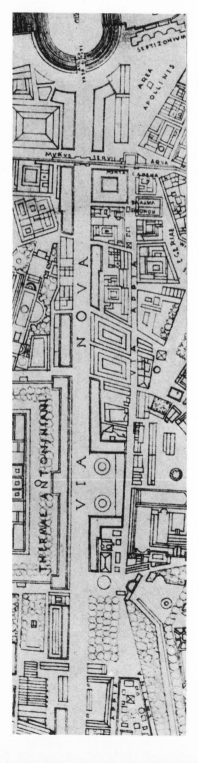

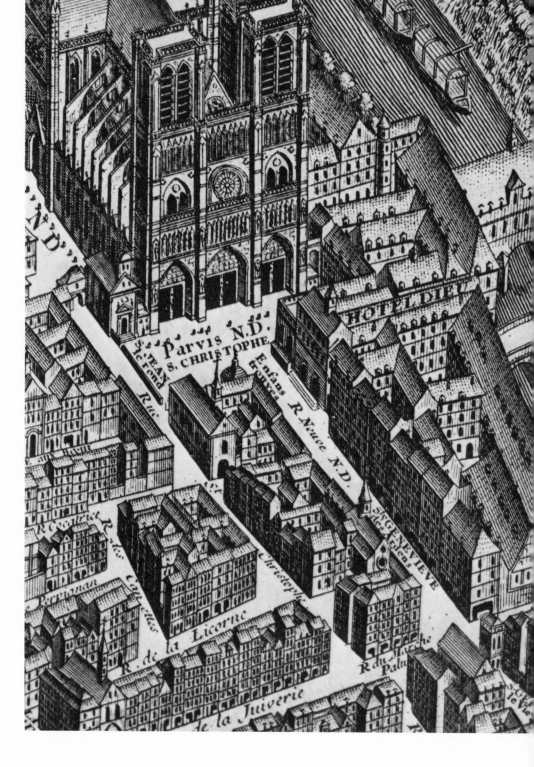

Surgical town planning is responsible for the destruction of most of the significant spaces which had been originally planned during the Middle Ages to create an extraordinary effect of surprise as the pedestrian walked into them.

The approach to a cathedral was typical of this lost art of suspense in composition. First, the traveler viewed the monument from afar, miles away, towering above the city. Then, as he came closer, it seemed to disappear into the ground until, after a blind search through crooked streets and nondescript buildings, he received the shock in full, as he turned the last corner and came to the presence of the Work, rising like an abrupt cliff and dwarfing man into insignificance before the House of his God.

There are still a few authentic medieval spaces of such grandeur in suspense left to awe the stranger: *Strasburg, Orvieto, Tournus*, have not—yet—been disfigured by the man-with-the-transit. But Notre Dame de Paris, dwarfed and isolated into a vacuum by the nondescript plaza called the parvis, looks like one of those lonely castles on a checker board on the losing end of a chess game. St. Peter's square in Rome, planned to be as closed as a womb, is now trumpeted into a long shot perspective by the new boulevard cut open by caesarean-expert Mussolini.

What war has achieved in Rouen and Cologne—destroying other highly significant spaces— town planners rejoice in designing today, thus cutting buildings from their environment, and isolating them as odd museum pieces, glass-cased for the convenience of the tourist's camera.

SUSPENSE IN COMPOSITION

This is not true only of story telling. It is true of all arts. A composition of any kind should always be an experience in suspense. Our being thus conducted by the artist into new areas of unexpected emotions is possibly the surest mark of genius. A composer learns how never to let his music come to what is called a perfect cadence until the very end. In his art, he leads his listener through a series of suspenses as though he were taking him through a succession of enchanted gardens. There is always another gate that opens until the last gate is finally reached, opening on the completed landscape.

We could also compare the short Schumann's melody below to an adventure in fishing. At (1) is a short stop on the bridge, while the melody temporarily rests on a semi-cadence: we know this cannot be a full stop, as the cadence ends on the dominant while the bass leads our fisherman across the bridge with the most dynamic interval—the second—to the other side of the river. In (2), a disguised cadence, he is already in view of his ideal spot and he finally reaches his final station (3) by an easy walk.

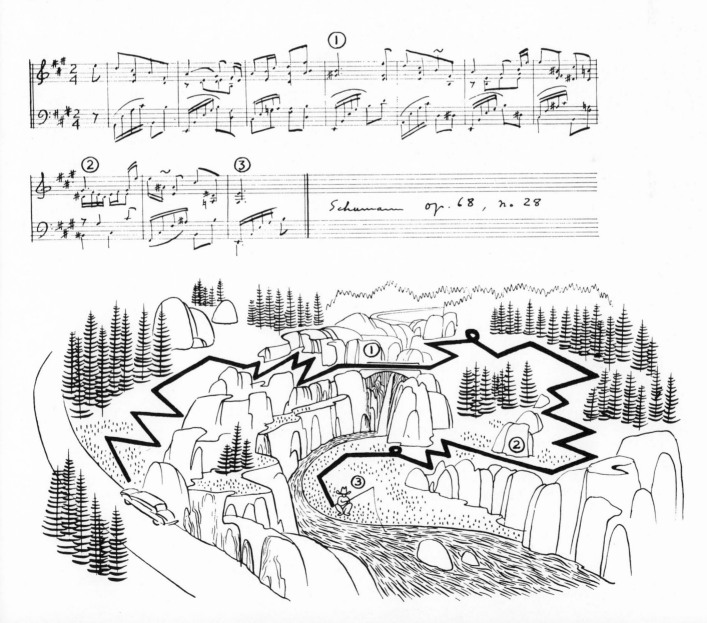

Schumann op. 68, n. 28

Lead nitrate crystals

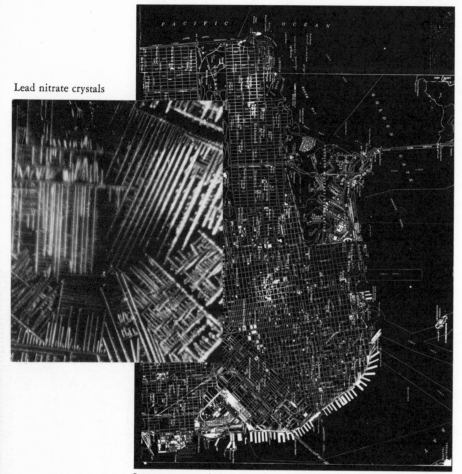

Street pattern of the city of San Francisco

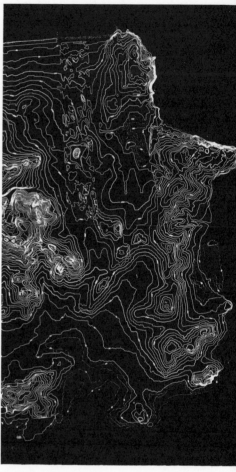

Geodesic contour of the city of San Francisco

XIX-XXTH CENTURY
CITY PLANNING

the contemporary city grows like crystal dendrites in a canvas of streets parallel to a few axis arbitrarily set once and for all, regardless of contour or denivellation of the land. The case of San Francisco is a remarkable example. No one would believe by only looking at the plan that the site is nothing but hills. Rio de Janeiro is another very striking example of the same type of abstract planning.

The *transit,* here, is the instrument responsible for this and so many artificial and absurd borderlines, from real estate lots to countries.

218

THE MEDIEVAL CITY

The friendly city of the Middle-Ages grew like a living organism. Its designers avoided all straight line. Like nerves and blood capillaries, streets and canals of Venice bring life through all parts of the city, and in this square mile of dense building, *from the Grand Canal, no spot is further than a thousand feet,* or a few minutes of gondola time.

The denivellation cannot be held responsible here for all this freedom, as the land is absolutely flat. The *Grand Canal,* in a superb S, is Main Street, but three times longer than modern engineering would have made it, making it close to all parts of the City in ever changing perspectives.

The analogy of this pattern with the pattern of dried mud cracks is striking: we shall analyze the reason later on, when we study the pattern of potential energy. This pattern of shortest distances to the main feed lines is also found in the blood capillary system, the circumvolutions of the brain tissue, the pattern of liver and kidney tissue, as well as the lungs. It expresses the easy and quick "irrigation" of all the cells of an organism by the vital flow of oxygen-loaded blood, and also the quick disposal of detritic material: it is the pattern of ideal *servicing* in any design made by nature, or by man

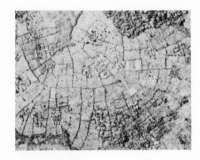

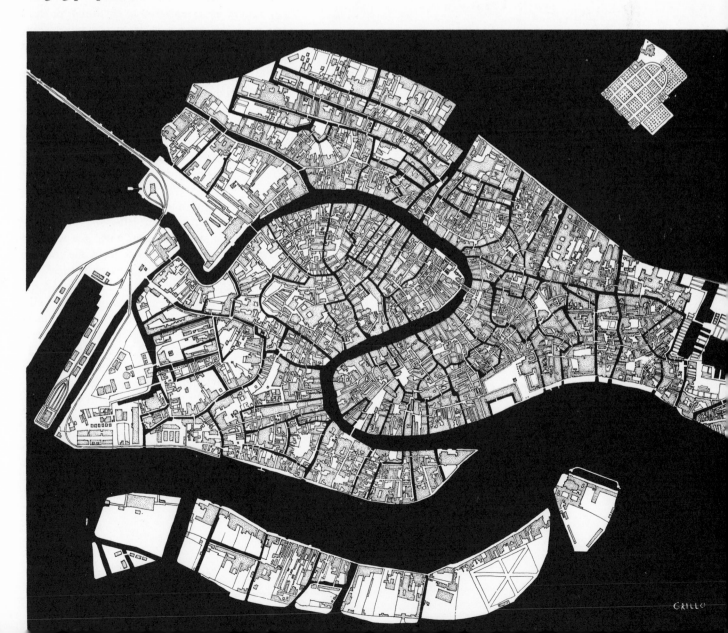

When planning occurs at various levels, ramps and stairs enter the picture, together with their mechanized cousins: elevators, escalators, shafts, and chutes, etc.

It remains that the design of ramps and stairs certainly is among the most difficult and also the most rarely well solved. Let us try to see why.

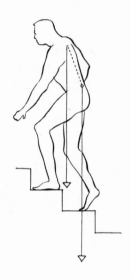

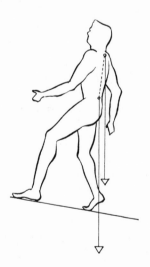

If we start our analysis with the *ramp* solution, we notice that it is coming more and more into use for two fallacious reasons: first, it is claimed to be the *safest* way, second, it is believed to be the *easiest* way.

The ramp actually is the most *tiring* type of circulation: not only does it increase the distance for the pedestrian to cover between two points, but it forces him to walk on a surface regularly sloped, which is *the most tiring kind of surface to walk upon*—whether up, or down—because it causes an undue strain on the back.

Walking is essentially a rhythmic process, composed of a succession of discontinuous steps. The propulsing effort is exerted during a very small fraction of a second, as the body is carried forward most of the time by the balance of its own weight in a resting position. As soon as we tread on a continuously sloping surface, our whole balance is changed as our propulsion tends to become continuous. This unusual shifting of our center of gravity *backwards* forces us to react by a continuous push forward from the back, calling to service muscles and ligaments that are not accustomed to give a continuous effort, and the result is a backache. The same thing happens for a similar reason when we work at a counter *at a certain distance* from the counter itself: the "toe space" that is now standard design in all cabinet work has no other reason for being. When we climb a mountain, we actually *scale* it, (the French call it an "escalade"), finding instinctively at every step for our feet a horizontal surface to climb upon. For a similar reason also, all alpine climbers know that going down is always more tiring than going up, because when climbing, the slow rhythmic motion of the climber allows him to choose his steps (he always looks *down* at his feet) while the quick pace of a descent does not allow him the same precision in the choice of his footing: as a result, he becomes *tense* by constantly trying to avoid the wrong landing, thus increasing a

fatigue that tells in his *back* when he reaches the valley. We all know that it is much more tiring to walk up for a long distance on a mountain highway even though its slope may only be 6%—than to climb a much greater distance on rough ground. Are not steep shortcuts preferred always to the "easier" roads?

As far as the factor of safety is concerned—in planning ramps for schools instead of stairs, for instance—we may wonder if the added expense of building a ramp requiring at least five times the development in plan of normal stairs, and the confusion, loitering, and loss of time resulting for the children, is worth a very doubtful safety gain. I never heard of a child breaking a bone or even twisting an ankle in school stairs any more than in running fast games atop the fenceless cliffs of the Irish shores of the Hopi mesas.

If we absolutely want to design ramps, let us limit their use to wheel chairs in institutions where the patient will actually *enjoy* a ride which the designer will plan as long and twisted as possible.

There is a saying that goes among frustrated clients that the architect may think of about everything in plan—but always forgets the stairway.

This quip has some truth in it. If stairways are rarely completely forgotten, they often are designed as an afterthought—or are not designed with the proper and *easy* rhythm that reduces the climbing effort and accident hazard to a minimum.

The stairway remains the oldest, most sensible—and easiest—way to join two levels. We may classify stairs into three types, keyed to the three main areas of *public* relation, *service,* and *privacy.*

The *public stairway* may be exterior or interior, as any other stairs, but in public areas, stairs should be as easy as possible, straight or in very easy curves, and cut with landings every six feet or less in height: their tread should be at least *twice* the height of each riser. Space in plan would thus provide for at least twice the height between two floors, *the tread never being less than one foot.*

The Chinese always design any important flight of stairs *uneven* in numbers. The liturgical requirements for the altar steps in a catholic church are that there would be *at least three,* and at any rate an *uneven* number. Although this may seem arbitrary, it makes much sense if we stop to consider that when we climb stairs, we always put the same foot forward. Some put forward the left foot, some start with the right foot. In either case, if the number of steps is uneven, you will land upstairs with the same foot you started with. The rhythm of your gait is thus not broken, and the fatigue is lessened. When going downstairs, the danger of tripping is also minimized. This becomes most important in military or religious ceremonials, where tripping or falling would ruin the dignity of the rites. Like in a most intricate ballet "combination", it is essential that the right foot should land at the right place at the right time. It is not sacrilegious to associate religion and ballet. We know that ritual dances have been associated with religion since time immemorial and still are a major part of religious rites. The rhythmic succession of movements and gestures involved in the celebration of the catholic mass, for instance, is in itself a sacred ballet combination fixed by centuries of precise tradition.

The single step should also be avoided in public areas for the same reason, when there is only a slight difference of level between two planes. A single step is difficult to see as it is unexpected. It causes tripping unless unwelcome signs (they have to be either large or luminescent) warn you in advance. Any difference of level should be equal to *three* steps (the uneven number again) as a minimum.

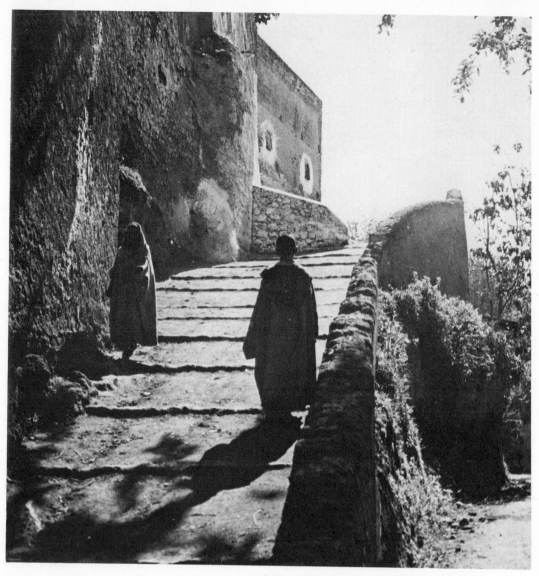

Stair road in Morocco. This kind of road makes an easy climb for pedestrians, while a ramp of the same slope soon becomes tiring

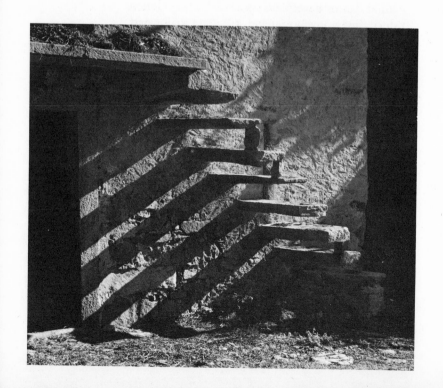

This archetype of cantilever steps (the one-man type of stairs) was designed by a Swiss farmer a long, long time ago. By many generations it preceded the "new" residential stairs designed today

In outside areas (garden stairs, terraces) treads may be wider than one foot, but never more than 18 inches, and the riser height should be diminished as the tread increases. We know that the average pace of people walking on horizontal ground is slightly less than three feet. This pace reduces quickly as the walk becomes a climb. For the same reason that we discard the single step as treacherous, we also discard the too low riser that is hardly noticeable and causes tripping. No riser should be less than 4 inches high. At this incline, the pace of a person climbing is reduced to about 18 inches, so that the step measuring 4x18 inches seems to be the lowest we can comfortably design.

In old towns, we often find "stair streets" made of very low steps 6 or more feet apart. Even though these were primarily designed for the normal gait of mules and horses, we find them easy to manage because we can make two steps on every "landing" and thus end up on every step with the other foot, thus keeping the rhythm of our walk unbroken.

Service stairs may have a steeper incline than public stairs, as in service areas speed of movement and economy of space are at a premium.

From the normal gait of a man walking on horizontal ground and covering about 2' 8" at each step—to the rope climber who goes up without moving horizontally at all—or the fireman who goes down by sliding on a pole—we find the whole range of oblique circulations.

As we incline the stairline toward the vertical, its width becomes smaller in proportion to its height. At the limit, we have the ladder, with its rungs one foot apart and almost vertical. Whether permanent (as in ships and reservoirs) or temporary (as in building construction), the ladder is a very important part of service circulations. But we find a gap between the most inclined ladder and the first stairs of steepest incline. This is because the movements involved in ladder climbing are of a completely different order from the ones used in stair climbing. We actually climb a ladder "on all fours", our arms actually working *more* than our legs (try just once to climb a ladder without the help of your arms . . .)—while stair climbing only calls the arms to the rescue to steady our balance, but not as a means of propulsion. The dutch houseboat stairs—or the medieval battlement triangular

step—composed of alternating half-steps that fit each foot in turn, is only a more comfortable type of ladder, as it actually fits the same incline. We may call it the permanent ladder for residential quarters—but be careful to start on the right foot.

Battlement stairs, after Viollet-le-duc

Then, as the incline decreases, we meet the first and steepest of all stairs, used for basements, utility rooms, etc., which follows a 45 degree incline. Tread and riser are then equal, but a nosing overhang is added to the tread so as to provide enough space to place the foot, unless the stairs are of the open type which is the best solution for this type.

In private areas, more fantasy is possible in stair design, as only the few people thoroughly familiar with the premises are to use them. More personal character may also be considered to fit the personality of the particular client.

Circular stairs, whether in open steel work or otherwise, are used to link a mezzanine office or a working room to another floor: This is the *singular* type of staircase, to be used by one person at a time. We can imagine an infinite number of variations of this fantasy, using all forms and conceptions. As long as the general law of human movement, balance, and rhythm, is complied with, fantasy will become an asset toward the general character of the design.

Now we have seen that mathematical work is not simply mechanical, that it could not be done by a machine, however perfect. It is not merely a question of applying rules, of making the most combinations possible according to certain fixed laws. The combinations so obtained would be exceedingly numerous, useless, and cumbersome. The true work of the inventor consists in choosing among these combinations so as to eliminate the useless ones or rather to avoid the trouble of making them, and the rules which must guide his choice are extremely fine and delicate. It is almost impossible to state them precisely; they are felt rather than formulated. Under these conditions, how can one imagine a sieve capable of channeling them mechanically?

It is certain that the combinations which present themselves to the mind in a sort of sudden illumination, after an unconscious working somewhat prolonged, are generally useful and fertile combinations, which seem the result of a first impression.

What is the cause that, among the thousand products of our unconscious activity, some are called to pass the threshold, while others remain below?

The useful combinations are precisely the most beautiful, I mean those best able to charm this special sensitivity that all mathematicians know, but of which the profane are so ignorant as often to be tempted to smile at it.

It is this special esthetic sensibility which plays the role of the delicate sieve of which I spoke, and that sufficiently explains why the one lacking it will never be a real creator.

HENRI POINCARÉ

Michelangelo.
Sistine Chapel

the idea

A spark is yet to come to transform the inert elements of design into a composition with a life of its own: the *Idea.*

The idea, suggested by the program, may be strong or weak, commonplace or brilliantly original, clever or poor. But *no creative work has any value if it does not represent an original idea.*

Imagination is more important than knowledge.
For knowledge is limited, whereas imagination
embraces the entire world, stimulating progress,
giving birth to evolution.

ALBERT EINSTEIN
On Science

IDEA AND PROGRESS

Idea comes from the greek εἰδεῖν, *to see.* It actually means the representation of a fact or a problem under a new light that suddenly makes it *clear* and *real* through the increased acuteness of vision that dawns on us as *the idea.* It is the exact definition of poetry as quoted from Jean Cocteau in the first part of this book: not the "unpractical veiled lady lazily resting on a cloud", but the sharp and sudden *realization* of a truth, the immediate and total *vision* of the solution to a problem, the *certitude* that suddenly comes to us that *we have been wrong all the time and that now, and from now on, we know what there is to be done to be right.*

As we can see, we are far from the conception of what we call today *idealism,* generally represented as a fuzzy netherworld where long-haired addicts struggle in utopian impossibilities. In the time of Plato, *idealism* had the strong meaning of a system of archetypal or basic ideas forming the foundation of the world around us. Today, in our gadget-conscious world, we are inclined to condemn as unpractical—thence useless if not even dangerous—all that still is in the pre-natal stage of industry. We stolidly admire the standard repetition of a door-knob as a tangible expression of progress (we can *handle* it, we *make* millions of them, etc.) without paying the slightest consideration or credit to the *idea* of the door knob, without which there would not be any door knob industry. The word "experiment" has become a password for doodling in fantasy, and if someone indulges too much of his time in experimenting, we call him inefficient and blame his waste of time on the fact that he does not really know what he is doing. We don't realize that for the great men who make our world, life is a constant succession of experiments, as the beaten path of routine no longer interest them, and all their ideas have to be re-adjusted, renewed, and dug up afresh from unploughed land every day. It is fortu-

nate that the creative urge is so great in man that the artist, the poet, the inventor, does not let himself be hindered by this misunderstanding of his immense role in the making of progress. Without his constant contribution to the world of ideas of all kinds, civilization would run dry and its idle motor would have to keep borrowing fuel from the past. We claim as an immense progress the world of mechanical reproduction of sound, for instance, that culminates today with binaural Hi-Fi soon to be completed by colored three-dimensional full-size TV. This type of progress is only equivalent to what we gain by using a typewriter instead of a pen. What we have to say will not be changed by the most exclusive and fastest type of electronic machine. Progress in culture and civilization still boils down to *what we have to say* and what creative ideas we bring forth to the world, *no matter how we say it.* The artist is tagged as unpractical and unrealistic. We cannot reconcile ourselves to the fact that these harmless freaks, merely tolerated by the hard-driving man of business, are in the end the most practical of realists, and many a business man would take it as a joke if we told him that his business would not even exist if it had not been invented in the first place by one of those very same freaks.

All shortcuts in design that are true *economy* are due to the work of the artist. I am not speaking here of the little gadgets "invented" by the man of small imagination or the "stylist" as meaningless variations on the chromium theme. I am talking about the truly revolutionary ideas that are sharp departures from accepted routine, ideas that are so different and so simple that they seem at first mad nonsense. I would even venture to quote such reputedly "useless" and "crazy" art as Picasso's, as the responsible agent for materializing many millions of dollars of income not in the actual sale of paintings, but in the

business of corporations and agencies: the world of business one day realized that Picasso, Braque, Dufy, born of the 1910 Revolt, and all the other unbearable super-fäuves of the 1910's had given with their "impossible" paintings the necessary food for bringing advertising art from its infancy of the '90's to its full contemporary maturity. Of course, who would have thought in the beginning of looking seriously at a Picasso painting as potential material for successful advertising art?

May be it all comes from the fact that *the artist has always tried to reach the impossible with the least visible effort, and thus when he does succeed, he makes the impossible practical, meaning within the reach of everybody.*

ART AND CRAFT

A work of art cannot be conceived without a certain mastery in craft. Craft, in turn, can be acquired by lessons, but must be ripened through experience. Every artist learns how to develop his own craft—what is also called his individual *technique.* But craft alone can exist without resulting in a work of art. We can say that craftsmen who obey all the rules of the game will rarely create a work of art, while *art is often the result of a masterly flouting of the rules.*

Examples of craft alone abound around us. Everyone likes to do things with his hands and has developed a certain skill in the craft he favors, but the majority of the do-it-yourself fans can never go further on the road of art. Their work may be well done—sometimes *extremely well*—but it lacks imagination and individuality and the innate sense of proportion and composition that only an artist fully possesses. The world of art lies beyond a kind of sound barrier that needs great daring to break through. Like the supersonic test pilot, the artist brings back to earth in his eyes the awesome beauty of a world for his fellow men to wonder about.

Art can only happen when the artist is carried away in total independence within reach of the impossible into a game where he is the only one to make the rules. It pre-supposes a total lack of inhibition or prejudice. An artist cannot afford the luxury of cynicism—he must believe in everything, everywhere, in every field of knowledge. In extremely rare instances can he even afford to belong to a cast, or a sect, or a creed without sacrificing a part of his universal vision. In art, creation comes first—then a theory is built up, more to explain the excellence and effectiveness of a certain accomplishment, than to establish rules to be followed by others. We all know that in the history of all art theories and schools, the initiator is always the only one that matters. The followers only attain second rate eminence. This brings in the concept of the artist as an absolute individual. Teamwork is excellent in business and football—it rarely works in art.

Renowned craftsmen are usually poor artists, and it is also often true that artists are rarely excellent craftsmen; they rarely fall in love with material perfection, since when a work is almost completed, they are already thinking of their new experiment with the next one.

In comparing an oil painting done by an experienced house-painter and a Vinci, it is most probable that the house-painter's work will last

Silver table ornament "decorating" (?) the coronation banquet table of Tsar Nicholas II

Pulpit in the Church
St. Andrew, Antwerp

228

longer, as far as the durability of paint and pigments is concerned, even though it has nothing of a work of art.

We come here to the point of general appreciation of a work of art by its materialistic value, represented by the amount of time spent in *finishing* it to material perfection. *The amount of time spent on any work of art has very little to do, if anything at all, with its artistic value.*

Often the error of public opinion is to judge a work of art by the time and patience spent on producing it. As a result, we have *domestic art,* this permanent exhibit at home of little monsterpieces of acrobatic work that we all know so well and are better known as *conversation pieces:* the microscopic miniature that shows no flaw even under a 10x magnifying glass ("How can they do it?"), the portrait done in mosaics and that looks exactly like the kodachrome that served as a model ("Those people are *such* artists!"), the reproduction actually sculptured in wood of a German castle (the original itself being already a fantasy of the Medieval castle theme designed by "architects" of the time of Wilhelm II) with windows and midget lights inside that blink at will with switch and all. These are masterpieces of a craftsman's patience, but they are not *art.*

Another misconception has taken hold of the mind of the public. Art, often seemingly conceived in a moment, sounds so *easy.* What artist has not heard at least once a year from his immediate friends and relatives the casual request for "a little sketch that you will do so well and so fast, you know?" What does not show on the "little sketch" are the hours, days, and sleepless nights when nothing seems to materialize, no idea of value, when the artist carries within himself unknown possibilities yet to be born, as monsters or supreme masterpieces.

The concept of *time*—although such a relative idea—has taken such a hold on us that we cannot admit that a work done in the fire of genius within a couple of days may be more valuable and requires more substance from a man than a whole life of work ploughed through the rhythm of time clocks and punch cards. Mozart did the Magic Flute in one night. So what? it was *easy* for him! We are apt to marvel at how little *time* he spent to conceive his masterpieces as more astonishing than the intrinsic value of the work itself. We ignore the rest of the picture: the early death in misery, his hectic and miserable life on earth, and only remember the glimpses of musical wonder he brought down to us from his few hours spent beyond the sound barrier, in the crystalline and cloudless kingdom of a million stars. Shall we forget also the time spent in preparing his mission, in waiting for the take-off, and only count his harvest of light?

Please, Mozart, another little sketch like the "Flute": take your wings, go beyond and back, and bring us some more of this stardust that you are so good at finding. . . .

THE BIRTH OF THE CREATIVE IDEA

It is most difficult to analyze how and why a workable idea comes into being. It may come as the result of hours and days of fruitless work. It may strike like lightning without any effort. But as a rule, there is much truth in the recipe sometimes given for art: 1% inspiration—99% perspiration.

Even when an idea comes with seemingly little effort, it is always the result of a great subconscious tension of the mind that makes it analyze all the facets of a problem and finally delivers the solution in the exquisite labors of birth.

The greatest and most fruitful ideas are not inventions of detail, gadgets, or small variations on a known theme (what we call *clichés*). Really great ideas are always *radical*—and characterized by great simplicity.

In design, the idea usually comes after a break in the process of thinking, when the artist comes back refreshed to his work and sees it under another light. Too much concentration on on a problem may end up in a kind of hypnosis that dulls all faculties of reasoning and makes the coming of new thoughts impossible. This is why the most valuable time for the idea to take

form is when, for the first time, we receive the full impact of a program, as we read it or hear it for the first time. We all know the importance of the first impression, that may shape up our whole opinion of an individual for years to come. It rarely proves wrong. Often in design, we shift away from this first idea in the process of study that may seem to prove the incorrectness of our first shock idea, but still more often do we come back to our first thought and try to reconcile the results of study and development with the dashing fellow that captured our attention at the very beginning of our work.

Ideas of all kinds may come to our minds, but how do we know how to choose the only one that will prove valuable? In other words, when can we say that a design idea is good, or bad? We know how difficult it is for us to give the reasons for our choice. The best way out would be to say—as we hear it so often said—"Oh, well, everybody has a right to his own opinion.

What someone else likes, I may not like. All tastes are in nature," and so on.

Still there are a few very simple cues to guide our judgment. What are these basic criteria for good design?

We have met with some of them, as imposed by nature and its laws. They are strong, and merciless. If we want any building to stand up, we had better follow them closely.

The others, that seem to be independent from any of the laws of nature, boil down to the principle of unity. Whether in materials, climatic design, or orientation, form and proportion, it is the same story told in various languages all around the earth.

In the final analysis, the authenticity and the elegance of a solution in design as well as in mathematics, are the surest signs of genius. We shall end this chapter by explaining this statement.

FUNCTION + CHARACTER = AUTHENTICITY

We may safely say that function is the main criterium of any design, if we care to give to the word *function* its widest sense, of something that *works* not so much as a plumbing fixture but as *fulfilling an intention.* If a terror movie ends by making people laugh, it does not work—hence it is a flop in design. But if it succeeds in scaring the life out of its audience, it works—and it is, in its own way, certainly a work of art.

The simile with the human body is an easy example: since Darwin, the slogan *"function creates the organ"* has been the much abused password for excusing everything. We all know that the proportions and disposition of the various organs of the human body are the magnificent result of their function. And we also know that in spite of—or rather because of—this completely and strictly functional reason for proportion, the human body has always been the choice subject for painters.

We should then agree that all design, to be good, must be "functional". Whatever is not functional is a cancer that destroys the best parts

of the work. But let's ask this question: is *fun* functional? And shall we discard it because we cannot see its "practical" and "efficient" reason for being, as compared with bathtubs, motors, and refrigerators?

We come here to the most common misinterpretation of the word *function* in all design. We seem to apply it more to describe the mechanical parts of a program, such as plumbing, etc., and forget too easily that unless the function covers *the entire activity* concerned in a program, it is meaningless.

To be functional in design does not mean to be mechanical at all cost. *Some* aspects of function are mechanical, *but the most important, and the most difficult to define are not.*

Let us go back to the two parallel programs of Versailles and the Escorial. In both palaces, the king's bedroom is fitted with the essentials that the function of any bedroom of the time required: a bed, windows, drapes, seats, wardrobe, a fireplace. We certainly could call very unfunctional and unpractical the plumbing and heating

design of such bedrooms as compared with any hotel bedroom of today. In other words, the design is a complete failure if we base our criticism on purely mechanical efficiency. But if we go a little further than the plumbing catalogue, we discover that in both plans, the bedroom design—its location, its proportion, etc., perfectly fits the function stated by the program: in Versailles, the bedroom lies right in the very center of the composition, while the chapel is on the side. This disposition was to fit the function of Louis XIV as the Sun King, who considered himself more important than God—at least in the planning of his residence.

In the Escorial, the bedroom is designed to fit the function of Philip II as His Very Catholic Majesty of Spain: in the center of the composition lies a tremendous church, while the Emperor's bedroom is just another monk's cell on some obscure corridor of the grill-shaped plan. Here the bedroom fits its function of *humility;* in Versailles, it fits the function of *pride.*

We come here to the border of function and character. Does function create character, or is character the reason for function? It is just like asking if it is the egg that made the chicken, or the chicken that made the egg.

I know of a friend of my younger years who used to condemn Versailles in one sweeping statement which, for him, was without appeal and should close any further discussion. He said that the floors squeaked. And whoever heard of a residence worthy of its name with squeaky floors?

This detailmania is carried along as a curse by most criticism today. The essential is left aside, and the work judged on the detail, or the finish. The most irritating question that is shot at any designer today by friends who look at his work is certainly the unavoidable—"What finish did you use on the wood—or the stone—or the metal". The essential of the design is left aside, but the finish—ah!—the kind of paint, varnish, powder, or lipstick that shall cover or color the genuine beauty of material and form—that is what *really* matters! . . .

Man has gone through the stone age, the bronze age, and others ever since, to reach the plumbing age. We seem now to have entered the cosmetic age.

Character and function cannot be disconnected. They are always completely interlocked with each other in all design, and must always be considered together.

That a building has character is the greatest achievement in any work of architecture, and the very goal to aim at in design. Structure should obey the form and space requirement imposed by the program, but it should always be considered as the most powerful contribution toward character in all design. Too often we see a divorce between a structure used in a composition and its function-characteristics: *thin shell* forms, for instance, indicate the geometrical perfection of a surface of transcendental character, and create a highly imaginative space that may fit a church, but they do not fit the space characteristic of the function of a factory. On the contrary, open joist *truss* structure is of a character that perfectly fits an industrial building, but is hardly acceptable in church design.

The pitfall of the kind of design where mechanical and structural function is divorced from character, is to create in the end, buildings that all look alike: hospitals that look like factories, churches that look like hospitals, restaurants that look like shoe stores, and vice versa. This international and interchangeable style of design was considered not so long ago—and still often is today—as the final solution to all design. *It is only another style,* and as such possesses the artificial and dictatorial character of all styles, without having true *style.* It only brings to design the kind of solution a dictatorial government brings to society. We know that buildings are planned for very definite and varied activities. To design them all alike is an insult to the dignity of man, whose essence is individualism. Of course, it is *much more difficult* to find an individual expression to fit every kind of activity, than to repeat the same formula for all. But is this not precisely the role of the designer?

The character of the activity that is to take place in a building should find its expression in the whole design: structure, planning of areas, layout of circulations, materials and decoration. There should not be any doubt about its function, when looking at it from any angle, inside, or out.

Again, this does not mean character *in detail*. Detail, as always, is secondary, although it should never be overlooked. No added decor or detail borrowed from the attic of history will add to the character of design. Because most churches were built when the gothic language of design was in use, does not mean that gothic *detail* should represent religious character today.

Character must radiate from the design of general forms and space. An insistence on *horizontal* lines will convey the idea of peace and quiet, and be welcome in any residential problem, from hotel to hospital—while *verticals* will bring in a feeling of power and dynamism that grips the senses of any newcomer in down town New York. From the blind walls behind which are stored the collections of a major library (New York Public Library as seen from the West Side—Bibliothèque St. Genevieve in Paris, etc.) come the character of a library building —not from the impressive flights of stairs, the neo-greek columns and the bored lions that may "grace" the main entrance. A northern wall of glass will dramatize people at work, either in factory or office building—or school.

Character and function add up to *authenticity,* the most serious compliment that can be bestowed upon any work of art. We all are familiar with un-authenticity in art: the Viennese waltz "arranged" for jazz band—the Calypso sung and danced by native New Yorkers—the New York Broadway tune played by a French accordionist, etc. We are also familiar with the fake negro art done by white artists—and vice-versa. We have also seen the language of gothic detail used in contemporary religious work and other translations of authentic works of art in different times and idioms that are all nothing but treasons. Art, like most plants, will not bear fruit unless raised in the very particular soil mixture that fits its original temperament. It needs a total harmony with its environment.

Have you looked at a modern airplane? Have you followed from year to year the evolution of its lines? Have you ever thought, not only about the airplane but about whatever man builds, that all of man's industrial efforts, all his computations and calculations, all the nights spent over working drawings and blue prints, invariably culminate in the production of a thing whose soul and guiding principle is the ultimate principle of simplicity?

It is as if there were a natural law which ordained that to achieve this end, to refine the curve of a piece of furniture, or a ship's keel, or the fuselage of an airplane, until gradually it partakes of the elementary purity of the curve of a human breast or shoulder, there must be the experimentation of several generations of craftsmen. In anything at all, perfection is finally attained not when there is no longer anything to add, but when there is no longer anything to take away, when a body has been stripped down to its nakedness.

ANTOINE DE SAINT EXUPERY
Wind, Sand and Stars

Someone has said, *"the artist who copies his own work is already a thief.* This claims absolute originality as an eminent quality of art—or at least claims for art the necessity to renew itself in every work.

But true originality must not be mistaken for bizarre effects obtained in forcing one's talent, or the exotic use of elements borrowed from another time, place, or idiom.

To be original does not mean to be queer or bizarre. Originality at all cost—just for the sake of being different from the neighbour or for making the headlines—is only a disease of the personality, the complex of a frustrated mind which cannot indeed create original work. A person may force attention in two ways—for one, he may ride up Broadway on a white horse backwards and clad in armor—for another, he may ride in a car and his street clothes, like everybody else, and be ticker-taped with fame if he happens to have been the first to cross the Atlantic by plane. And we know that only the second way is the way of art.

The most common expression of fake originality is to cling to oddities, borrowed from the repertory of memories that every man carries in himself. The designer's mind is like an attic where odds and ends are pigeonholed, unwelcome remnants of past experiences and travels, clichés from current magazines, caught in the spider web of memory. His most difficult feat of courage is not to yield to the temptation of using at least some part of this paraphernalia, as it is easier for him to dig his elements from the old reserve than to plough afresh a new crop of details that would exactly fit his special problem of the day. You know what I mean: the spinning-wheels transformed by a decorator's trick into a chandelier, the ship-model sailing briskly on the mantlepiece with a clock amidship, the cider jug turned into a lamp, etc. Lamps, in particular, have the remarkable propensity for being made of practically everything. A book could be written on *the lamp*—not as a source of light, but as the suburban home picture window center piece. It has replaced in the family "decoralia", the globe that used to shelter from dust and decay the orange blossom crown from the wedding,

and other cherished souvenirs. The glass globe has been changed into a wrapping of cellophane and the symbol of wedlock has become The Lamp. It is really uncanny what you may use as a lamp stand. We have mentioned the cider jug as the most obvious—but just think of anything else, and it will do—including the old kerosene lamps wired today for electricity through the now useless colored glass container.

This game of playing with travel curios, hobby horses and travel memories, is the temptation number one to avoid in any design. It leads to the most obviously bad design that can be found anywhere. The use of remnants and left-overs may be the culmination of art in cooking, but *only* in cooking.

Avoid the utilization of any element borrowed from another field or period of design, unless it is to fulfill the same function in the same manner. If you *need* a kerosene lamp, use an old one by all means, since when there was nothing else but kerosene, designers concentrated their efforts in making the best kerosene lamp—but never defile a kerosene lamp by wiring it for electric light.

Simplicity—a virtue so rare and essential in design, does not mean want or poverty. It does not mean the absence of any decor, or absolute nudity. It only means that the decor should belong intimately to the design proper, and that anything foreign to it should be taken away. It is not the cherry on top of an already well-rounded-off sundae that is its decor. But it is the frosting on an éclair, the steam on a cup of coffee, and the frost on the outside of a glass of mint julep. True decor cannot be disconnected from the rest of the subject without destroying its whole charm. Decor must be consistent and totally integrated with the whole design story. It should never be the excuse for exciting doubtful interest. The quality (?) of *being interesting* is too often given as reason for inconsistent design. One designer will put in his drawing a vertical window in the middle of a façade otherwise characterized by horizontal openings, just to create a so-called *effect* or interest. Another will cut open the overhang of a roof into an

open grid because he thinks it makes it interesting. Another will bring into the plan a strange curve without any other rhyme nor reason than —says he—to *add interest*. All these inconsistent *mannerisms* are the cancerous tissue of design; they must be removed by radical surgery before they contaminate and deface the whole organism.

The real truth is that *everybody is afraid of honest simplicity, because it hides nothing*. From the Middle Ages onward, people kept hiding their bodies under more and more clothes—the fancier the better—as their own structure was losing harmony and proportion as less and less importance was given to sports. The Greek and all Antique civilizations were not afraid of nudity, because their own build was sound. Their body was a work of art without any need for the added decor of drapery and fashionably cut clothes. Architectural decor also was, in all such civilizations, confined to the essential. The sculptured and painted decor was actually an integrate part of the structure, like the statues that guard the entrance of Abu Simbel, or the Greek Caryatides of the Erechteion.

It is very remarkable that, after the orgy of bad decor (together with bad taste in over-clothing) that characterized the end of the 19th century—the century when it was fashionable to die of consumption—came the clean-up of the old attic and the apology of bare walls, as well as a return toward the Greek ideal of athletic build-up through outdoor games and sports. Symptomatic of this change is the fact that, today, the "fashionable" way of dying is by the death of the athlete—a heart attack. Since they had to expose their bodies to sun and sight, people kept clean and tried to show themselves at their best. No wonder that architectural design —and generally speaking *all* design—was to benefit by this revolution in thinking, and did its own clean-up job.

In good design, the work of the painter and the sculptor is part of the whole. It cannot be disconnected from it without badly hurting the whole composition. In the 19th century, painters and sculptors alike were called on the job when the architectural game was up and the walls built without much regard to what was to cover them. The artists called in to finish the work then had to make the decision as to where their work would fit, much in the same manner as they would have chosen in a museum or an exhibition, the right spot to hang up their easel work. This explains some of the incredible mistakes made in those days—murals painted *behind* a colonnade or *above* a marquee, thus cutting the work in pieces like pepperoni, or showing to the passers-by only the heads of the painted figures, like in some kind of a swimming contest.

Art being essentially a one-man affair, collaboration between artists of great talent is not always successful, just as an excellent string quartet is the rarest of all musical ventures.

However, this way of working was everyday bread and butter for the artist of the Middle Ages. Their cathedrals show the most complete integration of all arts in a single building, as, in such an extraordinary symposium of all arts, even *music* is part of the composition.

This consistency in art was forgotten during decadent periods where art stuttered in a series of closed and repetitious chapters like the serials of a soap opera, and where the painter was kicked back to his easel and art gallery, the sculptor to his studio and museum.

Interest cannot be created by multiplying various elements into a busy design. By dispersing points of interest, we only create confusion by conflicting effects that, in the end, give no impression at all.

It is a rule in advertising never to bring more than one idea at once into a poster, display, or slogan. 5&10¢ stores jam their windows with an accumulation of all sorts of goods, not so much to sell each one separately but so as to create the impression of an extremely busy sale. They don't need to advertise with discrimination, as their daily sales are as sure as the daily needs of people for the inexpensive and necessary kind of goods that is their business. But the higher we go into the expensive and "unnecessary" luxury business, the more restraint is shown in the window display, and the less "busy" their show windows will be to entice the customer. The most valuable item of *interest* is always shown alone, and often a whole window is devoted to show it off all by itself—as is witnessed by the display of expensive perfume and jewelry.

As a conclusion, this brings the necessity of weaving architectural composition with strands

of all arts, intimately *woven* into a design like an oriental rug, and not *applied* afterwards like a printed fabric. It makes the work design-fast, and the most detergent criticism can never wash it off.

We arrive now at the last criticism of design which comes as a result of both originality and simplicity. This is what the mathematician calls *elegance* in a solution—not in the sensed abused by the language of fashion, but in the sense of the unique solution, so simple and so original that all others look cumbersome and awkward next to it, like an over-dressed and dowdy tourist would look next to an authentic native in his unique attire. We are also familiar with this concept of elegance in the field of commercial and mechanical design, where we see how unelegant and complicated the first machines (locomotives, airplanes, etc.) were, if we compare them to their better designed relatives of today. We also feel that we can *now* call these *beautiful*, as they have reached a true natural simplicity; before, we certainly admired them, but as manifestations of human ingenuity and achievement—and not for their "beauty".

The more we analyze the concept of beauty in design, the more we are led toward natural forms. We know, however, that we cannot copy nature in our man-made designs; everytime it has happened, it has ended up in sensational failures —what we call the *naturalistic* styles. But we also know that when a man-made design has achieved beauty, it has become in its own right another natural creation that belongs in its totality to the world around us, as normally as a plant, a rock, or a cloud.

Art then cannot afford mediocrity or awkwardness. The solution it offers to any program, in any field, must be of such obvious and simple elegance as to render all others inadequate. It must give the impression of *necessity and sufficience,* like a theorem of mathematics: as necessary as water and food, and—like water and food—as satisfying.

Possibly this is the reason why no one on earth is so organized as to be able to live without art, while we can easily live and be happy without the mechanical necessities of what we call progress.

☆

We might sum up this study of design by these three rules that stem from all that precedes:

1. Our source of inspiration should be found in *nature,* but nature should always stay as a source of inspiration and not as a direct model to *copy.* The error of copying nature blindly never evolved into great art.

2. Adding to the direct study of nature, we should also find our inspiration in the *arche-types,* elemental solutions of design evolved from the study of nature by the generations before us of simple minded, straightforward, and sensitive people.

3. We must be of our time and never borrow from the language of the past. The monuments of the past should be considered as reminders of their time and milestones of universal art— never as examples to be copied.

These are our only guides in the extraordinary and superb adventure that we call *design*.

Acknowledgments

The author extends his thanks and acknowledgments to the authors, publishers, and copyright holders whose illustrations have been reproduced in this book or have served as bases for some of the drawings, as noted in the following list: all illustrations not mentioned in this list are by the author.

Page

10 "Jeep" Universal, Model CJ5 1960, drawing courtesy Willys Motors, Inc., Toledo, Ohio.

15 Iceberg in the North Atlantic. Photo Herbert O. Johansen, courtesy *Popular Science Magazine*, New York 1955.

21 Paris Exposition 1937, Editions Art et Architecture.

24 Naarden, Holland. Photo *KLM Aerocarto Ltd*, Amsterdam.

26 Earthenware from Cyprus, Louvre Museum, Paris. *Encyclopédie Photographique de l'Art*, Editions TEL, Paris 1938.

27 X-ray of a shell, by Konescny. Courtesy Elkhart Hospital.

36 Pyramid of Cheops, Photo Chicago Oriental Institute.

39 Project for an Olympic stadium in Rio de Janeiro by Oscar Niemeyer. From *the Works of Oscar Niemeyer*, by Stamo Papadaki, Reinhold, New York 1954.

41 Spiral nebula 18 NGC 3031, Messier 81. 200 inch photograph courtesy Mr. Wilson—Palomar observatories.

Votive stela from Cyprus—VIth century BC. The Cesnola Collection, purchased by subscription 1874-76. The Metropolitan Museum of Art, New York.

42 Electron density projection diagram of Adenine Hydrochloride. Courtesy *Acta Crystallographica*, Copenhagen 1953.

43 Geodesic film of Angel Island. Geological Survey, U.S. Department of the Interior.

Analytic curve of flow. After Frank Morley, *Inversive Geometry*, Ginn & Co., Boston 1933.

Thracia trapezoides and Cimitaria species. After Geological Survey, U.S. Department of the Interior.

45 Bouquet basket of bleached bamboo, by Shounasi. From Harumichi Kitao, *Formation of Bamboo*, Shokokusha, Tokyo 1958.

46-47 Pristis zijsron (Photo Cluton), Ganges Shark (after Muller and Henle), Ox Ray (Photo Roughley), and Daemomanta alfredi (After Whitley), from G. P. Whitley *The Fishes of Australia*, The Royal Zoological Society of New South Wales, Sydney 1940.

McDonnell Voodoo F-101A (1954), Vulcan medium bomber VX-777 (1952), Northrop experimental bomber YB-49 (1947), Horton twin-jet fighter bomber HO-IX V-2 (1945), From William Green and Roy Cross, *The Jet Aircraft of the World*, Hanover House, New York 1955.

V-2 Corporal Rocket, from Willy Ley, *Rockets, Missiles & Space Travel*, The Viking Press, New York 1945.

49 The Coanda Turbo-Jet (1910). Photo courtesy Henry Coanda.

56-57 Nagoya Castle and Nijo Castle, photos Sato. From Arthur Drexler, *The Architecture of Japan*, The Museum of Modern Art, New York 1955.

Crocodylus palustris, photo Zoological Society of Philadelphia, and Cayman sclerops, photo Medem, courtesy Clifford H. Pope, *The Reptile World*, Knopf, New York 1955.

Inca wall in Cuzco, Peru, from G.H.S. Bushnell, *Peru*, Frederick A. Praeger, New York 1957.

58 Coutances and Chartres cathedrals, photos courtesy French Government Tourist Office.

61 Earthen hut in the Cameroons, from *L'Habitat au Cameroun*, courtesy Office de la Recherche Scientifique et Technique Outre-Mer (ORSTOM), Paris 1952.

65 Bamikele store house, plan section and construction detail, from *L'Habitat au Cameroun*, courtesy ORSTOM, Paris 1952.

67 The Garabit bridge, by Gustave Eiffel, after *Le Magasin Pittoresque*, Paris 1886.

68 Window wall in the author's home. Photo courtesy Maurice Frink.

70 Shipyard at Toulon, from Claude Farrère, *Navires*, Hachette Paris 1936.

72 S. Maria in Cosmedin, mosaic detail. Photo Alinari.

81 Tambu and group of Santa-Ana natives, Solomon Archipelago. From Elysée Reclus, *The Earth and its Inhabitants*, Appleton-Century-Crofts, New York 1890.

87 The Shoden, Ise Shrine, Japan, from Arthur Drexler, *The Architecture of Japan*, The Museum of Modern Art, New York 1955.

97 Agriopodes Fallax. From Alexander B. Klots, *The World of Butterflies and Moths*, Horizons de France, Paris.

98 Mt. St. Michel and St. Michel d'Aguilhe, from old photographs.

99 Vézelay Photo Jean Roubier.

Roya Valley. Photo courtesy French Government Tourist Office.

Monastery, Sinai peninsula. Photo courtesy Frank Montana.

101 Clouds, photo courtesy John Grillo.

107 Village at the foot of Mt. Fuji, Japan. From Jiro Harada, *Japanese architecture*, The Studio Publications Inc., New York 1936.

109 Fragment of the Turgot plan of Paris (1660).

111 Limousine (1905). From A. Parmentier, *Album Historique*, Armand Colin, Paris 1907.

112 Stone age Nuraghi settlement in Sicily.
Pile dwelling, Federseemoor, Wurtemberg. After Schmidt, *Jungsteinzeit-Siedlungen im Federseemoor*.

116 Vincent Van Gogh, courtyard of a prison, after Gustave Doré. Museum of Modern Art, Moscow. From *Van Gogh*, Phaidon, Paris 1945.

118 Hotel Latitude 43, St. Tropez, France, courtesy Pingusson, architect.

119 Grevasalvas, Oberengadin. Photo courtesy Albert Steiner, from G. H. Kidder Smith, *Switzerland Builds*, Reinhold, New York 1950.

120 Hyacinthus Africanus. From J. Commelin, *Horti medici Amstelodamensis rariorum tam orientalis,* Amsterdam 1697.

123 De admirabili proportione orbium coelestium, from Johannes Kepler, *Mysterium Cosmographicum* Vol. I of *Johannes Kepler Gesammelte Werke.* courtesy C. H. Beck'sche Verlagsbuchhandlung, München 1938.

125 Detail from Luca Signorelli, *Birth of John the Baptist,* Louvre Museum. Photo Giraudon.

128 Welder at work. Courtesy Hobart Bros. Co.
Amon-Ra, detail of statue. Louvre. Eighteen Dynasty. Photo Giraudon.

129 Welding helmets, drawn by C. Koester.
Medieval helmets, after Viollet-Le Duc.

130 Room in the Kobuntei, Tokiwa Koyen, Mito. From Jiro Harada, *Japanese Architecture,* The Studio Publications Inc., New York 1936.

131 Dinkelsbuhl, Germany. Photo courtesy Otto Seeler.

132 The Carolers. By Charles Addams, *The New Yorker Magazine,* 1946.

133 Raffles Place. Photo courtesy Ministry of Culture, Singapore.

134 Detail from Paul Bigot, *Rome Antique,* Vincent Fréal, Paris 1942.
China, Honan, subterranean dwellings, from Count Zu Castell, *Chinaflug.*
Court of the great Mosk in Damas, Syria. Photo courtesy Frank Montana.

135 The Tschihil Sutun, Ispahan. From Gustave Le Bon, *La Civilization des Arabes,* after a drawing by Coste. Firmin-Didot, Paris 1884.

138 S. Appolinare in Classe. Photo courtesy Frank Montana.
St. Chapelle, Paris. Photo courtesy French Government Tourist office.

140 Chateau de Chenonceaux. Photo courtesy Frank Montana.
Romanesque house at Cluny. After Gailhabaud.

150 Fountain in Damas, Syria. Photo courtesy Frank Montana.

151 Fountain, Liége, Water World Fair (1935)· Photo courtesy Frank Montana.

152 Plans of tea houses, from Arthur Drexler, *The Architecture of Japan,* The Museum of Modern Art, New York 1955.

154 Fragment from Bach's manuscript of the *Chaconne for unaccompanied violin.* Courtesy Messrs. Breitkopf & Härtel, from the Leipsig Edition of *The Works of Bach.*
East Frieze of the Parthenon, fragment. British Museum. Photo Mazulle, London.

155 Detail of fragment of Poncho in tapestry weave, Coast Tiahuanaco, Peru. Photo courtesy Nickolas Muray. Museum of Primitive Art, New York.

169 Complete chart of stereograms of the 32 crystal classes, from F. C. Phillips, *An Introduction to Crystallography,* Longmans, Green and Co., New York 1946.

171 Fragment from the Beethoven manuscript of the *violin sonata in G.* The Pierpont Morgan Library, New York.

173 Wood relief from the tomb of Hesiré, Cairo Museum. Photo Hirmer Verlag, Munchen.

175 Drainage pattern in tidal mud flats near Yarmouth, Nova Scotia. Courtesy photo Royal Canadian Air Force.

176 Drawing from Georges Braque's notebook. Courtesy Georges Braque. Verve, Paris 1955.
Geometrical drawings after D. Hilbert and S. Cohn-Vossen, *Geometry and the Imagination,* Chelsea Publishing Co., New York 1952, and after Vigodskyi, *Differentsial'naya Geometriya,* Gosydarstvennoye Izdatel'stvo Tekhniko-Teoreticheskoi Literaturei, Moscow 1949.
Baluba mask, after a photograph from the Ratton collection.

177 The Buffalo Hunter, Santa Barbara Museum.
Botticelli, *Spring,* Fragment. Uffizi, Florence.

178 Ko Yao Vase, Ming Dynasty. Thiel Collection. From A.W.R. Thiel, *Chinese pottery and stoneware,* Borden Publishing Co., Los Angeles 1953.
Whale. Engraving. Skogervein, Buskerud, Norway.
From Johannes Maringer and Hans-Georg Bandi, *Art in the Ice Age,* Frederick A Praeger, New York 1953.

179 Head, from Georges Braque's Notebook. Courtesy Georges Braque, Verve, Paris 1955.
Woolly-haired rhinoceros, Font-de-Gaume, Dordogne. After Breuil. From Johannes Maringer and Hans-Georg Bandi, *Art in the Ice Age,* Frederick A. Praeger, New York 1953.

180 Dent de Burgin, Meribel, France. Photo courtesy Serrailler.

183 Circus Maximus, Rome, after Rodolfo Lanciani.
Circus Maximus, Rome, after Paul Bigot.

185 Bobsleigh run and typical curves used in bobsleigh racing track design, courtesy Louis St. Calbre.

186 Sandia Mountain Area, New Mexico. Photo courtesy Geological Survey, U.S. Department of the Interior.
Great Sand Dunes National Monument, Colorado. Photo courtesy Geological Survey, U.S. Department of the Interior.

187 The Lamont Harp, from *Famous Composers and their Music,* J. B. Millet Company, Boston 1901.
Cape St. George, Florida. Photo courtesy Geological Survey, U.S. Department of the Interior.

189 Crowd. Photo Brown.

Page

194 House by Emilio Terry, after *Art et Industrie*, Paris 1948.

House by Andrea Palladio, from Durand.

197 Fragment from the Turgot plan of Paris.

198 Detail from the plan of Rome by Piranesi.

199 Fragment from a poster describing the entertaining "routine" of Sieur Brila, a celebrated acrobat of the 17th century. From *Le Magasin Pittoresque*.

Pelvis bones from prehistoric birds and reptiles, after William K. Gregory, *Evolution Emerging*, The Macmillan Co. and the American Museum of Natural History, New York 1951.

200 Farmstead of the Massa tribe, Cameroons. From *l'Habitat au Cameroun*, ORSTOM Paris 1952.

Hotel in Sestrières, Italy. Bonadé Bottino, architect.

Red Rocks Amphitheater, Denver, Colorado. Burnham Hoyt, architect.

Slave ship. From Claude Farrère, *Navires*, Hachette, Paris 1935.

201 Roman camp after Polybius, from Daremberg and Saglio, *Dictionnaire des Antiquités grecques et romaines*, Hachette, Paris 1873.

203 Part of the town of Palaecastro, after Bosanquet and Dawkins, Palaecastro excavations, 1923.

Fontanella al Monte, Bergamo. From Arthur K. Porter, *Lombard Architecture*, Yale University Press, Newhaven 1915.

208 Floor layout in the Goldman Department store, Pittsburgh. From Louis Parnes, *Planning Stores That Pay*, F. W. Dodge Corporation, Corporation, New York 1948.

211 Rio de Janeiro 1900. From *Les Merveilles du Monde*, Hachette 1905.

Rio de Janeiro 1950. Photo Viollet.

Chart of the visual displacement of stellar positions due to the Einstein Effect. From Pierre Salet, *Bulletin de la Société Astronomique de France*, Paris 1924.

212-213 Spade-ard from Denmark.

Fish hooks and sickles, prehistoric Norway, from Harold J. Peake, *Early Steps in Human Progress*, Lippincott Co., Philadelphia 1933.

Slüssen, Stockholm. From Louis Parnes, *Planning Stores That Pay*, F. W. Dodge Co., New York 1948.

216 Via Nova, Rome, from Paul Bigot, *Rome Antique*, Vincent Fréal, Paris 1942.

Fragment from the Turgot Plan of Paris 1646.

218 Geodesic film of the city of San Francisco. Courtesy Geodesic Survey, U.S. Department of the Interior.

219 Aerial view of Bamandu Farmsteads. Courtesy ORSTOM, Paris 1952.

222 Stairway in a Farm near Gondola, Switzerland. Photo courtesy G. H. Kidder Smith.

Battlement stairs, from Viollet-le-Duc. Michelangelo, Sistine Chapel. Photo Anderson, Florence.

228 Pulpit in St. Andrew Church, Antwerp. Silver table centerpiece for the coronation banquet of Tsar Nicholas II. From *Le Magasin Pittoresque*.

I am also indebted to Dr. Funk Hellet for the source of most of the material about absolute proportion. He was the first to show the remarkable relation between φ and π and to bring out the existence of an esoteric unit in Egyptian metrology. I refer the reader to his excellent books on the subject, particularly De la Proportion (1951) and La Bible et la Grande Pyramide (1956), both published by Vincent, Freal & Cie, Paris.

I also wish to acknowledge the courtesy of the authors and publishers who made it possible for me to use quotations from their books:

Page

32 JEAN COCTEAU: *Le Rappel a l'Ordre*, Marguerat, Paris 1923.

50 PAUL VALÉRY: *Regards sur le Monde Actuel*, Gallimard, Paris 1931.

76 PLATO: *Critias*, The Dial Press, Little and Ives Co., New York 1936.

79 HERODOTUS: *History*, by George Rawlinson. Appleton & Co., New York 1859.

100 IKHNATON: *Hymn to the Sun*, from T. Eric Peet, Schweich Lectures of the British Academy 1929, *A Comparative Study of the Literature of Egypt, Palestine, and Mesopotamia*, Oxford University Press 1929.

124 THOMAS GRAY: *A Long Story*, Little, Brown & Co., Boston 1857.

156 PROCLOS: *The Eudemian Summary*, 64,3-68,6. Translation by John F. Davies, Dublin 1889.

172 PERCY GOETSCHIUS: *The Structure of Music*, Theodore Presser, Philadelphia 1934.

204 EMILE BURNOUF and L. LEUPOL: *Selectae e Sanscritis Scriptoribus Paginae*, Maisonneuve, Paris 1867.

224 HENRI POINCARÉ: *The Foundation of Science*, The Science Press, Lancaster, Pennsylvania 1946.

226 ALBERT EINSTEIN: *On Science*, in *Cosmic Religion*, Covici-Friede, New York 1931.

232 ANTOINE DE SAINT-EXUPÉRY: *Wind, Sand, and Stars*, Harcourt, Brace & Co., New York 1939.

It is also my great pleasure to thank all the technicians for their patience and understanding in setting, proof-reading, and printing this book, particularly Mrs. Marjorie Schorr, Mrs. Eva Morgan, Mrs. Elizabeth Petrikenas, James Palek, and Howard Rasch, and in executing the final engravings, especially Albert Lindquist, Frank Kuda, and Harold Fornoff. I owe a particular debt of gratitude to James Powell for having guided my first steps in the art of book design.

And finally I want to express my deep appreciation to the publisher, Mrs. Theobald, who made this book a reality and all along gave me precious advice and encouragement.

ELKHART, October 1960

P. J. G.